art:21

Robert Adams

Allora & Calzadilla

Mark Bradford

Mark Dion

Jenny Holzer

Pierre Huyghe

Alfredo Jaar

An-My Lê

Iñigo Manglano-Ovalle

Judy Pfaff

Lari Pittman

Robert Ryman

Laurie Simmons

Nancy Spero

Catherine Sullivan

Ursula von Rydingsvard

Interviews by
Susan Sollins

Edited by
Marybeth Sollins

Wesley Miller
Associate Curator

art:21

4

ART IN THE TWENTY-FIRST CENTURY

ABRAMS, NEW YORK

Contents

Acknowledgments

I prepare these acknowledgments with pleasure, in anticipation of this volume's publication and the broadcast of Season Four, *Art:21—Art in the Twenty-First Century*. I am grateful to Art21's extraordinary staff—Eve Moros Ortega, Migs Wright, Wesley Miller, Nick Ravich, Amanda Donnan, Jessica Hamlin, Kelly Shindler, Beth Allen, and Erin Cesta, and former staff members Sara Simonson and Alice Bertoni—for all their contributions to Season Four. I also owe special thanks to Allison Winshel and her colleagues at PBS; Consultant Directors Charles Atlas and Catherine Tatge; and all who worked with Art21 in the filming, editing, and production of Season Four, including David Howe and Ed Sherin, and Lizzie Donahue, Monte Matteotti, Mark Sutton, and Steven Wechsler. I also thank Margaret L. Kaplan of Harry N. Abrams, Inc., publisher of all four Art21 volumes.

For the provision of images reproduced in this volume, I thank Ameringer & Yohe Fine Art; Tanya Bonakdar Gallery; Galerie Chantal Crousel; Double Wide Media; Fraenkel Gallery; Barbara Gladstone Gallery; Marian Goodman Gallery; Galerie Lelong; the Los Angeles County Museum of Art; Matthew Marks Gallery; Metro Pictures; The Moore Space; Murray Guy; Pace-Wildenstein; Pennsylvania Academy of the Fine Arts, Peforma 05; Max Protetch Gallery; Regen Projects; Salon 94; Seattle Art Museum; Sikkema Jenkins & Co.; and Sperone Westwater Gallery. I especially acknowledge Lisa Albaugh, Vanessa Bergonzoli, Bettina Bruning, Tyler Cufley, Sophie Dufour, Jeanne Englert, Samm Kunce, Cristobal Lehyt, Mindy McDaniel, Febienne Stephan, and Art21 interns Nora Herting, Milena Hoegsberg, Muna Qamar, and Karen Seapker, all of whom assisted in compiling information for this volume.

The support and involvement of Marybeth Sollins, who edited this volume, created the text from my interviews with the artists, and assisted me with the Introduction, has been invaluable. Her editorial skills, wisdom, and calm have made this book possible. To Russell Hassell, the designer who has applied his magical touch and talent to create this fourth splendid Art21 publication, I extend affectionate gratitude and admiration. Once again he has designed a book that mirrors Art21's spirit and philosophy. Wesley Miller worked ceaselessly with artists and galleries to select the images for the book and made important contributions in all phases of its production. We are grateful to him for his attention to myriad details.

To the artists in the series, I extend my grateful appreciation for their generous and open participation in the series and its ancillary education projects. To my steadfast friends, Agnes Gund and Susan Dowling, I send heartfelt thanks for support and belief in this entire endeavor. In closing, I wish to acknowledge the extraordinary generosity of the individuals, foundations, and corporations listed here.

Susan Sollins
Executive Producer & Curator
Art21, Inc.

Art21 Funders

The Art21 Board of Trustees
The National Endowment for the Arts
Agnes Gund and Daniel Shapiro
The Nathan Cummings Foundation
Public Broadcasting Service
JPMorgan Chase
The Andy Warhol Foundation
 for the Visual Arts
Bloomberg
Horace W. Goldsmith Foundation
The Bagley Wright Fund
The Gilder Foundation
Margie and Nate Thorne
Anonymous
The Lawrence Levine Charitable Fund
The O'Grady Foundation
Daniel P. and Nancy C.
 Paduano Foundation
Mary and Patrick Scanlan
Francis H. Williams
New York State Council on the Arts
M. Joseph and Caral G. Lebworth
Norman S. Benzaquen
Jeffrey Bishop
David Teiger

Introduction

Protest, Ecology, Paradox, and *Romance* —these are the thematic divisions of the fourth season of the broadcast series, *Art:21—Art in the Twenty-first Century,* and this companion volume. At first glance, perhaps, they may not seem qualitatively different from those of past seasons. But look a little deeper and you will find that these themes lead us to an undeniably political perspective comprised of many points of view, each provocative in its own right. As the end of the first decade of the twenty-first century approaches, the topics of the day are ideological conflict, ecology and environmental change, and population displacement due to war or ethnic strife, among other issues—all of which stem in part from the tumultuous events and changes of the twentieth century. Given the troubled times in which we live now and the backgrounds of the artists included here, it is no surprise that politics (broadly defined as the examination of our place in global society and culture) is the thread that binds our themes together. Many stories lie beneath the surface of the interviews collected in this volume. Formative (and transformative) experiences of displacement, immigration, acculturation, and adaptation to new places, languages, and social networks affected the young lives of almost half the seventeen artists profiled here. These are bilingual and trilingual artists with roots in Chile, Colombia, Cuba, England, France, Germany, Martinique, Poland, Puerto Rico, Spain, and Vietnam, whose works and conversations reveal direct experience of war and its aftermath, revolution, social upheaval, and the mixing of histories and cultures. For the native-born American artists who complete Art21's fourth-season roster, there have been equally transformative experiences, albeit tempered until 2001 by our country's generally complacent belief in the protective power of geographic isolation. The nature of our own sociopolitical backdrop—wars; covert interventions abroad; exploitation of natural resources and disadvantaged peoples; and internal divisions characterized by antipathy toward those perceived as outsiders (expressed in still-unresolved issues of racism, homophobia, and anti-choice and anti-immigrant politics)— has provided equally powerful inspiration for artists born and raised here.

Still, beauty—thought to be dismissed by most artists today—is present, though the terms of its consideration clearly move beyond the purely visual toward the political and philosophical. For Iñigo Manglano-Ovalle, beauty lies in the realm of high aesthetics where it's hard to discern whether one is discussing the beautiful or monstrous, good or evil. "Are they so intertwined," he asks, "that we can't locate either one?" Lari Pittman equates the managed aesthetics of his work and life with personal safety: "Beauty is not an additive. . . . It's ideological, political, and conceptual." Robert Adams, reflecting on beauty, says, "I hold onto that word; I refuse to surrender it." Beauty is "the confirmation of meaning in life . . . the one thing that is invulnerable, in some cases, to our touch." Adams, like Manglano-Ovalle, begs us to note a deeper context in all that we see. Does beauty survive or even surmount the collective horrors of our time? Alfredo Jaar and An-My Lê, in their respective investigations of the atrocities in Rwanda and the subject of war and landscape, seem to answer affirmatively. Beauty is a frequent, if sometimes unintentional, corollary of work that comments upon, protests, and investigates the state of the world and reality. This is not beauty for beauty's sake, but it is beauty nonetheless. Is it perhaps intrinsic to life, the necessary counterpoint to life's darker side?

"My idea of art," says Mark Dion, "isn't necessarily something that provides answers or is decorative or affirmative. I enjoy . . . things toward the dark side that tend to have a more critical function. That's what I see as the job of contemporary artists—to function as critical foils to dominant culture." Viewed superficially, Dion's *Neukom Vivarium* (2006) resembles a kind of optimistic and positive ecological art. But look more carefully. Although the work celebrates the continuing life of a diverse, living bio-system, it is also redolent with melancholy and mourning—a memento mori. It is a tool for discourse about the ultimate reality that confronts us today: the destruction of the natural world. In a controlled environment, Dion illustrates the difficulty of replacing nature's life-sustaining

processes. He shows us nature (reality) 'recontextualized', nature on life-support. Look more carefully, too, at Robert Ryman's fifty-year-long experiments with form and his exploration of the act of painting. Instead of just looking at white in his paintings, try looking at reality. "I don't think of my painting as abstract because I don't abstract from anything. It's involved with real visual aspects of what you're looking at . . . with real space, the room itself, real light . . . surface . . . shadow," says Ryman. "The paintings do not signify anything other than how they work in the environment." Like many of Dion's projects, Ryman's persistent investigation of the nature of the real questions the assumptions, the authoritative 'givens', of generations of viewers and critics. With clarity of purpose and fierce independence, he follows an inherently political path.

Mark Bradford, like Mark Dion, holds a mirror to the present, to memory and social history. "An artist has a choice," he says, "to be as political or apolitical as anyone else who's making choices. I don't think an artist is necessarily apolitical if he or she doesn't make overtly political work. For me, the subtext is always political." The formal beauty in his work rests atop layered surfaces of materials scavenged from commercial signage in his community. Bradford's videos address politics and culture. Of *Practice* (2003), a video of himself playing basketball while wearing a hoop skirt, he says, "I'm being very iconoclastic. You just don't put a hoop skirt on a black male body and go play basketball. . . . The dress was an obstacle. For me, it was really about roadblocks on every level—cultural, racial, gender." Lari Pittman also acknowledges political resonance in his work. Recent paintings, titled after the rooms of his house, reveal the difference between residential space and public space in terms of aesthetics and safety. For Pittman, public space is intrinsically male and heterosexual, while residential space allows for more polymorphous identity. The chaotic quality of American culture, he says, gives him a freedom on

which he thrives in his work and in his life, but its homophobia and "the aggressive strains in American culture wonderfully put me in my place." For Robert Adams, "the nature of photography is to engage life." Through the medium of perfectly composed images, his engagement addresses a different strain of American aggression—the destruction of the natural environment. Of his earliest work, he says, "I thought that I was taking pictures of things that I hated, that were inexcusable. But there was something about these pictures that was beautiful." Adams continues to make images of landscapes that contain the beautiful and the hateful. He states without equivocation that we are now "compelled to recognize that we have no place to go but where we've been . . . which is oftentimes pretty awful, and see if we can't make of this place a civilized home. We've in a sense built a house, but we haven't made a home."

Shadows of postwar Europe's social and political upheaval hover over the personal histories of Ursula von Rydingsvard and Judy Pfaff, both of whom were born in Europe and experienced the aftermath of World War II. Elements of those early experiences surface in their work and in their studio practices. Von Rydingsvard remembers her early life in postwar refugee camps, the wooden barracks in which she and her family lived, the simple utensils they used, and the texture of her childhood clothing. All this resonates in her choice of material and form for her sculptures. "I feel like I drank from the world through visual means," she says. "My home was one in which words were not used very often. . . . Anybody that used too many words was automatically suspect." For Judy Pfaff, words are too specific and perhaps also suspect. Of her work, she says, "The work is a kind of system. . . . If I said what I really thought, things would be so literal . . . so sometimes I do this canceling thing. If it gets too 'one thing', I will try to overlay it with another so it doesn't get too literal . . . poetic . . . tough . . . too anything, too

red." Pfaff considers herself extremely romantic. "A lot of the work is about my life," she says. For this reason, "there has to be a scrim, structural . . . , physical . . . , a tool" to temper emotion, evidence perhaps of an unexpected political interplay between rationality and romance.

Of her childhood experience of the Vietnam War, An-My Lê says, "I think we're all dealt a card in life, and I used to think that I was dealt a very difficult one. Then I came to realize that it has made my life richer and that it has been a great foil for my work." Without conscious intention, Lê has always tried to understand the meaning of war. She photographs landscape in such a way to suggest history—universal, personal, and cultural. Fascinated and repelled by military structure and strategy, she seeks the "idea of the sublime— moments that are horrific, but . . . beautiful, moments of communion with the landscape and nature" within her investigation of war. Le considers her work ambiguous and says it's meant to be. War is an inextricable part of history, she says, but can we not avoid it?

Questions abound in conversations with all the artists included here. But critical interrogation of the status quo plays an especially important role in the work of such apparently disparate artists as Pierre Huyghe, Iñigo Manglano-Ovalle, and Jennifer Allora & Guillermo Calzadilla. Huyghe's simple, visual metaphor of a moving door causes us to ponder whether we are inside or outside, here, there, or nowhere. "I guess if the doors are moving, there is no more inside or outside. It's definitely about boundaries and culture, and fluidity," he says. And the neon sign, *I do not own Snow White,* asks us to question the meaning of ownership— individual, collective, corporate—of culture itself. Like Manglano-Ovalle whose childhood exposure to the work of the consummate modernist, Mies van der Rohe, deeply affected his ideas about art and identity, Pierre Huyghe is also interested in modernity. And so he creates and questions fiction and reality in *A Journey that*

Wasn't (2005)—a vast whiteness of a film that may or may not have been set in Antarctica. How are we to know? For Allora & Calzadilla, critical questioning and engagement with the world are essential to their collaborative practice (itself a challenge to the norm). "What is the nature of this thing that's affecting me or that's around me? What is the nature of my actions upon others or the place where I am at this moment?" *Under Discussion* (2005), a film conceived of the metaphor of a community discussion table that the artists turned into a boat, celebrates the resolution of the power struggle between the islanders of Vieques (the former U.S. Navy bombing range) and the U.S. government. "For us," say the artists, "it is specific to Vieques . . . but it also reverberates in other places and other contexts." Allora & Calzadilla's work often grows out of a juxtaposition of opposites, melding metaphor into paradox, to create something new that seems to be the perfect expression of their critical thinking. How does one put together so many apparently incongruous things? "You use glue," they say. "Glue can be an idea or a word. You use an ideological glue."

Musings about ethics and morality, nature and culture, art and science, and current events echo and re-echo throughout this volume. And the work of Iñigo Manglano-Ovalle seems to reverberate with all of them. "All my work, even the most formal work, has an underlying politics to it," he says. "But I don't want to reveal my position. The moment I reveal my position is the moment that I think art is about telling you something I know, and that you should know it. I'm more interested in . . . creating moments in which people have the possibility to think and take a position. Ultimately, for me, art does not reside in the object. It resides in what's said about the object. That's where it makes change."

Like Nancy Spero, who says that her art can be said to be a protest, Jenny Holzer has long been thought of as an artist who is a political activist. Both women tackle difficult subjects—torture, the atrocities of war, obscenity, cruelty, injustice, the condition of women—but also revel in visual beauty in works such as Spero's *Cri du Coeur* (2005) and Holzer's *For 7 World Trade* (2006). But, says Holzer, "I do make work that focuses on unnecessary cruelty, in the hope that people will recoil." And Nancy Spero says, "Maybe the strongest work I've done is because it was done with indignation. I just do what I do, and if people want to take something from it I'm thrilled because that gets my message to the world." For Alfredo Jaar, every work is a response to a real-life event—most often a tragedy. "To make sense of a certain reality or situation is an essential part of my work," he says. "I strongly believe in the power of a single idea. So the most difficult thing for me and, I think, for most artists is to clean up—to arrive at the essence." Trained as an architect, Jaar rejects descriptive labels that characterize him as a conceptual or political artist: "I'm an artist, and believe it or not I'm interested in beauty and I'm not afraid of it. It's an essential tool to attract my audience, and sometimes I use it to introduce horror because the audience has to be seduced." In his six-year investigation of the atrocities in Rwanda, Jaar made twenty-one pieces. "They all failed," he says. "I kept looking for the perfect way to communicate that experience to my audience. Of course, there is no way. . . . How do you transfer this into a work of art? I have no idea." Jaar rejects the label 'political', but his work teaches us to confront the ultimate political realities—Rwanda, Angola, AIDS, corporate and government exploitation of the disadvantaged.

Catherine Sullivan, in whose work performance and staging are central, is fascinated with the transformative potential of acting. Sullivan's work explores the nature of public address, assembly, and interlocution, she says, "to get at something about social engagement which is abstract and doesn't have to do with speech, but with a combination of a lot of different phenomena." Of the movement style that is characteristic of her work, Sullivan says, "The content itself suggests oppressive cultural regimes to which I would like the movement to be analogous. There's a place . . . where automation . . . is like a kernel of mindlessness. It's meant to be frightening because it's arbitrary." There is a very different kind of dramatic staging—in diminutive form—in Laurie Simmons's early work. In those still, pristine versions of reality, Simmons presented the notion of frozen time. She expected viewers to believe that they were "entering a real place . . . where time stood still." Simmons was looking back to the perfect equilibrium of childhood, creating images of the American dream—reflections on a way of life that existed only in the imagination. Was this not also a reflection on 'real life' and something darker—the anxiety of the Cold War period? In Simmons's film, *The Music of Regret* (2006), nostalgia, romance, and beauty still play roles as important as those of the puppets, dummies, and dancing objects of her earlier work. But now regret plays the most important part of all. Can we imagine anything farther removed from Catherine Sullivan's delineation of the brutality of mindless regimes than Simmons's sweet, melancholic film? Nonetheless, it tells a related story. "It's about the different guises of regret," says Simmons. "The whole country's in a state of regret . . . no matter what you think . . . no matter what side you're on."

And so we return to politics, the thread that binds our themes together. Throughout these pages I have said, "Look more carefully . . . look a little deeper." This perhaps is the most meaningful tribute we can offer the artists presented here. To look deeply is to thank them for the gifts they give us—those courageous questions they ask. Alive to the world, they look outward with unfailing clarity of vision, observing and absorbing a complex reality. Alive to the world, they give the world back to us with powerful insight in works that are thoughtful, glorious, challenging, provocative. Look: politics and beauty.

Susan Sollins

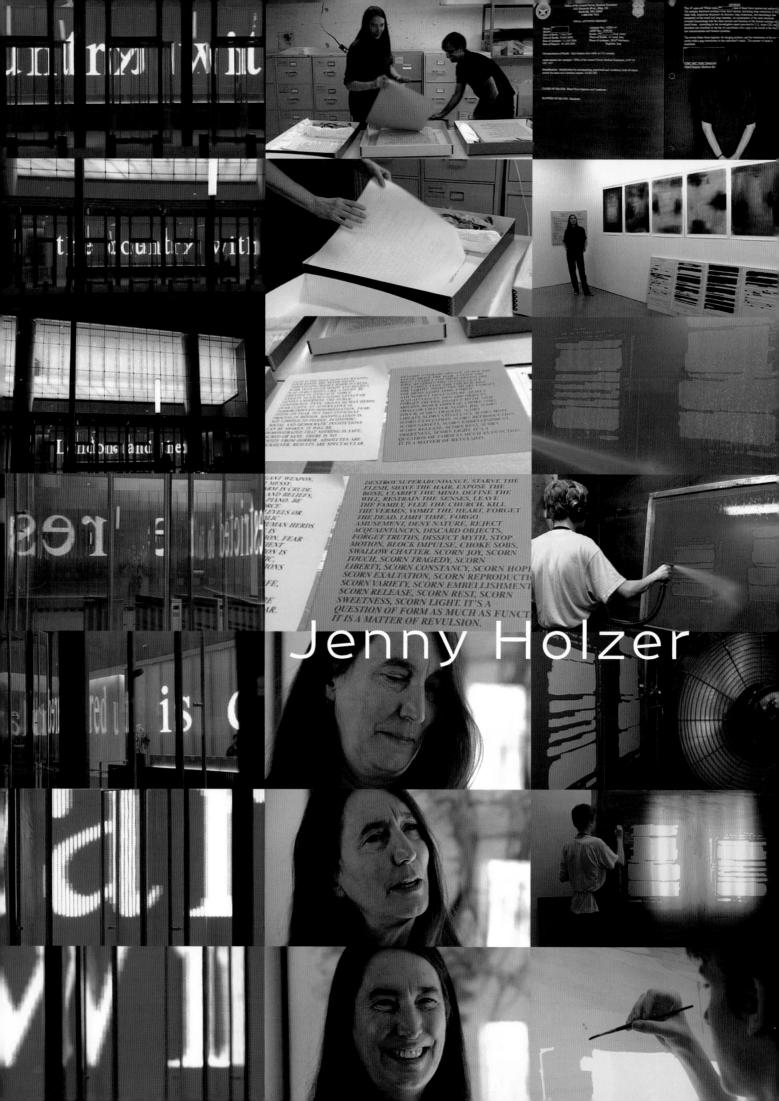

DESTROY SUPERABUNDANCE. STARVE THE
FLESH, SHAVE THE HAIR, EXPOSE THE
BONE, CLARIFY THE MIND, DEFINE THE
WILL, RESTRAIN THE SENSES, LEAVE
THE FAMILY, FLEE THE CHURCH, KILL
THE VERMIN, VOMIT THE HEART, FORGET
THE DEAD. LIMIT TIME, FORGO
AMUSEMENT, DENY NATURE, REJECT
ACQUAINTANCES, DISCARD OBJECTS,
FORGET TRUTHS, DISSECT MYTH, STOP
MOTION, BLOCK IMPULSE, CHOKE SOBS,
SWALLOW CHATTER. SCORN JOY, SCORN
TOUCH, SCORN TRAGEDY, SCORN
LIBERTY, SCORN CONSTANCY, SCORN HOPE,
SCORN EXALTATION, SCORN REPRODUCTION,
SCORN VARIETY, SCORN EMBELLISHMENT,
SCORN RELEASE, SCORN REST, SCORN
SWEETNESS, SCORN LIGHT. IT'S A
QUESTION OF FORM AS MUCH AS FUNCTION.
IT IS A MATTER OF REVULSION.

Jenny Holzer

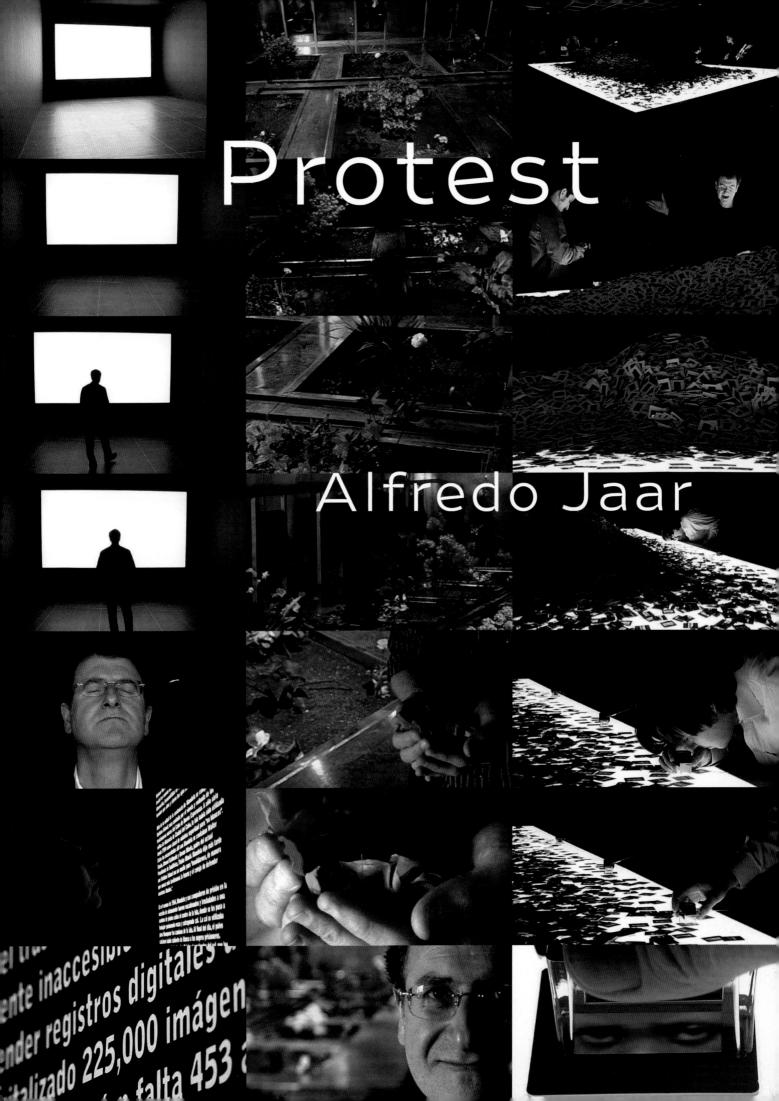

Protest

Alfredo Jaar

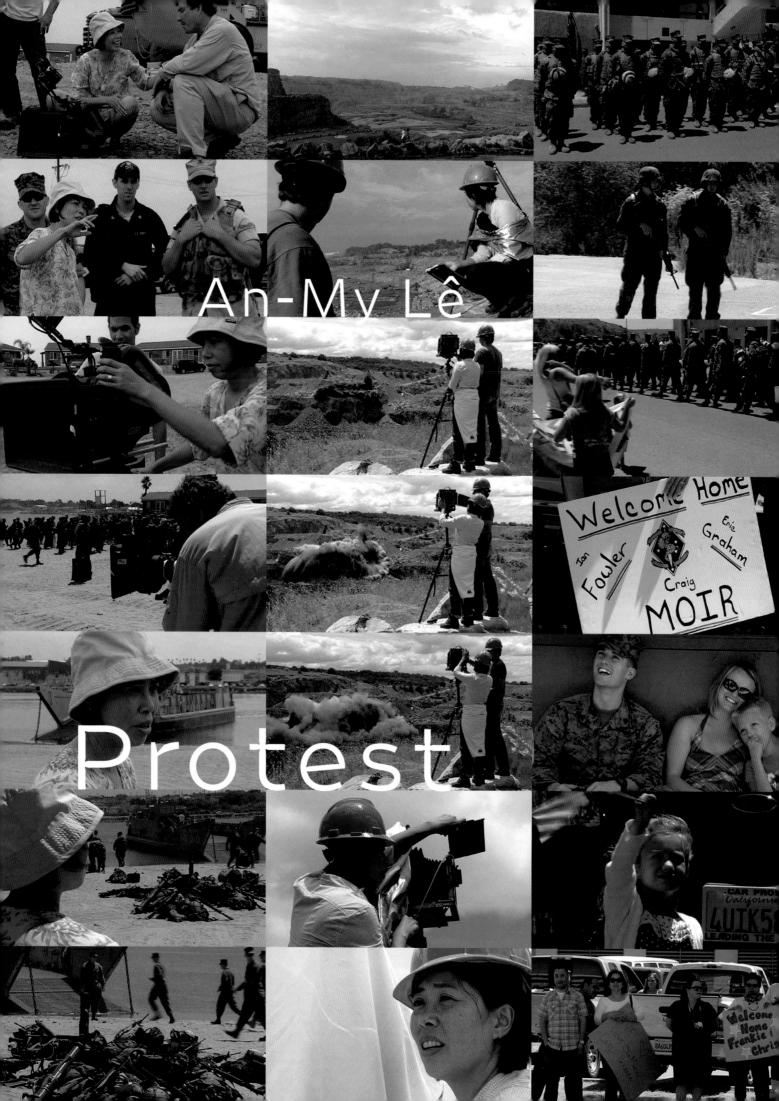

An-My Lê

Protest

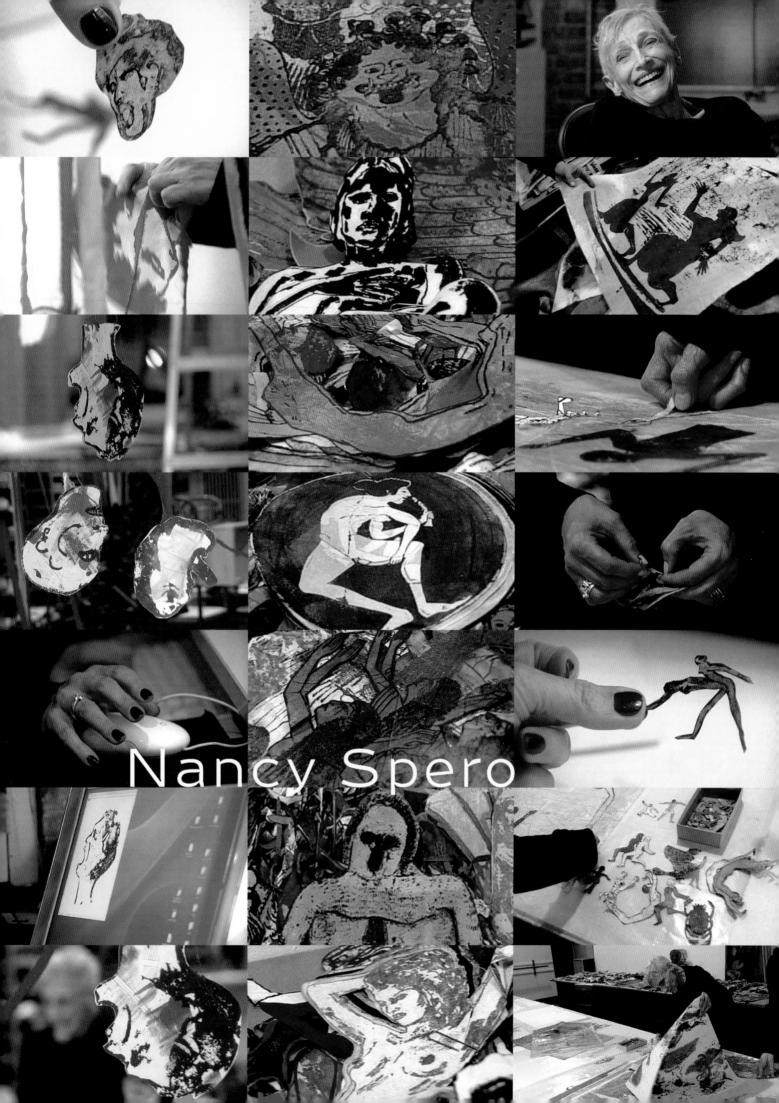

Nancy Spero

Jenny Holzer

I was invited to make something for the lobby at 7 World Trade Center. After much stewing, I came up with the idea of doing text in the wall—not memorial text, but text about the joy of being in New York City. I despaired of writing for the piece, as I often do, and I came to poems by a number of different authors—everyone from Walt Whitman to William Carlos Williams, Elizabeth Bishop, and many more. I stopped writing my own text in 2001. I found that I couldn't say enough adequately, and so it was with great pleasure that I went to the texts of others. I'd begun practicing that for projects such as the one at the Reichstag, where I went to the stenographic records of what had been said by various political parties about everything from the boundaries of Germany to the role of women in society. After doing that, I started looking at this as a solution for projects such as *For 7 World Trade* (2006). It's clear that my work is not poetry. Occasionally people have charged me with it not being poetry and they're correct. I've always been certain that it's not. It might take the shape of a poem, but that has nothing to do with literature. It has to do with the demands of the medium on which I place it. The space at 7 World Trade Center demanded that I fill the lobby—in particular, the glass wall—and I thought that the text should float by. To make the piece, I had to look at a number of drawings and renderings, make quite a few site visits, and not only stare at the space but walk it and feel it. After innumerable visits I finally had some confidence in what I should do next. I like to make pieces that fill interiors. Glass walls are my friends because they let people outside see what's happening inside.

RIGHT
For 7 World Trade, 2006
Electronic LED sign
7 World Trade Center, New York

OPPOSITE
Xenon for Bregenz, 2004
Light projection
Kanisfluh, Austria

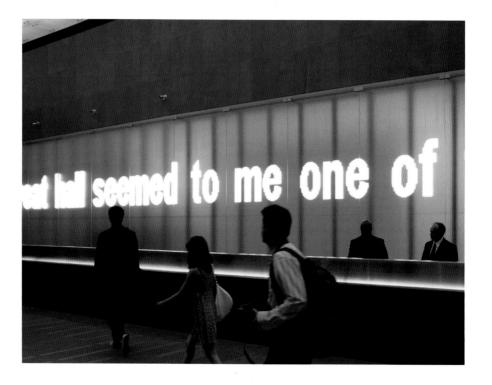

14

Department of State TELEGRAM

SECRET

AN: 0030761-1027

SECRET

PAGE 01 BAGHDA 03163 01 OF 02 261207Z
ACTION SS-25

INFO OCT-00 COPY-01 NEA-00 SSO-00 7026 W
 376X5 261210Z /21

P 261150Z DEC
FM USINT BAGHDAD
TO RUEHC/SECSTATE WASHDC PRIORITY 6150
INFO AMEMBASSY ABU DHABI
AMEMBASSY AMMAN
AMEMBASSY ANKARA
AMEMBASSY CAIRO
AMEMBASSY DAMASCUS
AMCONSUL JERUSALEM
AMEMBASSY JIDDA
AMEMBASSY LONDON
AMEMBASSY MUSCAT
AMEMBASSY QATAR
AMEMBASSY PARIS
AMEMBASSY TEL AVIV
AMEMBASSY TOKYO
USCIO ROMOH
USMISSION USNATO
JCS WASHDC
AMEMBASSY ROME
USMISSION USUN NEW YORK

S E C R E T SECTION 01 OF 02 BAGHDAD 3163

E.O. CAPTION REMOVED S/S (EX) ON 11/29/
DEPT PASS S/SN TOM WILLI

E.O.12356 DECL OADR
TAGS: PREL, MOPS, IZ, US, XF
SUBJ: FOLLOW UP ON RUMSFELD VISIT TO SUDA

1. SENSITIVE TEXT
SECRET
SECRET

PAGE 02 BAGHDA 03163 01 OF 02 261207Z

2. DECEM R 26, I CA UNDERSECRETARY-S AF AT

Jenny Holzer

LEFT
Inflammatory Essays, 1979–82
Installation view at Fundació
Caixa de Pensions, Barcelona, 1990
Offset posters

BELOW, LEFT
Inflammatory Essays, 1979–82
Offset poster

OPPOSITE
President, 2004
Red pine log branded with text
Johanniterkirche, Feldkirch, Austria

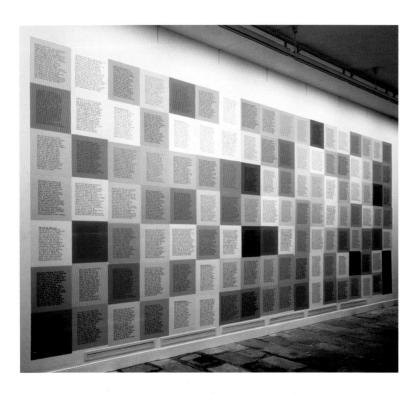

*DON'T TALK DOWN TO ME. DON'T
BE POLITE TO ME. DON'T
TRY TO MAKE ME FEEL NICE.
DON'T RELAX. I'LL CUT THE
SMILE OFF YOUR FACE. YOU
THINK I DON'T KNOW WHAT'S
GOING ON. YOU THINK I'M
AFRAID TO REACT. THE JOKE'S
ON YOU. I'M BIDING MY TIME,
LOOKING FOR THE SPOT. YOU
THINK NO ONE CAN REACH YOU,
NO ONE CAN HAVE WHAT YOU
HAVE. I'VE BEEN PLANNING
WHILE YOU'RE PLAYING. I'VE
BEEN SAVING WHILE YOU'RE
SPENDING. THE GAME IS
ALMOST OVER SO IT'S
TIME YOU ACKNOWLEDGE ME.
DO YOU WANT TO FALL NOT
EVER KNOWING WHO TOOK YOU?*

Often, I'll use the first person in my work.
I will assume that voice. Or I will represent
many people in the first person. There are
lots of *I's* and *You's* in the *Inflammatory
Essays* (1979–82), but they're not me.
They're many different voices on a host
of unmentionable subjects. I'm present
in the choice of the subjects addressed
in the work, in the form that they take,
and the places they go. There's a reason
I'm anonymous in my work. I like to be
absolutely out of view and out of earshot.
I don't sign my work because I think that
would diminish its effectiveness. It would
be the work of just one person. I would
like it to be more useful than that—to be
of utility to as many people as possible.
I think if it were attributed to me it would
be easier to toss. I want people to con-
centrate on the content of the work and
not 'whodunit'.

I was invited to see what would make
sense to put in the middle of an aban-
doned church in Austria. And Henri Cole's
poem, "To the 43rd President," burned into
a tree seemed right at the time. I'm reluc-
tant to characterize someone else's poem,
but it seemed something between a prayer
and a reproach. In the poem there are a
number of questions that are addressed
to the president. And the poem was a live
question in the church. The Church is much
invoked recently, so we put this question
in the center, dead center, of the sanctuary.
This church, like many, is symmetrical.
The axes are important. We put this in the
middle because the questions are central.

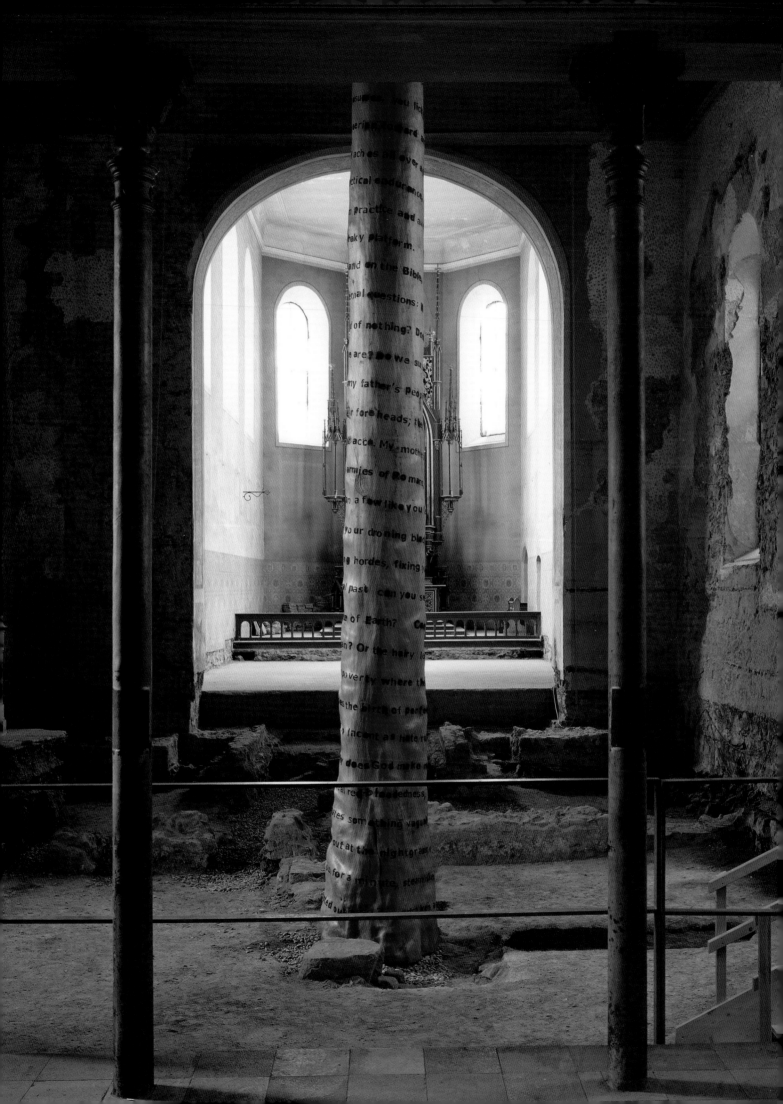

WAKING HUNGRY FOR FLESH

WAKING HUNGRY FOR FLESH

WAKING HUNGRY FOR FLESH

WAKING HUNGRY FOR FLESH

WAKING HUNGRY FOR FLESH

WAKING HUNGRY FOR FLESH

WAKING HUNGRY FOR FLESH

WAKING HUNGRY FOR FLESH

WAKING HUNGRY FOR FLESH

Jenny Holzer

OPPOSITE
Purple Cross, 2004
Installation view at Galerie
Yvon Lambert, Paris, 2004
Electronic LED sign

RIGHT
Truisms, 1977–79
Spectacolor electronic sign
Times Square, New York, 1986

BELOW, RIGHT
Truisms, 1977–79
T-shirt worn by Lady Pink, New York, 1983

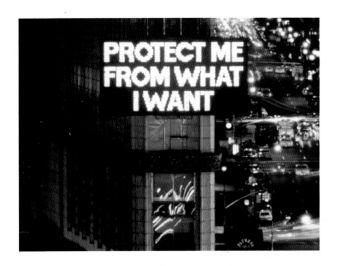

It has always been hard for me to write, as I think it is for anyone who wants to write well. I was pleased to leave it, and I have no idea whether I'll write again. One reason why I stopped was because I tend to write about ghastly subjects. So it's not just the difficulty of having something turn out right, but it's also the difficulty of staying with the material long enough to complete it. It's necessary to be emotionally engaged when writing about these topics. It's exhausting.

The *Truisms* (1977–79) were perhaps an overly ambitious attempt to make an outline of everything that I wanted to do. I'm not sure I knew that at the time I wrote them, but that's what I've come to recognize. I wanted to have almost every subject represented, almost every possible point of view, and then I had to sort out what those sentences should appear on. That turned out to be the street posters. Subsequent series had different demands because they had to fit in any number of places. I had to find the right medium, be that stone or electronics. So I tried to sort this out as I went. I'm afraid to talk about values these days. Usually, any time values are invoked, it's to dismiss or maybe incarcerate somebody! I do make work that focuses on unnecessary cruelty, in the hope that people will recoil. I would like there to be less fear and cruelty.

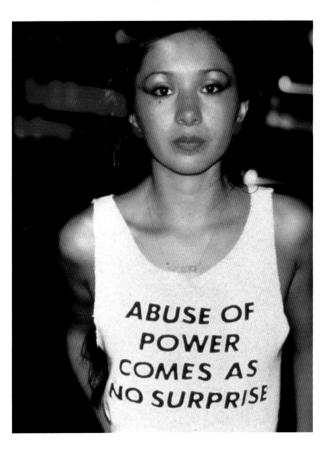

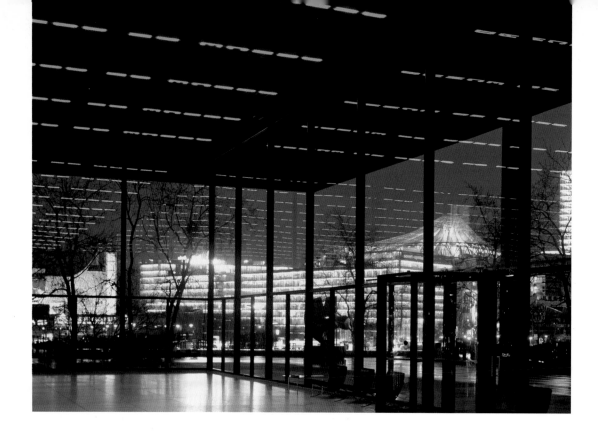

The big installations not only include the creation or choice of the text, but they also have much to do with filling the space and programming the electronics. That programming includes pauses, flashes, phrasing, and more. I really like the programming aspect. I was a typesetter, and typesetting is not unlike programming. You have to make text correct, complete, and pretty—and fitted. The presentation needs to make sense with the content and then needs to engage people. The poetics come from poetry by others, not from myself, but what I can contribute is something like a visual poetics that can have to do with the color, the pauses, the omissions. I don't know how to program, so I'm reliant on others to do it, but I participate. We often decide what to do in the place, at the site of the installation—not in advance. We will have our ideas about what's going to happen and then we go and see if they were right. And, often, they aren't—and we'll fix them. There are many ways to have it wrong—if it's boring, if it seems wrong for the content, if it doesn't complete the space—and often you can't tell until you're there. We don't have much time to rehearse. We can pre-think, but often we have just a few days before something opens to test the ideas in the real space. So it's hair-raising.

I like my pieces to be very short, at moments, and other times I want them to be sustained and capable of holding people's interest. It's a practice that bounces back and forth between a very quick burst to a very slow projection. I try to set it up so that a piece can work in five or ten seconds. But I also want the installations to be full so that, if someone is willing to dedicate the time, there's a lot there. Time is an especially important consideration with the public works because I know that people going by won't have much of it. But when I'm working indoors I want to offer a lot, so that if people are willing to lie down on the floor, they will be rewarded. It was more than a little intimidating to work in the Mies van der Rohe building in Berlin because it is a perfect building. That's what stymied me for a while. It didn't need or want any art, and I didn't want to spoil it in any way. One doesn't want to make an imperfect mess in a masterpiece. I visited the building many times. Finally I realized that melting the building might be interesting. I did that with LEDs in the ceiling and, courtesy of the glass walls, the reflections from the LEDs made it seem as if the building were infinite, and the amber color seemed to liquefy the top.

Jenny Holzer

ABOVE AND OPPOSITE
*Installation for Neue
Nationalgalerie,* 2001
Electronic LED sign
Neue Nationalgalerie, Berlin

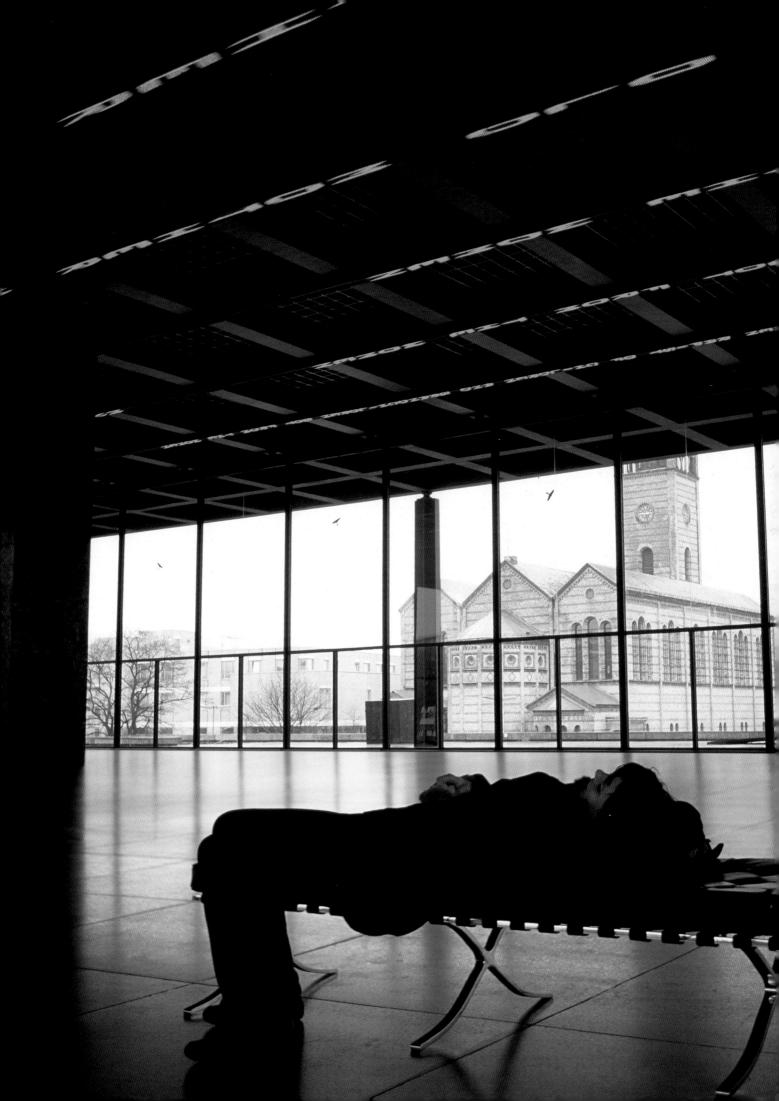

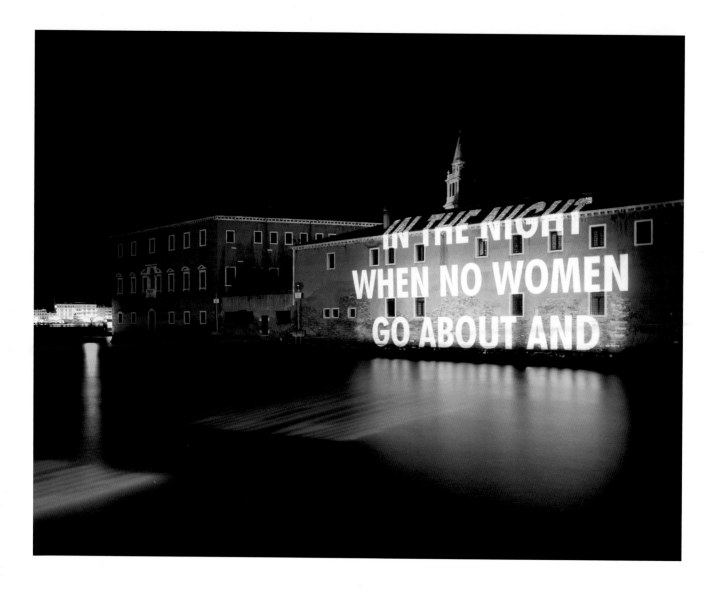

Jenny Holzer

ABOVE
Xenon for Venice, 1999
Light projection
Fondazione Cini, Venice

OPPOSITE
Xenon for Oslo, 2000
Light projection
Lillehammer Skijump, Norway

I've been able to do two projections in Venice. The water in cities like Venice and Florence amplifies the projections. It will make another copy or two or three of the text, and so we'll have the text backward and forward and backward again. It seems accurate to have the text legible and knowable and then—a second later—to have it in a form that's almost unrecognizable. That's like being able to get or not get the meaning. I want the meaning to be available but I also want it sometimes to disappear into fractured reflections or into the sky. Because one's focus comes and goes, one's ability to understand what's happening ebbs and flows. I like the representation of the language to be the same. This tends not only to give the content to people, but it will also pull

them to attend. When I work in a building with glass, I know that there will be reflections but I don't know what kinds. And when I work on a river, I know that there will be reflections, but I don't know how they will break and how many there will be. So it's a combination of being able to anticipate some things and then being able to learn from what I have seen over the years and try to incorporate that the next time. I started doing the projections in 1996, and have been working on those since. Xenon is a word that describes what used to be in the lamps of the projectors. I've clung to it because I just like the word. The projectors are exceptionally powerful and, because they're so bright, they let me throw text on mountains and rivers and on giant buildings.

YOU SPIT ON THEM
BECAUSE THE TASTE
LEFT ON YOUR TEETH
EXCITES
YOU SHOWED HOPE
ALL OVER YOUR FACE
FOR YEARS AND THEN
KILLED THEM

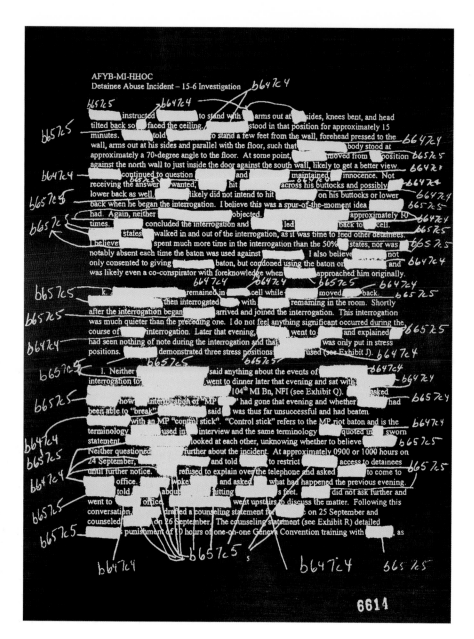

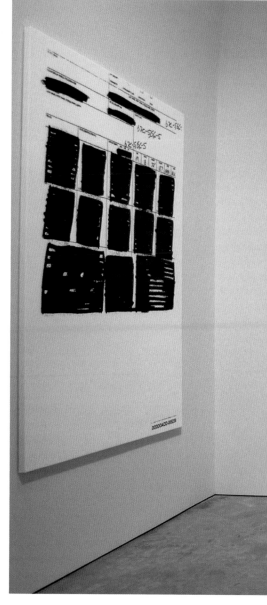

Jenny Holzer

I'm not the best qualified to figure out what I have to do with art history or what art history has to do with me, but I know that I've always admired Goya's black paintings. These are what I would do if I could. I've been walking up to the black paintings for so many years, and I couldn't figure out what they meant to me. I think I salted that away, though, and when the material started coming out about the conflict in Afghanistan and Iraq, and about the camps in the Middle East and Guantanamo, Goya was at hand. I loved being a painter at the Rhode Island School of Design, but I wasn't good enough. So I put that away for a long, long time. It wasn't until I started working with these secret documents that I decided that they could be paintings. I was very lucky to find Ben Snead, who also graduated from RISD, to paint the grounds for me. He's a master painter; I'm a theoretical one. My contribution is finding the text and figuring out what color should go with what. We looked at the colors in Goya's black paintings, and we went to the ochres and deep browns and black, cadging what we could from Goya reproductions and then trying to have it make sense for these documents. We wanted some paintings to be pretty enough that you would want to walk up to them and see the terrible things that have transpired in Guantanamo or

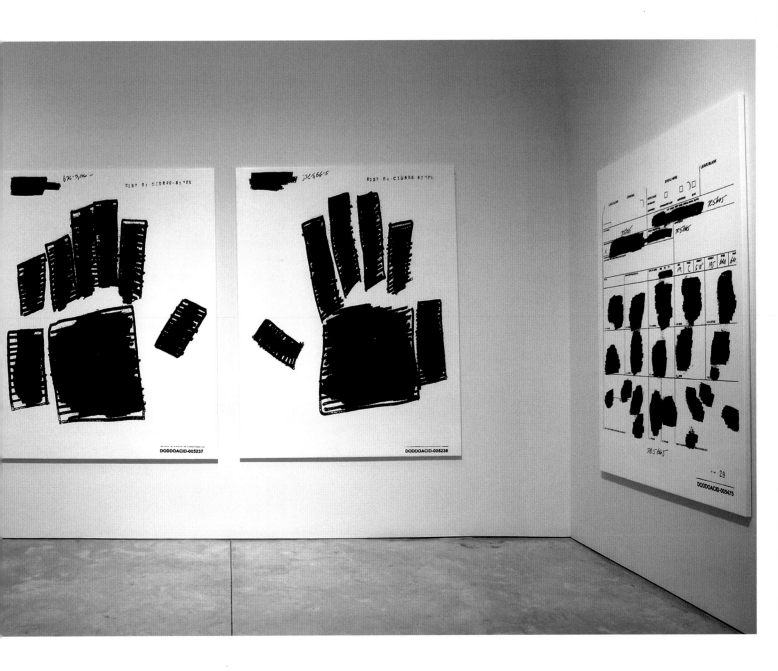

Afghanistan. Others we wanted to be black and white so they seem credible—as real as the documents unfortunately are. I've focused on documents about the conflict in the Middle East, both the last Gulf War and this one. I've only worked with material that's already been released. I have not made any Freedom of Information Act requests because there's so much to sift through that's already out. I draw from everything—from the National Security Archives collection to old material from the FBI's website to postings by the ACLU. I concentrate on the content. It tends to be very rough material about what's happened to soldiers in the field, about the good and bad choices they've been forced to make,

and what has happened to detainees and civilians. I also go to material that's almost completely gone, either whited out or blacked out, because that represents the issue. You don't have to spill words when the page is completely black. The most compelling texts are the ones in the first person, and the ones that are handwritten. It's often the handwriting of someone who's been charged with transcribing, not the handwriting of the victim. Most of the paintings are only three times page-size because I wanted them to refer to the real documents. Others I made very tall so that they would be physically overwhelming—so that they would be the same as the information is in its effect. I made a number of

paintings of redacted handprints because this seemed an extreme example of what's been happening—that there was once a body, and then the body was blacked out. We have found handprints of dead people, and these are extraordinary. I turn these handprints into paintings with apologies to the dead, and then I move to make them as precise, as clear, as possible. In addition to all the paintings—the still works—I wanted to have a moving message piece so that I could include more text than is possible in the paintings. So we had any number of declassified documents transcribed, and we showed them on LEDs so that the writing would stream by like more bad news than one can bear.

Alfredo Jaar

I've never been capable of creating a single work of art that just comes from my imagination. I don't know how to do that. Every work is a response to a real-life event, a real-life situation. That's why I always describe myself as a project artist. I'm not a studio artist. I do not create works in my studio. I wouldn't know what to do. I do not stare at the blank page of paper and start inventing a world coming from my imagination. My imagination starts working based on research, based on a real-life event—most of the time, a tragedy—that I'm just starting to accumulate information about, to analyze, to reflect on. But the original impulse is the event to which I'm trying to respond. A few years back I was always reading five, six, ten newspapers a day. Sometimes in New York, they would come a day late. Today, with the Internet, it's much easier. I start my day early in the morning, spending maybe an hour or an hour-and-a-half looking at the news. I'm interested in the world. I'm fascinated by what's happening in the world. There is no fiction better than this reality that surrounds us. So I analyze the news. I'm interested in the way different media convey the news.

RIGHT AND OPPOSITE
Gold in the Morning, 1986
Installation at Venice Biennale, 1986
Lightboxes with color transparencies, metal boxes, gilded frames, and nails
Overall dimensions variable
Collection Museum of Contemporary Art, San Diego

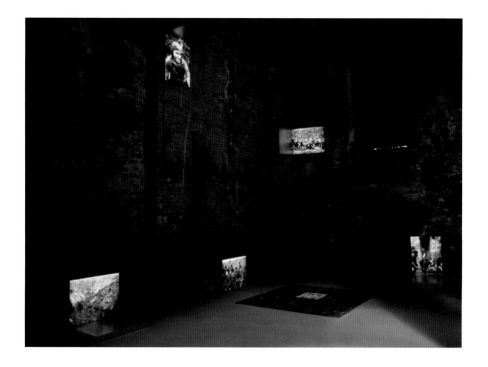

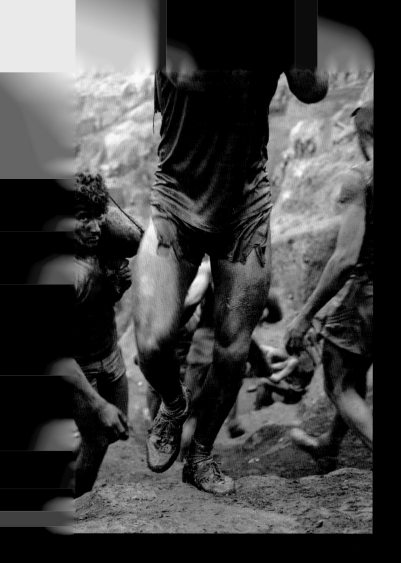
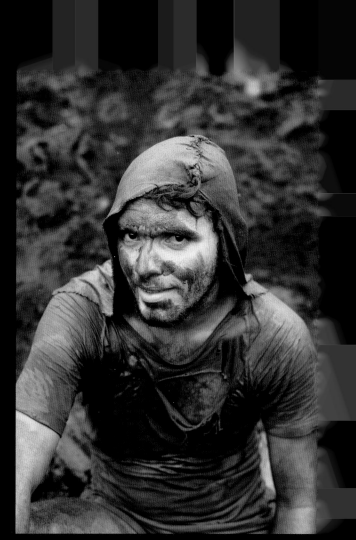
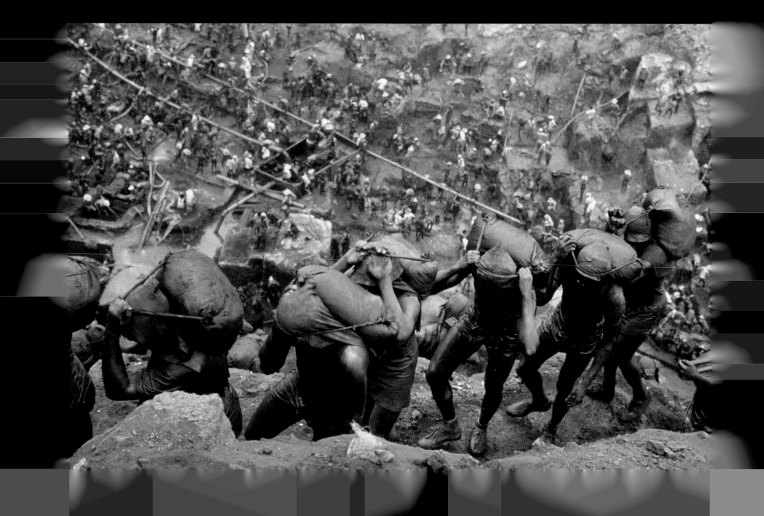

Alfredo Jaar

RIGHT AND BELOW
One Million Finnish Passports, 1995
Installation view at Museum of
Contemporary Art, Helsinki, 1995
One million replicated Finnish
passports and glass
31 x 315 x 315 inches

OPPOSITE
The Skoghall Konsthall, 2000
Public intervention
Skoghall, Sweden

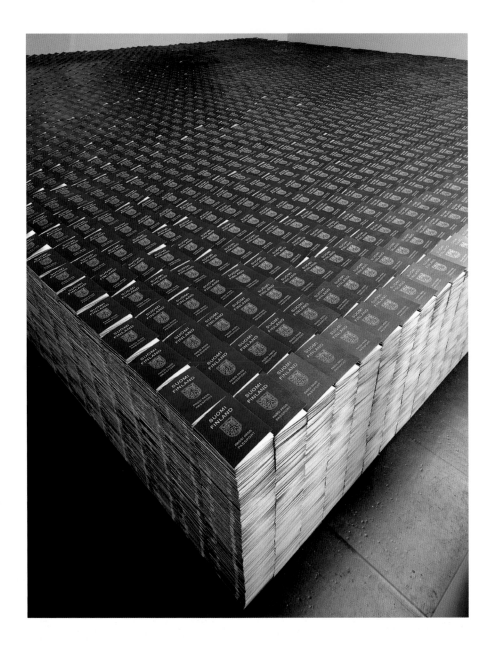

I can actually say that I became an artist when I discovered Duchamp and what he did with the Readymades, when he gave the artist the freedom to say, "This is art because I name it." That was what interested me. I didn't have to study art. I didn't have to use any particular material. I could work with ideas and then find the right materials for those ideas. People look at my work, see a hundred pieces in the last twenty-five years, and think they're done by fifty different artists because I move from material to material according to the issues I'm dealing with. My way of thinking is Cartesian, coming from my French education. I'm very logical. To make sense of a certain reality or situation is an essential part of my work. I could say that everything I know about art, I learned as an architect. As an architect, I give myself a program, taking into account a specific space. Space is not just physical. It's also social, cultural, political. Studying the space, I try to reach what we call the essence of the space. Then I combine that with the essence of what I am trying to say. All these elements are incorporated in the program, in which I have an objective. One very important element is the economy of means. I strongly believe in the power of a single idea. So the most difficult thing for me and, I think, for most artists is to clean up—to arrive at the essence. Most artworks today try to say thirty-seven things at the same time. I try exactly the contrary. When you reach that essential idea, it's extraordinary.

Alfredo Jaar

Muxima, video stills, 2006
Digital video with sound on Mac Mini
computer, 36 min

I have a very strong emotional link with Africans, and I think that is present in the way I approach my work. Africa has been exploited and now completely abandoned by the rest of the world. The United States has never cared about Africa and now, suddenly, they're in Angola. Why? Because Angola is offering them ten percent of their oil production. I first traveled to Angola without a camera. That's the way I work. The first visit or two, I control myself and I do not shoot. I just observe because I would like to understand first, capturing that essence I was talking about before. I didn't set up the scene that I'm going to tell you about, but I learned that it happens every Sunday morning in exactly the same way and I wanted to use it in my film, *Muxima* (2005). There is a beach on the outskirts of Luanda and the scene is very dramatic because you see old tankers and refineries just offshore. Every Sunday morning on that beach you see these kids playing in a beautiful choreography. When you look at it from a distance you marvel at the dance of their bodies. For me, that dance was a sign of innocence. And because of the physical presence of the oil industry right there I immediately thought, "How much of the benefit of that oil industry are they actually getting? How are the lives of these children affected by the billions of dollars coming into the country?" The answer is in the film, and the answer is none. I felt that this scene was a poetic way to show their innocence and dreams of a better future in that landscape.

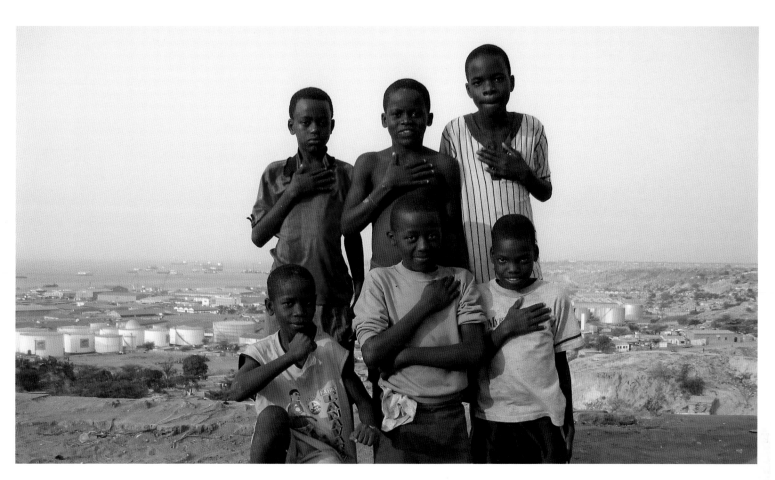

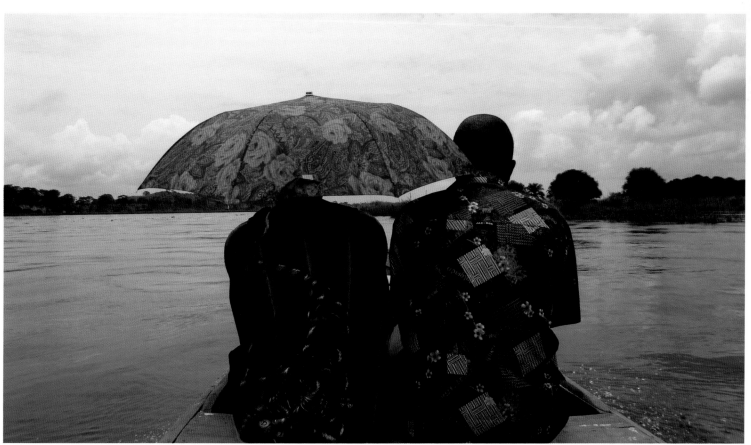

Alfredo Jaar

Rwanda Rwanda, 1994
Public intervention in Malmö, Sweden
Offset print, 68½ x 46½ inches
Edition of 100

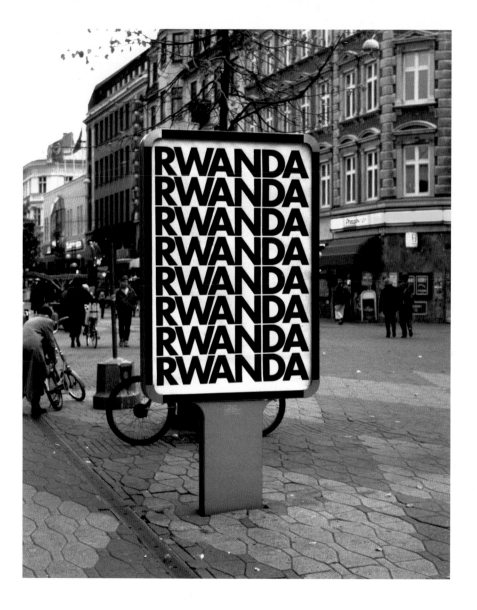

In the case of Rwanda, I followed the tragedy from the beginning. I was outraged at how we were told this was happening. *Yesterday, 35,000 bodies were recovered; they were floating on the Kagera River.* 35,000 bodies, and it was just a five-line story on page seven. "I have to go," I thought, "there is something I have to say about this." It was the most horrific experience in my life. We went to gather evidence, myself and one assistant. We spent time talking to people, photographing the situation. We accumulated probably 3,500 images of the most horrific things—so much so that when I got back to New York, I didn't want to look at them. But when I finally had the courage to analyze them I realized that I couldn't use them. It didn't make sense to use them; people did not react

to these kinds of images. Why would they react now? I was starting to think that there must be another way to talk about violence without recurring to violence. There must be a way to talk about suffering without making the victim suffer again. How do you represent this, respecting the dignity of the people you are focusing on? That's why the Rwanda project lasted six years. I ended up doing twenty-one pieces in those six years. Each one was an exercise of representation. And how can I say this? They all failed. I kept looking for the perfect way to communicate that experience to my audience. Of course, there is no way: you cannot represent reality. The work is always the creation of a new reality. So how do you build this new reality that, one way or the other, translates the lived experience?

Alfredo Jaar

The Silence of Nduwayezu, 1997
1 million slides, light table, magnifiers,
and illuminated wall text
Table: 36 inches x 217 ¾ inches x 143 inches
Text: 6 inches x 188 inches

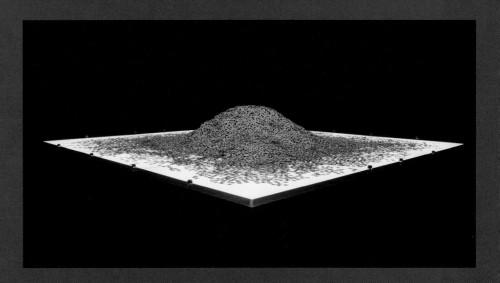

If I kept going for such a long time on the Rwanda project it was because I was first outraged by the international community's reaction—the barbaric indifference. It was going so much to the essence of what it means to be a human being because, as I am trying to tell you, when you witness something like this you're ashamed of being a human being. It's as simple as that. You're ashamed. So how do you transfer this into a work of art? How? I have no idea. *The Silence of Nduwayezu* (1997) is one of my last attempts. I was still trying to reach that moment when you finally manage to articulate the issue and communicate it to the audience. Because of my background as an architect, I design every work based on a program. The program here was to tell a story in a very dark space and to enter a space of light where—instead of light—we find another kind of horror. Sometimes light is liberating and light is hope. Here, light is horror. It reveals the eyes of this kid who witnessed a genocide that we did not want to witness. I'm interested in that moment when the audience takes a look. They look at the eyes very carefully, and that is the moment I'm looking for—when their eyes are a centimeter away from the eyes of Nduwayezu, who witnessed what we didn't want to see. Nduwayezu actually saw his mother and father killed with machetes. His reaction was to remain silent for approximately four weeks. He couldn't speak. His eyes were the saddest eyes I had ever seen, so I wanted to represent that and speak about his silence—because his silence refers to the silence of the world community that let this happen.

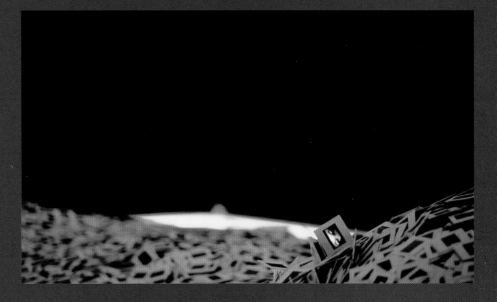

Alfredo Jaar

ABOVE
Infinite Cell, 2004
Iron bars, painted wood, and mirrors
145⅝ x 177⅛ x 102⅜ inches

OPPOSITE
Let One Hundred Flowers Bloom, 2005
Installation view at Museo d'Arte
Contemporanea Roma, 2005
Zinc platform, 25 zinc containers, nine
compact axial fans, air conditioning sys-
tem, irrigation system, lighting system,
100 flowers, earth, and video projection
Platform: 26¼ x 26¼ feet
Video duration: 9 min

I was invited to do a series of exhibitions in Italy in 2005. I wanted to make an *homage* to Antonio Gramsci and Pier Paolo Pasolini—two Italian thinkers whom I admire greatly. Gramsci was one of the first thinkers who really believed in the power of culture to affect social and political life. And Pasolini was an artist like no other—a thinker, a filmmaker, a poet, writer, and critic. What brought me to *Infinite Cell* (2004) was Pasolini's com-ment that culture is a prison and that we intellectuals have to get out of that prison. Enough of me speaking to you, and you speaking to me—me applauding you, and you applauding me. Let's get out. Let's reach a larger audience. This could have been my motto for many, many years. *Infinite Cell,* which is part of the *Gramsci Trilogy* (2004–05), is a metaphorical repre-sentation of the cell where Gramsci, one of the founders of the Italian Communist party, died—imprisoned by the fascist gov-ernment of Mussolini. I was also thinking about Jean-Luc Godard's statement that art is not only the reflection of reality, but also the reality of that reflection. This work uses that metaphor as a starting point. I wanted to create a situation where the audience enters the cell, looks out, and asks "What are we doing here? Aren't we in a cell? Is culture a cell? Who am I speaking to? Who cares?" I wanted every person in the audience to feel the size of the cell, which is very tall (Gramsci was a very small man). I expected the audience to feel their bodies compromised by the space. This is a key element in my installa-tions. The body has a language, and I'm interested that when people enter this space their body language changes. I'm interested in those shifts. Architecture and art have the capacity to produce physical changes but, of course, the metaphor here also suggests the possibility of an intellectual change—a mental shift. The most important elements of the work are the mirrors that project us into infinity.

I'm obsessed with mirrors. A mirror is a simple object of daily life, and the perfect articulation of the narcissism of our society—a society that only cares for itself. In *Infinite Cell*, it's about seeing ourselves in infinite projection and thinking about what we want to do as artists, as intellectuals. What do we want to say as producers of culture? And to whom are we speaking? Am I my public, or is it someone else? It also has to do with the horrors of the twenty-first century. This piece is probably one of my most emotionally charged works. Unfortunately, it has a universal life: all countries have histories of horror. And so, in a way, this piece asks, "How do we make art in the world, the way it is now? How do we make art today?"

People describe me sometimes as a conceptual artist, as a political artist, with work of a strong political connotation or social content. I always reject those labels. I'm an artist, and believe it or not I'm interested in beauty and I'm not afraid of it. It

is an essential tool to attract my audience, and sometimes I use it to introduce horror because the audience has to be seduced. If we learned anything from the activist art of the 1960s it is that when you make that kind of work people don't even get close to you. They don't want to see another drop of blood on the floor. So beauty becomes a tool to bring the audience in. And once they are closer, they discover other things. That's a very good metaphor for what life is. We see beauty all around us, and we should never forget the beauty of life. But that doesn't mean that we should just stay with beauty. We should not be afraid sometimes to confront beauty and horror. *Let One Hundred Flowers Bloom* (2005), from the *Gramsci Trilogy*, does that in a very direct way. It is based on a Chinese poem *(Let one hundred flowers bloom / Let one hundred schools of thought contend)* that Mao used in a campaign in the 1950s, calling upon Chinese intellectuals to critique the

Revolution from within. They were afraid, but the campaign lasted a year and, at the end, the intellectuals were convinced that Mao wanted to hear their opinions. They questioned the essence of the Revolution. Mao was unhappy with their reactions, and what the intellectuals feared actually happened. They were imprisoned, tortured, and quite a few were killed. This piece stands as a metaphor for the struggle of intellectuals all over the world. Here are a hundred flowers being subjected to contradictory forces. When you enter the space, some flowers will be alive, some struggling, some dead. Fed with water and light, they're being killed by strong winds and cold. I'm interested in the audience witnessing some dead flowers when they enter the freezer-like structure, and feeling what the plants feel. It's another metaphor to involve the public in an active and physical way, to move them to make intellectual projections. Intellectuals may die—they may be suppressed—but ideas never die.

Alfredo Jaar

Lament of the Images (Version 1), 2002
Three illuminated texts mounted on
Plexiglas and light screen
Text panels: 23 x 20 inches each
Light wall: 6 x 12 feet
Text composed by David Levi-Strauss
Commissioned by Documenta 11, Kassel

At one time I felt that I was getting
too dependent on words, and then I
recovered the power of architecture
to communicate. I decided to stop
using words and let the language of
the piece—meaning the use of light,
scale, and movement—speak for itself.
So I thought it would be interesting to
experiment with light. It became a tool
with which to communicate. I discovered
a new world, and I've been using the
language of light in different fashions,
and in different situations, ever since.
Light has a spiritual element. It's also a
very important healing tool. Our need
for light is essential: no light, no life. And
photography, too, is light (no light, no
image). Light is life; everybody under-
stands it. So I thought that if I used
light, the language of the work would
be easily readable. People could read
light and understand without words
what I'm trying to say. It's another
simple way to connect with people.

Lament of the Images? We are going
through a very paradoxical situation.
There have never been so many images.
We are bombarded with thousands of
them daily, without mercy and without
warning. And most of them ask us to
consume, consume, consume. So how
does an image of pain survive in the
sea of consumption? It doesn't. But the
paradox is that there has never been so
much control of images by governments
and corporations—control of images,
control of our landscape, of this landscape
that affects our lives. What we see is
what makes us. What kinds of thoughts
do we have, based on this landscape
that surrounds us, this landscape that
is so much under control?

An-My Lê

I grew up during the Vietnam War. We lived in Vietnam through many of the offensives and coups. In 1968 after the Tet offensive the Viet Cong took over part of the city for a while. My mother was distraught, and she thought she should try to get us out and live somewhere a bit more peaceful. She received a fellowship to go to France. She took us—the three children—to Paris, and our father stayed in Vietnam as a guarantor. We came back after the Paris Agreement in 1973 and stayed in Vietnam for another year and a half before the war ended. War was part of life for us. People ask, "Wasn't it frightening?" We were really too young to know it the way an adult would. As a child, it's just part of your life and you deal with it when it happens. But I think we're all dealt a card in life, and I used to think that I was dealt a very difficult one. Then I came to realize that it has made my life richer and that it has been a great foil for my work. Without really being conscious of it when doing my work, I've always tried to understand the meaning of war, how it has affected my life, and what it means to live through times of turbulence like that. A lot of those questions fuel my work. You approach different issues at different times of your life. When I first made the pictures in Vietnam, I was not ready to deal with the war. Being able to go back to Vietnam was a way to reconnect with a homeland, or with the idea of what a homeland is and with the idea of going home. As soon as I got to Vietnam, I realized that I was not so interested in the specific psychology of each person. I was much more interested in their activities, and how those activities splayed onto the landscape. It seemed to me that that suggested a lot more about the culture and history of the country. And this was more fitting for me in terms of the way I worked and what I was interested in. There are some people (like Judith Ross) who can photograph one person and somehow suggest a collective history, a collective memory. But it seems that I try to do that with landscape. When you live in exile, things like smells and memories and stories from childhood all take on such importance. So this was an opportunity to reconnect with the real thing, and to be confronted with contemporary Vietnam. It's not the way it was twenty years ago, or the way it's described in folktales my grandmother and mother used to tell me, or even in stories from my mother's own childhood in the North. So I really looked for things that suggested a certain way of life—agrarian life—things that connect you to the land. Unfortunately, pictures don't smell, but if I could do that they would be about smells as well.

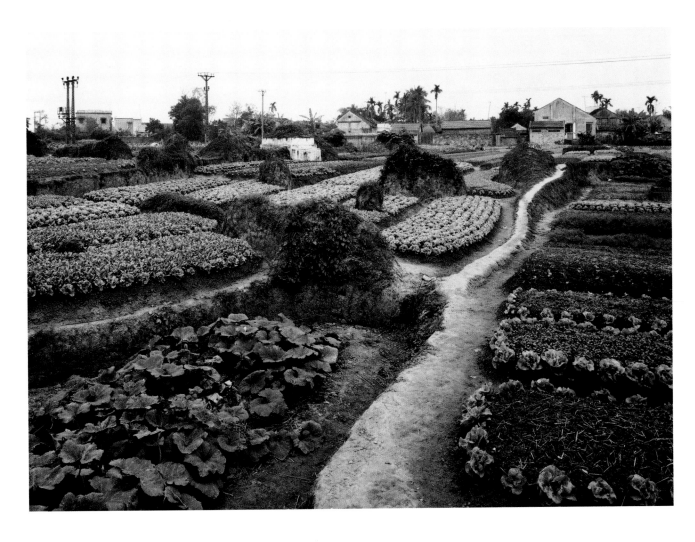

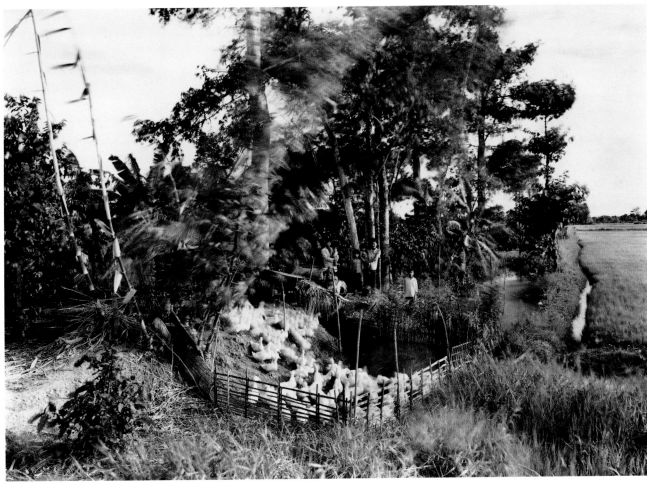

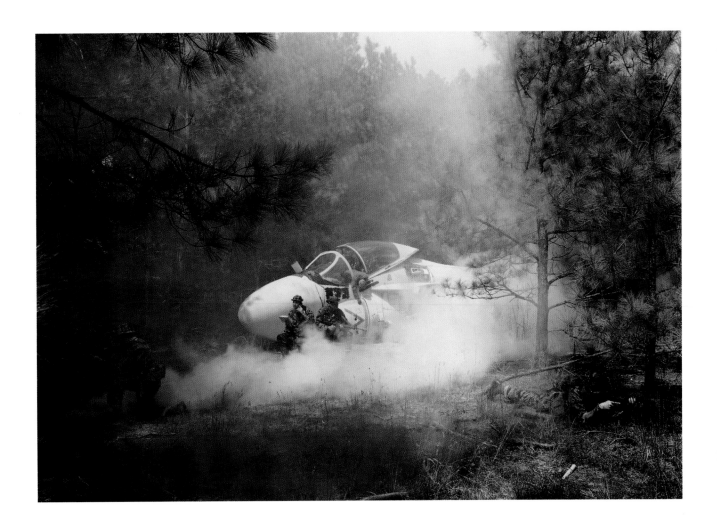

An-My Lê

OPPOSITE, ABOVE
Small Wars (sniper II), 1999–2002
Gelatin-silver print, 26 x 37½ inches
Edition of 5

OPPOSITE, BELOW
Small Wars (explosion), 1999–2002
Gelatin-silver print, 26 x 37½ inches
Edition of 5

ABOVE
Small Wars (rescue), 1999–2002
Gelatin-silver print, 26 x 37½ inches
Edition of 5

I think each body of work grows out of the last one because you resolve something and then feel ready to move on to tackle another issue. But after my work in Vietnam it was obvious that I had still not tackled the issue of war, so when the opportunity to work with a group of people who were reenacting scenarios of the war presented itself, I took it. The Iraq war had not started, and this was the only way to deal with the idea of war— with something that had happened so long ago. Working with reenactors was difficult. They had their own activities, and I needed to interrupt them to set up my pictures. And, working with the large-format camera, I had to direct them somewhat. At one point I wondered if I should hire actors— but I'm glad that I didn't because not having complete control was very interesting.

It created moments of uncertainty and forced me to resolve issues in a different way. The pictures of the reenactors shy away from some of the more subversive scenes that they performed—whether taking prisoners or their rough handling of the other camp. I didn't find it fruitful to dwell on that or try to replicate some of the horrific moments that happened during the war. I stayed away from that, and obviously that comes from my personal background. But with the help of the reenactors, this was a way to direct my own movie without having the means and potential to be my own director. I don't have such a great imagination, so seeing certain things that they did inspired me. I was able to make a Vietnam War that was ultimately safe, a game. In that way, I was able to bring in my own experience.

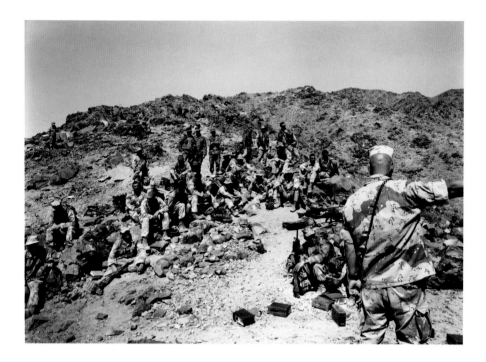

When I became a photographer one of the first things I learned from speaking to other artists who had more experience was that unless you're a conceptual artist it's best to draw from what you know the most. And what did I know the most? It was how much of a mess my life was, and trying to make sense of it and the questions of war and destruction—how things are still unresolved with the Vietnam War in America. That's something I wanted to touch, as well as the representation of war in movies and, now, the war in Iraq. I was distraught when the war started in March 2003, and I felt my heart going out to the soldiers being sent to Iraq. I wanted to explore that and to know more about how we were preparing for the war. My immediate impulse was to go to Iraq. But that did not work out, and when I saw pictures of marines training in Twenty-Nine Palms I thought it could be a stand-in for Iraq. The kind of work that I make is not the standard political work. It's not agitprop. You would think, because I've seen so much devastation and lived through a war, that I should make something that's outwardly antiwar. But I am not categorically against war. I was more interested in drawing people into my work to think about the issues that envelop war—representations of war, landscape and terrain in war. When I'm working with the military, I still think of myself as a landscape photographer. My main goal is to try to photograph landscape in such a way that it suggests a universal history, a personal history, a history of culture. But I also wanted to address issues of preparation (moral and military). It drew me in, but at the same time it was repellent. I'm fascinated by the military structure, by strategy, the idea of a battle, the gear. But at the same time, how do you resolve the impact of it? What it is meant to do is just horrible. But war can be beautiful. I think it's the idea of the sublime—moments that are horrific but, at the same time, beautiful—moments of communion with the landscape and nature. And it's that beauty that I wanted to embrace in my work. I think that's why the work seems ambiguous. And it's meant to be. War is an inextricable part of the history of high civilization; I think it's here to stay. But I also think we need to try to avoid it as much as possible. I was not so interested in making work that you see on the news page, which has the effect of wanting you to condemn war immediately. I wanted to approach the idea in a more complicated and challenging way.

An-My Lê

ABOVE
29 Palms: Infantry Officers' Brief, 2003–04
Gelatin-silver print, 26 x 37½ inches
Edition of 5

OPPOSITE, ABOVE
29 Palms: Mechanized Assault, 2003–04
Gelatin-silver print, 26 x 37½ inches
Edition of 5

OPPOSITE, BELOW
29 Palms: Night Operations III, 2003–04
Gelatin-silver print, 26 x 37½ inches
Edition of 5

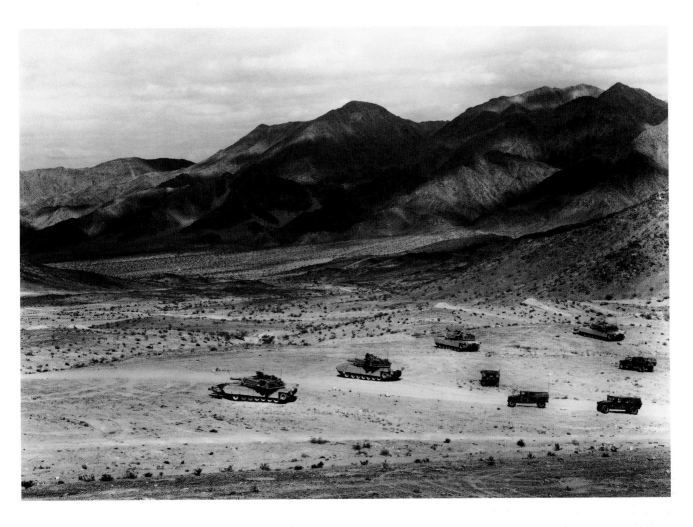

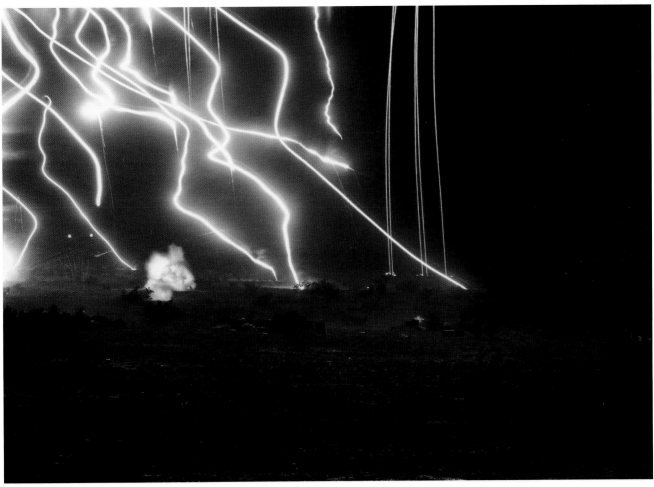

An-My Lê

Work in progress, 2006–07
Archival pigment print, 26 x 38½ inches

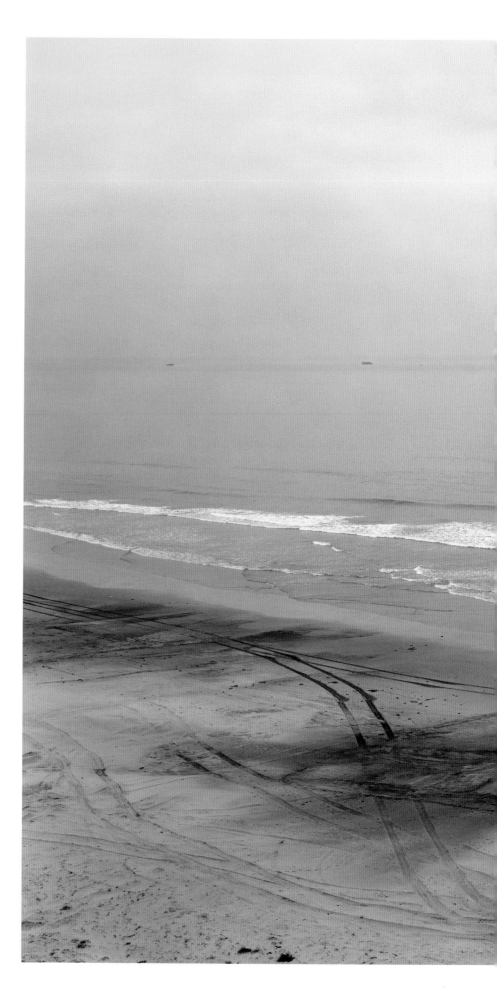

Black and white was always my choice because of my interest in drawings. A black-and-white photograph is just more pronounced because it's all about lines and the changes are tonal, from grays to darker grays to blacks and to whites. So drawing is conserved in the black-and-white palette. What's interesting to me is that the fact that color is removed somehow makes certain things more obvious. One is not distracted by the fact that it's connected to real lives—or perhaps I should say that black and white is a little bit more removed from real life than color photography is. It is removed from reality—it's its own thing. People talk about black and white and how it's associated with memory, but that doesn't really work for me. They also talk about it being old-fashioned or obsolete, but I think it is very contemporary. It's so unlike anything else and so removed from reality that if you use the right subject matter it can be very powerful. I thought of using color for the project on the military and the sea mostly because I was drawn to the way color would describe a gray on the hull of a ship versus a gray that's more organic—the gray of the ocean at certain times of the day or the gray of the sky on an overcast day. I don't think black and white could distinguish between a cold or metallic gray and something that may have a bit more warmth and that's more organic. That's my only reason for switching to color, and that's a good instinct. I tend not to like garish things, so I have probably developed my own palette—which is black and white, and color—perhaps. I'm learning and, over time, I think I'll develop my own color palette.

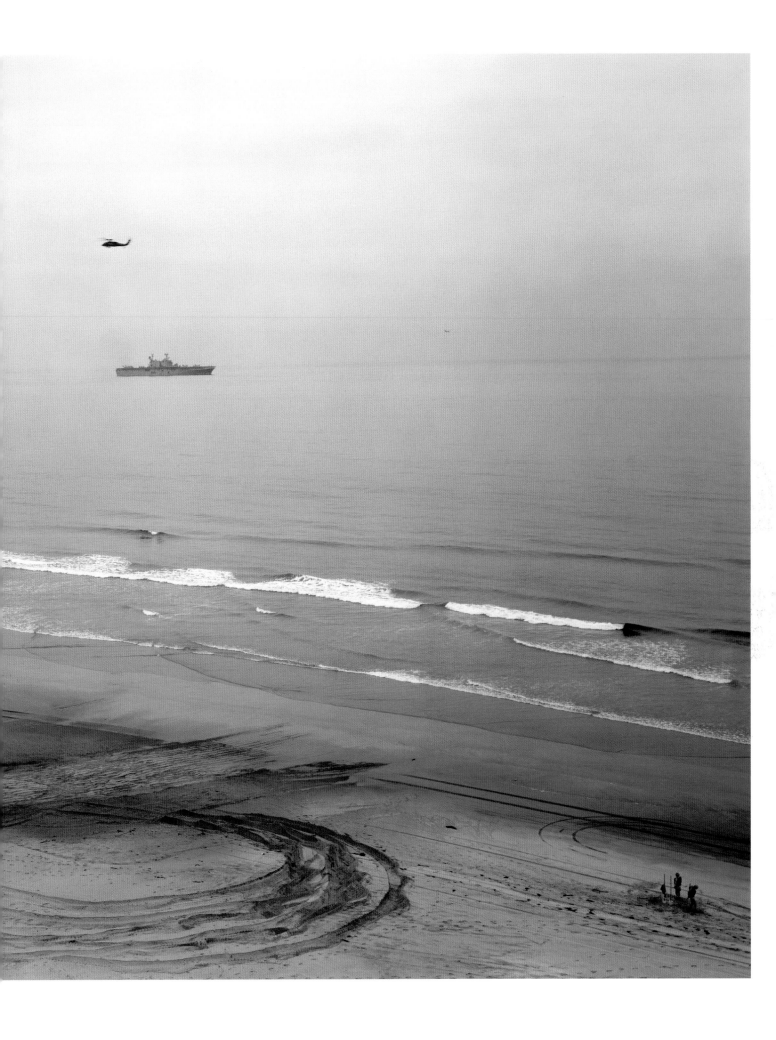

An-My Lê

BELOW AND OPPOSITE
Works in progress, 2006–07
Archival pigment prints, 26 x 38½ inches

I think about the horizon a lot. Do you want the horizon to be in the middle of the picture? Do you want it to be a third? For me, it's usually balanced by whatever is below the horizon. Sometimes I feel that a picture needs a lot of air, so I will give it more sky and lower the horizon. It's not always that much of an issue for me. You know, I see the image upside down on the ground glass and it's very intuitive how it's balanced out. It's always a question of air versus solid ground. Being at sea, you really start paying attention to the horizon and how it's defined. Sometimes it's very sharp; sometimes it's hazy. Sometimes there are residues of colors on the edge. It's something I was mesmerized with. I love Hiroshi Sugimoto's work, and I've always paid close attention to his horizons—always at the same place. But that was not my interest. I saw a helicopter coming down, and the idea of photographing it just before it hit the horizon became of utmost importance to me. This reinforces the idea of the helicopter flying, just floating on air. That's

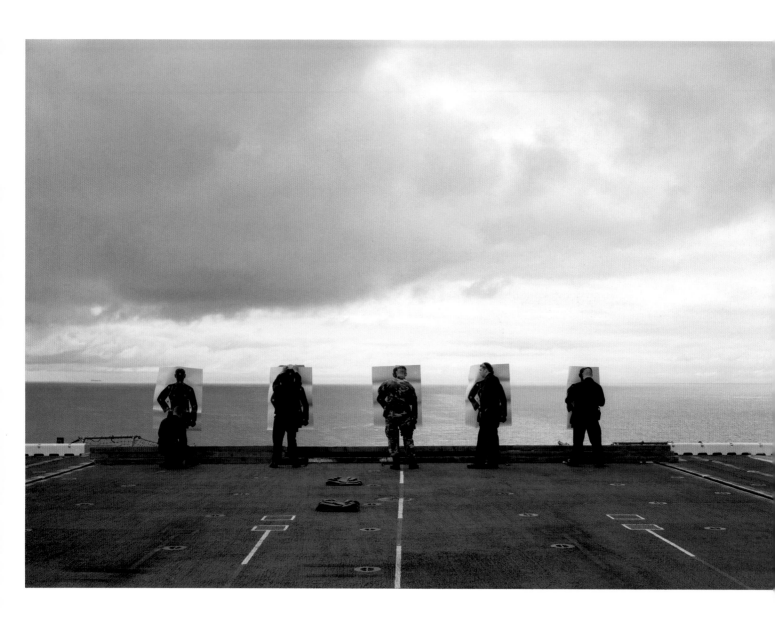

what they do, of course, but this visually reinforces that idea or describes it in a way that I hadn't seen before. I think there's always an element of something not quite understood in the sublime, something otherworldly, conflicting—something beautiful that's not always beautiful, and something that's not quite controllable and not within our reach. I don't think that photography is made to capture and describe magic, but there are great magical moments in still photographs. I feel so much more confident about the kind of photography I do now. It has answered a lot of the questions and the anxiety I had as a graduate student—feeling that I wasn't doing enough as an artist. Looking at the picture of the helicopter hovering above the horizon is magic for me. It gives me great confidence in the wonderful stuff that straight photography can do. It's about discovering new things, going somewhere. It's about having your expectations defied, and being able to take advantage of the moments—the gifts—that one is offered, and just being open, receiving them, and grabbing onto them. I don't know what the future holds for this kind of work. Things always go in waves and cycles. At one point people were talking about a return to straight photography. But maybe this is the end of it already and we've moved on to something else that I don't even know about. I'm very optimistic for this type of photography and the joy and satisfaction it has given me, I'm constantly being surprised by what I see, what I learn, and—once in a while—by a great picture.

An-My Lê

When you photograph the real world, you cannot escape the reality of it. But I think the magic of photography happens when you can escape the facts—the factual aspect of what's being represented. One is always striving to suggest something beyond what is described. It's something I'm very aware of. Someone who doesn't know straight photography would have issues with this and, maybe, would see my work as plain documentary. It does describe certain facts. But I think the strength of it comes from what I can suggest that was not in the photograph at first—what was not in what I saw, and not in the situation itself. A quarry's just a quarry—just a pit. The landscape could be a battlefield from World War I or II. Maybe there are overtones of devastation

and catastrophe—things exploding and being broken down. But within that context, the pictures are also about renewal. Something's been taken away, but the vegetation is growing back, and it's about life coming back again. I'm interested in landscape and the way history can be suggested through landscape—a history of war, a cultural history, an industrial history—any sort of history. So I was also really intrigued with the mill, which was in a shambles and falling apart. Most of it hadn't really been touched since the 1920s, and I was intrigued by the contrast between something that looked like the beginning of the industrial era and something that was part of the contemporary working of a quarry. I'm very interested in the way the industry and landscape relate

to each other, and the tension from that relationship is what interests me most. I was originally thinking about the Hudson River School or the European painters— or landscape painting in general and nineteenth-century photography. While I was working, that idea receded back into my consciousness, but it's definitely something that I've been influenced by. It has to do with scale, the distance from which you're describing something. It's usually stepped back, and it's usually about the relationships of things. When you step back you still have to worry about that tension. You can't just let go of the space that suddenly becomes apparent. But how far back can you go and still have that thing make sense? I want to go back as far as I can.

Nancy Spero

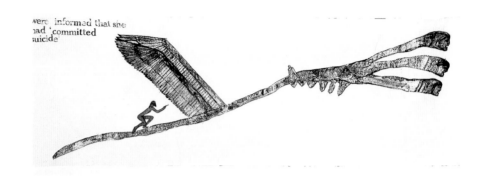

were informed that she
had committed
suicide

ABOVE
Torture of Women, detail,
panel 10, 1976
Handprinting and typewriter
collage on paper, 14 panels,
1²/₃ x 125 feet overall

BELOW
Girls, Girls, Girls, detail, 2001
Handprinting and printed collage
on paper, 19¾ x 96½ inches

OPPOSITE
Female Bomb, 1966
Gouache and ink on paper,
34 x 27 inches

My husband—Leon Golub—and I were from Chicago, and then we lived in Paris. When we came to New York in 1964, Leon already had a reputation as a very powerful Expressionist painter. But I had not been established in any way. It was pretty damned difficult contending with Leon. Not only did he do big paintings and fantastic ones, but he was really brilliant. And I had a hard time. But I decided that I just had to do my thing, and so I started doing very small work, figures that were sometimes an inch tall, or even less—almost microscopic. In a way, that was a retort to the large works of the mostly male New York artists. It's shocking how much I responded to that. Leon fit in to that category of male New York artists, but in my mind he was an exception. And he was totally sympathetic to my very fragile art. (We had our separate art careers, and people hardly realized that we were attached until the last dozen or so years. We became an 'art couple' at the very end.) We were always talking to one another and discussing things. He had the whole studio for a while but when I moved in to the other side of the studio this discourse of ours went on with even more intensity. Our work was so different. We each worked on our own thing, but occasionally we would cross. Knowing about the two of us, one could easily see the crossovers and influence.

Coming back to New York from Paris, I heard about a group of artists and writers who were meeting—both men and women—to investigate how artists worked, what the politics were, what was going on in the art world. For the most part, the women coming into that group did not speak up much. But I heard about WAR (Women Artists in Revolution), a group of women artists who realized that women's voices were not being heard. I joined that group. I researched; I picketed against the Vietnam War. And I became interested in women artists and how the art world was set up—how mostly male artists got attention—and what it meant to be a woman artist. That shifted my art a lot, toward the political. I guess I decided at that point that I would put my art where my head was, thinking about women's artist groups and the position of the woman artist—how strong or weak her voice was. I did this in *Torture of Women* (1976). I had fourteen panels that I push-pinned to the wall around the gallery, mostly about the torture of Central and South American women political prisoners and the conditions in which they were jailed and abused. I was zeroing in on the subject, investigating as a woman the condition of women. What does it mean to be a woman political prisoner? And, again, what does it mean to be a woman artist?

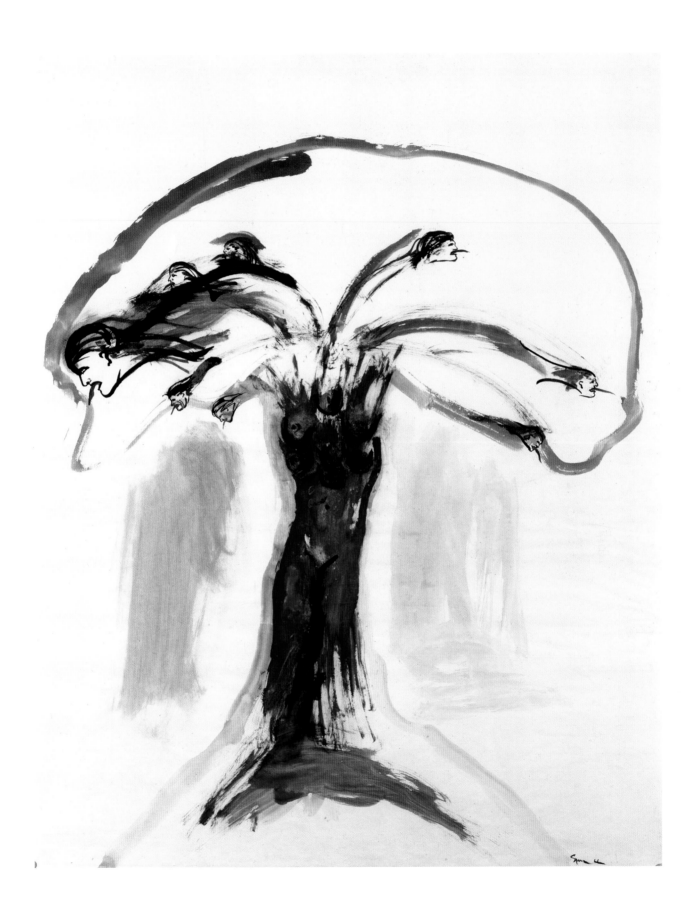

Nancy Spero

Search and Destroy, detail, 1967
Gouache and ink on paper, 24 x 36 inches

Search and Destroy, 2005
Installation at the Drawing Center, New York
Handprinting on wall; 2 walls, 13 x 49 feet each

Eagles, Swastikas, Victims, detail, 1968
Gouache and ink on paper, 24 x 36 inches

Victims, Holocaust, detail, 1968
Gouache and ink on paper, 25 x 39 inches

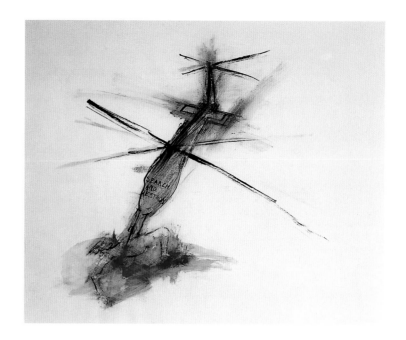

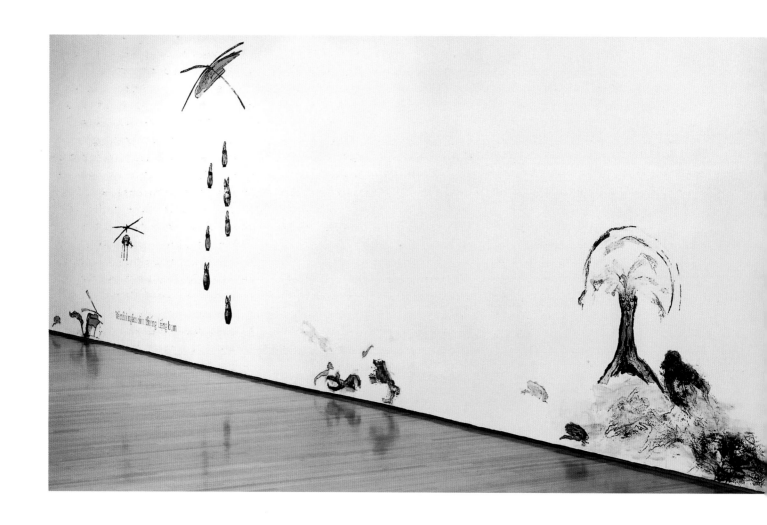

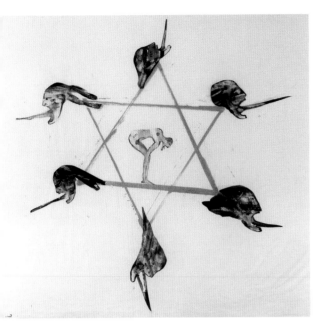

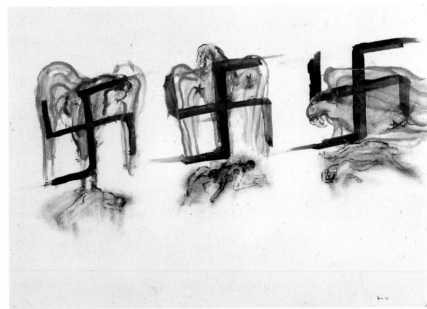

I cannot re-draw the images I did long ago. I'm in another time. But what's the difference? Death is death, and there's my subject matter—the ever-present helicopter, from Vietnam to Iraq. There's a terrible similarity running through all this stuff. So instead of going into photographs or any other kind of media, I just dipped into what I had reacted to forty years ago. It's horrific, trying to show the insanity and brutality of war. I couldn't do it in a realistic fashion so it got kind of surreal. Even though I was responding to Vietnam, all these grotesques—these surreal images—are my response to *war*. That was my subject matter, and it still is. For the most part, one wouldn't realize it was about Vietnam. You know, as they say, "It's art because I say so," so it's Vietnam because I say so, or Iraq because I say so. Why do I have to take something from today, when my anger showed so long ago? So I cannibalize what I did then and I go on with what I'm working on. I had this idea for a number of months about what I would do next—to liberate myself from what I have done

and to think about what I really want to do in the future. I thought I would take images from the *War Series* (1966–70) and pull them apart, re-do them, shove them around, and make an installation on the wall. I have been thinking that I don't want to continue in this extended linear format that has been absolutely crucial in the way I think about my art. I want to extend into space in different ways. But I hope that my art is a continuum and that it moves through the years like a melody.

When we came back from Paris and saw that we had gotten involved in Vietnam, I realized that the United States had lost its aura and its right to claim how pure we were. We had entered a war when it was uncalled for. And why? It was specious reasoning from Washington as far as I was concerned. I realized how guilty we were as Americans. I felt a responsibility, and that was working on me when I started the *War Series.* I had been wanting to change the way (and what) I was painting. I had been doing black paintings of lovers, oil on canvas, drawings or paintings on paper. And then I saw all

this on television (not even censored)—open images of bombing and strafing of Vietnamese villages by helicopters. I remember a terrible image of a woman running from her house, which had been set afire. The helicopters were flying low, strafing people who were running from their houses. And we were the ones causing this. I felt then that the symbol of the Vietnam War was the helicopter, and that became my primary subject matter. The images of the severed heads in the war paintings are from my imagination. I had read about men who cut off their victims' heads and stuck the heads onto the spikes of an iron fence. Or they cut off the ears. Terrible stuff. It was to make tangible the booty of war—what a warrior would take from a battlefield, dismembering his victims and using those parts as decorations for himself. I wasn't quite as sure of drawing the helicopters as I was about heads, so I got some kids' toy helicopters so I could draw them. I thought of the victims in Vietnam—the peasants—and what they would think of these war machines, tanks, and helicopters.

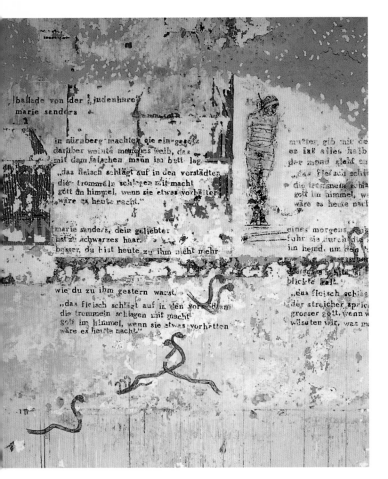
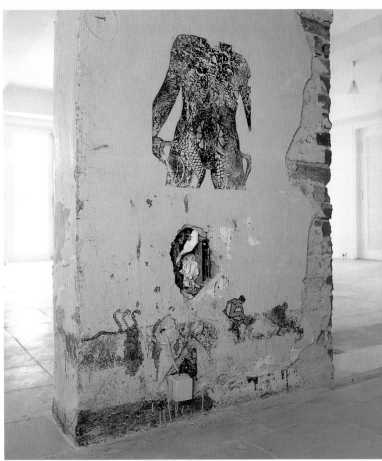

Nancy Spero

ABOVE AND OPPOSITE, ABOVE
Ballad von der Judenhure
Marie Sanders III, (Brecht), 1998
Installation at Festpielhaus,
Hellerau, Dresden, Germany
Handprinting on walls,
dimensions variable

OPPOSITE
Masha Bruskina/Gestapo Victim, 1994
Handprinting and printed collage on
paper, 19 x 26 inches

I guess maybe my art can be said to be a protest. I see things a certain way, and as an artist I'm privileged in that arena to protest or say publicly what I'm thinking about. Maybe the strongest work I've done is because it was done with indignation. Considering myself as a feminist, I don't want my work to be a reaction to what male art might be or what art with a capital A would be. I just want it to be art. In a convoluted way, I *am* protesting—protesting the usual way art is looked at, being shoved into a period or category. But I don't want to tell anyone they have to do this or that. I do what I do, and I'm not standing up for women's art. I just do what I do, and if people want to take something from it I'm thrilled because in a way that gets my message to the world.

I think my political instincts came by having a partnership with Leon Golub. He always had one foot in the political in his art, whether it was overt or not. And I think that drew me to him, and to his theories and his art, and that aspect of his thinking influenced me a lot. I had been apolitical in my art until I knew him. We had this back-and-forth of ideas, and all that must have been latent. (But my first encounter with even thinking about politics, what it meant to be an American and thinking that it wasn't secure, came as a real jolt when I became aware of the Second World War, maybe in my last year in high school. Being a Midwesterner from Chicago, I didn't really think we were vulnerable until the Japanese bombed Pearl Harbor. We were literally

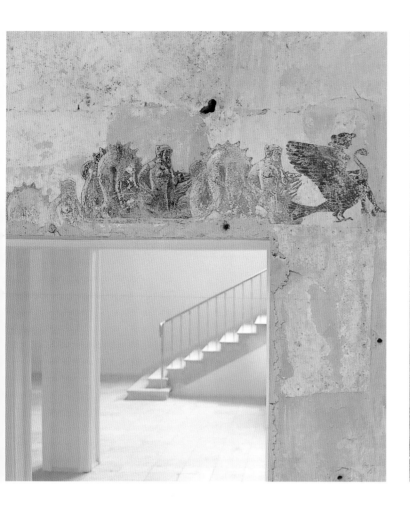

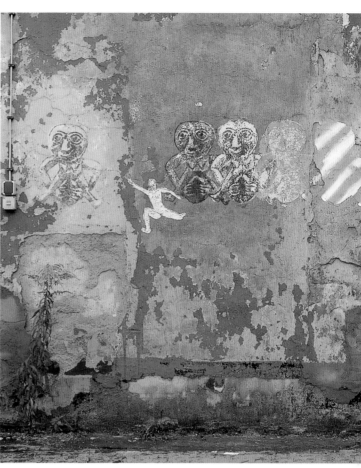

oceans apart from the rest of the world until then, not just physically but mentally.) I took the image of Masha Bruskina from one of the most famous series of photographs of World War II. It shows a young woman, and others—Russian partisans who were victims of the Gestapo. They were not tried—just as it seems to be with our prisoners in Guantanamo. I have been so moved by that photograph and, knowing what it was, I have used it a lot. Marie Sanders was also a victim of the Gestapo. When the Nazis found out that she had slept with a Jew, they took her, cut off her hair, tore her clothes off, and she was walked down the street to her shame and—most likely—to her death. Bertold Brecht told her story in the song, "Ballade von der Judenhure."

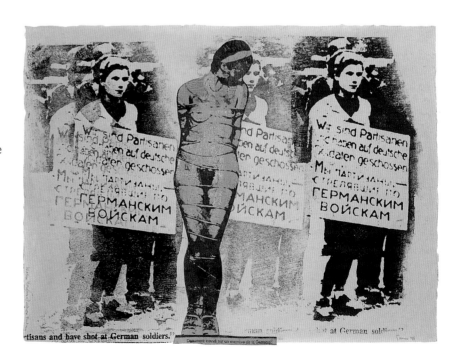

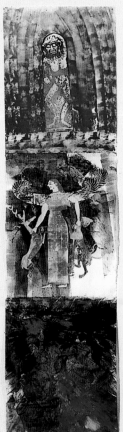
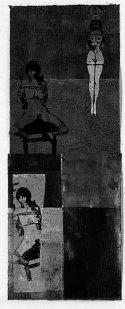
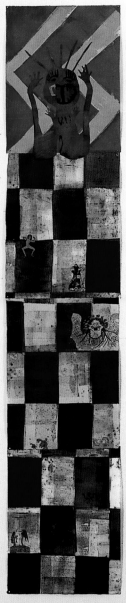
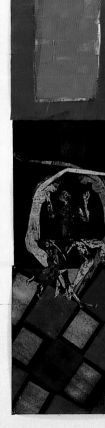

Nancy Spero

The Hours of the Night II, 2001
Installation view at Galerie Lelong, New York
Handprinting and printed collage on paper, 11
panels approximately 9 x 22 feet overall

I suppose I felt doomed to be an artist early on because of the way I drew all over the books that I needed for school, from ancient history to math. I was more interested in drawing in the margins than actually doing the work. I went to the University of Colorado for a year or two. I didn't like it at all. I was worried about being an artist. That was the only thing I felt I could do—draw and paint—and it was the only thing I wanted to do. Yet, for some strange reason, I felt that it wasn't of use to society. Where I even got that idea is beyond me. I went back to Chicago and, luckily, there was a space at the Art Institute. At that time, the students were in the Art Institute itself—in the museum—and I was able to look at the work. What was really interesting and what may have influenced me most was a show of tapestry. The tapestry had a real narrative and a format with repetitions. I was excited by that, but I didn't really use it until much later in my career.

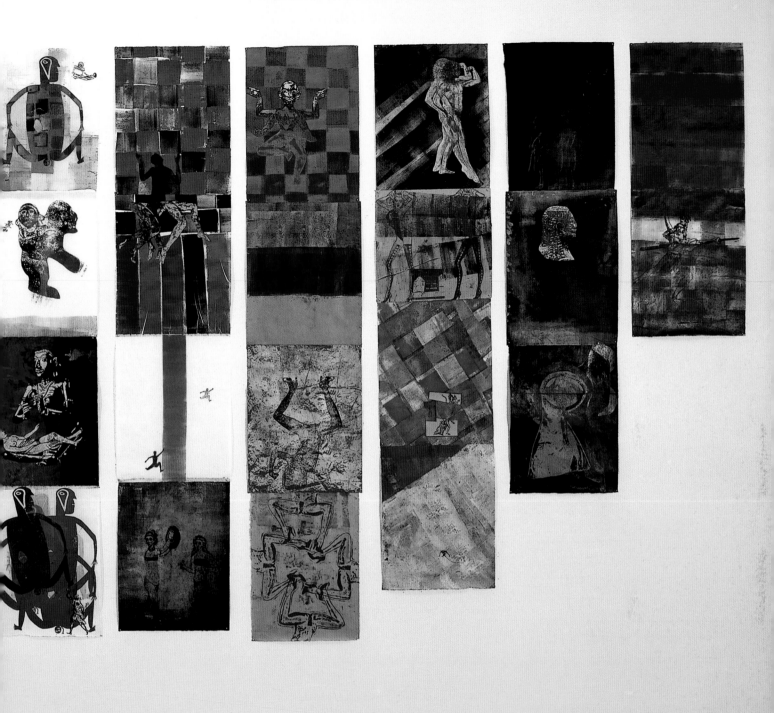

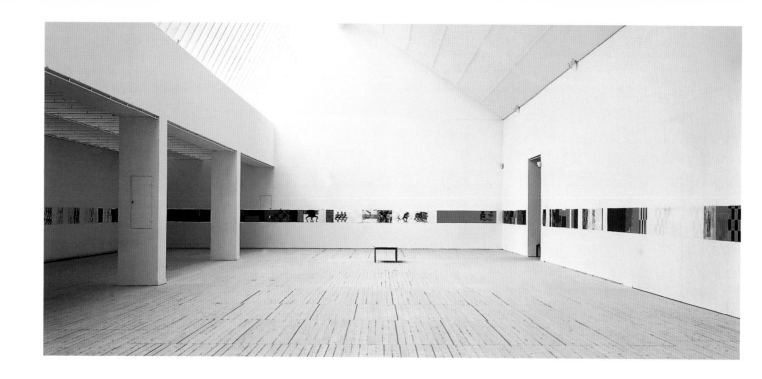

Nancy Spero

Black and the Red III, 1994
Installation at Malmö Konsthall, Sweden
Handprinting and printed collage
on paper, 22 panels approximately
19½ x 96½ inches each

I never thought of my work in terms of being radical, although I tried to make it radical—that is, to shift the premise of what goes for pictures on a wall. I wanted my work to say something other than the usual—the usual format for an artwork being a rectangle, a square, or anything flat, framed, and attached or hooked on the wall. That was accepted practice, mainline thinking. So I decided to experiment—to extend the square or rectangle that was straight ahead of the viewer and to have something that one would have to look at with peripheral vision engaged. Your eye wouldn't just rest on the work right in front of you. You would have to get down and go look at it carefully. When I showed *Black and the Red III* (1994) in Malmö, Sweden, it was a continuum—a band—all around the gallery. It was an enormous room, and the plan was that I was going to hang the work push-pinned to the walls however I wanted, and then do an installation. At that time, when I was doing installations in the 1980s and '90s, I used a black-and-white letterpress plate to print the images and then, instead of using metal plates to print on paper, I used polymer plates to print onto the wall. But seeing this huge space in the gallery in Malmö, I just took a deep breath and I put the paper around in a single band. Then I continued along, printing on the wall like a *trompe l'oeil* to reiterate the images in the work printed on paper that I had push-pinned to the wall. I literally took the rhythm and the images from *Black and the Red III* and continued that on the wall. I wanted to paint, and I wanted to shift from dancing all over the place to do something more geometrical, to get it down to a patterning and a control in the space that looked less coded than one might otherwise think if I added black and red. In a continuous line on the wall, it was like a message. The figures that were black and red were taken from Greek vases, the ancient Greek vases on which the images were black on red. I don't know if the image of what I call the dildo dancer was from a vase, but in any case I transformed it. I loved that figure when I first saw it; it was so full of vitality. Everything I show here is exaggerated; it's all from my imagination—all of these highly sexualized poses and activities, all either murderous or joyous. I like the idea that I can have that freedom. I'm really grateful.

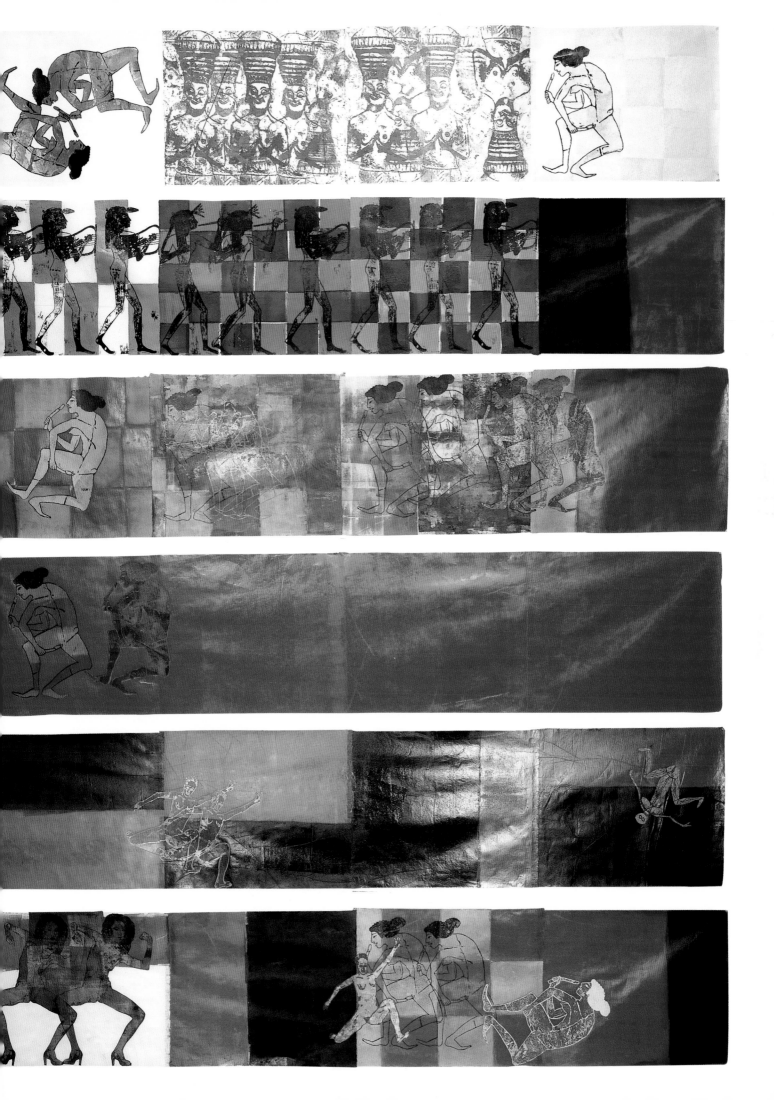

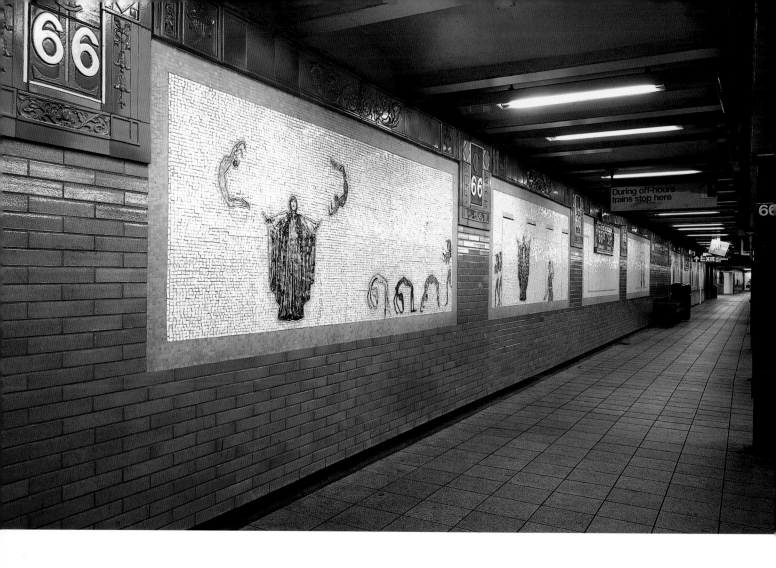

Nancy Spero

ABOVE AND BELOW
Artemis, Acrobats, Divas and Dancers, 1999–2000
Installation at New York MTA, 66th Street Station
Glass and ceramic mosaic, dimensions variable

I have over five hundred images in my art at this point to choose from, to re-use. Originally, the images were mostly from art books. And a lot came from magazines, contemporary media. Ancient art has influenced me, and I've taken great liberties in using the format of the Egyptian papyrus and writing, and the imagery of the ancient Greeks. I have my stars. The dildo dancer is one, and so are the ancient Egyptians and the musicians. They occur and re-occur. The musicians can be playing or dancing, either for a melancholy or happy occasion, and in a procession. I do a lot of story-telling, but it's without a real narrative.

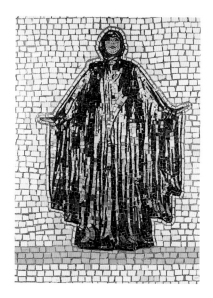

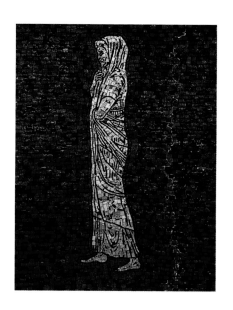

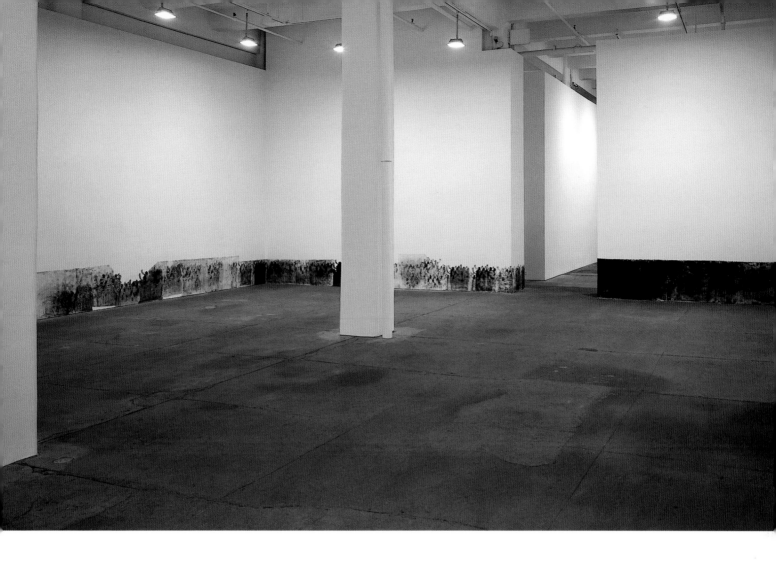

Nancy Spero

ABOVE AND BELOW
Cri du Coeur, 2005
Installation view at Galerie Lelong, New York
Handprinting on paper, dimensions variable

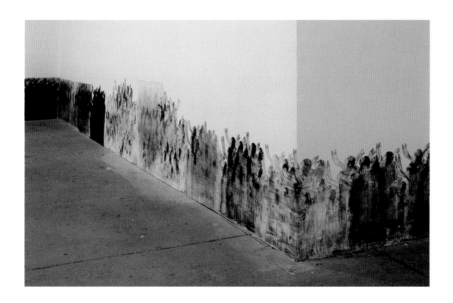

Cri du Coeur (2005) was the first piece I did after Leon died. A *cri du coeur* is a cry of the heart, something of intense emotion, almost like praying or pleading with heaven. Since it was about mourning, I wanted to emphasize a kind of prayerful looking up—looking up to heaven or God knows what—looking down—in a gallery with very tall rooms. I decided that it should be on the ground, like a funeral procession. And I decided that was what I wanted to do in *Cri du Coeur*. Like this installation, a lot of my work through the years has been truly ephemeral—printing on walls, which are painted over after a show. It's like theatre or dance. When the show is over, it's finished. It's gone. It only remains in the memory or in photographs. When you call, "Strike!" you stop and the installation's finished. There are no more showings of it, and it's gone.

Robert Adams

Ecology

Mark Dion

Iñigo Manglano-Ovalle

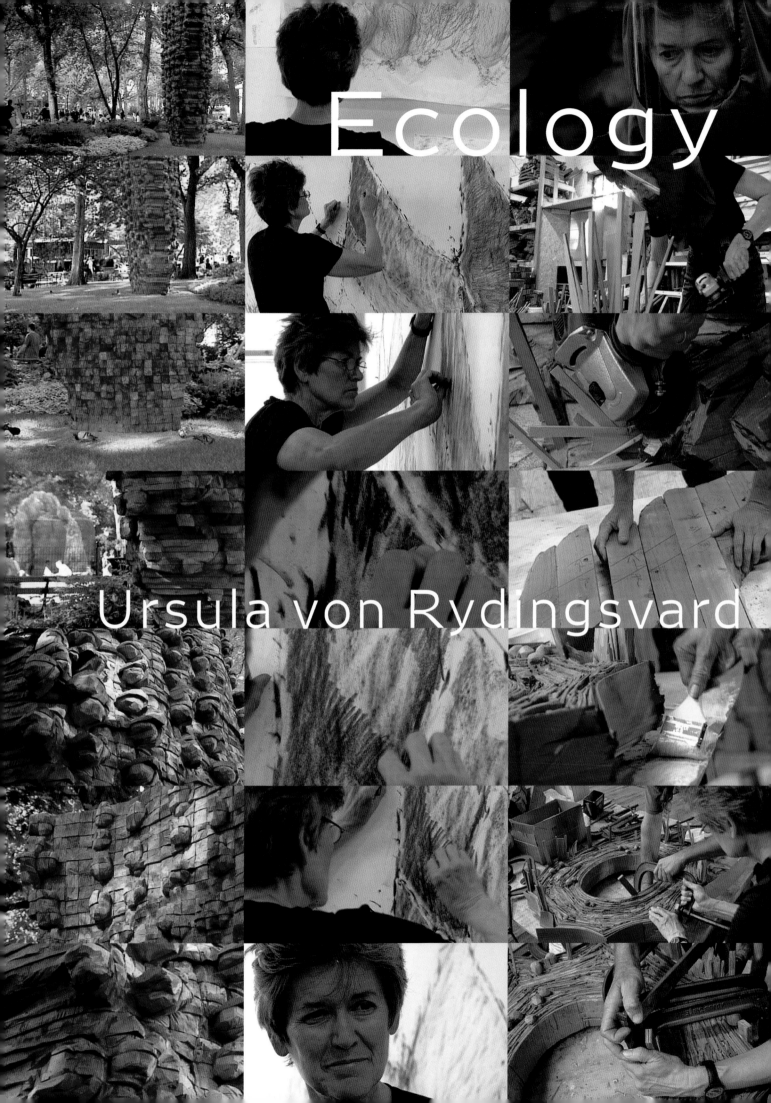

Ecology

Ursula von Rydingsvard

Robert Adams

The nature of photography is to engage life. It's made of life. Life is complex, and I often think photography is similarly complicated. At least it seems so to me. The early twentieth-century photographer Lewis Hine, who photographed child labor problems, said at one point that what he wanted to do was to show what was good so that we would value it, and what was bad so that we would want to change it. And in somewhat the same way that's what I've always hoped to do. I'd like to document what's glorious in the West and remains glorious, despite what we've done to it. I'd like to be very truthful about that. But I also want to show what is disturbing and what needs correction. The best way to do that—and it's the way every artist dreams of—is to show it at the same time in the very same rectangle. You're always in quest for the picture which will catch both, and occasionally that happens. There's a picture of mine that I'm happy with, taken above Boulder, Colorado. . . . We're up on a foothill, probably a thousand feet above Boulder. The bottom of the picture is a kind of bowl of dark trees. And in this bowl is the city of Boulder and beyond it a view of the plains. To me that's an unusually successful picture because it suggests some of the contradictory nature of the Western experience.

RIGHT
East from Flagstaff Mountain, Boulder County, Colorado, 1975
Gelatin-silver print, 11 x 14 inches

OPPOSITE
Dead Plant, Barbed Wire, and Razor Wire, Palos Verdes, California, 1983
Gelatin-silver print, 14 x 11 inches

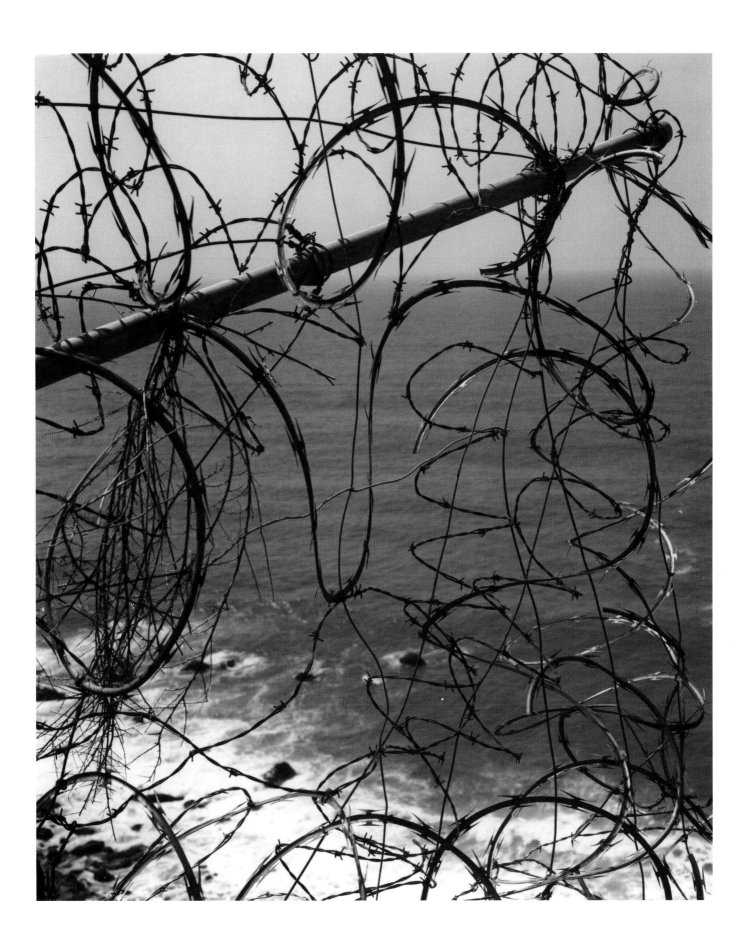

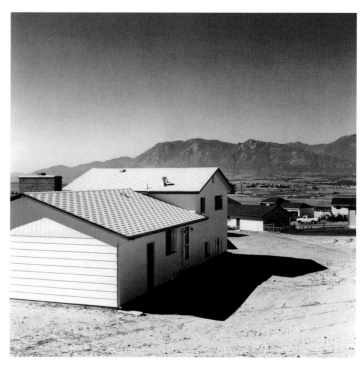

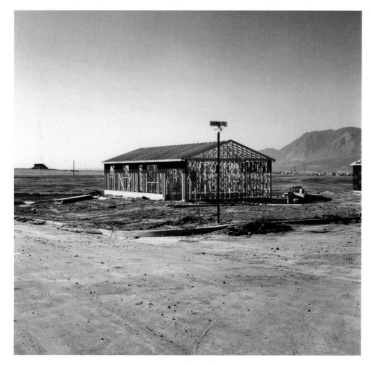

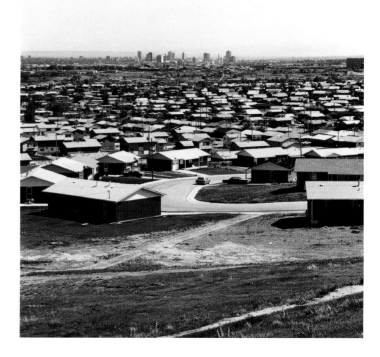

Robert Adams

OPPOSITE, CLOCKWISE FROM TOP LEFT

Sunday School, a Church in a New Tract, Colorado Springs, 1970
Gelatin-silver print, 11 x 14 inches

Newly Completed Tract House, Colorado Springs, Colorado, 1968
Gelatin-silver print, 11 x 14 inches

The Center of Denver, Ten Miles Distant, ca. 1968
Gelatin-silver print, 11 x 14 inches

Frame for a Tract House, Colorado Springs, Colorado, 1969
Gelatin-silver print, 11 x 14 inches

BELOW
Colorado Springs, Colorado, 1968
Gelatin-silver print, 11 x 14 inches

The first serious photography I did was when I was teaching at Colorado College. I had been taking pictures, more or less in the manner of Ansel Adams, up in the mountains. They were okay, but they were like what Ansel took—and, clearly, that wasn't going to go very far. Colorado College had a week-long symposium on new cities in the West. And so, knowing that I was fooling around with a camera, my colleagues suggested that I go and take pictures around Colorado Springs. It was in the middle of the Vietnam War and the soldiers returning from Vietnam were being mustered out of Fort Carson. The city was in chaos, and there were new expansive developments everywhere. So they said, "Why don't you go and take pictures and print them, and we'll put them up as a sort of thematic statement for the symposium." And I did. I hiked around and felt a little foolish taking pictures of tract houses and highways. But I came into the darkroom and printed them and I was really surprised. I thought I was taking pictures of things that I hated, that were inexcusable. But there was something about these pictures that was beautiful. It made no sense to me at all. They were unexpectedly, disconcertingly, glorious. And so right then I knew I was confronted with something I didn't have a clue about, but it was interesting.

I took a picture once of a woman silhouetted in a tract house window. And in one sense that's a picture of the saddest kind of isolation and most inhumane sort of building. But also raining down over this picture onto the roof and the lawn is glorious high-altitude light. Nabokov said there's no light like Colorado's, except in central Russia. And you can see it in this picture. It's absolutely sublime.

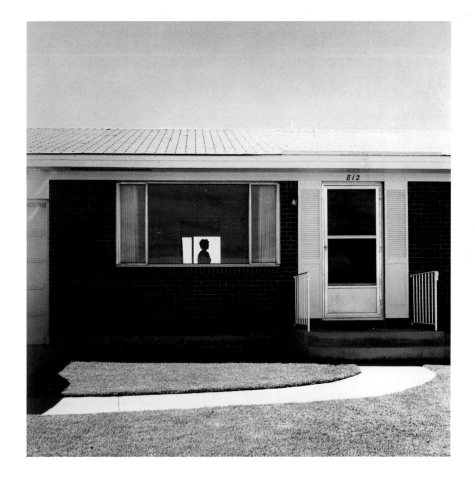

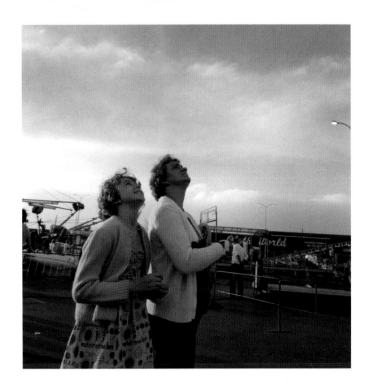

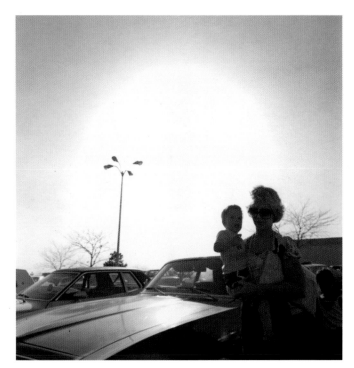

Robert Adams

ABOVE, LEFT
Untitled, ca. 1981
Gelatin-silver print, 11 x 14 inches

ABOVE, RIGHT
Untitled, ca. 1981
Gelatin-silver print, 11 x 14 inches

OPPOSITE
Denver, Colorado, 1981
Gelatin-silver print, 14 x 11 inches

Beauty, which I admit to being in pursuit of, is an extremely suspect word among many in the art world. But I don't think you can get along without it. Beauty is the confirmation of meaning in life. It is the thing that seems invulnerable, in some cases, to our touch. And who would want to do without beauty? There's something perverse about ruling out beauty. It's not only in nature, incidentally. It's in people. I took pictures in suburbs surrounding a nuclear weapons plant in the 1980s. And a number of things came clear as I went over the contact sheets where I printed out small pictures of all the film I exposed. One was the burden of sadness which seemed to be on most people's faces. I was shocked. I was also shocked by how many people are in one way or another deformed. But I also discovered that, if I looked hard enough, there were an amazing number of people with resilience and courage and who, for a moment or two, had something in their eyes that was very admirable. And all of that, I think, is worthy of the term 'beauty'. I hold onto that word; I refuse to surrender it. It's the traditional end of art. And tradition is part of this occupation as far as I'm concerned. Creating out of nothing is something only God is reputed to have done.

In the case of the pictures of people that I was taking near the weapons plant, I was actually shooting blind. I determined before I started the project that I did not want to have just pictures of people who were staring at me, who were fully conscious that I was working on them. I wanted them to be unaware. So I strapped a wide-angle Hasselblad onto my hand and set the focus for between about three and seven feet, which I could do because of the brilliant light. I carried a bag of groceries on my left arm and as I approached people I would try to assess whether they had a promising expression or were in promising relation to each other. Then, as I got within the range for which the camera was focused, I would pretend to shift the weight of the bag of groceries with my right hand, which also held a camera, and I would make an exposure. So there were pictures that I didn't fully know I had. But life is full of blessings that you have to work for, and they're a wonderful surprise. That happens in landscape photography, too. You never know on a given day when you're going out whether it's going to be one of those utterly dead days or whether the sky is going to be something you couldn't have dreamed of.

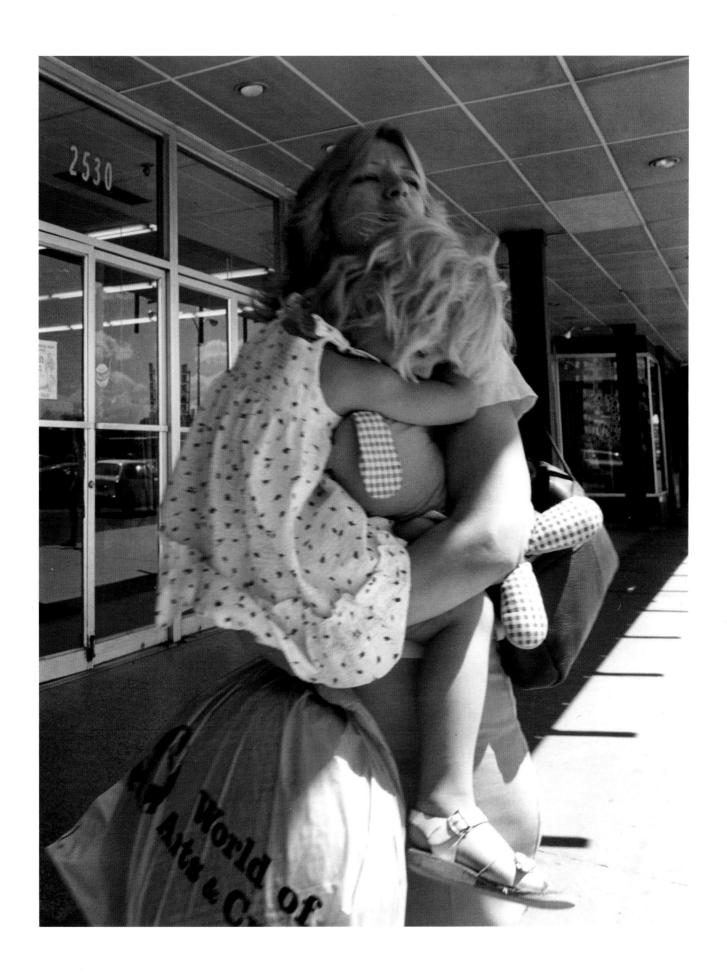

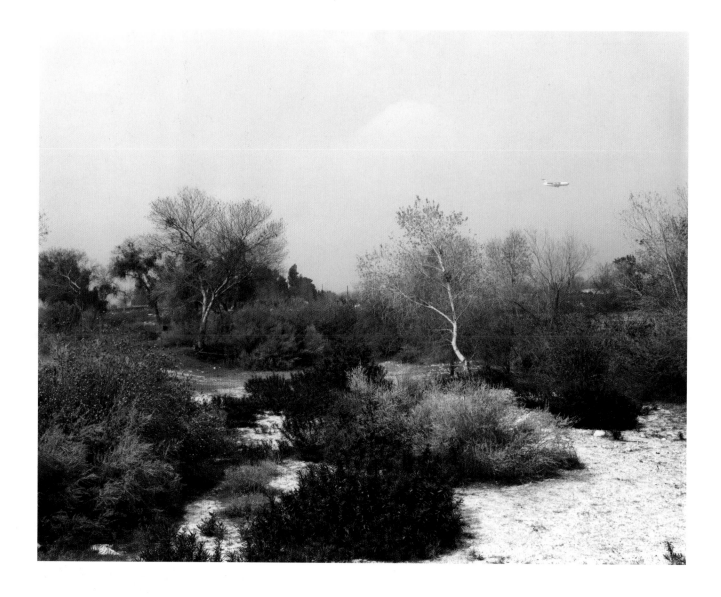

Robert Adams

The process of finding a picture I want is a long one. Ansel Adams talked often about pre-visualizing everything down to the last level of gray, when he was looking out and making all his calculations before he made the exposure. That has not been my experience. You do try to get as much as you can right there on the spot when you make the exposure, but there are a lot of surprises in photography. If you're not interested in surprises you shouldn't be a photographer. It's one of the great enlivening blessings of the medium.

When we moved to Oregon, I spent time continuing what I'd begun in the '70s, which was to photograph westward, toward the ocean, and basically to photo-graph what is conventionally beautiful. And it was great. I discovered a few ways to refresh the subject a little. But as we approached the bicentennial year (2004) of the Lewis and Clark expedition, I began to ask myself, "Where is the frontier? Is it to the west or the east?" Clearly, the frontier now is to the east. And I would submit that it's just as dangerous as the western direction used to be. So it seemed to me that on the occasion of the bicentennial, the real job was to remind people that what we're up against now is having to turn and look at our own creation and try to correct and value it so that we create the country we thought we were creating (but neglected to do) as we went west.

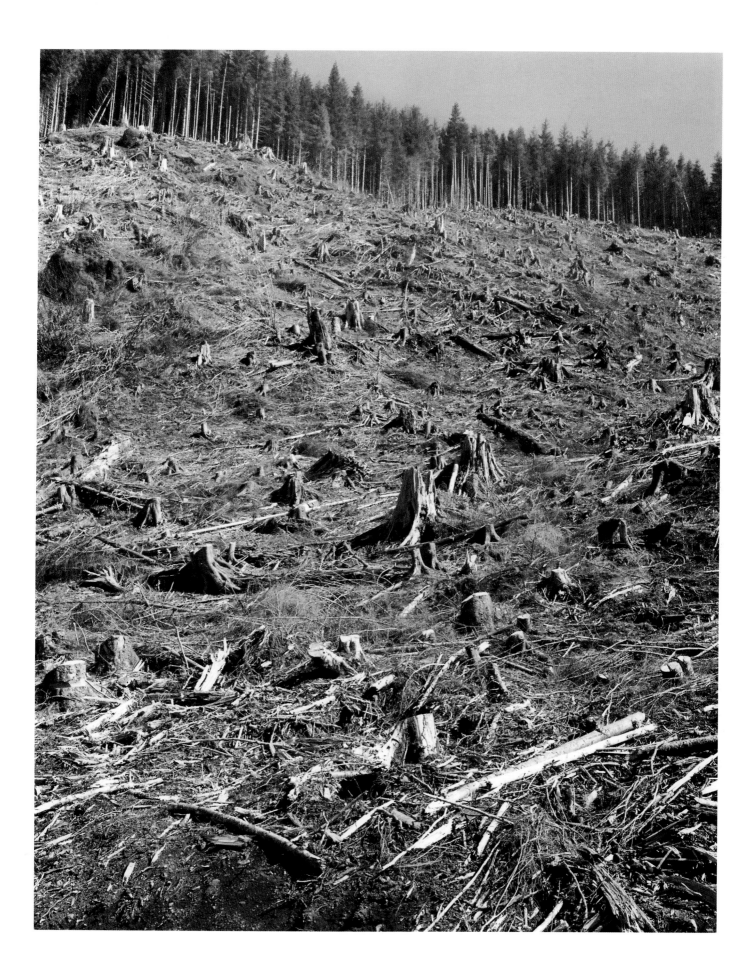

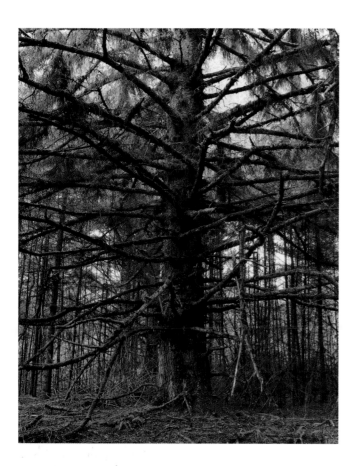 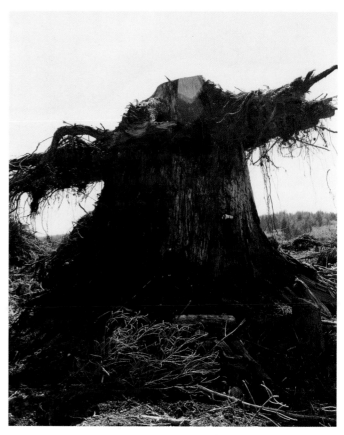

Robert Adams

LEFT
*Sitka Spruce, Cape Blanco State Park,
Curry County, Oregon, 1999–2003*
From the series, *Turning Back*
Gelatin-silver print, 14 x 11 inches

RIGHT
*A second growth stump on top of
a first growth stump, Coos County,
Oregon, 1999–2003*
From the series, *Turning Back*
Gelatin-silver print, 14 x 11 inches

It isn't all bad, looking inland. There are a few state parks where there's still some indication of what it meant to be in a forest. This is a picture at Cape Blanco, which is often fog shrouded. This Sitka spruce stands within about a hundred feet of the edge of the headland. . . . The center, though, of turning inland for us was the discovery that the Northwest has basically been deforested and is very unlikely ever to change back. There's a picture taken down along the southern Oregon coast in a large and particularly desolate area near Charleston. This particular scene is of an old growth stump (if it's not old growth, it's something pretty close to it). It's an enormous stump. And as sometimes happens when a tree is cut, a seed will fall and it will start grow-ing a new tree on top of the stump. In this case, the new tree has itself been cut. It gives you also a sense of how much bulldozing goes on in some clear-cutting. In order to clean it up and start again, there's a lot of waste piled up, twenty to thirty feet high. The picture—the stump—was terrible, and we knew it as we worked at it. And I actually didn't print it for a while, but I came back to it and did. And then events followed. And a year or two or three, I suppose, after it was taken, I was looking at it and I suddenly sensed there's a resemblance between that picture and the terrible picture of the person being abused with the wires at Abu Ghraib. It's not a one-to-one but there is an odd something there that I can't shake from my mind.

Robert Adams

Kerstin, old-growth stump from early cutting, surrounded by the remains of recently cut small trees, on Humbug Mountain, Clatsop County, Oregon, 1999–2003
From the series, *Turning Back*
Gelatin-silver print, 11 x 14 inches

It seems to me that we are now compelled to recognize that we have no place to go but where we've been. We've got to go look at what we've done, which is oftentimes pretty awful, and see if we can't make of this place a civilized home. We've in a sense built a house, but we haven't made it a home. The importance of what's going on in terms of clear-cutting is that there is no indication that this can go on forever. If you turn the globe you see a history of deforestation that changed societies and from which there has not been, in many cases, a complete recovery—in some cases, no recovery at all. The nub of it is that if you keep cutting (and bear in mind that the cutting now is sustained by the use of artificial herbicides and fertilizers), the soil is eroded more and more. It's a major contributor to global warming. I'm not just concerned with a beer can on a stump. I'm concerned with the dis-

appearance of one of the world's great rain forests. It's not just a matter of biology or of exhaustion of resources. I do think there is involved an exhaustion of spirit. I can see it amidst my fellow citizens here in this small town and in this region. They go to great lengths not to visit and not to confront what is happening. And I think from that accrue other cases of cultivated blindness, civically. I am deeply disturbed that the only thing we want to really get concerned about is something we can quantify, something we can put in terms of dollars and cents. Every one of us knows that the things that are most important to us cannot be measured in that way. So if you haven't loved a tree enough (if not to hug it, at least to want to walk up to it and touch it as if you're touching a profound mystery)—if that experience has eluded you—I feel bad for you because you're not going to live a happy life.

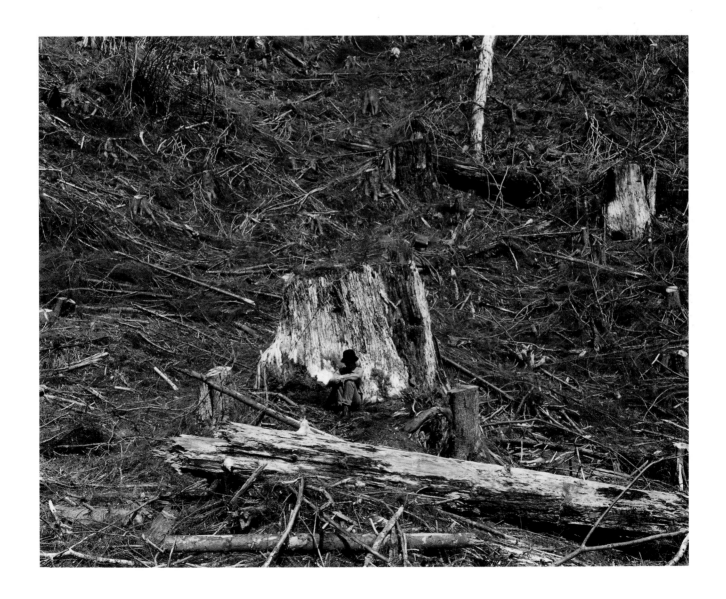

Robert Adams

Light is a physical thing that you're working with. It's also obviously metaphor. It's what you're working with to arrive at metaphors. It's the age-old symbol for truth. So it's loaded. But, fundamentally, it's just a deeply mysterious, compelling ingredient for your understanding of life and your response to it. . . . It's at the center of why and how one makes pictures. Natural light has a mysterious quality that is always perfect. You can't screw up natural light (you can use it more or less effectively), but it's perhaps the compelling mystery. It's why you become a photographer. To paraphrase Paul Caponigro, quoted by John Szarkowski, your decision to make a photograph is a kind of seduction, and the seduction is worked by light.

Kenneth Clark remarked in one of his books that the thing that distinguishes a landscape painter is an especially intense emotional response to light. And I do believe that's true. It sounds crazy to say but, after I'd been working for days or sometimes months outside, if I was working in a darkroom and I knew it was daytime, I swear I could tell in the darkroom when the sun came in and out from behind clouds. I swear I could feel when the sun was striking the house. Some people who live in Colorado can't stand it. When we used to come out to Oregon, it was usually for a rest. It was like somebody just flicked a little switch and I no longer had to photograph. And when I went back to the southwest, it was like the switch was on and a bolt of electricity was going through me. You can say that's a blessing or a curse. I don't know. I don't think you choose to be an artist. I think it's definitely an assignment. That's why it's always somewhat painful to hear people talking about *considering* being an artist. It's just something you have to do, or not.

The majority of the work that I do involves very close concentration on framing. When you watch a photographer work, what's going on is that seemingly almost demented search . . . moving a little this way, moving a little that . . . looking from a little higher, a little lower. The effort is to find that perfectly balanced frame where everything fits. It's not exactly the same as life. It's life, seen better. Weston said that composition was just the strongest way of seeing. It's true, but you have to mean it in a little more serious way than I think he meant it. It's the strongest because you're seeing the most lasting—the truest—way you can, assuming you believe that ultimately things do fit. And of course not all us, most of the day, would want to subscribe to that. Life is too chaotic. But the thing the artist is trying to give you is a reminder of those rare times when you did see the world so that everything seemed to fit—so that things had consequence. The majority evidence is for chaos, let's face it. Most of the time things don't seem consequential. But the value of art is that it helps us recall transforming times that are of such a quality that they last.

Mark Dion

With some of my work, you can sense that it has a pretty dark tone. As much as I'm engaged in a discourse that is ecological, I'm not one of those artists who is spending a lot of time imagining a better ecological future. I'm more the kind of artist who is holding up a mirror to the present and to the kinds of problems that we have right now. As much as I would like to have a more utopian sensibility, my sensibility tends to the dystopian, to the dark side. We're at a moment in time when we have a great test ahead of us in terms of our relationship to the natural world. If we pass the test we get to keep the planet, but I don't really see us doing a very good job of that right now. So my work isn't really a crib note for that test; it's not really the answers. It's more like a notice of a bill past due, a kind of a grim perspective, because I really see the outlook as reasonably grim.

My idea of art isn't necessarily something that provides answers or is decorative or affirmative. I like Goya. I enjoy the still-life tradition, and hunting painting, and things toward the dark side that tend to have a more critical function. That's what I see as the job of contemporary artists—to function as critical foils to dominant culture. My job as an artist isn't to satisfy the public. That's not what I do. I don't necessarily make people happy. I think the job of an artist is to go against the grain of dominant culture, to challenge perception, prejudice, and convention. A big flaw in some public art schemes is that they seem to be about trying to find an artist who's going to please everyone. That's not interesting to me. I think it's really important that artists have an agitational function in culture. No one else seems to.

RIGHT
Landfill, 1999–2000
Mixed media, 71½ x 147½ x 64 inches
Collection Museum of Contemporary Art, San Diego

OPPOSITE
Tar and Feathers, 1996
Tree, wooden base, tar, feathers, and various taxidermic animals, 102 x 40 inches (diameter)

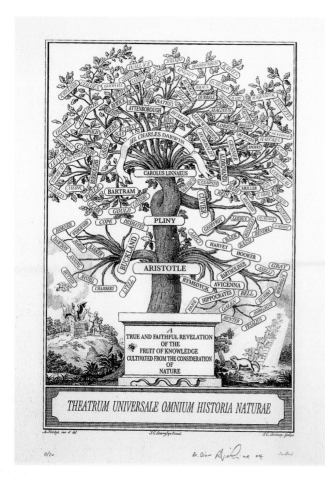

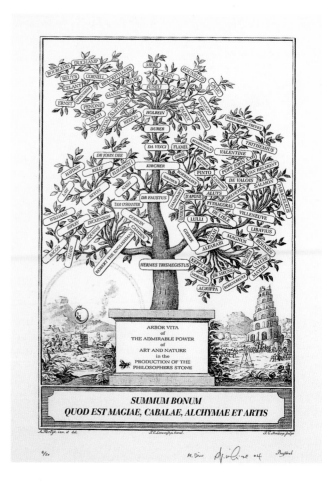

Mark Dion and Robert Williams

ABOVE, LEFT
Theatrum Universale Omnium Historia Naturae, 2004
Lithograph, 31 x 24¾ inches
Edition of 20

ABOVE, RIGHT
Summum Bonum Quod Est Magiae, Cabalae, Alchymae et Artis, 2004
Lithograph, 31 x 24¾ inches
Edition of 20

Mark Dion

OPPPOSITE
Scala Naturae, 1994
Stepped plinth, artifacts, specimens, taxidermic animals, and bust,
93¾ x 39⅜ x 117 inches

It's a very complex relationship between the natural and the cultural. Certainly, we are of nature. But if you begin to blur that to a certain point and believe that all artificial culture—the noosphere, the sphere of human activity—is natural, that seems to cause a lot of problems. Then we don't need the terms 'natural' and 'cultural'; we can just say everything's natural. But I don't really think that's the case. We come from the natural world but, clearly, we are distinctively different in our relationship to every other animal on the planet because of our language capabilities, because we have a sense of history, because we are able to store information and knowledge in a way that other animals can't. Of course, we've evolved that way naturally. I'm a secular person. I don't believe in any kind of mystical mumbo-jumbo. For me and for a number of artists today, science really functions as our world view. I don't see that as terribly different from the way artists used the Church in the past. Our relationship to science is very much like the Renaissance artists' relationship to theology. We are trying to tell our story, our cosmology, our way of understanding the world, through our work in the same way as the Renaissance painters who were doing Annunciation and Crucifixion scenes. Each one of them did it differently—just as artists like me and Matthew Ritchie or Alexis Rockman, or any of the other artists who are interested in these kinds of things, will use different languages to tell the same story.

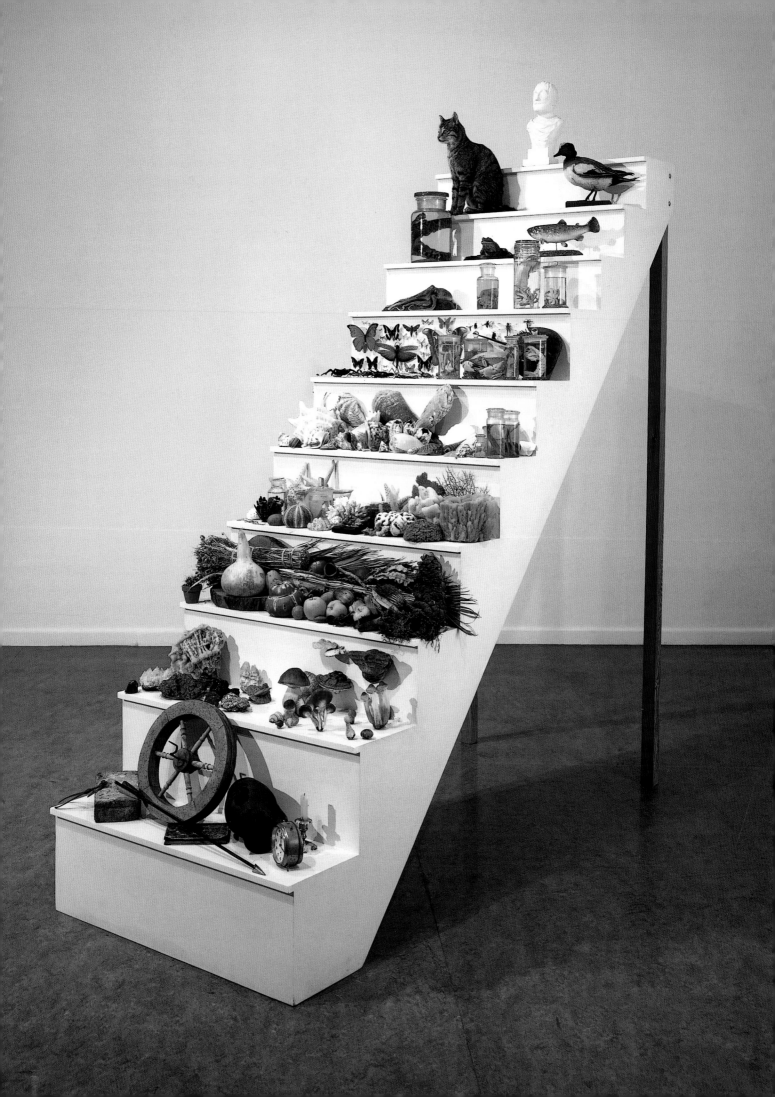

Mark Dion

BELOW

Toys 'R' U.S. (When Dinosaurs Ruled the Earth), 1994
Installation view: American Fine Arts, Co.,
New York
Children's bed, desk, chair, bedside table,
television, audiotape, dinosaur bedside
lamp, toys, cereal, wallpaper, posters, stencils,
inflatable Tyrannosaurus Rex, calendar, pennant,
bedspread, pillow, slippers, clothing, wastepaper
basket, umbrellas, games, plastic figurines,
books, framed picture, videos, baseball cap, fan,
bulletin board, postcards, pencils and pens,
pencil holder, book bag, rug, stuffed animals,
cup and straw, and assorted other dinosaur
memorabilia, dimensions variable

OPPOSITE

The Curiosity Shop, 2005
Installation at Tanya Bonakdar Gallery,
New York
Mixed media, 12½ x 28 x 12 feet
Private collection, New York and Amsterdam

I'm very interested in surrounding myself with the stuff that inspires me. I'm an artist who gets a lot from *things*, and in that way I'm very much a sculptor. I really love the world of stuff. I know a lot of artists who prefer to have very Spartan lives. Their inspiration is very much in their heads. They like clean, white, empty New York kinds of spaces. But I really like the surprising juxtapositions when you put things together on the bookshelf and when you start to collect things. I'm always acquiring massive amounts of material, not knowing whether I'll use it or not. Sometimes those things stay in the barn and sometimes they enter into my everyday life. Sometimes they become part of a sculpture, an installation. For me, what this is really about is stuff. That's why I like museums and why I'm inspired by places like that. I identify with the mission of the museum where you go to gain knowledge through things. And I think that mission is very close to what sculpture and installation are about and, for me, what contemporary art is about.

I'm constantly going to flea markets, yard sales, and junk stores and buying things specifically for projects, but also for myself and my friends. I try to keep these compartments stable but they tend to blur into one another, so an object may find its way into a work or into my private collections. I have very eccentric collections— oil cans, wooden mallets, stuffed birds, cabinet cards, photographs of boats and animals in zoos, and just dozens and dozens of things. It's a way to continually be engaged with my work. Some artists paint, some sculpt, some take photographs, and I shop. That's what I do.

For a lot of people collecting is an impulse that begins in childhood. I was a child who had collections and was constantly in search of things like butterfly nets and cigar boxes. These things still have a particular attraction, a patina of engagement that is fascinating. As I go through museums, I see that a lot of the motivation of curators and people who are scientifically trained comes from finding productive ways of using these impulses.

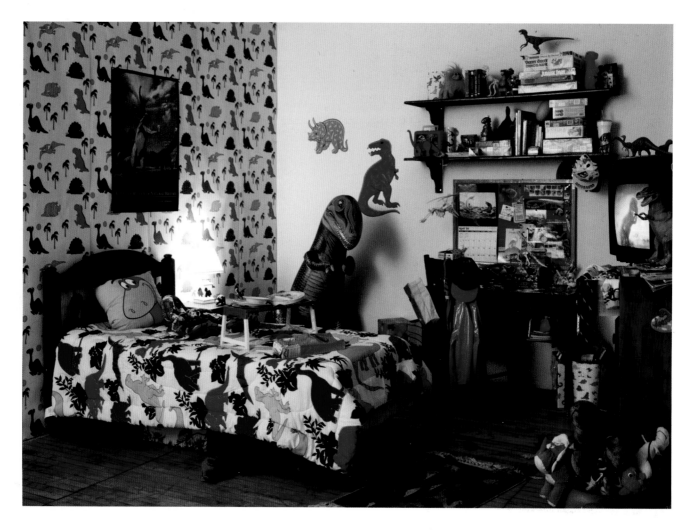

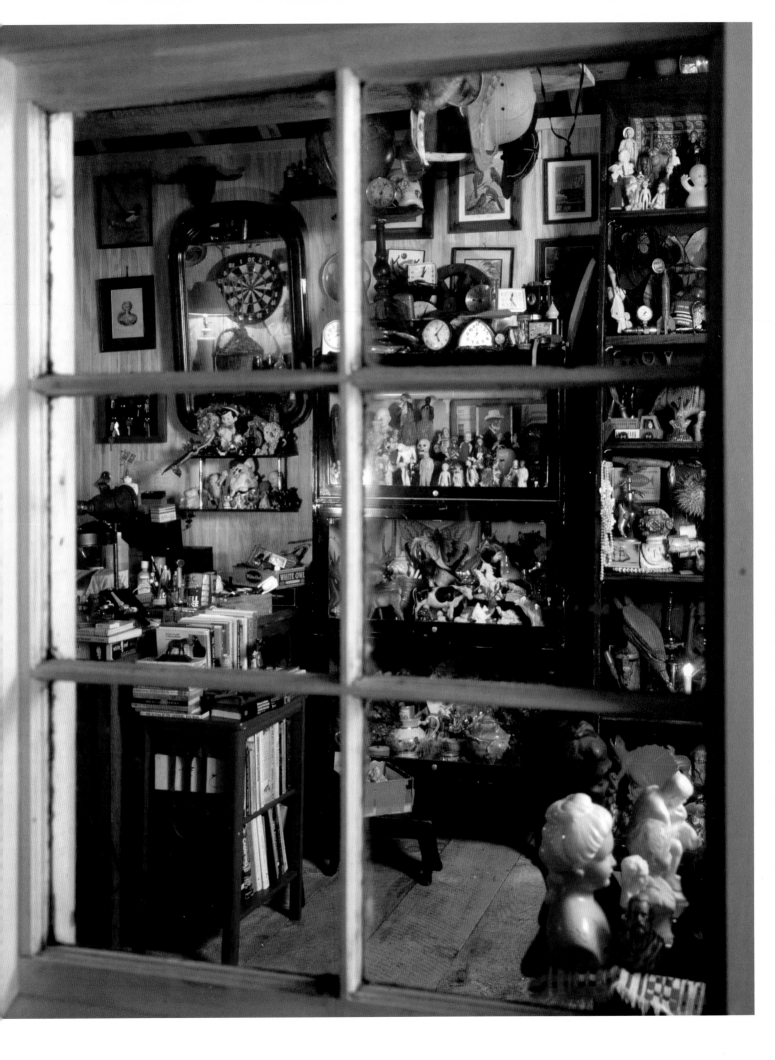

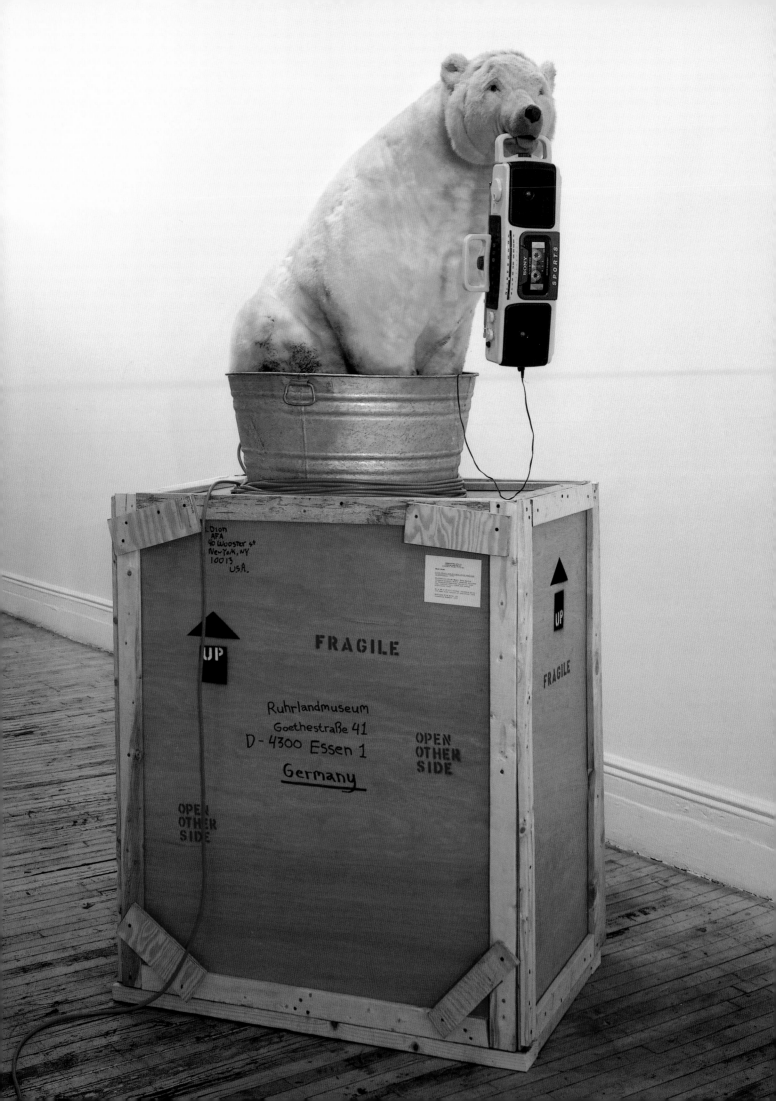

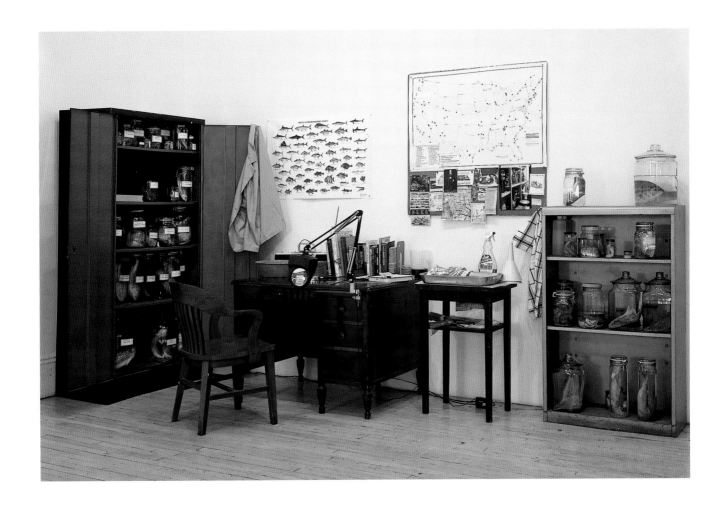

Mark Dion

OPPPOSITE
*Polar Bear and Toucans
(From Amazonas to Svalbard)*, 1991
Stuffed polar bear, Sony Sports
cassette player, cassette recorded
in Venezuela—Amazonas territory, wash
tub, tar, crate, and orange electric cord,
91 x 44 x 29½ inches

ABOVE
*The Department of Marine Animal
Identification of the City of New York
(Chinatown Division)*, 1992
Marine animals collected in Chinatown,
door, metal cabinet, and blue lab coat,
dimensions variable

Collecting may be a passion or it may be impulsive, but then there's ordering, taxonomy, classification—putting things together in a way that makes sense. Of course we have a scientific way of organizing things—but there are other kinds of taxonomies based on use, folklore, personal tastes, and imaginary hierarchies. That's really what is fascinating for me. Scientific classification is constantly changing as information shifts. Knowing about genetics, for example, drastically changes systematics in terms of putting animals and plants in categories. Now, instead of just judging on appearance, on comparative anatomy, we have a molecular way of putting things together.

My way of putting things together and the filters I'm using to organize knowledge in my own head are also changing drastically. So certain things, like my re-engagement with some elements of Surrealism (which were always in my work), increasingly come out. My relationship to the politics of environmentalism and ecology changes as I learn more about the history of science and the shifts in the representation of nature. All of those things inform the way my work functions. My interest in Surrealism really comes from the way that the Surrealists used museums and collections with an overlay of the irrational onto the rational. They were also engaged in museum culture and were very interested in the recently obsolete. For me, that's an interesting element of museum culture— that sense of obsolescence. I'm not looking for the newest museum. I'm always looking for the oldest museum. I'm looking for museums that are windows into the past. And because my topic really is the representation of nature, I'm looking mostly at natural history museums. But there are taxonomies in art museums as well, and those taxonomies shift. We're constantly rediscovering long dead artists and putting them into a different context, a different place. We're constantly shuffling the deck.

Mark Dion

Costume Bureau, 2006
Mixed media, 74 x 108 x 39 inches

I am very interested in the figure of the dilettante, the amateur. Amateurs have made great contributions in science, but now we live in a time when there's such a radical degree of specialization that it's very difficult for professionals in physics or biology to be able to communicate to a general public. Trying to be this character in between is fascinating. At the same time, I'm always suspicious of the way artists use science because science has such tremendous influence and authority in our culture. Whenever you encounter the kind of authority that seems unquestioned and unquestionable you need to find ways to challenge it. One of the reasons for taking a play-acting approach is to create a situation in which people regard the trappings of authority with suspicion. It's not that I'm suspicious of myself, but I want to create a situation in which the information I'm presenting is looked at critically—not taken for granted—and is examined with caution. There are people who read culture very cautiously and critically. That's a healthy way to approach the information that we're given every day. That's one of the things I'm very engaged with in my work—trying to hone that skill in myself and, I hope, in people who look at my work. . . .

My work has a pretty complicated relationship to performance. Part of that is because there's no traditional audience-performer relationship. But there *is* a Bouvard-and-Pécuchet element in my work: in a way, I'm working through the natural sciences as a dilettante. At the same time, I'm doing that in a very playful way to probe and question the trappings of authority. I'm examining the trappings of authority while, at the same time, I have some relationship at least to the history of the discipline itself.

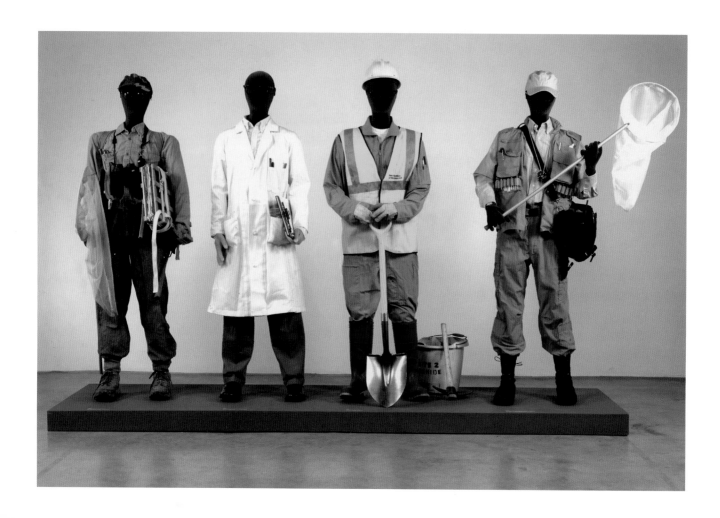

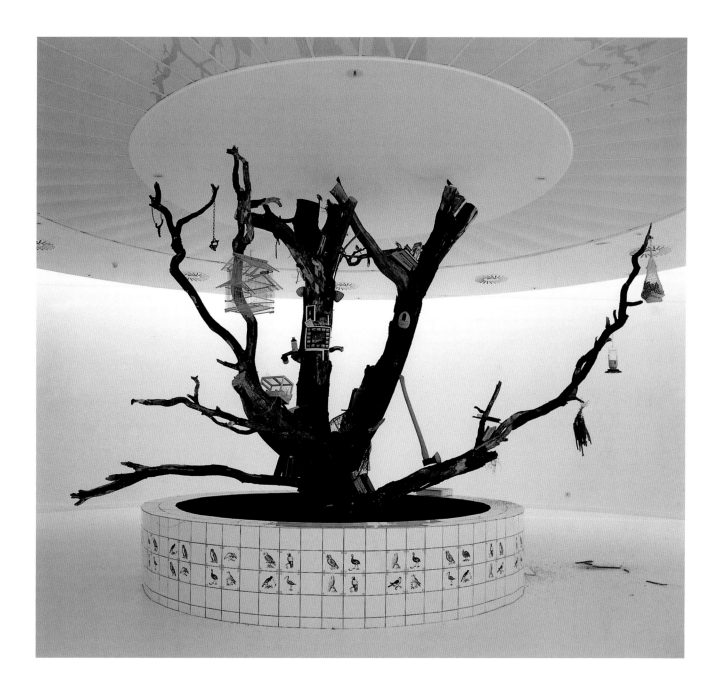

Mark Dion

The Library for the Birds of Antwerp, 1993
Installation view: Museum van
Hedendaagse Kunst, Antwerp, Belgium
Eighteen African finches, tree, ceramic tiles,
books, photographs, bird cages, bird traps,
chemical containers, rat and snake in
liquid, shotgun shells, axe, nets, Audubon
prints, bird nests, wax fruit, and assorted
objects, dimensions variable

I'm not sure my engagement with this
work is based on beauty. There are certain
things that are visually and intellectually
compelling for me, and very often they're
the same things. I'm drawn to notions
like complexity . . . to very sophisticated
systems that interrelate. I'm interested
in ecologies, whether those are political
and social ecologies or natural ecologies.
Understanding the interrelatedness of
things is interesting to me, and I think that
it's something that we often miss in our
culture—being able to see the connections
between things, between our actions, our

personal behaviors, and the way they affect
a broader field, the rest of the world for
example. Those are the kinds of things that
I find beautiful and exciting. I'm not inter-
ested in the virtual; I'm interested in the
actual. I like to be in places and work with
things to create a situation that is experien-
tial. I don't want people to see my work
only through representations, through
images. I want them to be able to move
through the spaces. It's important that
things have a texture, a smell, a feeling . . .
something that you can never capture
from a photograph.

Mark Dion

RIGHT
Drawing for *Neukom Vivarium*, 2006

OPPOSITE
Neukom Vivarium, 2006
Installation view at Olympic Sculpture Park, Seattle
Mixed-media installation, greenhouse structure:
80 feet long
Gift of Sally and William Neukom, American
Express Company, Seattle Garden Club, Mark
Torrance Foundation, and Committee of 33,
T2004.101

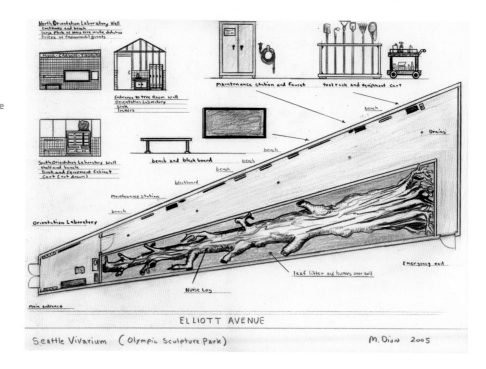

If people examine my work in a superficial way, it may appear to be one thing. If they look and think a little harder, they might find that it's something quite different. *Neukom Vivarium* (2006) superficially resembles a kind of ecological art that is very optimistic, very positive, very *gee whiz.* If you look at it a little more carefully you'll find that it's a bit more critical—that it's darker. The conclusions you can draw from it are not necessarily the most positive but, rather, are worrisome—that, in fact, we can't replicate a natural system.

On the evening of February 8th, 1996, a massive hemlock tree fell over a ravine in a small area of old growth about forty-five miles outside Seattle, in a protected watershed area. Therefore it didn't touch the ground and rot away as quickly as it would have. In some ways, this project is an abomination. We're taking a tree that is an ecosystem—a dead tree, but a living system—and we are re-contextualizing it and taking it to another site. We're putting it in a sort of Sleeping Beauty coffin, a greenhouse we're building around it. And we're pumping it up with a life-support system—an incredibly complex system of air, humidity, water, and soil enhancement—to keep it going. All those

things are substituting what nature does—emphasizing how, once that's gone, it's incredibly difficult, expensive, and technological to approximate that system—to take this tree and to build the next generation of forests on it. So this piece is in some way perverse. It shows that, despite all of our technology and money, when we destroy a natural system it's virtually impossible to get it back. In a sense we're building a failure.

I'm interested in thinking about nature as a process. So this isn't really about the tree, even though the tree is the superstar. It's really about what's *happening* to the tree, about the process of decay. We shouldn't really feel particularly bound up in the demise of this tree because on this tree is the basis of the next forest. The tree supports a living bio-system, from single-cell organisms all the way up to vertebrates—mice, shrews, and birds. I want this piece to talk to the audience, but not necessarily spoon-feed them or give them what they want. I want to acknowledge or even enhance the uncanniness of nature—the wonder of the vast complexity and diversity within a natural system. I want to show how difficult that is for us to grasp, not just conceptually

but also practically—how difficult it is for us to figure in all of the variables needed to replicate a forest. You should look at this and get the impression of looking at someone in a hospital under an oxygen tent. There should be pangs of melancholy when you see this. Of course it is, in some way, a celebration, but at the same time it's full of mourning and melancholy. This tree has been ripped out of its site, so there is something monstrous and violent about the very nature of this work. And in the same way as in a natural history museum, there is a simultaneous feeling of awe at the skill of the reproduction and terror at the 'tragic-ness' of people destroying an environment, killing animals, and reproducing them for an urban audience. That's very much the kind of logic I'm playing with here. The tree is essentially an optimistic organism, giving life through its death, but it is also an organism that is out of context. It's nostalgic for its original site. It's a memento mori, an appreciation of decay as a process, and a tool for discourse. And that's really how I imagine it, because it isn't a natural system. It is really a garden we're making. It's a garden that emphasizes a particular natural process.

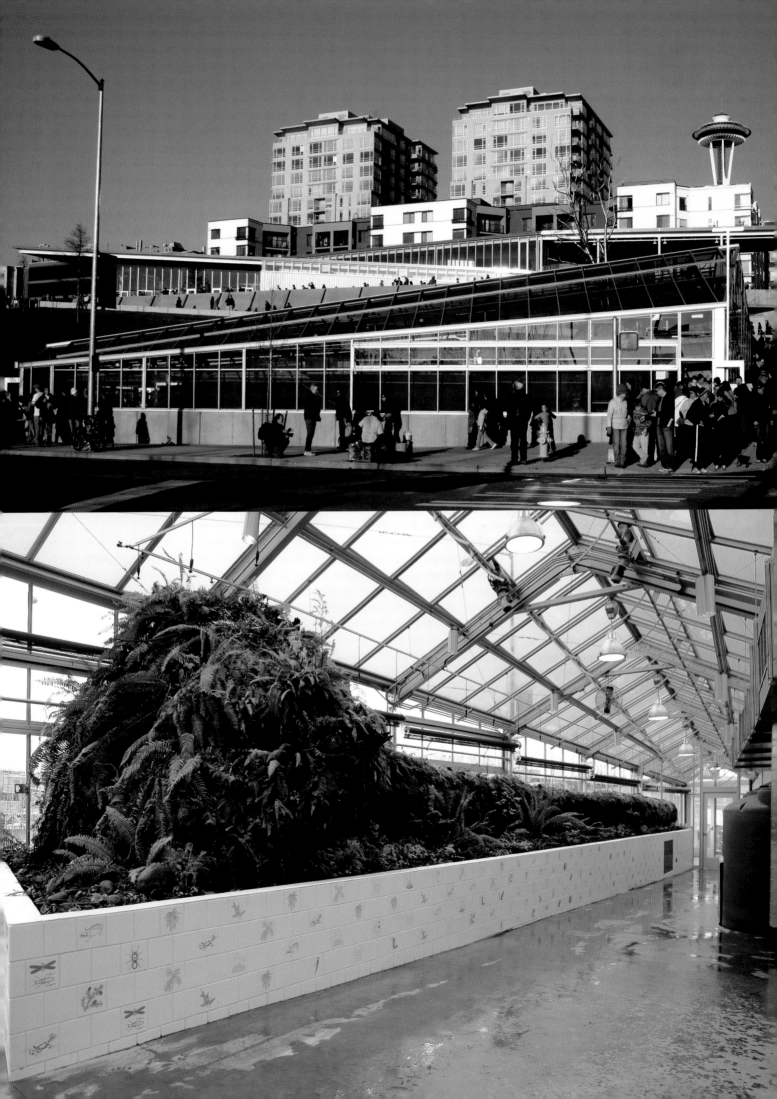

Iñigo Manglano-Ovalle

The beauty that I'm interested in is involved in high aesthetics, where you debate good and evil, the beautiful and the monstrous. At that level, it's very hard to discern whether what you are talking about is the beautiful or the monstrous—whether what you are embracing is truly good or evil. So when you stand in front of a Francisco Goya painting of Saturn devouring the sun, and you see this monstrosity, you look at the painting and say, "Man, that's beautiful." What does it mean? What's beautiful and what's monstrous, or are they so intertwined that you can't locate either one of them? This becomes the ethical dilemma, with both artist and viewer trying to clarify where they stand. To me, that's one of the important parts of beauty. When I make a beautiful cloud, I still want people to think of a nuclear explosion. In *Cloud Prototype No. 1* (2003), I was responding to our quest to find weapons of mass destruction and our memory loss of the fact that we *created* them.

I'm more comfortable in quoting than I am in speaking. I am just quoting a cloud. *Cloud Prototype No. 1* was a thunderstorm that erupted over Missouri and then progressed into southern Illinois, and was captured as three-dimensional data by the

Department of Atmospheric Sciences at the University of Illinois, Champaign-Urbana. We were watching twenty minutes of data flow, and I had to select a moment that I wanted. It was just before the storm erupted. It wasn't about shape, although I ended up with a shape that was about that moment. But it's a quotation. *Cloud Prototype No. 1* is the moment just before the storm unleashes; *Cloud Prototype No. 2* (not pictured), a moment before that; and so on, just receding away, backwards in time. The idea is not to go out and capture any more storms but just to stay with the same storm.

When I talk about weather, it's about a broader definition of climate. Weather is about yesterday, today, and tomorrow. Climate is historical: its present moment is a state rather than a condition. One of the ways for me to get people to think about environment or climate is to have them recognize that they're always in those states. Even when they're in institutions that have set up parameters and structures to protect themselves from the outside, they are still in permeable systems that affect other systems. In order for a museum or home to sustain its climate, it affects the state—the politics—that surrounds it.

BELOW
Climate, video stills, 2000
Suspended aluminum framework,
multi-channel video projections with
sound, dimensions variable

OPPOSITE
Cloud Prototype No. 1, 2003
Installation view, *Purgatory*, at Max
Protetch Gallery, New York
Fiberglass and titanium alloy foil,
132 x 176 x 96 inches

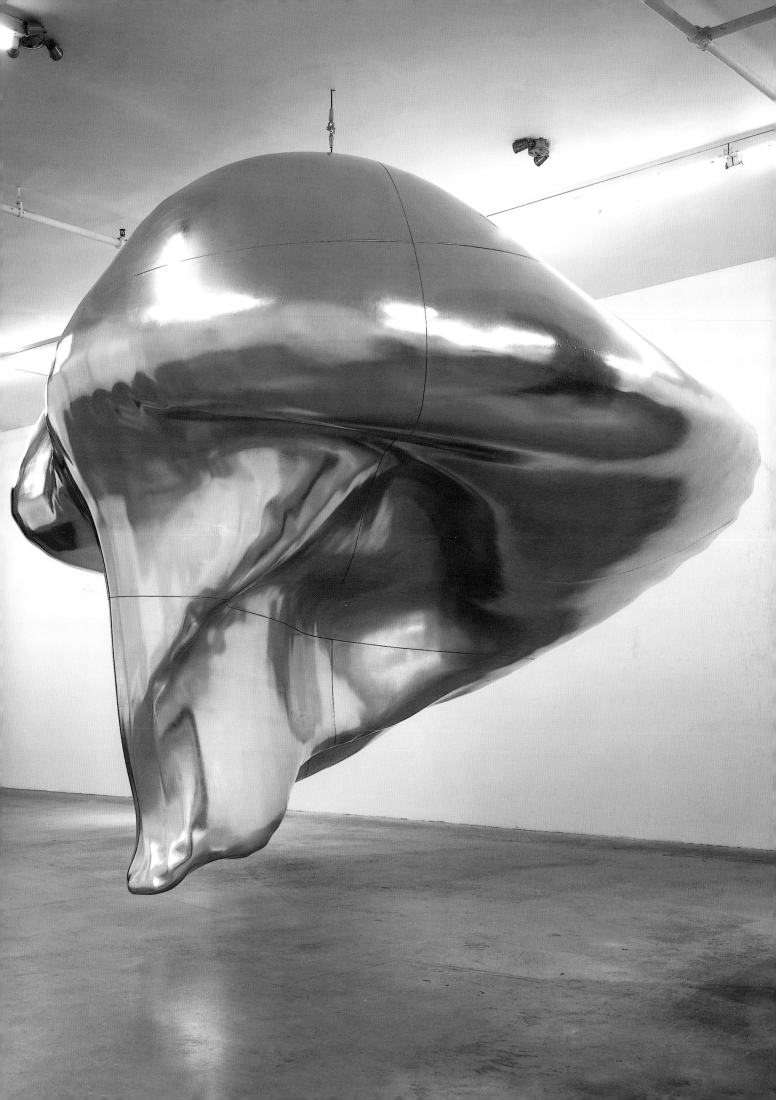

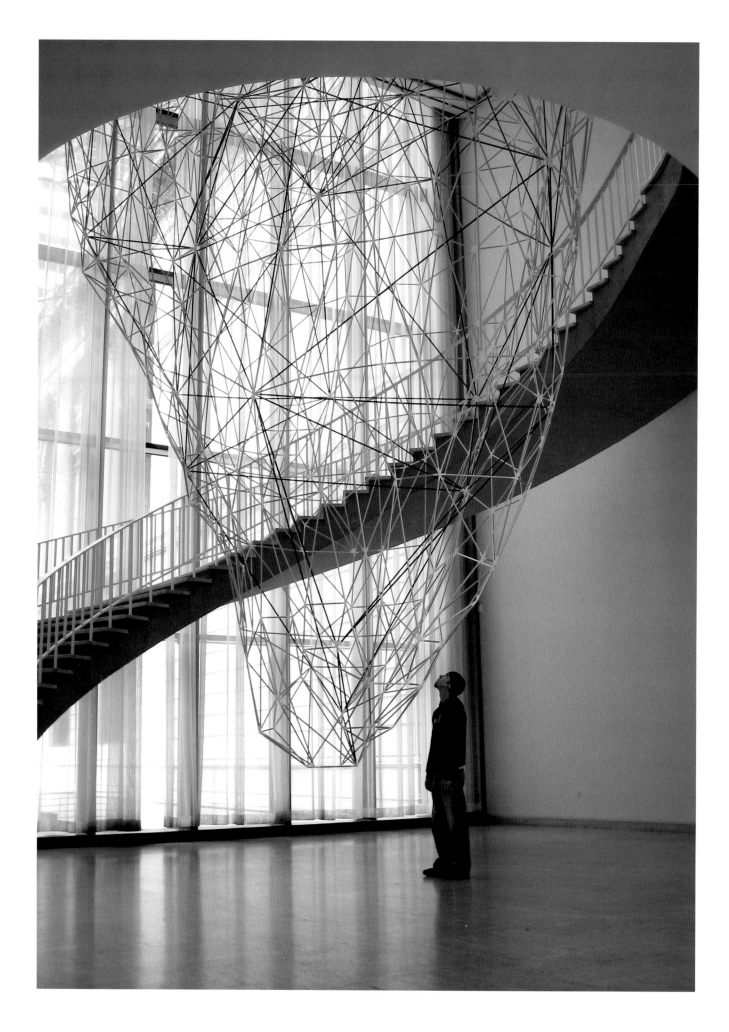

Iñigo Manglano-Ovalle

OPPOSITE
Iceberg (r11i01), 2004
Installation view: Art Institute of Chicago
Suspended anodized aluminum tubes,
rapid prototyped ABS plastic and nylon,
approximately 25 x 20 x 18 feet

BELOW
Oppenheimer, video still, 2003
16mm film transferred to digital video, 8 min, loop

Iceberg (r11i01) (2004) and the *Cloud* are about stopping time. You take an animation and suspend it, so you have suspended animation of a frozen moment—a three-dimensional photograph of one moment. *Iceberg* and *Cloud,* and other projects I'm working on, are almost literally about capturing ephemera. In the end, it's an impossibility. You really haven't captured ephemera; you've made a thing—a sculpture. You've negated the notion of ephemera. Then, it's only the public moving around the piece,

experiencing it, that becomes the ephemeral moment. I think that's also true with the film, *Oppenheimer* (2003). What I'm doing in the film is thinking about Oppenheimer in Purgatory. So I set it in a tropical jungle. He's standing on water, surrounded by hundred-year-old ferns, but this flora speaks of the tropics rather than of Los Alamos. And he's caught there and the camera just revolves around him. So even though it's a moving image (that is, it moves in time), think of it as a photograph that *has* time.

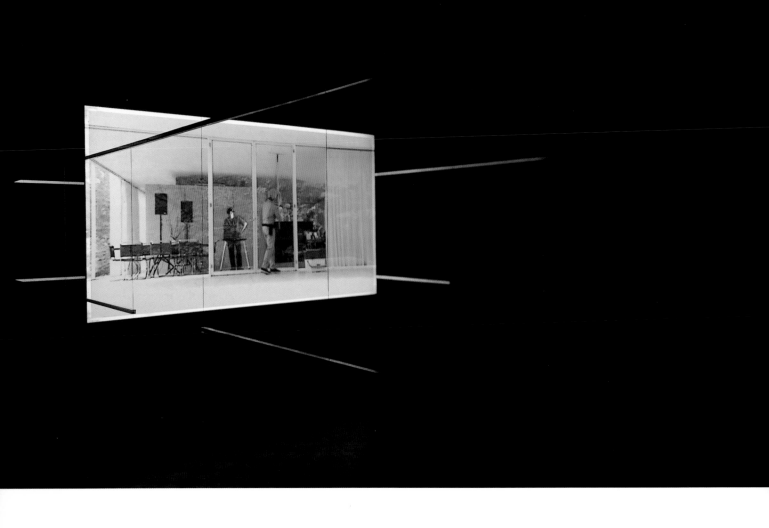

Iñigo Manglano-Ovalle

I grew up looking at art all the time without thinking it was art. In Spain you had the ability to walk into beautiful Gothic cathedrals, into a Romanesque church, or under a Roman viaduct. In Colombia, you had colonial rococo or something more indigenous. I remember coming to the U.S., and finding that in Chicago you really couldn't bring anybody to see those kinds of old classical masterpieces. But Chicago had history. For example, I have a strong connection to architecture in my work. If at a very young age you're walking into these marvels in Europe and in South America, you're not treating them as architecture. Then suddenly in Chicago, the marvel is the nonexistent Gothic cathedral—replaced by something that's specifically called architecture, modern architecture. We were in Chicago when Mies van der Rohe was building there. This is what the U.S. had to offer, this

modernity. Nothing like it was happening in Bogota or in Madrid. It really was a kind of marvel, and I captured it. So there are concrete moments that affect one's view of where you locate art, where you locate identity. And, in one case, modernity was locatable to a particular moment of looking at a building.

When I worked on *Le Baiser/The Kiss* (2000), I had done enough research about Mies's Farnsworth House to know a lot of its history—and about his supposed affair with Dr. Farnsworth, his patroness. I didn't set out to make a film that would deconstruct or investigate these things, but they were all there. For me, on one level, it was about visiting a shrine of modernity—like going to another kind of shrine and having a problem with institutionalized religion, but still gawking at the cathedral above me. When I visited, not realizing I was going to make a film, I took in the

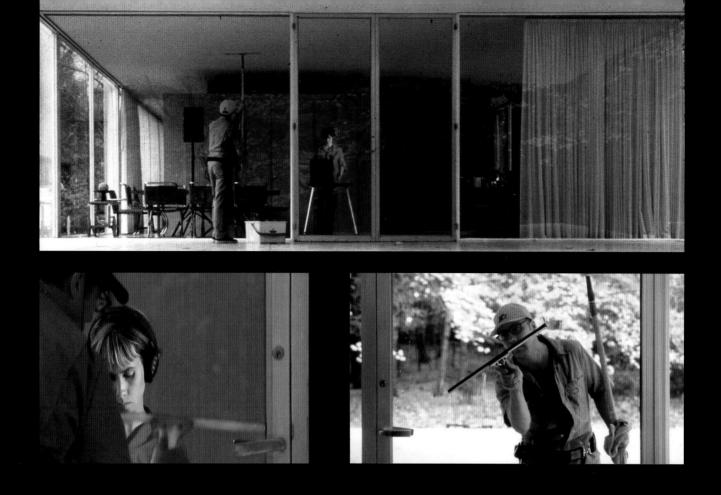

fact that you can't touch the building (you have to wear booties), that somebody would open the door for you, you could come in, follow them around, and go out. The place had a sort of hygienic sacredness to it. I think Mies intended this, whereas Edith Farnsworth intended it as a home. There was a real ideological separation between the two. And so when *Le Baiser* was made, it was about trying to figure out a way to actually touch the building. I figured the strategy would be to take the place of the window washer— to become his assistant. This way we could get authority to touch the building. At that moment, I was interested in that sort of transgression. But it's a transgression that fails because the moment you transgress, you caress. And the moment that you intervene to subvert the building, you erase your intervention. You don't leave a mark behind. So it's all about the

artist trying to critique the father, or modernity, and then failing. As the actor, you're artist, laborer, and architect. You're the artist because you're making the film and because sometimes, when you're washing the windows, the camera watches your hand in a gesture, almost a painting gesture across the pane. But you're also the laborer who, in that gesture, is just simply washing a window. It's mundane. Then you're outside the building tending to its form, so you're the architect. Inside, a young woman with headphones spins some discs. The figure outside is all about the visual, about form, and touching. Inside, the figure is introverted, inside herself—a little reference to Mies and Farnsworth being separated by the very thing they both constructed—a thin skin of transparency but, ultimately, total separation. *Le Baiser* is about love, but it's a

restrained love. It's like looking at work by Donald Judd and drooling—hating the fact that you're drooling, looking at Donald Judd or Sol LeWitt, for that matter. It's a relationship artists in my generation have had with particular forms of modernity, whether some people call it reductive minimalism or just minimalism, and wanting to throw content back into that, saying, "Hey, maybe the way we can embrace this stuff that we love to look at but we don't allow ourselves to love is if we make it our own and put in content." I think the content was always there. We were all just taught via somebody like Greenberg that it wasn't there and wasn't important. But I know it was always there. So *Le Baiser* is about that. But it's also about the most interesting part of love—about desire—at that moment when there's something between you and the object.

Iñigo Manglano-Ovalle

The Garden of Delights, 1998
Installation view at XXIV São Paulo
Bienal, São Paulo, Brazil
Forty-eight c-prints arranged as sixteen
triptychs, 60 x 23 inches (each print);
metal lockers, anodized aluminum
benches, fluorescent lights and fixtures,
towels, Petri dishes, and colored ballistic
gelatin, dimensions variable

Sometimes I think that people mistake my
interest in science, thinking that I'm delving
into science for its technology and its
research. Really, I'm going through a kind of
back door. I'm interested in science as part
of culture, as a cultural manifestation. I think
of art as not necessarily being made in the
studio, but through many conversations,
interruptions, and different types of inputs
so that one can't discern if one made the
work oneself or if so much has penetrated
the process that the work—its authorship—is
exploded and unlocatable. I also think that
is part of science. So when I'm working with
a scientist we're not talking about science.
We're talking about philosophy, politics,

music, and movies—about where we fit in
the culture. People think that art fits solely in
culture, and that science is not culture. I'm
interested in science generated as a cultural
necessity. The creative process for me,
whether it's scientific or artistic, is driven by
a number of forces. And one that I'm most
interested in is desire, a desire for something
that will change us. I often think that science
and art are both contending with the desire
for the new. Even at the moment when we
say the avant-garde is a lost cause or non-
existent, desire is still out there. And I think
even the most critical and cynical artists have
to acknowledge that little kernel that still
connects them to that belief, much as a

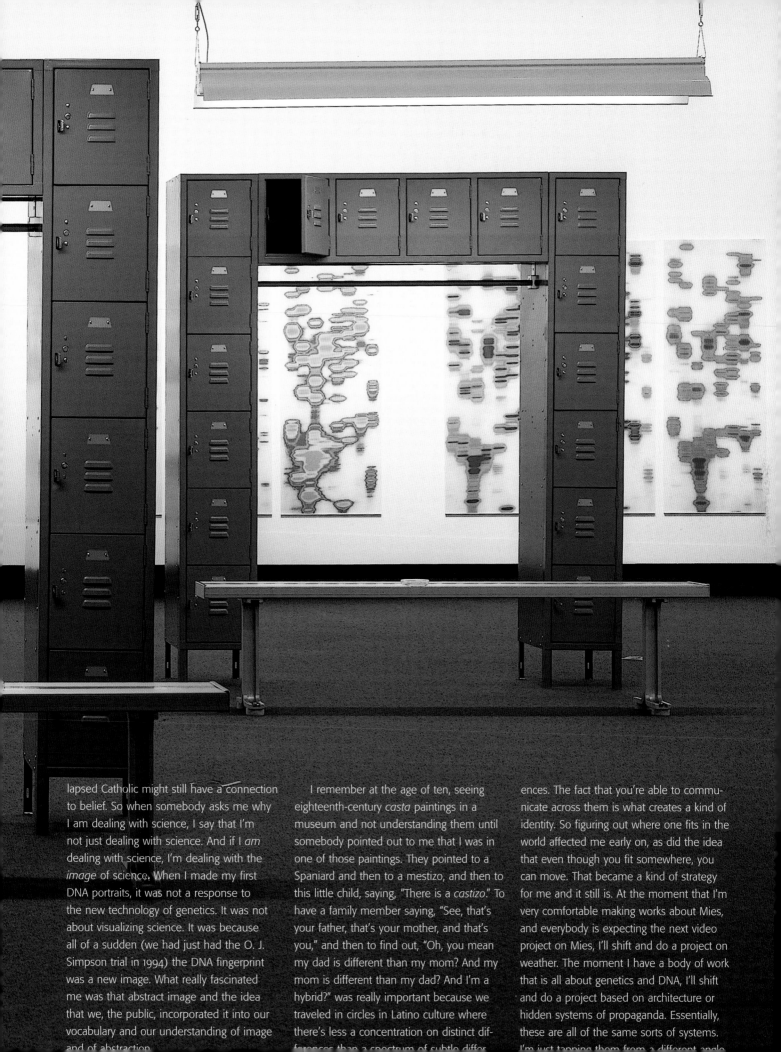

lapsed Catholic might still have a connection to belief. So when somebody asks me why I am dealing with science, I say that I'm not just dealing with science. And if I *am* dealing with science, I'm dealing with the *image* of science. When I made my first DNA portraits, it was not a response to the new technology of genetics. It was not about visualizing science. It was because all of a sudden (we had just had the O. J. Simpson trial in 1994) the DNA fingerprint was a new image. What really fascinated me was that abstract image and the idea that we, the public, incorporated it into our vocabulary and our understanding of image and of abstraction.

I remember at the age of ten, seeing eighteenth-century *casta* paintings in a museum and not understanding them until somebody pointed out to me that I was in one of those paintings. They pointed to a Spaniard and then to a mestizo, and then to this little child, saying, "There is a *castizo*." To have a family member saying, "See, that's your father, that's your mother, and that's you," and then to find out, "Oh, you mean my dad is different than my mom? And my mom is different than my dad? And I'm a hybrid?" was really important because we traveled in circles in Latino culture where there's less a concentration on distinct dif-ferences than a spectrum of subtle differ-

ences. The fact that you're able to commu-nicate across them is what creates a kind of identity. So figuring out where one fits in the world affected me early on, as did the idea that even though you fit somewhere, you can move. That became a kind of strategy for me and it still is. At the moment that I'm very comfortable making works about Mies, and everybody is expecting the next video project on Mies, I'll shift and do a project on weather. The moment I have a body of work that is all about genetics and DNA, I'll shift and do a project based on architecture or hidden systems of propaganda. Essentially, these are all of the same sorts of systems. I'm just tapping them from a different angle.

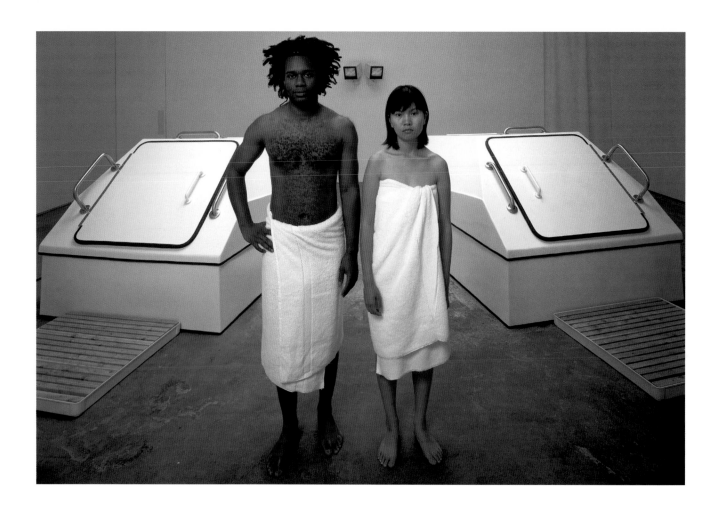

Iñigo Manglano-Ovalle

Niño and Niña, from *El Niño Effect,* 1998
Color photograph laminated to Plexiglas,
40 x 60 inches

The *El Niño Effect* (1998) converts either a museum or gallery into a free public-service spa for sensory deprivation flotation. What I didn't want in the *El Niño Effect* was for the work to be about the artist wanting to share an experience with you, or that art was a way to open doors into the soul of the artist, or that if we could penetrate the artist's experience or aesthetics we would be better off for it. In this work, the viewers' experience was something that I never had. What they were experiencing inside the flotation tank, or when undergoing shiatsu facial massage by identical twins, was something that I hadn't experienced. The real reason for that is that I don't like to be anywhere alone with just my thoughts. I'm terrified of that. That's what a flotation tank is all about. And then, also, it *is* about me, but it's not about me floating, undergoing this spatial experience, and then sharing it with you. It's about the politics of the El Niño effect as an institution, as a kind of weather. It's about migration, the politics of crossing the border. That is, it's about me.

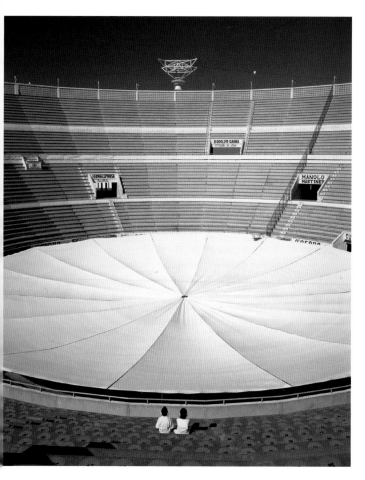
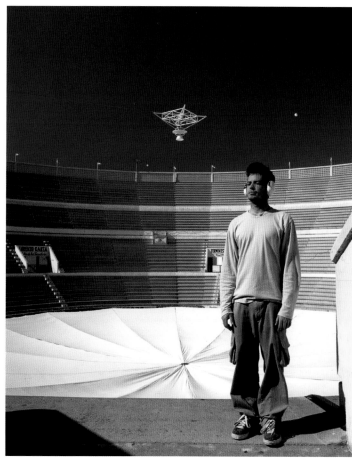

Iñigo Manglano-Ovalle

Search (En Busquedad), 2001
Radio telescope installation at the Plaza
Monumental Bullfight Ring, Tijuana, Mexico

The world was very small for me at a very young age. Lines between things did not exist. I almost had to *learn* that there were borders, rather than growing up with the notion that there were borders and then trying to dismantle them. It was the experience of moving great distances at a very young age. The first time I came to the United States, I was under a year old. But very soon I was back in Spain, and then in Bogota. The trip was very natural, and soon it was not an event. So that's very much a part of my work and the way that I look at systems. They're very fluid, and things that are at great distances are immediately *there*. But I also had the idea that the world was so big that it was not in one's control. My locale was not under my control. I moved from here to there, to a new language, a new school, a new neighborhood, a new city, a new country, a new culture—to cultures that seemingly were the same but radically different. The Old World, the New World, the U.S. Growing up in that triangle between Spain, South America, and the

U.S., the politics were always very different. You had to learn fast and catch up. That's played a significant part in the way I think about creating. I think I'm most comfortable when I'm not in control of systems. So I often make work in which I almost attempt to make my hand disappear. I'm more comfortable with thinking that it's not there—that the world is acting on the work or that the true generators of image, of ideas, are a vast compendium of people and factors rather than artists in their studios. You have to remember that when I first came to the United States as a baby, I came in as an alien—an *alien*. I have the card still, with my baby picture on it. It's interesting how the term 'alien' has different uses. So I wanted to do a piece about alienation—and about UFOs—and immigration, placing the work in Tijuana. There's this large monitor and surveillance system pointed up at the cosmos in Hollywood B-movie fashion, searching for 'real' aliens and subverting the meaning of the word. Everybody in Tijuana, from cab drivers to artists to politicians, got the joke.

Iñigo Manglano-Ovalle

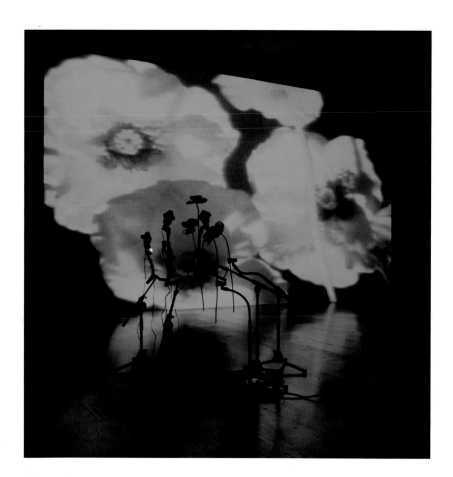

LEFT
Nocturne (White Poppies), 2002
Installation view: Museo Tamayo de Arte
Contemporáneo, Mexico City, Mexico
Live video installation, night vision camera, LCD
projector, live audio, Night Vision with wild opium
poppies and live audio, dimensions variable

BELOW
Black Jack, 2006
Carbon fiber and aluminum, 138 x 158 x 96 inches

OPPOSITE
Bulletproof Umbrella, 2006
Kevlar, graphite, ABS rapid-prototyped polymer,
36 x 36 x 33 inches

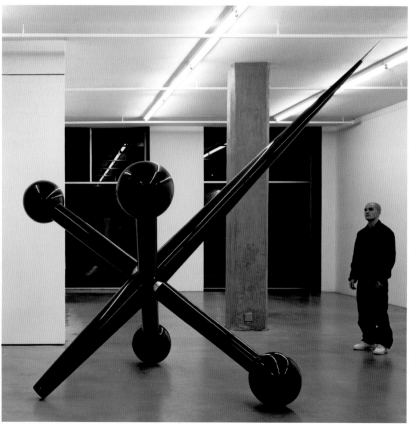

All my work, even the most formal work, has an underlying politics to it. But I don't want to reveal my position. The moment I reveal my position is the moment that I think art is about telling you something that I know and that you should know it. I'm more interested in thinking about something, arriving at a position I will take towards it, and creating moments in which people have the possibility to think about something similar and take a position. So if art for me is a platform from which to speak but not tell you something, that's good. And if that's a way in which I give you a platform from which to think and debate, that's even better. Ultimately, for me, art does not reside in the object. It resides in what's said about the object. That's where it makes change.

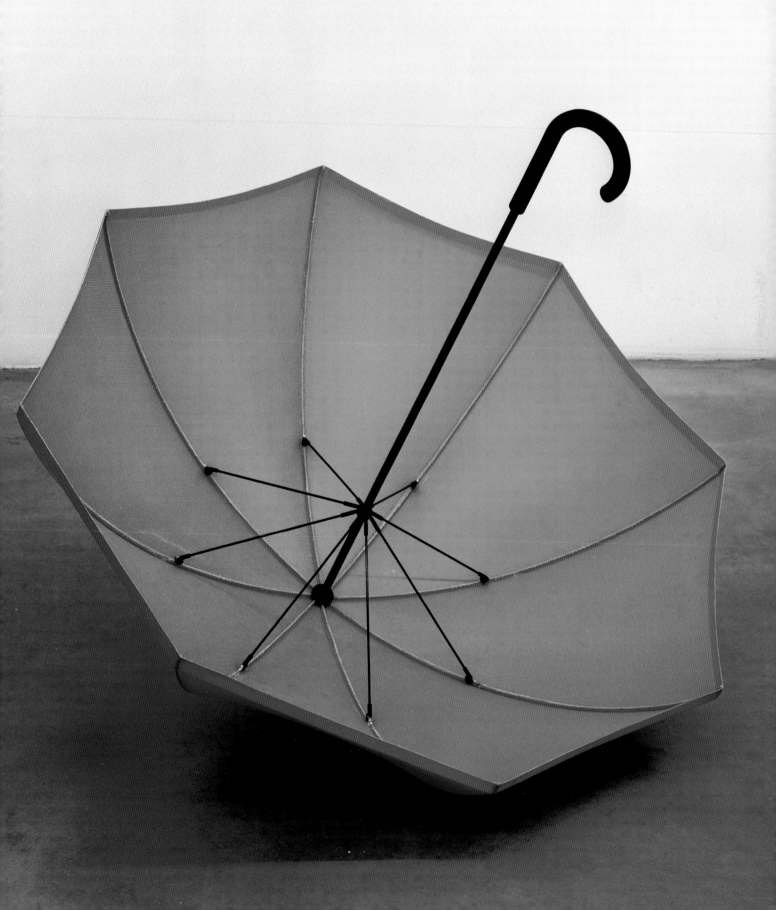

Ursula von Rydingsvard

I was born in 1942 in a beautiful little town called Deensen, in Germany. Between 1942 and '45 my father was a forced laborer on farms. When the war ended my father saw no opportunities. He decided to try to go to America—a huge wish, given that he had seven children. You could go alone as a single man, but it was much more difficult to go as a member of a family of nine. But he and my mother made the decision to go through the postwar refugee camps for Polish people who didn't go back to Poland— so we went through eight camps, working our way north. From Bremerhaven, the northernmost port in Germany, we took a ship to the United States. If I were to point to something from the camps that one can see most directly in my work it is that we stayed in barracks—with raw wooden floors, walls, and ceilings. I have a feeling that that fed into my working with wood. And the first time I ever saw Poland—all of the villages, all the homes there, were made of wood. There were stacks of wood, doors, and troughs of wood. Wood was the building material. So it's somewhere in my blood, and I'm dipping into that source. The way in which I manipulate the cedar is very important to me, but I have a feeling that I even learned from things that I never saw. Working with it and looking at it feels familiar.

But the memory that I do have (although I've thought about it so much that I'm not sure what I'm projecting and what was the memory itself) is that I remember sitting on steps and having on something like a nightgown. This nightgown was made of a raw linen that was quite stiff, and it folded in ways that had almost mountainous landscapes to it—a kind of erect landscape that made all kinds of indentations and crevices, little hilltops and so on. And I just remember feeling it on my body, the harshness of it and at the same time the softness of the parts that were more worn down. And I remember the sun hitting those structures on my body. That's a memory that has vagueness in it, but I've dipped into it a lot.

BELOW
hej-duk, 2003
Cedar, 119 x 107 x 141 inches

OPPOSITE
Dla Gienka (For Gene), 1991–93
Cedar and graphite, 88 x 53¼ x 31¾ inches

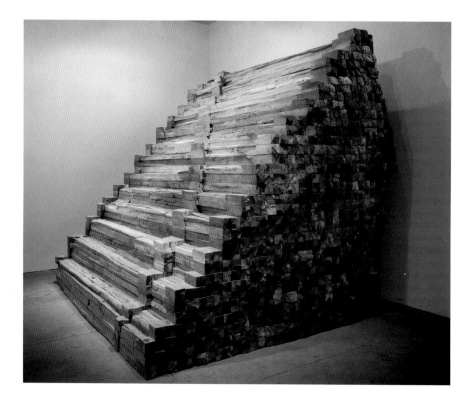

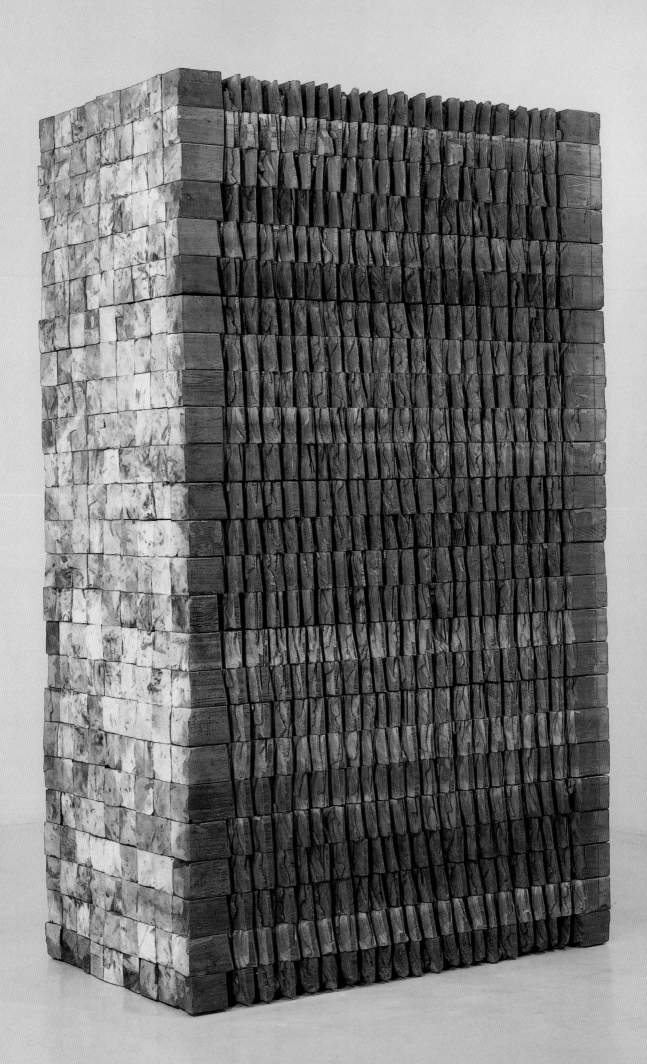

Ursula von Rydingsvard

BELOW
Mother's Purse, 1997
Cedar and graphite, 24½ x 78 x 91 inches

OPPOSITE
Czara z Babelkami, 2006
Installation at Madison Square Park, New York
Cedar, 202 x 125 x 74 inches

I had a sweater as a little girl (in the refugee camps in Germany), and it was hand-knit out of unbleached wool from sheep. It had wonderful *babelkami* (popcorn stitches) on it, on the grid that was at the top part of the body. And of course, in no time at all (because it was not as though I had more than one of these . . . it was actually the only sweater I had during all those years) it got worn on the sleeve, around the shoulders and around the belly, so that it was kind of wayward. The grid got disrupted. It went organically wayward. It started flowing. It started falling. So I used that, or a kind of intrigue with that, in part, as a source of my imagery for this enormous bowl—actually the biggest I've ever built. She sits there, and her profile from the side is very slender. From a three-quarters view she spreads out. She's like a sail, eleven feet wide at the top.

Obviously it was impossible for me to consciously think that I was going to be an artist because I'd never heard of anything like an artist until I came to the United States. I just know that I feel like I drank from the world through visual means—that that was a huge source of the information by which I lived. My home was one in which words were not used very often. With my parents the only words that were exchanged were in connection with assigning labor. "This is what you have to do, and this is what has to be done." So words were very, very sparse. And in fact, anybody that used too many words was automatically suspect.

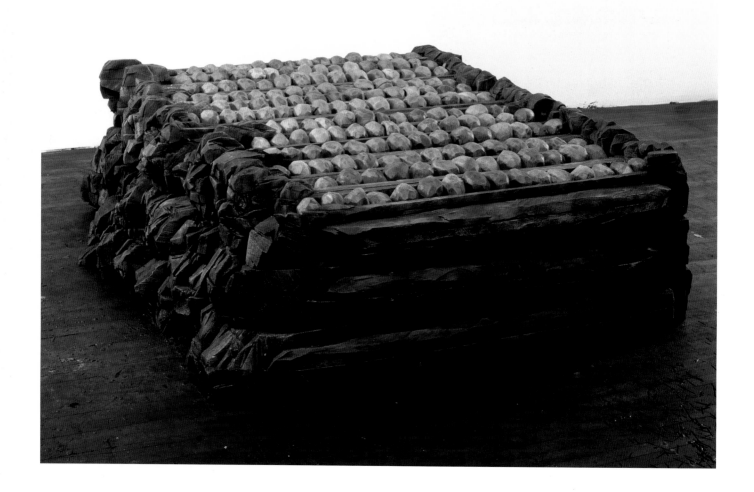

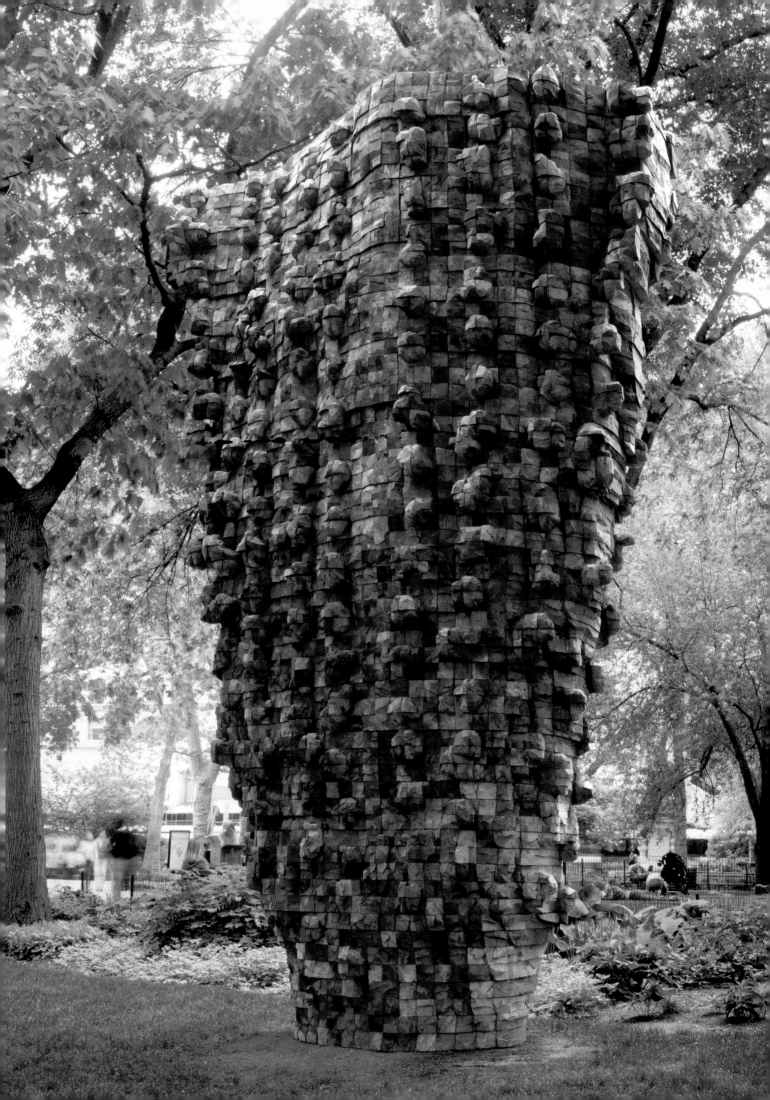

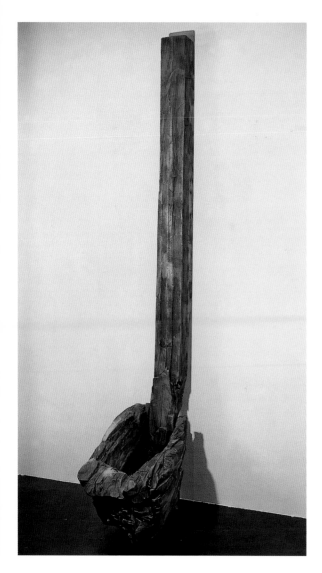

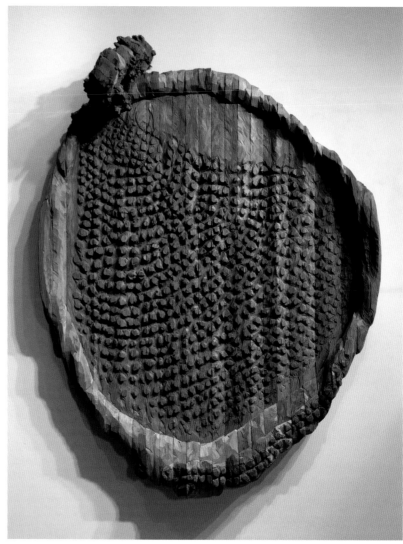

Ursula von Rydingsvard

With my sculptures, I will take a bowl and I will get carried away with that bowl. And the license I give myself is the pleasure. The tangents I take with that bowl are an extension of me and where I want to wander, visually. So mine are definitely not utilitarian objects. But I learn from them. I learn from that which is vernacular. I love things that I use—like the *tarika*—which is the washboard—or bowls, wooden spoons, big pots. They're all very primitive, very crude. . . .

I'm not even sure that it's sculpture that I drink the most from to reap imagery for my work. I think it's vernacular architecture—everyday kinds of objects like bowls and cups—that enables me to springboard. And that gives me a lot of room and a lot of leeway because none of it has been so explicitly defined. Usually the utilitarian object is just that; it's made to be used. And the whole design, if one wants to call it design, is made for the purpose of its being used so that the options surrounding it are huge. If I were to say how it is that I break the convention of sculpture (and I'm not sure that's what I do or even if that's what I want to do) it would be by climbing into the work in a way that's highly personal, that I can claim as being

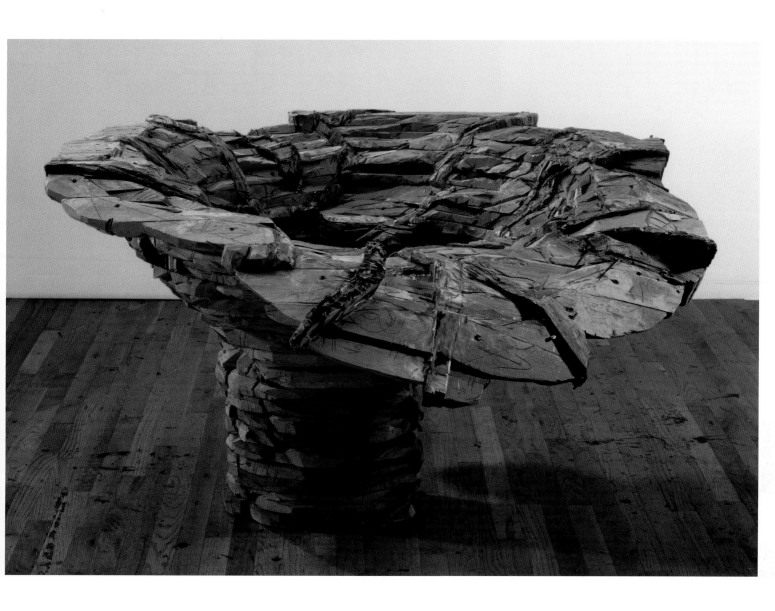

mine. I have this feeling that the more mine it is, the more I'm able to break the convention. So it's not radically erasing, with this drama, what's been done in the more immediate past. It's more like finding many ways into the work that feel potent psychologically, that feel potent emotionally, but only feel potent for me. And maybe that'll overlap onto what others might or might not see. But I think the most important thing for me is to figure out what it is that'll give me a rise. What it is that'll turn me on. What it is that feels really interesting to me. Or what it is that feels compelling—why I would be driven

to do something like that seventeen-foot bowl with all the *babelkami* on it.

Magic is such a difficult thing to even point out, but you can feel when it's starting to happen. Sometimes in a sculpture it'll start and then I'll lose it. And then I can't regain it again because when it starts you say, "This is good, keep it going," and you keep it going for too long or you overdo it, or you get too greedy. You take advantage. So you have to come to it—not in any kind of a forceful way but on tiptoes—very quietly, in a very hushed way. And if you see the

magic happening, let it stay for a while. I love to keep the options open so that there are metaphorical possibilities within a lot of realms. I hate the thought of closing in on *this* particular, specific thing that had *this* reason for existence. It's one of the reasons why I never do a model. I never do drawings for my works because they close me in, because they limit my options. I love the thought of having a whole range of multiple metaphors that are possible. But, still, if your range gets too broad and too all-over, it's possible to lose the intensity and it's possible to lose some of the magic.

Ursula von Rydingsvard

RIGHT
River Bowl, 2001–02
Cedar, 174 x 120 x 120 inches

OPPOSITE
Damski Czepek, 2006
Installation at Madison Square Park, New York
Polyurethane resin, 143 x 406 x 400 inches

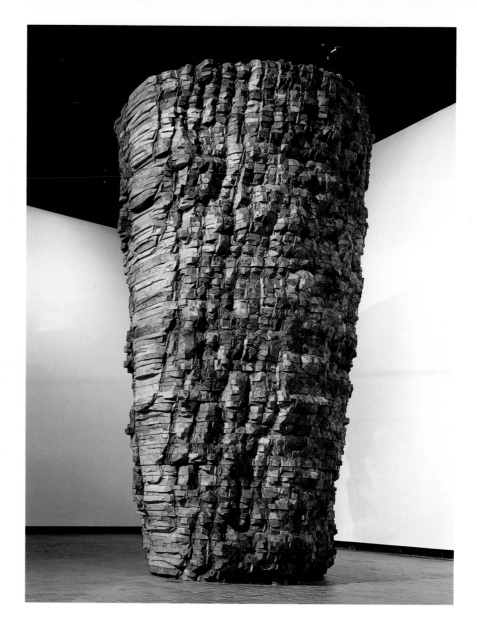

I start first by drawing a circle on the floor. It's just a beginning, a way to start. I then take one four-by-four, put it on the circle, draw lines around it, send it to the cutters, put it back. Take another four-by-four, put it next to that. Draw another line and send it to the cutters, put it back. . . . So you get one structure that is kind of a sister or a brother of the next. And, from the end-grain side, what you see is a grid. But what I do is I screw up the grid. I bulge it—make it go into agony. I sort of have fun with it, try to give it anxious moments, so that the end grain is almost like a grid stack. It looks much more organized. It looks much more regulated. And we mark this structure on the outside in order to know how to screw the entire piece together layer by layer. As I'm drawing and they're cutting, we build it upwards, and

then, when I get through with the piece, they unscrew the top layer, put it down on the floor, unscrew the next layer, and put it down on the floor. We call this reverse stacking. Then, we glue it layer by layer. Each gluing takes about eight hours. . . .

Damski Czepek? Czepek is something that belongs to an Old World bonnet, and *damski* means 'belonging to a woman'. I never wanted to be literal. And I never wanted the explanation to be so simple and so clear with such a hard dot at the end of it. But I like the porch-like cover over the cavernous section a lot, and I didn't know how else to refer to it. The working title was *The Bonnet.* I tried so hard to get rid of it, not to make references to it with the people that I worked with at Madison Square Park. It just kept popping out. The urethane bonnet was

extraordinarily time-consuming. I did the entire bonnet out of cedar first, and the cedar walls were very, very slender. I sent that bonnet (a life-size form in cedar of exactly what was made in urethane) across country to Walla Walla Foundry in Washington. I think it's the biggest pour that was ever done in the history of this kind of urethane. And there were huge amounts of things that failed in the process of learning how this material works. I wanted a transparent look of walls that the light went through. I wanted a very agitated surface. And the hood that is over the bonnet—almost like a little porch—is very erratic and very celebratory, and it needed that translucency of the light. It's not just the sun. . . . When the skies are cloudy, there's a whole different thing that happens with that material.

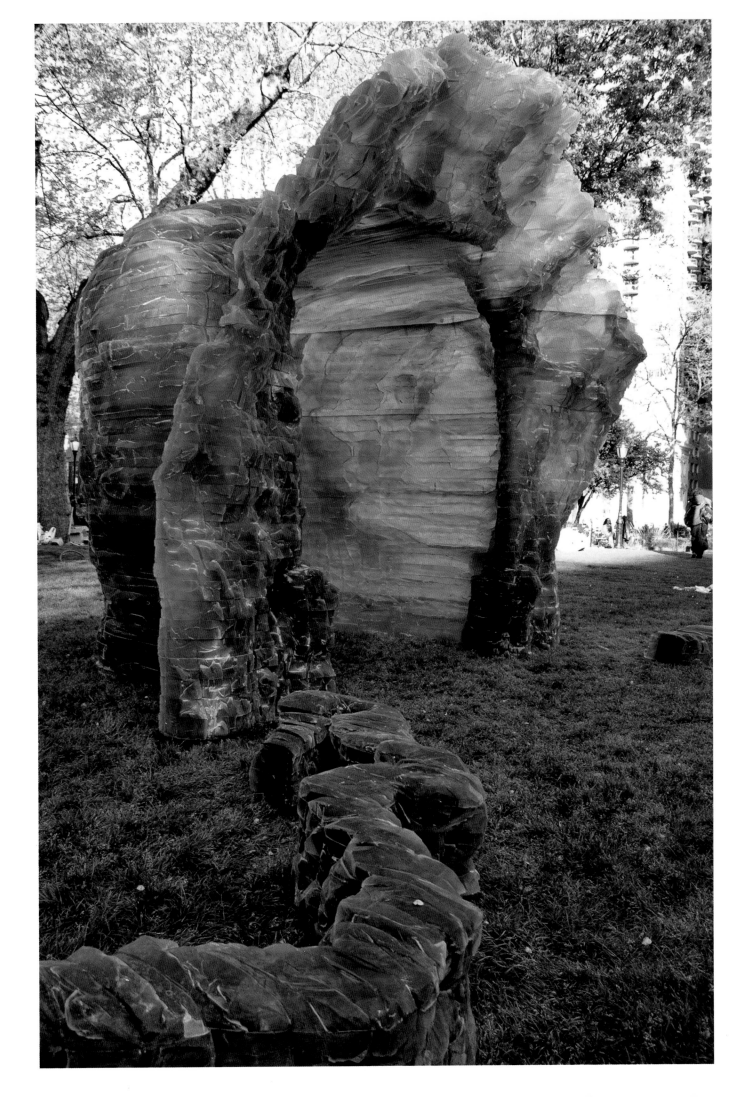

Ursula von Rydingsvard

BELOW
Doolin, Doolin, 1995–97
Cedar and graphite, 83 x 212 x 77 inches

OPPOSITE
Mama, your legs, 2000
Cedar, graphite, and steel, 114 x 186 x 142 inches

Nothing can exist in my head without opposites. The opposites don't have to be complete opposites, but they can be things that don't ordinarily belong together—as within a setting or within a piece that has tremendous agitation and agony there can also be something very hushed and very quiet, and very lyrical and very humane. Within the context of something that feels as though it's full of violence, one can have something that feels humble, that feels as though it's capable of petting you on the head in a most gentle sort of way. But I think, to have any level of interest, you have to have some sort of combat occurring within the work—some sort of conflict. You don't want a blandness; you don't want a sameness—although a sameness can also bring about conflict. It's not as though there's any kind of a rule as to how to get there. For me it's all instinctive as to what sort of a mixture is needed. And I never verbalize this as I do the work. I'm just thinking about that in retrospect.

Often, no matter what I say—especially about how to make art or how to think about art—I could almost say the opposite and the opposite would be equally true. One can't hold to anything that securely or that adamantly, thinking that that's the right way to think. I think that's probably one of the most important things. The confrontation in part lies with my struggle with the cedar. It's always telling me what *it* needs to do and I think that I'm trying to tell it what *I* want it to do. So obviously there has to be a kind of compromise.

Mama, your legs (2000) is the first moving piece I ever made. As outrageous and wayward as I thought I was being by making this moving piece, there's something important about reaching out to places that are wayward, outrageous, and downright stupid in the way they look and behave. But the sound this big thick wooden tongue makes, the thick tongue hitting against the lip of the bowl as it goes up and then against the back lip as it goes down, and then when it hits the bottom, is pretty astounding. It has something to do with what a pier does when boats hit up against it, wooden boats. . . . I don't know, but somewhere in my life this stirs up something that feels pretty critical.

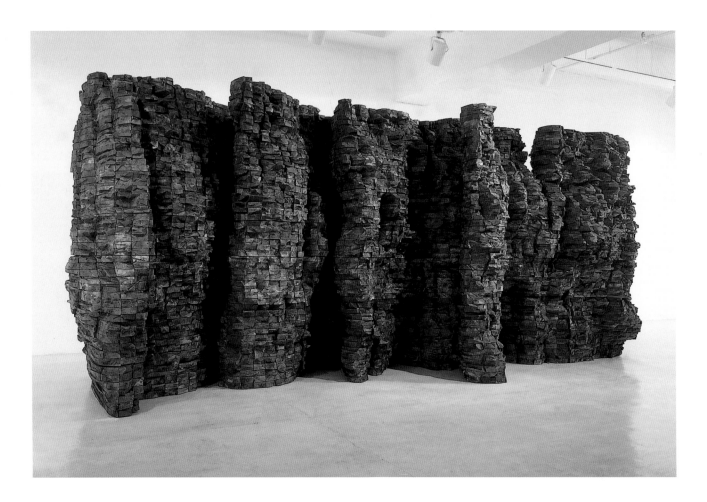

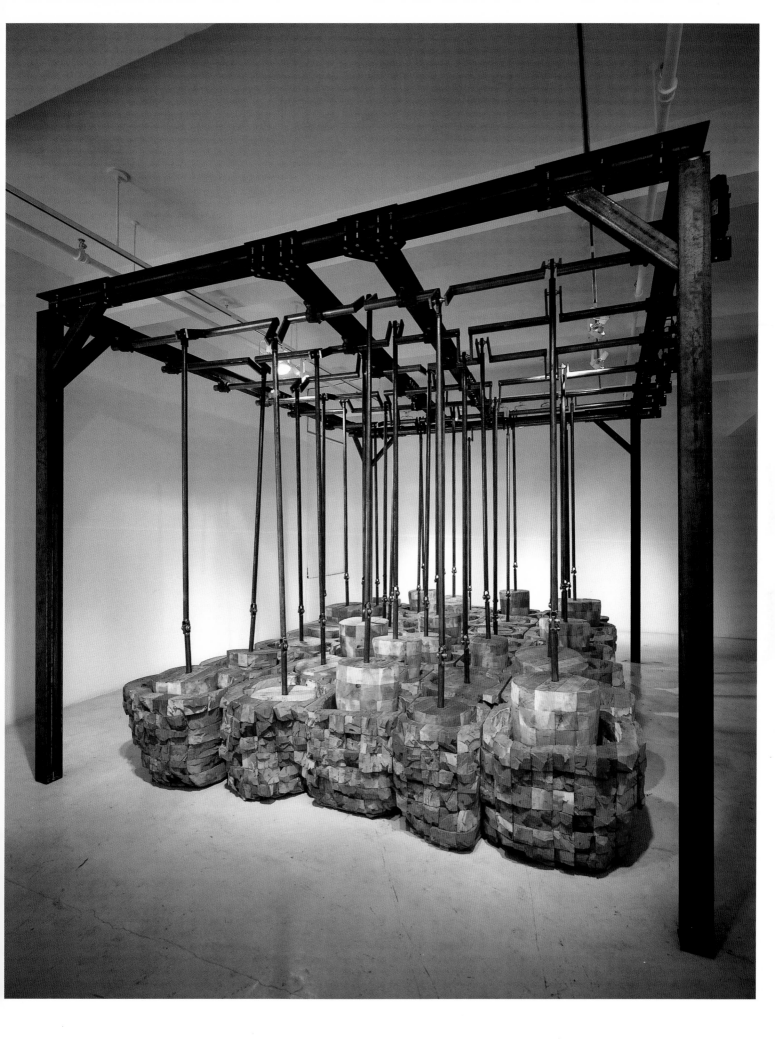

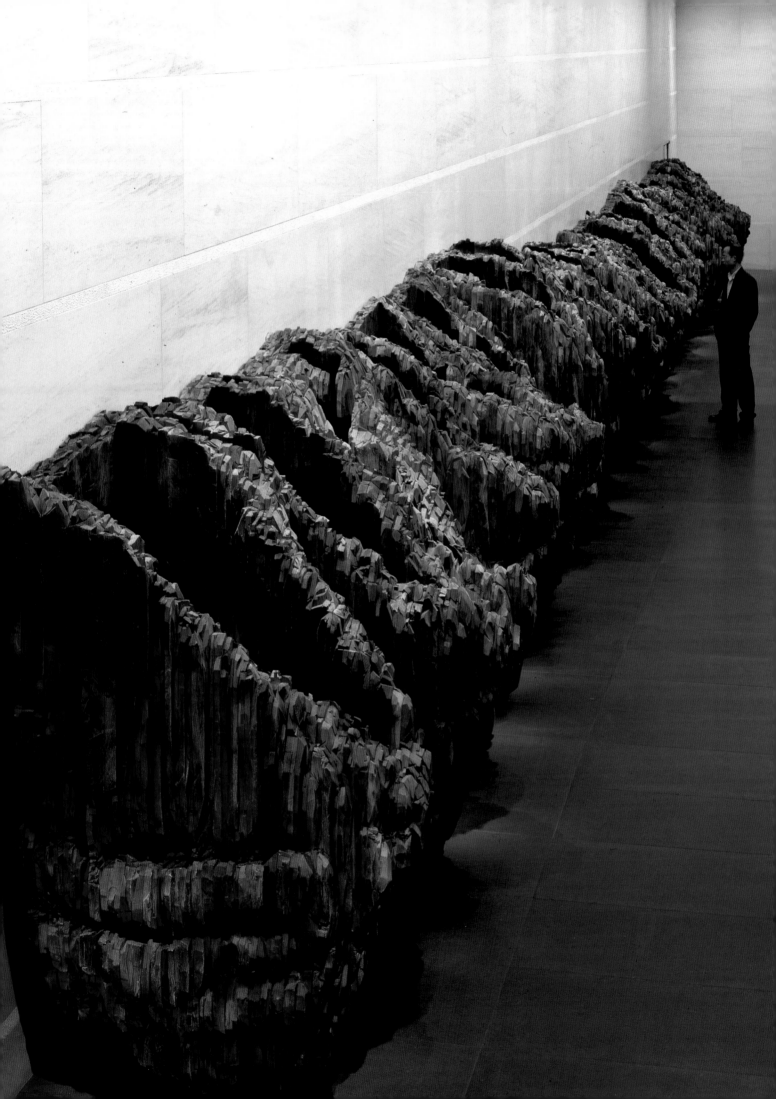

Ursula von Rydingsvard

OPPOSITE
berwici pici pa, 2004
Cedar and graphite, 8 x 86⅔ x 5½ feet
Public commission for the Bloomberg Building, New York

RIGHT
Wall Pocket, 2003–04
Cedar and graphite, 162 x 72 x 65 inches

Berwici pici pa (2004) is loaded with lips.
(I call it a lip because, of all the parts,
it's the only one that sort of hangs loose
toward the front. I could almost call it a kind
of apron, but that wouldn't be quite right.
I think lip is closer to it.) The piece has a
very flat back, but it's got these voluptuous
lips that come in and scoot out in a way
that's very different from the way my flat
pieces function. This is very primitive volup-
tuous wandering. That's what I wanted, a
procession that you go through, when you
enter the building. It's a kind of procession
that the sculpture makes with the people as
they walk in. *Wall Pocket* (2003–04) was
made with two-by-fours instead of four-by-
fours. Two-by-fours are very, very slender.
It has a whole different definition because
you get at least twice as many chances to
go into details. And there are shifts to the
left, to the right, as you see when it climbs
up. It's not like a simple staircase, neither is
it like the inside of most of my bowls that
have a kind of smooth descension. This is
more erratic, more chopped. It definitely
matters that this is not an outdoor piece.
It's inside because it's made in a way that's
more vulnerable. I made very thick walls
on the outdoor pieces. I've never made an
outdoor piece with two-by-fours. I've always
used four-by-fours. I don't have anything
that's quite this vulnerable (little things,
ledges sticking out) on my outdoor pieces.
You can't have little pokers that stick out
because they'll be the first things to go.
So my outdoor pieces are very contained,
stable, anchored-looking structures. This is
much more flirtatious and erratic in the way
that it moves up. And the layers are not
exactly fitted. They shift as they go. That's
an important part of the energy of this
piece. One of my favorite parts of this piece
is the structures up above that lean toward
the front. They're almost like little rolls of
something that respond to one another.
They have a complexity that I like. It gives
you visual food that I enjoy giving.

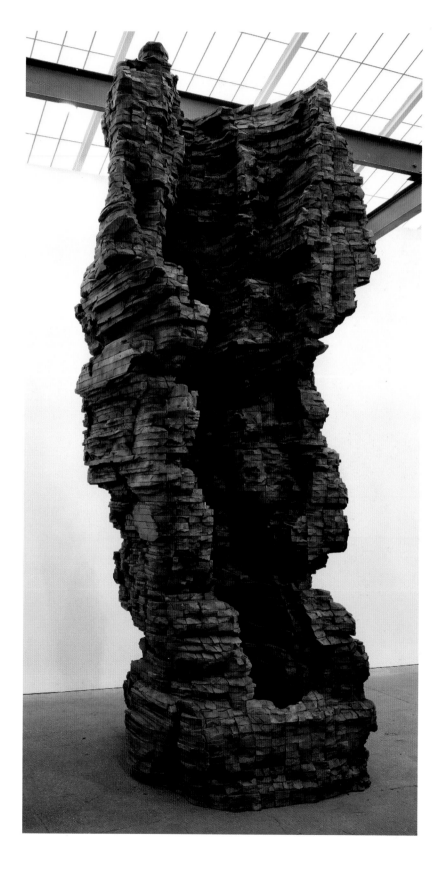

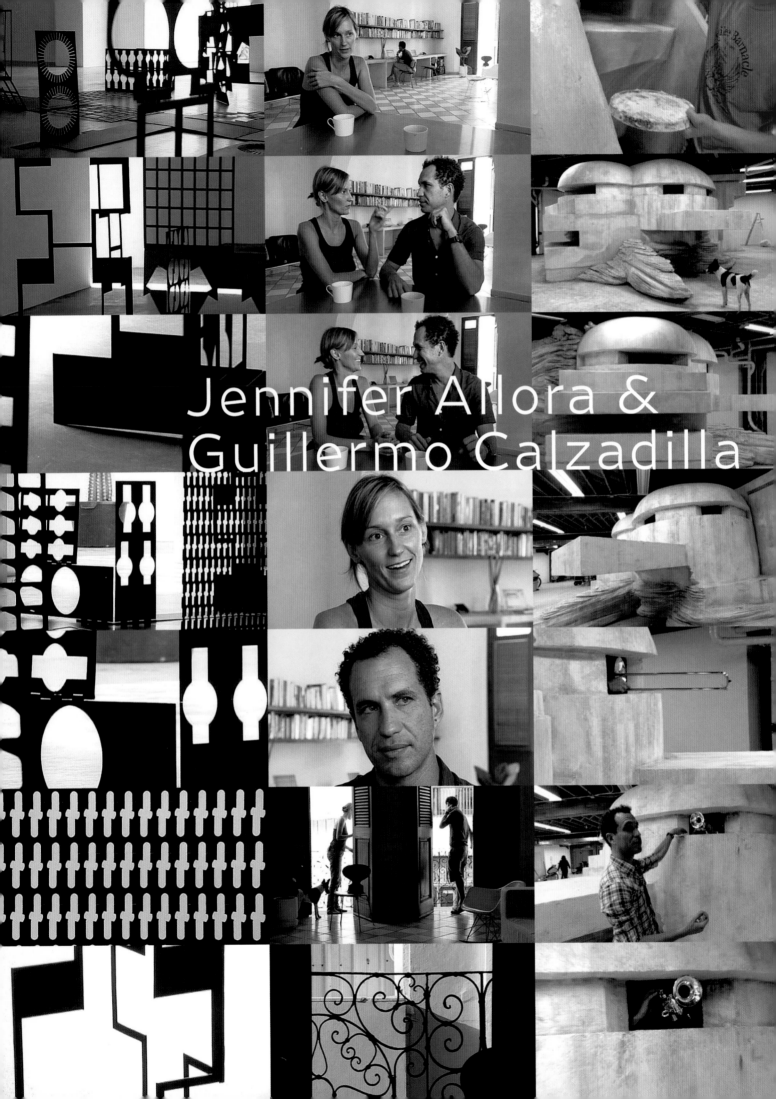

Jennifer Allora &
Guillermo Calzadilla

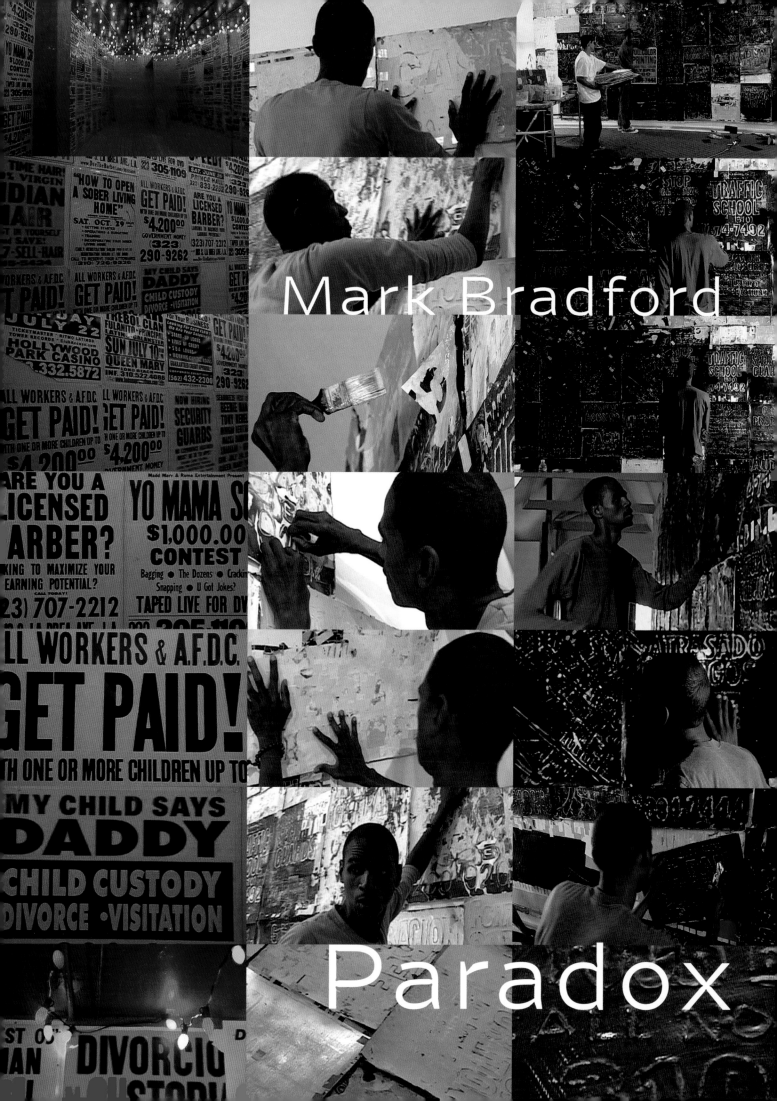

Mark Bradford

Paradox

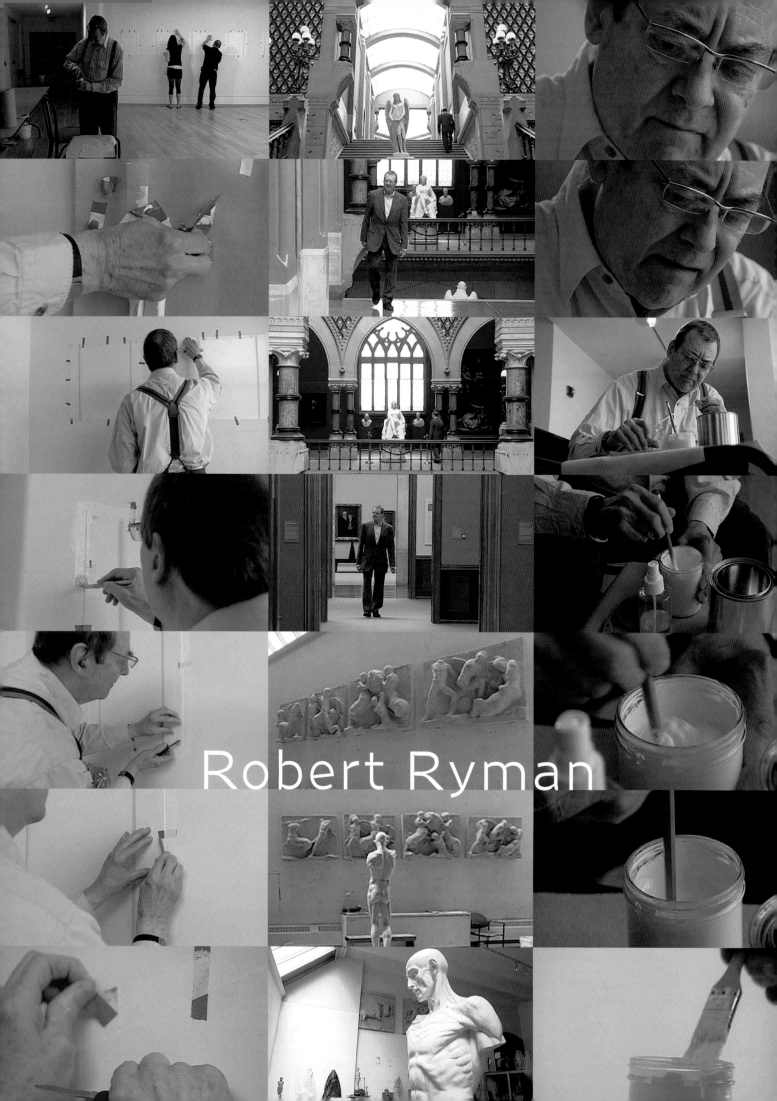

Robert Ryman

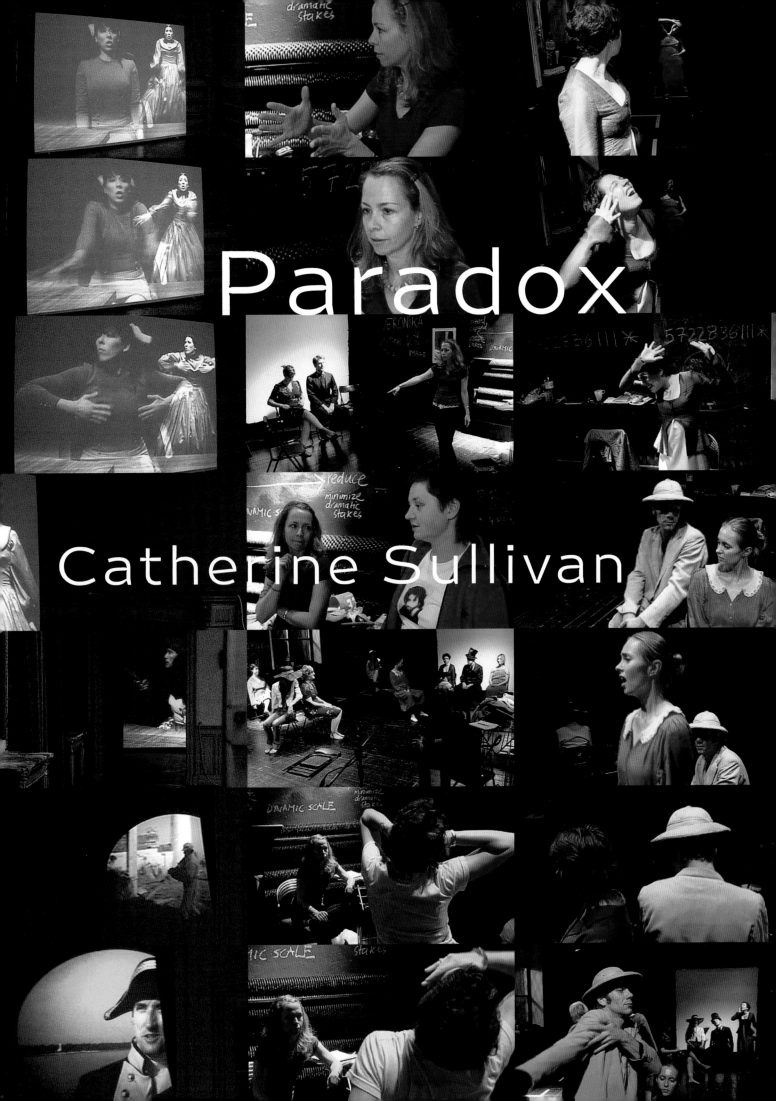

Paradox

Catherine Sullivan

Jennifer Allora & Guillermo Calzadilla

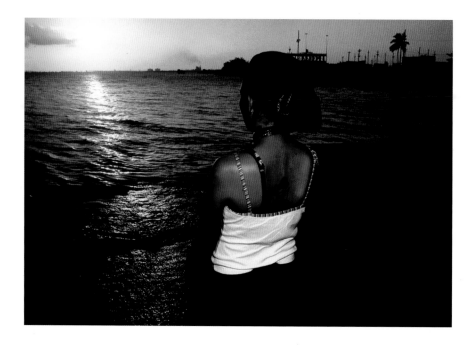

What is really important in our practice is criticality. We constantly want to question and have our work trigger a possibility of self-questioning and questioning about the world. What is the nature of this thing that's affecting me or that's around me? What is the nature of my actions upon others or the place where I am at this moment? A lot of our projects are an opportunity to learn something about an area or an interest that we didn't know much about, whether it's abstract or philosophical or pragmatic. It's always a chance to learn more about something in the world and to formulate some kind of response. This has a lot to do with vulnerability. How can you be vulnerable to the things that surround you to such a degree that you can have them affect you—change you, shape you, and form you? The idea of vulnerability is something that's an interesting and important part of our work and, more generally, about what we want to be—how we want to be—ethically, in the world. This is a challenge. How can you be shaped by the things around you, and then also try to assume a critical position and not just let yourself be absorbed by the world?

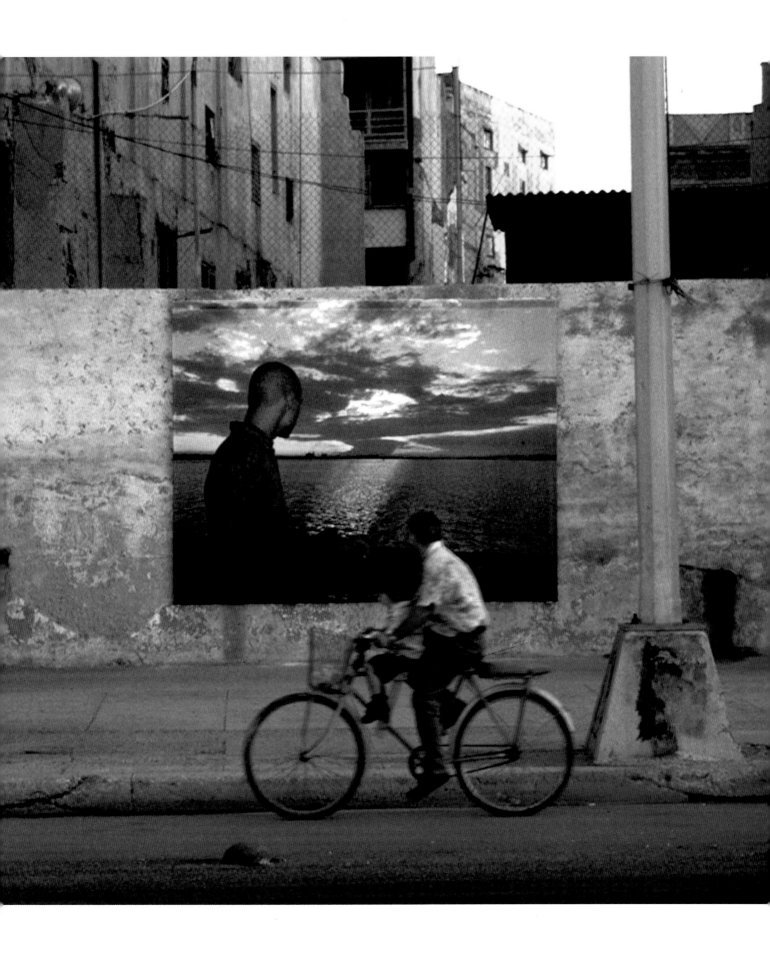

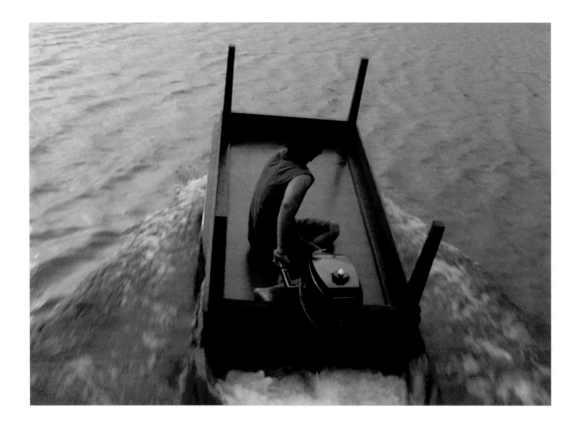

We arrived at *Under Discussion* (2005) through the metaphor of the discussion table. We just followed through formally on the logic of the words. The work developed during the time when the civil disobedience movement of Vieques succeeded in demilitarizing the island. Who was going to benefit from this—economically, politically, culturally? How was this conversation about future development going to develop democratically? We got interested in the idea of the conversation being stuck. Nothing was moving, and that was a common frustration for everyone, so we started with the idea that we wanted to mobilize the discussion. The very people who had been involved in the popular resistance to the Navy's bombing range were among those who were excluded from the conversation. And the policies that had been created since the Navy's departure had been dictated from above by the U.S. government, as opposed to incorporating our municipal and local perspectives. So we took the Vieques discussion table and we turned it upside down and made it into a boat. We put a motor on the back and found someone of fisherman background from Vieques to drive it. We used this person as a way to trigger that historic group mnemonically and then to take the discussion table into the

areas being debated or discussed. So he drove along the historic fishing route, along the eastern lands of Vieques, where the local fishermen had first witnessed the destruction of the local ecosystem and mobilized against the ecological damage that also damaged their livelihood. We were interested in their way of bringing together ideas of environmentalism and civic or social justice in one equation so that what they were talking about was their own right to survival as an endangered species. We think of the work as a case study of a power struggle. For us it is specific to Vieques and what happened there, but it also reverberates in other places and other contexts. For viewers who don't know this context, there are enough visual signs in the film that give clues. You will never be able to know the full story. There will always be something that escapes. This relates to everything in life, and that includes a work of art. You see the image; you hear the sound; all these moments generate signs. Out of these signs you create images, passions, emotions, experience. But you will never be able to know every little detail about this thing or this work. Tomorrow we will imagine something else and there will be new things that we discover about the work we did.

Allora & Calzadilla

ABOVE AND OPPOSITE
Under Discussion, video stills, 2005
Single-channel video with sound,
6 min 14 sec

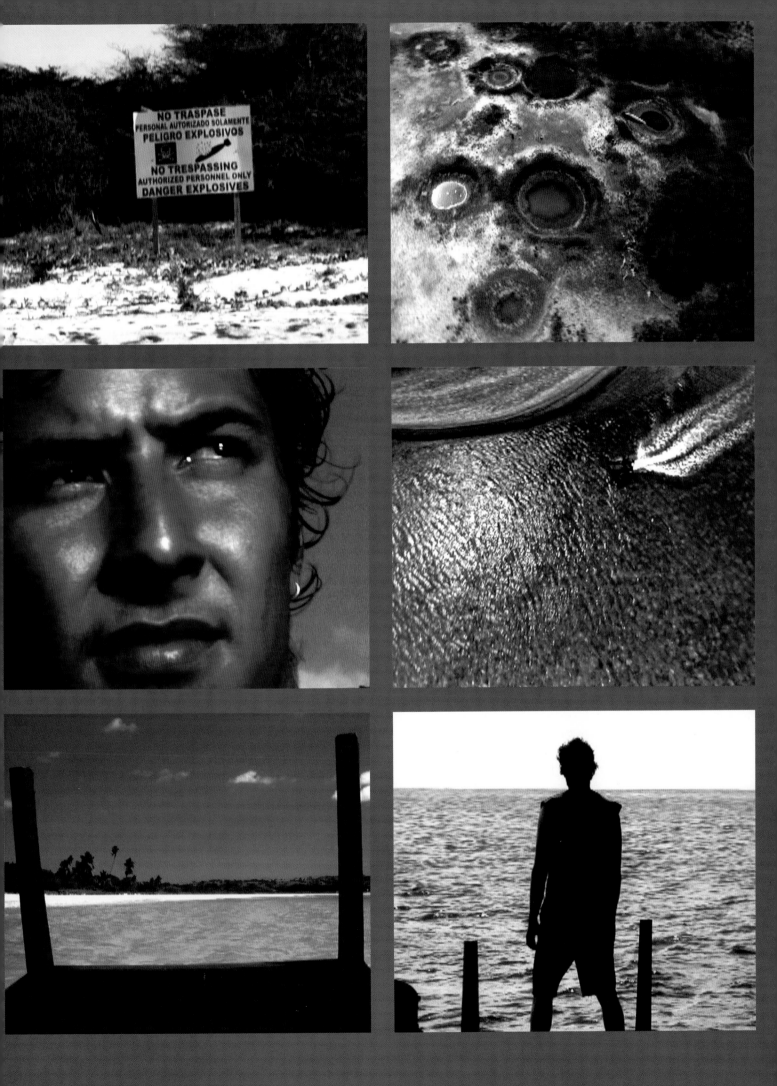

Allora & Calzadilla

Returning a Sound, video stills, 2004
Single-channel video with sound, 5 min 42 sec

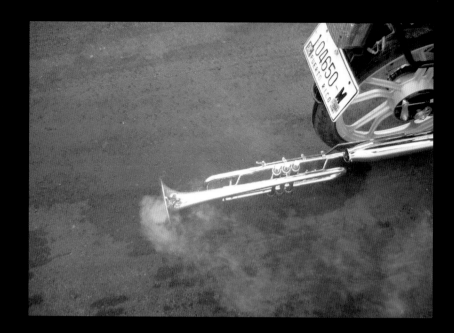

Returning a Sound (2004) and *Under Discussion* have something in common. The protagonists have reacted, taking control of the events unfolding in the fictitious space of the video. While their actions are absurd—driving around on a moped with a trumpet attached to the muffler or taking the discussion table of the island and making it into a boat—it's a way to confront something which in general may seem overwhelming, and then to own it, have agency over it, embrace it, and contribute something—even if it's a kind of odd action. The metaphor can also be frustration, absurdity, nonsense, humor. An upside-down table is a metaphor; the absurdity of this guy driving is a metaphor. The muffler is an instrument to reduce sound; the trumpet is an instrument to produce a loud sounding call. The juxtaposition of two things completely opposite to each other creates a sort of absurd new instrument. There are tons of things like that, but this absurdity, this nonsense, this paradox . . . all these things constitute part of the meaning of the work. All the videos we have done have a very strong sculptural presence. The trumpet in the muffler is sculptural. A table upside-down is sculptural. All of these function as sculptures, only they don't make sense in the gallery. It doesn't make sense to put the moped with the trumpet in the muffler in the gallery. Its meaning is more important, or it's more meaningful, functioning in the world, and then it gets brought back to the gallery not as documentation but as a way to show how it functions in a very particular moment in time. The work is the video but, nevertheless, it has sculptural presence.

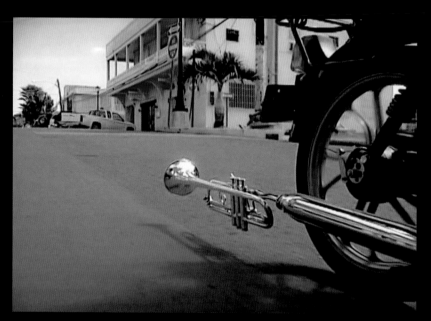

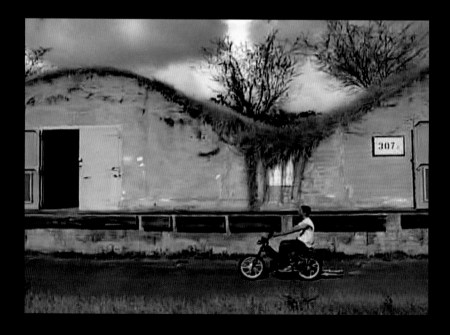

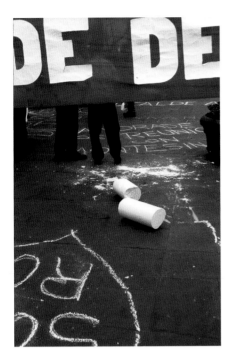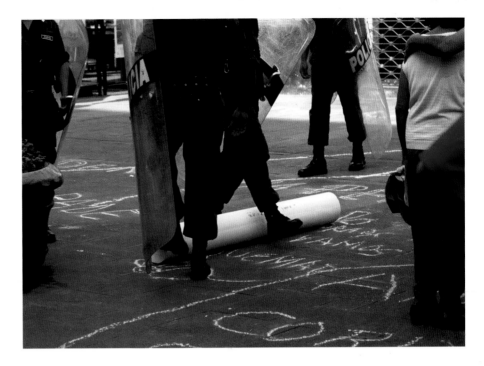

Allora & Calzadilla

Chalk (Lima), 1998–2002
Installation view: Pasaje Santa Rosa,
Bienal de Lima, Peru
12 chalks, 64 x 8 inches (diameter) each

From the very beginning of our work together, we were interested in materials—how materials function and what meanings are connoted by the use of certain materials. In *Chalk (Lima)* (1998–2002) we were interested in the matter-of-factness of what chalk is—a tool—something you find in the classroom. But it's also a geological substance, found naturally in the earth. Because of its nature, it is ephemeral and fragile. It's a beautiful white form, minimal looking and very clean—but paradoxically it's also something that can have a connotation of something dirty because it is used to mark a surface. This was interesting, how this material could be symbolic, iconic, and also nothing else but itself. It was like trying to think about or reconcile a minimalistic form made of this material and putting it in a public setting to see what might unfold. What we like about this work is that it's just a form that is full of potential. Depending on where it is placed and who uses it, it has a different outcome. Being unable to anticipate and control its outcome is what makes it dangerous. In Lima, it was really interesting. Our idea was to place the chalks in the plaza where the city, state, and federal governmental buildings of Peru are located. Every day at noon, they allow protesters to make a lap around the plaza—exactly one lap and then they have to leave. That is their opportunity to publicly voice whatever demands they might

have. When we put our work there, the protesters realized that the huge chalks provided another way to vocalize and make visible their demands. There were also other people there, writing declarations of love or banalities. There was a multiplicity of positions and traces left there. It was like a debate about the use of that public space and about the government, on the pavement itself, and it became a complex sort of forum registered on that floor. But eventually the government officials saw all this stuff happening on the plaza and they didn't like what they were seeing. They came down and brought a police squad, and they arrested the sculpture. They put all the chalks in a paddy-wagon, and they took them away. Then they cleaned up every trace that made direct accusations against the government. The government officials gave a speech that day, on the inauguration of the exhibition, celebrating the liberating potential of art, a unique form of expression vital to society. And so the work shows the limits of free speech in a so-called democratic society, but it's about sculpture, too, and about the specificity of the medium, about historical references—or about poetic dimension. A word cannot be reduced to a thing, a functionality, or a practicality. It claims many different things, but nothing in particular. It can be precisely about this and also precisely about that—and that and that—many things at one time.

Allora & Calzadilla

Growth, 2006
Installation view: *Entropics,* Galerie Chantal
Crousel, Paris
Plant grafts, dimensions variable
Left to right: *Pathycerus pecto-abrigine* and
*Pachycereus Pringlei; Marginato cergus
marginatus* and *Pilosocerens; Tricho Cereus
Hertringinnis, Pilosocerens azureus,* and
*Wetoerocereus yohnstonii; Isocato cereus
pumortgrii* and *Pilosocereus hu*

We also like the idea of the monstrous. What's interesting is that it's a deviation that's still part of nature, or part of culture or humanity, but it stands as a kind of distorted mirror against it. It becomes an active point from which to understand what a society or culture views as its norms and boundaries, and to show the limits of one's own thinking or a set of cultural values. It can also present the possibility of a direction from which society or people can move. In that sense, it doesn't attach to itself an ethical or moral connotation of being negative. A monster could be benign; it could be the future of civilization. It could be a thing that none of us are able to imagine, which could give rise to something better— or worse—or unexpected—like something from mythology, like the Hydra. Endlessly forming and suggesting new things. Full of specificities and eternally in conflict with itself.

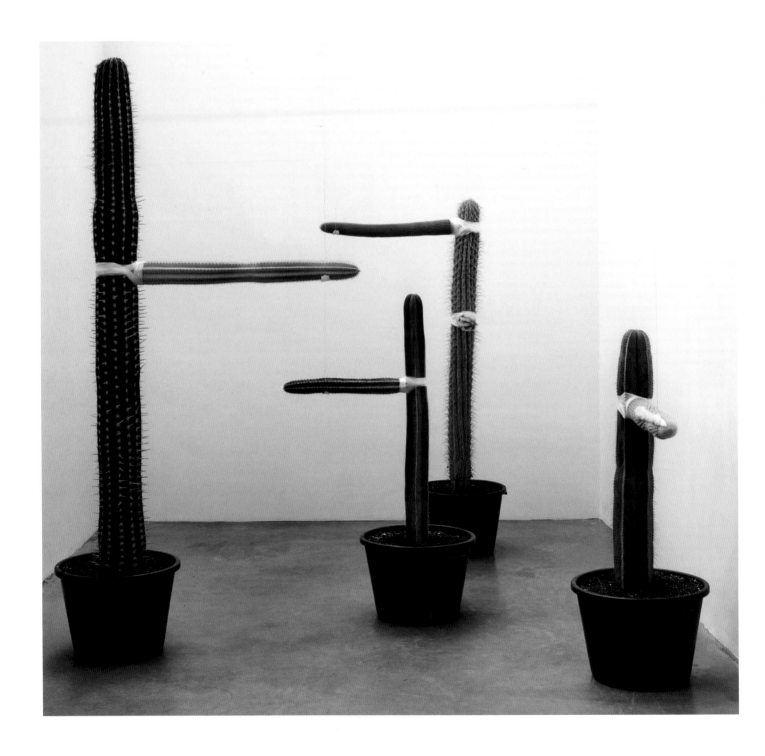

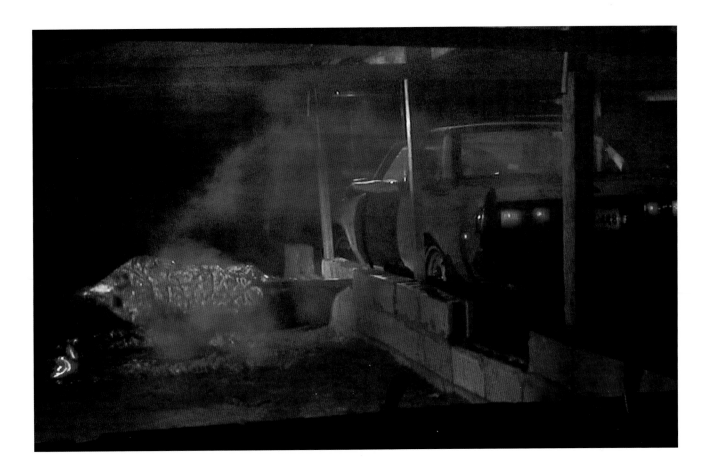

Allora & Calzadilla

Sweat Glands, Sweat Lands, video still, 2006
Single-channel video with sound, 2 min 21 sec

It's interesting to try to understand the non-human world and tease out the historical and contemporary relationship between human and non-human life. That's an interest we were exploring in *Sweat Glands, Sweat Lands* (2006), which has become the foundation of other things we're doing. The work has gone through many transformations. It's one of the more complicated video projects that we've made. It started with thinking that almost everyone in Puerto Rico roasts a pig at Christmastime. You have to roast it for hours by hand—turning the spit. We wanted to do something that could relate to the practical as well as the symbolic dimension of the motion of roasting the pig. So we extended the piece of metal on which the pig is roasted and welded it to the back wheel of a car that is lifted. When you accelerate, the car wheel rotates and the pig rotates, and you roast it that way, which otherwise would be done by human labor. The image of a person trying to roast a pig by driving a car that is not moving (essentially driving this animal

and trying to cook it) is provocative and strong. It's very violent. We're interested in the grotesque vulgarity of it—a kind of excessive overheating of society, and violence. You are implicated in this violence; you generate it. It's not like you're speaking or preaching of violence as something removed from itself. The work recognizes violence itself as part of its constitution, and at the same time it reflects upon the social organization of animals and other social organizations that share a collective intelligence. The scene is about excess—a situation filled with heat and smoke and excess. The boy in the car is not really doing anything; he's just sitting there overseeing this activity. He's chain-smoking, so he's being smoked while the pig is being smoked. Everything is up in flames, being smoked, or in some way exhausting itself. Forms are changing: as the animal is being cooked its form changes. The image of this flesh impaled by the pole is very violent because it's an image of an animal being cooked. But, at the same time, it's a common, culture-specific image of a pig roast at Christmastime.

Allora & Calzadilla

Clamor, 2006
Installation at The Moore Space, Miami
Mixed-media sculpture,
approximately 15 x 30 feet (diameter)

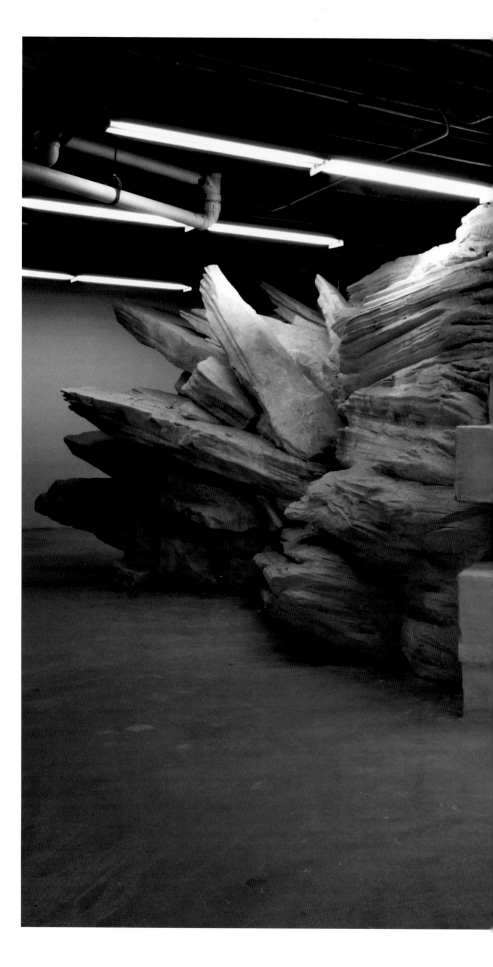

We made an archive of war music from different areas of the world and different times, from Chile and Russia to the American Civil War to what the soldiers listen to today in Iraq with their head-phones while they're enduring combat. We juxtapose that over the archival material to make it very complex. We're not only mixing war music from many eras, but we're also combining the kinds of music that CNN and Fox News use when they're doing war announcements. The subject of the work is very much in the title, *Clamor* (2006). It's the music of war, music as a weapon, everything that has to do with music and war, in a complex montage that is part of a sculpture in which there's going to be a concert (the musicians will be inside). The sculpture resembles a bunker or a cave, like a piece of the earth with various geological forms. Instead of guns, there are trumpets or flutes sticking out. What triggered this piece was our interest in how people use music or sound as a weapon—how you can have a gun made of sound that can immobilize you. Then we started getting interested in the relationship between sound or music and war. Our research opened up an enormous quantity of material related to this idea, an incredible archive of sounds related to war—from actual combat, where music was historically used to command and control troops, to more contemporary uses such as propa-ganda to instill patriotism. Just as in our other works, you see juxtapositions—an image before, an image after—in complete opposition to each other. Or you recognize a material that has a function, but then you see that it's made in a way that suggests a completely different function. But, here, it's done exclusively with sound, with music.

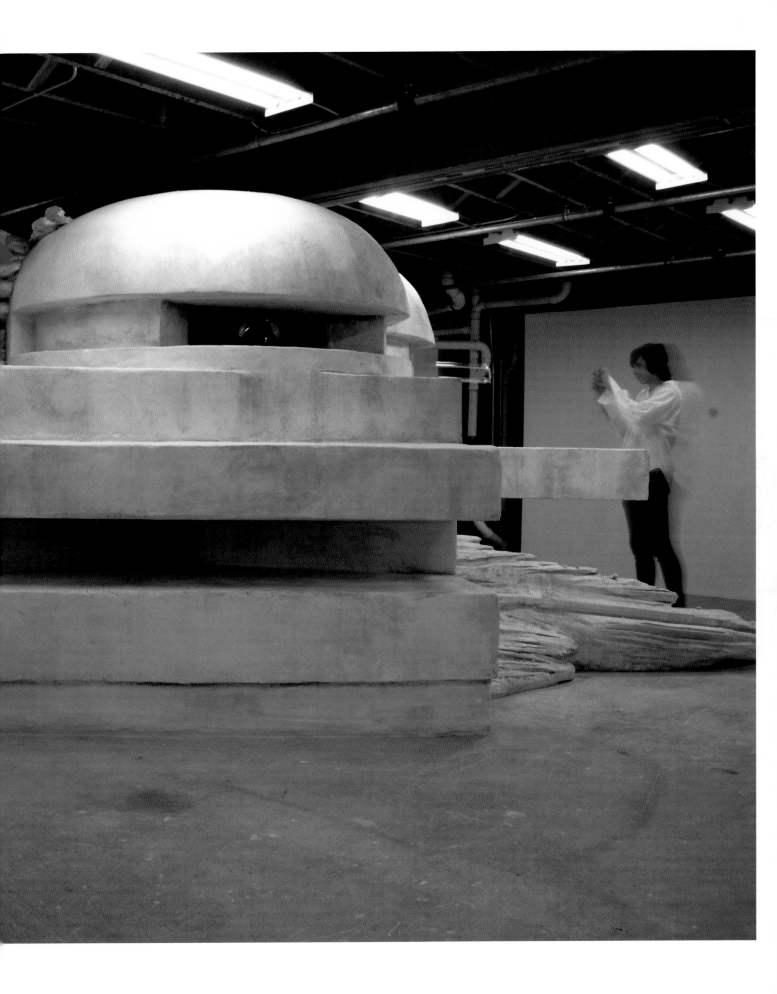

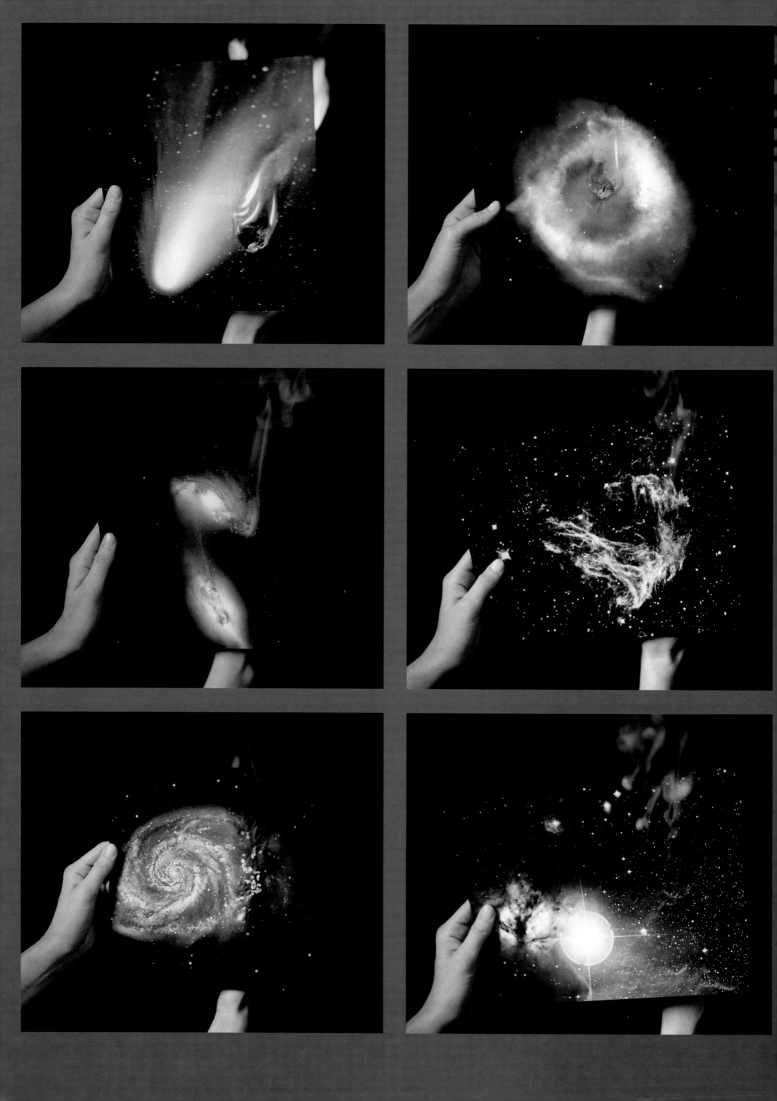

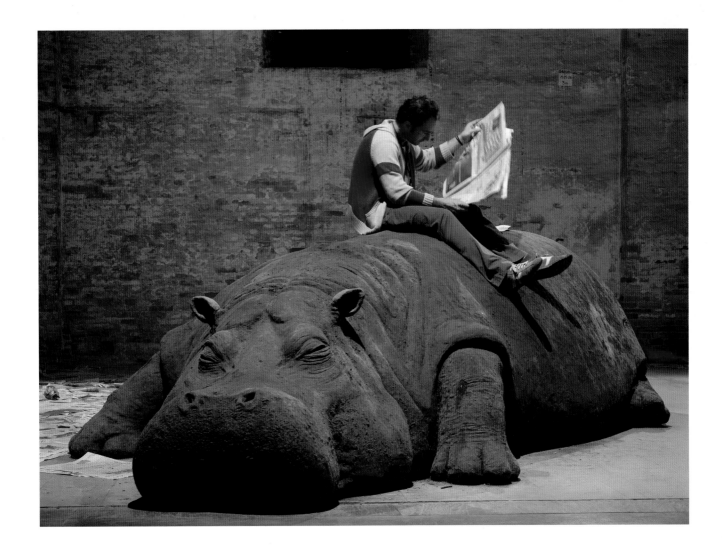

Allora & Calzadilla

OPPOSITE
Back Fire, 2004
13 color photographs, 16 x 20 inches each

ABOVE
Hope Hippo, 2005
Installation view: 51st Venice Biennale
Mud, whistle, daily newspaper, and live
person, approximately 6 x 16 x 5 feet

It's important as an artist to be involved in
one's own time and to try to be part of
what contemporary reality is about—to try
to engage the world, find a position within
that, and respond to it. How can you
respond back to the world? How can you
respond to the weather? How can you
respond to government or policy? How can
you respond to something through form?
Or by doing or undoing something? As an
artist, it's very important to respond to the
things that affect you—millions of things:
religion, people, animals, excess, violence.
Each person has to respond differently,
and that response is involved with ethics,

morality, history. This is, in the most basic
sense, responsibility. But what does it
mean to respond, take all this research,
and find a form for it? Is there a way that
any work of art can accommodate all of
the material that is generated in the
process of research? For us, the idea of
having a work that has contradictions is
very important—when, in affirming some-
thing or speaking of something, it includes
itself and attacks itself. How can you put
together all of these things that have
nothing to do with each other? You use
glue! Glue can be an idea, a word. You
use an ideological glue.

Mark Bradford

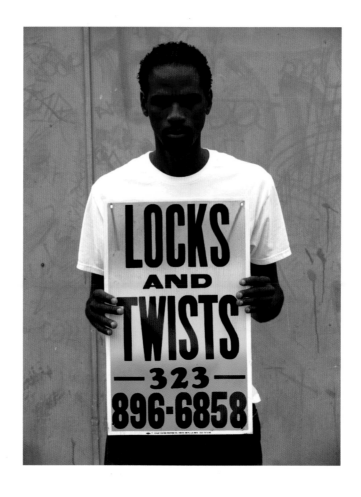

Early on, I was interested in using material that came from my merchant roots. My mother was a hair stylist; I was a hair stylist. But then I started thinking, *"Where is what I do?"* It doesn't sound right, but that was my question. And the answer to *where?* was *community*. Once I looked out of the hair salon and became interested in the environment around me—and the language of that environment—everything that I had been trying to talk about was already there, speaking and having dialogues. I wanted to engage that material more directly. The conversations I was interested in were about community, fluidity, about a merchant dynamic, and the details that point to a genus of change. The species I use sometimes are racial, sexual, cultural, stereotypical. But the genus I'm always interested in is change. In *Market>Place* (2006) I wanted to create an environment that had something to do with trade, with public space, and the way people use it for pleasure, for business, for meetings, for secrets. I like that. And this was the amalgamation of all that put together. I wanted to create the feeling of being outdoors and indoors at the same time—those little passageways, alleyways, or narrow spaces between buildings that people turn into private places to talk and gather in. It was metaphoric, almost like a funhouse. I wanted to create a saturation—and reflections and memory of things you thought you saw that weren't quite clear—which to me is what happens when you're in a public environment or walking down the street. If you relate the story back, it's going to be about memories that layer on top of each other, reflect each other, and about conversations between the two.

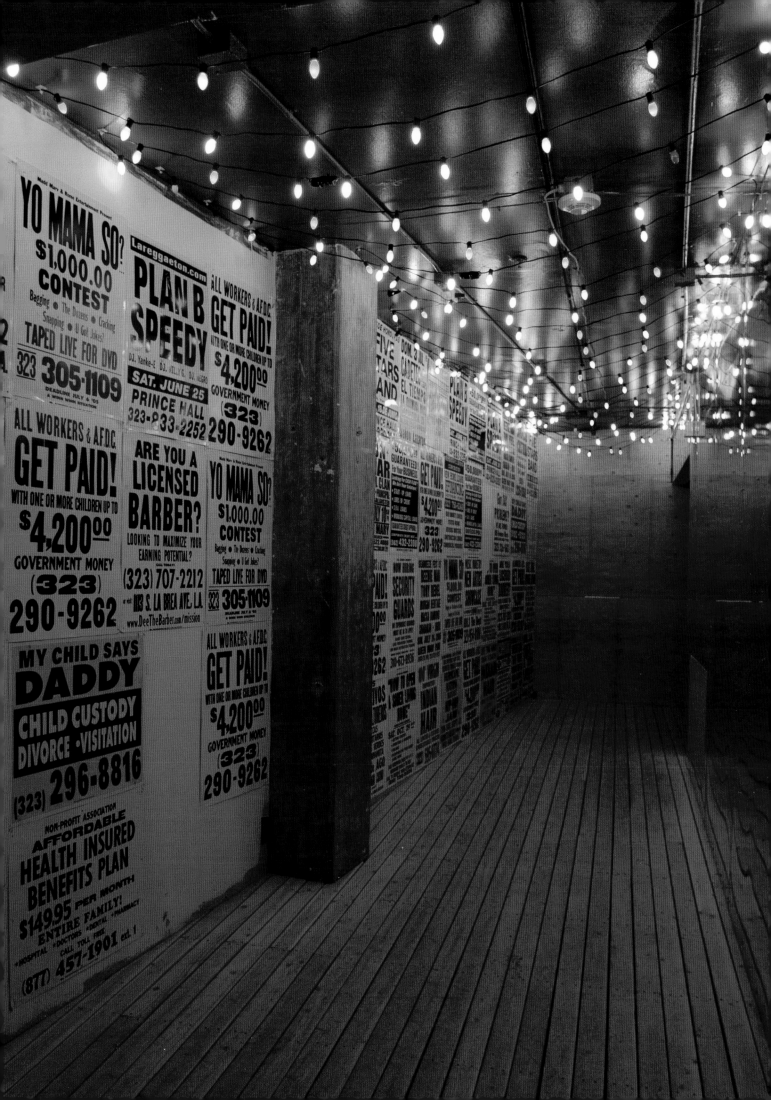

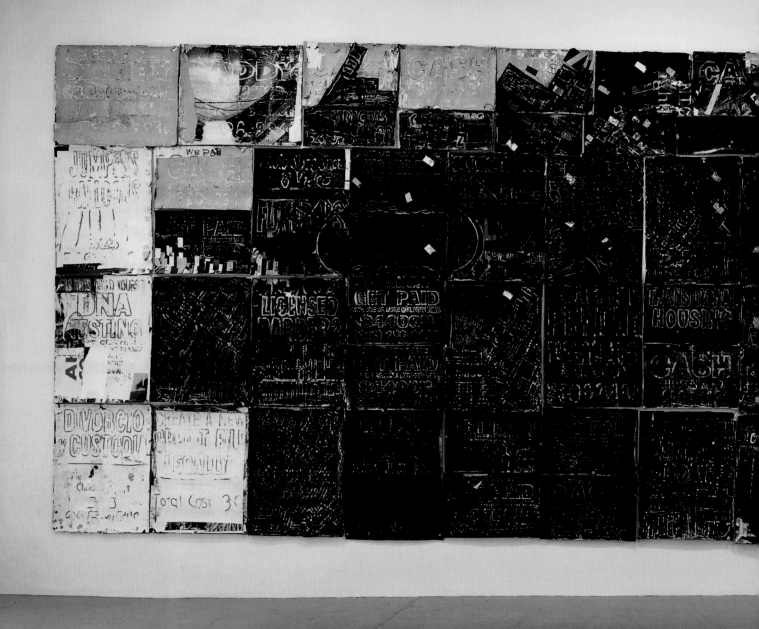

Mark Bradford

ABOVE
Ridin' Dirty, 2006
Mixed-media collage on paper,
78 panels, 109 x 336 inches overall

OPPOSITE
Ridin' Dirty, detail, 2006

What's interesting about signage is that it's about the conditions at a particular location. Informal advertising has always been around. But it just exploded in 1992 after the civil unrest in Los Angeles, when buildings were burned down and demolished. The riots cleared the land; they created huge open spaces. Because the memory of what cleared the space was violent, people made barricades. They put up cyclone fencing or plywood so it felt like a walled city. You had all these interiors, and peripherals, with memories of something. Memory still inhabited the land, but there was nothing there. But there was all this free advertising space, and that's when you saw explosions of

informal advertising, sort of like parasitic systems, coming and laying on top of these spaces. I scan when I'm walking. Maybe it's about mapping or tracing the ghost of cities past. It's the pulling off of a layer and finding another underneath. It's the reference and the details that point to people saying, "We exist; we were here."

An artist has a choice to be as political or apolitical as anyone else who's making choices. So I don't think an artist is necessarily apolitical if he or she doesn't make overtly political work. But so much of contemporary art is engaged in the ideas that are circulating in the atmosphere, in the press and the media, and

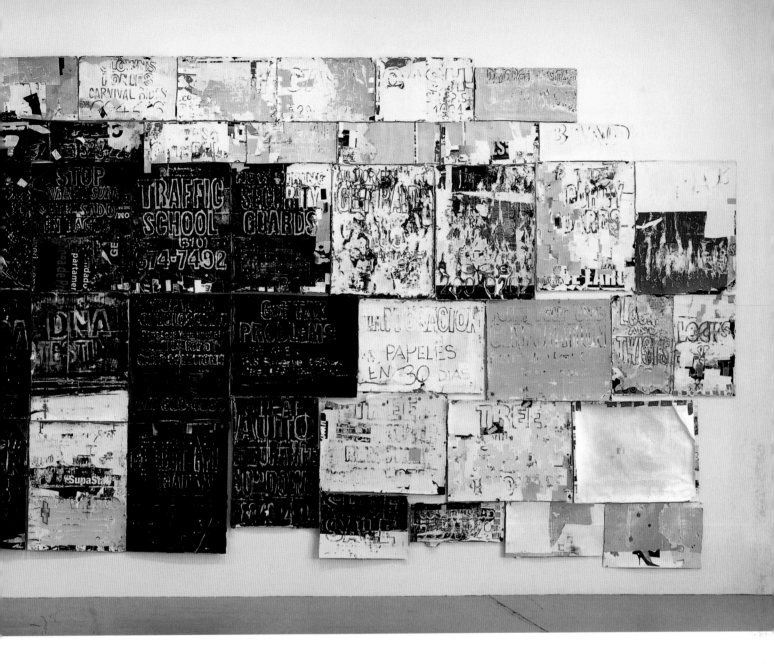

oftentimes we're influenced by that. So it seems comfortable to me to have that bleed into my work. For me, the subtext is always political. You look at a sign and you realize it belongs to popular culture. But on another level, the sheer density of advertising creates a psychic mass, an overlay that can sometimes be very tense or aggressive. The colors shift; the palette becomes very violent. If there's a twenty-foot wall with one advertisement for a movie about war, then you have the repetition of the same image over and over—war, violence, explosions, things being blown apart. As a citizen, you have to participate in that every day. You have to walk by until it's changed.

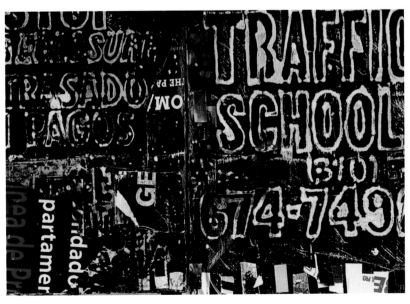

Mark Bradford

BELOW
When We Ride, 2006
Mixed-media collage on canvas, 46⅜ x 62¼ inches

OPPOSITE, ABOVE
Window Shopper, 2005
Mixed-media collage on canvas, 48 x 60 inches

OPPOSITE, BELOW
Disappear Like a Dope Fiend, 2006
Mixed-media collage on canvas, 47⅜ x 61⅛ inches

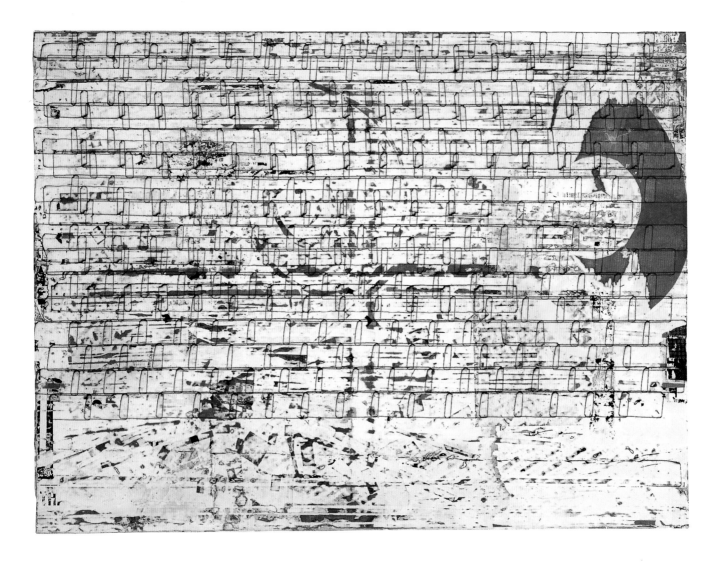

My art practice goes back to my childhood, but it's not an art background. It's a making background. I've always been a creator. My mother was a creator; my grandmother was a creator. They were seamstresses. There were always scraps of everything around. There were always two or three or four projects going on at the same time. We just never had an art word for it. But I would go to the museum as a child, and I was bored. They would tell me about art, and I would look around and say, "This is art." Then I'd get on the bus and go home. It never touched me. But the projects at home touched me. There wasn't really a light-bulb moment at the shift from the idea of just making to the idea of being an artist. At CalArts, there was no shock—no *oh, wow!* There was no uh-huh moment. But there were bodies of ideas, writings by people who were basically writing how I was born. I felt like I'd discovered friends in these books and writers, these revolutionary people. It was like a coming home to language, to people who were critiquing, questioning, remixing larger bodies of ideas. It was the reading, the writing, the written word—not so much visual art, photography, painting, sculpture. But the written word can be poured into any vessel. I do it now. It's poured into video, into a painting, into a public-domain practice. It's the idea that holds it together for me.

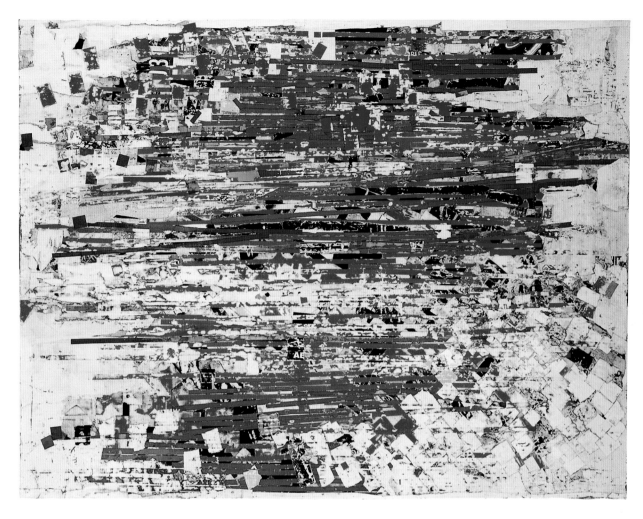

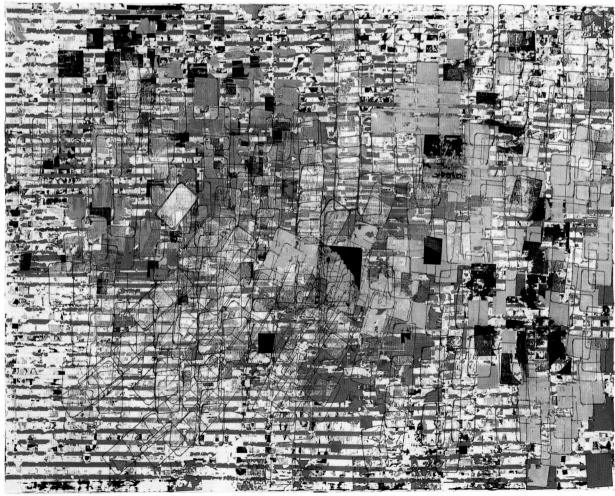

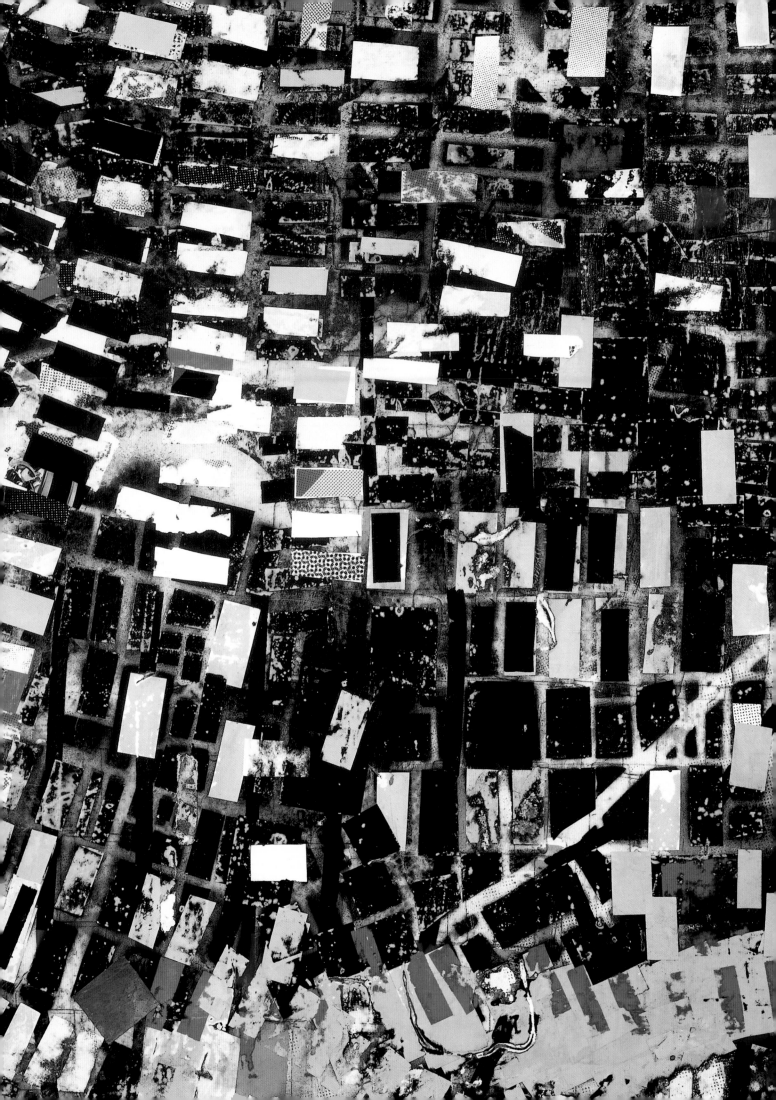

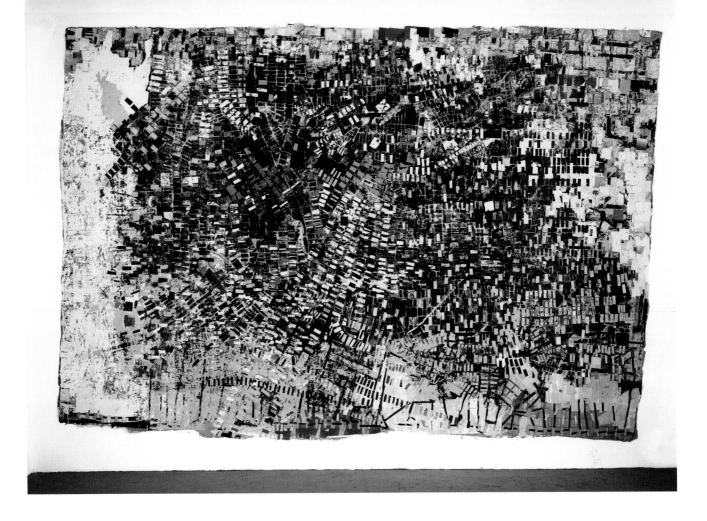

The worst part of what I do is the fabrication, the small details. I want to get working. I don't really care about the small details, even though as time goes on I realize they matter. Usually I don't care about edges and stuff. But at some point it becomes part of the conversation. Sometimes I use little Post-its, or those little dot-thingies, to try to see where I want a color, if I want to bring the color in. But sometimes I'm timid. I don't like something, so I'll cover it up. I bet it says a lot about me, hiding stuff—stuff peeking through. My practice is décollage and collage at the same time. Décollage, I take it away; collage, I immediately add it right back. It's almost like a rhythm. I'm a builder and a demolisher. I put up so I can tear down. I'm a speculator and a developer. In archaeological terms, I excavate and I build at the same time. As a child I actually wanted to be an archaeologist, so I would dig in my backyard. When I was six, I was convinced that I could probably find a dinosaur bone there, but after about a week I realized

that it was only in particular places that you find dinosaur bones.

For me, art is a network. It's about taking one site and trying to connect it to another. And the imagery that goes between them is the art. It's not actually the sites. It's the kinetic energy between them. I'm always moving. I'm just an intense person, always in motion, but my art practice is very detailed. That's a way of slowing myself down so that I can hear myself think—so I can hear the voices a little more quietly. Sometimes I find that the quieter voice has a more interesting idea—if I can get to it. So I have a labor-intense practice— cutting and cutting, which is grunt work, almost mechanical. That's foreground. But what's going on in the background is a thinking process that's very slow, almost like a meditation. Improvisation is what I like. I limit myself materially—another way of slowing myself down. When there are too many choices, I get confused. So I tell myself something like, "I'm only going to use black paper." It puts pressure on my creativity to make that black paper sing.

Mark Bradford

ABOVE
Black Venus, 2005
Mixed-media collage, 130 x 196 inches

OPPOSITE
Black Venus, detail, 2005

Mark Bradford

BELOW
Untitled (Shoe), 2003
Paper collage, 30 x 31½ inches

OPPOSITE
Practice, video stills, 2003
DVD, 3 min

When I started thinking and reading about the postmodern condition—or fluidity—I saw it as taking independence. It was revolutionary for me that you could put things together based on your desire for them to be together. Not because they were politically correct, not because they are culturally comfortable or sociologically safe, but because you decide they're together. If you decide those tennis shoes and those polka-dot socks are together, they're together because you say so. I had always done that, but I was aware that it wasn't always the 'right' thing to do—not because I didn't feel it was right, but because I was made aware by some people—in society, say, or in school—that that behavior was not correct. So my mother and I would go to the store, and I'd get a G.I. Joe and a Barbie, and I'd bring them to school when we had Show and Tell. "So which one is yours?" said the teacher. "Both," I said. "Well that's not going to work," she said. "Why not," I asked. And she answered, "Well, what does your mother think about this?" I was always supported in the domestic realm, and I was always strong about standing up for myself, but there were still struggles in my life. Reading about these kinds of conditions made me realize it was about independence, about doing your own thing. And that's a state of mind. It's not an art work or a book. It's a state of mind. Fluidity, juxtapositions, cultural borrowing—they've all been going on for centuries. The only authenticity there is what I put together.

The only time I do video work is when I stumble on a detail that I really want to blow up, when I really want to create a spectacle around a detail. It's about putting two things together—two bodies of ideas that are pretty hot and politically charged. So I'll do a video because it's a way of capturing ideas head on and more directly. The paintings are about another conversation. People ask me all the time if I'm a basketball player. And I say that I'm a painter. Then they ask me if I have a card, thinking I'm a house painter. So I wanted to do a video of me playing basketball, but I wanted to create a condition—a struggle. So I constructed an outfit inspired by the Lakers uniform. It was one piece. The top looked like a Lakers jersey, and the bottom was an antebellum hoop skirt that fanned out about four feet. It's a simple proposition: I just want to play basketball, and I just happen to have this on. But politically, culturally, I'm being very iconoclastic. You just don't put a hoop dress on a black male body and go play basketball. It became increasingly difficult: the dress was an obstacle. I would fall and get up, stumble and get up. Sometimes I would make the shots; sometimes I wouldn't. But I would always get up. And for me, it was really about roadblocks on every level—cultural, gender, racial. Regardless of walking into my own show and having people say, "Oh, I can't wait till the artist gets here. I'd like to meet Mark Bradford," I just had to keep going because the worst thing that can happen to anybody, not just to a black person or a woman, is that you become so frustrated with stereotypes being projected onto you that you give up. You keep going. For me, the hoop skirt was about the antebellum fair lady's dress and all the naughtiness that went underneath. And I was being naughty, and there was a lot going on underneath the lady's dress which was not a lady's dress anymore. It was just my afternoon outfit, playing basketball. I like naughty.

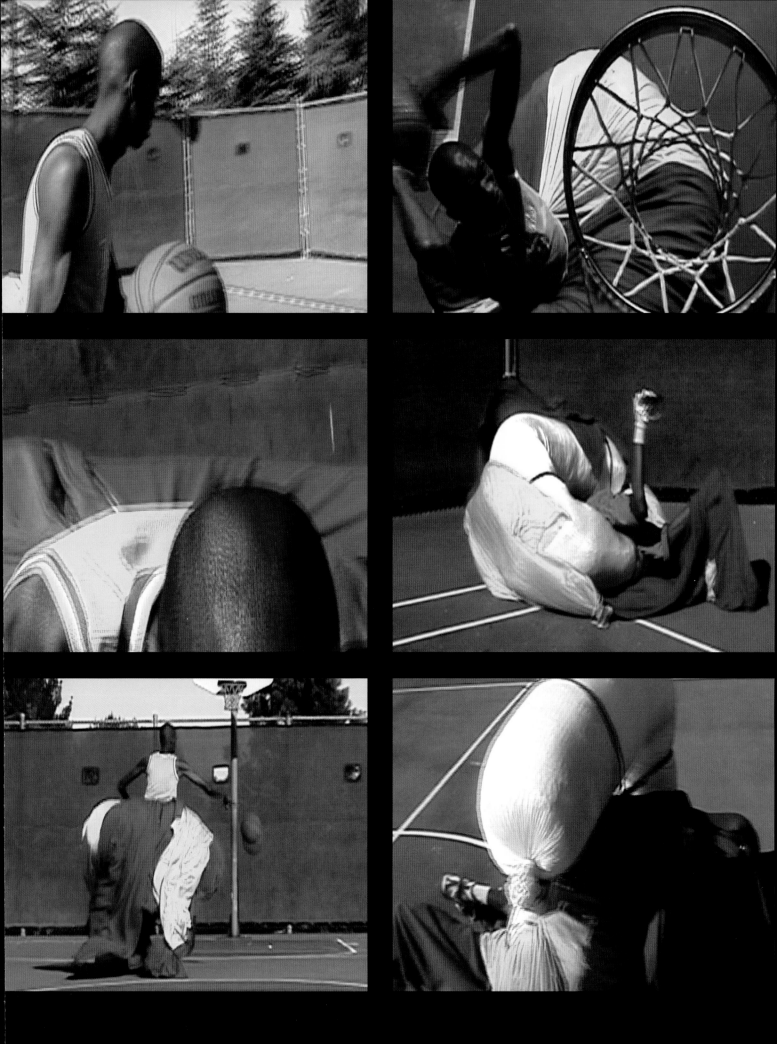

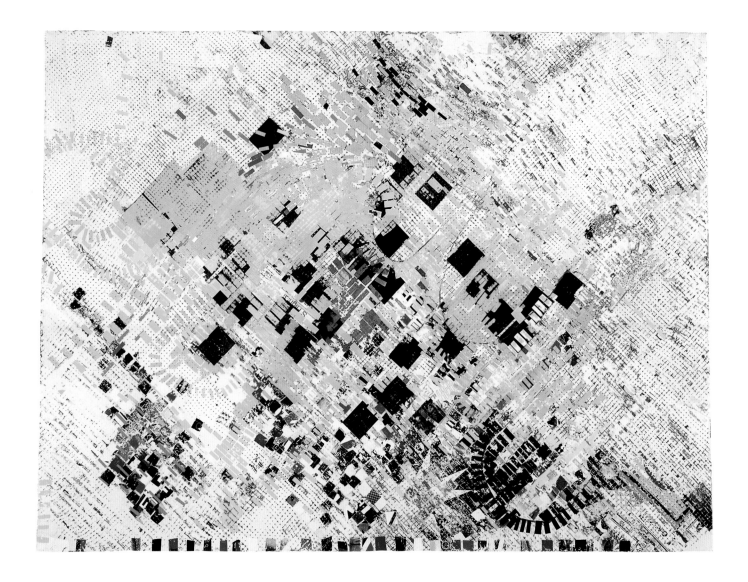

Mark Bradford

ABOVE
Grace & Measure, 2005
Mixed-media collage on canvas,
90 x 120 inches

OPPOSITE
Backward C, 2005
Mixed-media collage on canvas,
84 x 120 inches

Because I'm very fluid, I need to set up rules. I have a very organized work schedule. I work every day, a certain number of hours. I don't have creative blocks: if it's going bad, it's just a bad day and I wind my way through. I push myself to stay on task and work. I do really large-scale paintings. The one I'm working on now is nine by thirty feet. And somewhere in that landscape you get lost, completely lost, inside the body of a painting. You don't know where you're going, and it's not speaking to you, but you just keep moving through it and you find your way. You find a space that looks familiar, and you make your home there for a little bit. And you don't get too comfortable because you've got to charge off again. When the whole work becomes too much for me I centralize on a space that's manageable, and it unfolds and unfolds. But what I mean by rules has to do with pushing myself creatively. If I have an idea, the rule is that I ask myself whether I have pushed far enough, into something that's uncomfortable. Is it making my heart go pitter-patter, or is it making me think I'm great? If it makes me think I'm great, it's not a good idea. Who cares? But when I'm feeling a little bit shaky, a little bit nervous and awkward, I know it's going somewhere. I'm all for biting off more than you can chew.

Graffiti is interesting to me because it's in the public domain but it's full of secrets and unless you're part of that system, you can't unlock those secrets. I can see it for its shapes, its forms, but I don't understand it. Another person will say, "Oh, you can't read that?" And he'll tell me this means this—that means that. It's all the interconnected secrets and overlays that I really find interesting in public space. I guess I keep talking about that. Why not private space? Because private space is private, and public space has the potential to be inclusive. It's the difference between instant messaging on the computer and going to a café or bar to meet and talk. When you're home, you're behind closed doors. That's another kind of conversation. Looking back, some of the earliest memories that formed my subject are about growing up in my grandmother's boardinghouse. In a boardinghouse, each room is actually a house—with all the things that go on in a house. What was interesting about it was the collision of subjectivities—and that's really what my art's about. Everything always has a relationship to another part of me. I'm in and out of a lot of stuff; I know a lot of people. The thing that binds them all together is me. And I'm really an open book—I don't have a problem putting my business out on the streets or, you might say, all in the same room. And that's what my art's about; it's the boardinghouse. But I've always been interested in the places where people gather outside of their homes because you're always a little more vulnerable in public. I see the relationship between public and private over and over in my work. It's not something I set out to do. I take a lot of information from the public sector. Then I go to my very private studio and I make something that exists between the two. Maybe it has a lot to do with me as a person. I'm in a very public body: six-foot-eight is very public, and I don't have much privacy when I'm out. At any moment, someone will just tap me on the shoulder and say, "Excuse me. Uh . . . how tall are you?"

Robert Ryman

When I came to New York from Nashville it was music that was the most important thing. I was studying and practicing. But I went to museums, and for the first time I saw paintings that interested me not so much because of what was painted but how they were done. I thought maybe it would be an interesting thing for me to look into—how the paint worked and what I could do with it. I looked at everything. I didn't know anything about art. I didn't even know any artists. I accepted everything; I had no prejudice. If it was in a museum, it was a good thing. When I got a job in a museum it was ideal for me. That was a fantastic education. But I came from music. And I think that the type of music I was involved with—jazz, bebop—had an influence on my approach to painting. (We played tunes. No one uses the term anymore. It's all songs now, telling stories—very similar to representational painting where you tell a story with paint and symbols.) But bebop is swing—a more advanced development of swing. It's like Bach. You have a chord structure and you can develop that in many ways. You can play written compositions and improvise off of those. So you learn your instrument

and then you play within a structure. It seemed logical to begin painting that way. I wasn't interested in painting a narrative or telling a story with a painting. Right from the beginning, I felt that I could do that if I wanted to but that it wouldn't be of much interest to me. Music is an abstract medium, and I thought painting should also just be what it's about and not about other things—not about stories or symbolism.

I don't think of my painting as abstract because I don't abstract from anything. It's involved with real visual aspects of what you are looking at—whether wood, paint, or metal—how it's put together, how it looks on the wall and works with the light. I use real light, so there's not an illusion of light. It's a real experience. The lines are real. You see real shadow. The wall is involved with the painting. Of course, realism can be confused with representation. And abstract painting— if not abstracting from representation—is involved mostly with symbolism. It is about something we know, or about some symbolic situation. I don't make a big deal about this realism thing. It just seems that what I do is not abstract. I am involved with real space, the room itself, real light, and real surface.

ABOVE
Classico #6, 1968
Acrylic on paper mounted on foamcore
6 panels, 30 x 22½ inches each;
79½ x 77½ inches overall
Private collection, New York

OPPOSITE
Hansa, 1973
Oil on canvas, 53⅛ x 53⅛ inches
Private collection, New York

My approach to painting is pragmatic. I work with different materials and I generally do a lot of tests before I do paintings—tests on paints to see which is the best to use on a certain material and how it's going to hold up; how the fastenings are going to work; how the light is going to work. My approach tends to be from experiments. I need the challenge. If I know how to do something well, there's no need to do it all the time because it becomes a little monotonous. So I like to find a challenge. Of course, all these things are rooted in the basics of painting. It's not that I do anything crazy, but I tend to work within a structure and see what other possibilities there can be. Sometimes, after I finish a group of paintings, I'm not sure what to do next. I have to wait, and then—slowly—things fall into place. I try a few things and then I realize what could be done and what interests me at the moment. I don't know where these thoughts come from exactly. There are all kinds of influences—not really art influences, either—just daily experiences, life experiences. But always, in the back of my mind, is the structure that I approach and work from. . . . In all of my paintings I discover things. I never know how they are going to be at the beginning. I almost stumble through to the result. And sometimes I'm surprised. They turn out differently than I had thought they might.

White has a tendency to make things visible. With white, you can see more of a nuance; you can see *more.* I've said before that if you spill coffee on a white shirt, you can see the coffee very clearly. If you spill it on a dark shirt, you don't see it as well. So it wasn't a matter of white, the color. I was not really interested in that. I started to cover up colors with white in the 1950s. It has only been recently, in 2004, that I did a series of white paintings in which I was actually *painting* the color white. Before that I'd never really thought of white as being a color in that sense. Until then it was just that white could do things that other colors could not do. If I look at some white panels in my studio, I see the white—but I am not conscious of them *being* white. They react with the wood, the color, the light, and with the wall itself. They become something other than just the color white. That's the way I think of it. It allows things to be done that ordinarily you couldn't see. If the panels were black or blue or red, they would become a different thing. You would see the color and the panels would become more object-like themselves, and more about that color. But white is such a neutral situation that when you see it, you're not thinking white. You're just able to see something as what it is.

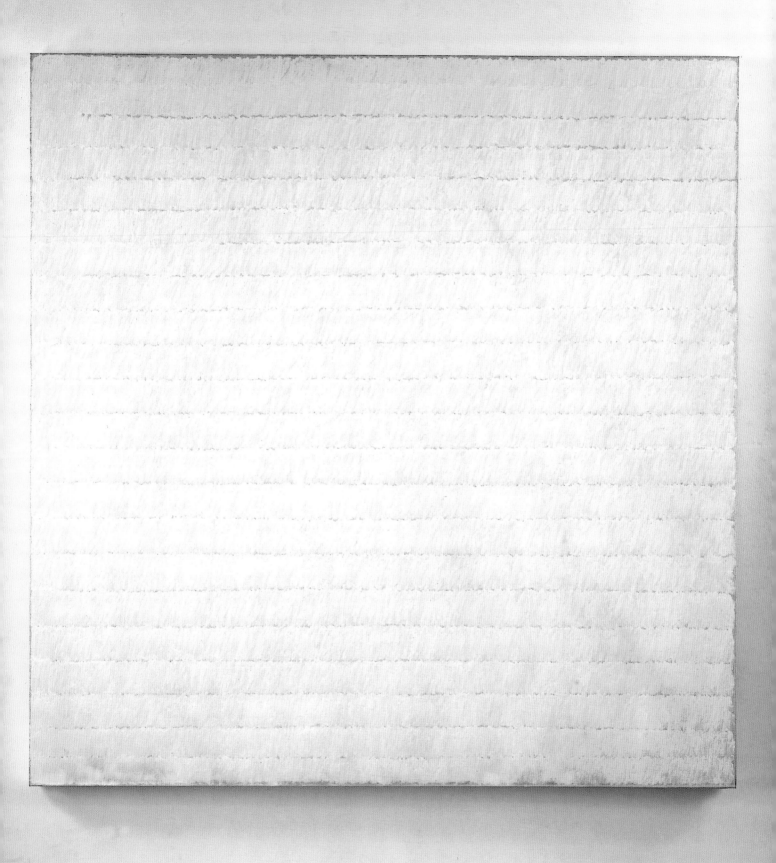

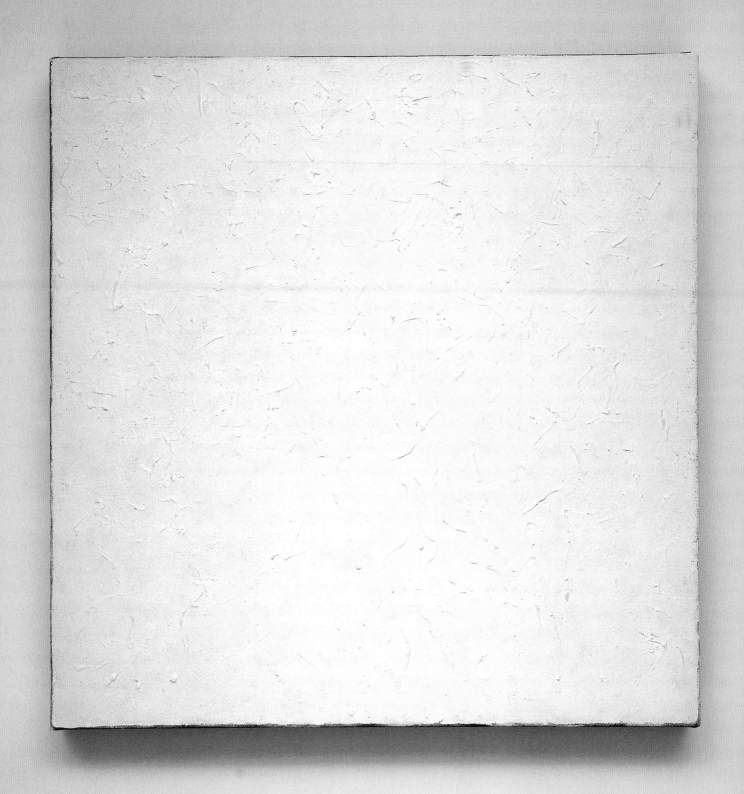

Robert Ryman

OPPOSITE
Series #14 (White), 2003
Oil on canvas, 24 x 24 inches
Private collection

RIGHT
Series #13 (White), 2004
Oil on canvas, 42 x 42 inches
Private collection, New York

BELOW
Series #23 (White), 2004
Oil on canvas, 15 x 15 inches
Private collection, New York

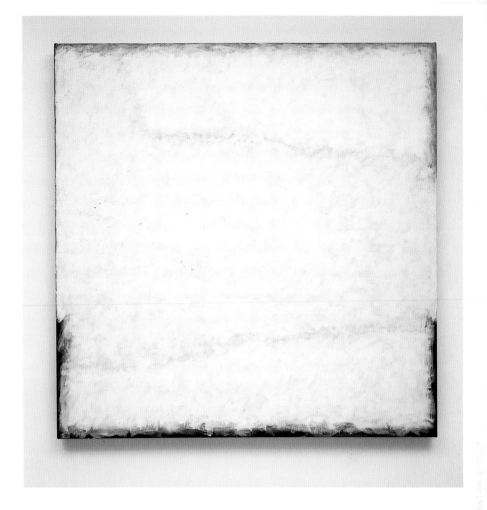

The *Series* paintings were done on canvas on a dark gray ground which projected the white and the color. I used three different whites—titanium, zinc, and a kind of mixed white—which I don't usually do. (Usually I'm just using one because I'm not involved with painting the color white.) The white on the dark ground sometimes made blue, so you would have a kind of blue halo—but there was no real blue pigment involved. It was just the white and the dark gray that caused that. I was aware of that, and it all became part of the composition. Some of the paintings, particularly the smaller ones, had heavy edges and I used the sides as part of the composition. So sometimes the paint would go off the right or left side, and when you looked at the paintings obliquely you would see them in a different way.

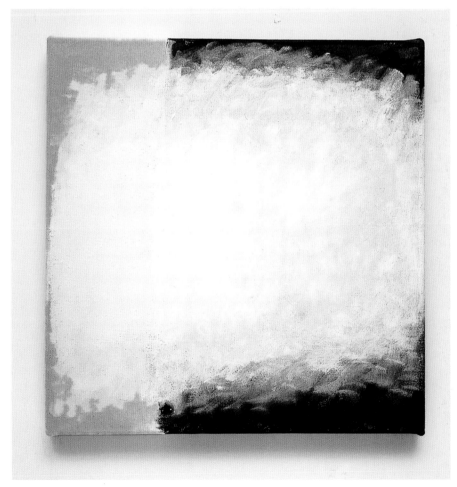

Robert Ryman

Versions IV, 1991-92
Oil and graphite on fiberglass
with wax paper, 78 x 72 inches
Private collection

The *Version* paintings were on very thin fiberglass panels. I used that material because I wanted thinness and strength, but something that was so close to the wall that it would look almost like paper. It had a nice gray-green color, which I liked, and I could use that color as part of the composition and the painting itself. Most of the *Versions* (there were a number of them in different sizes) had a wax-paper top. It was actually on the wall but it was on the top of the paintings, and I used it because it had a slight soft glow to it with the light. It pulled your eye up to the top. Wax paper had properties that plastic or glassine didn't have. The wax was just so soft and translucent.

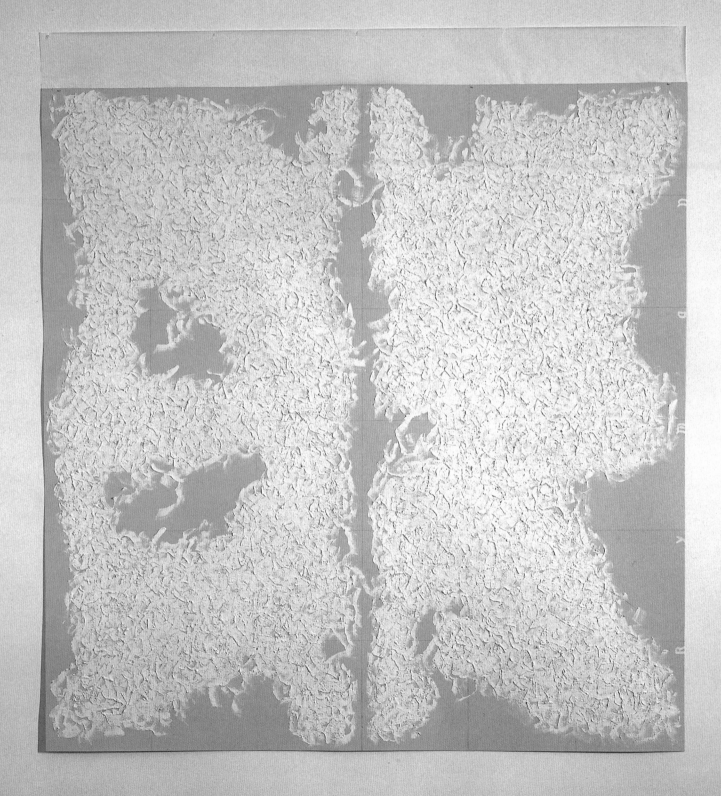

Robert Ryman

BELOW
Initial, 1989
Oil on gator board with wood,
23¾ x 23 inches
Private collection, New York

RIGHT
Context, 1989
Oil on linen with steel, 117 x 111 inches
Private collection, Europe

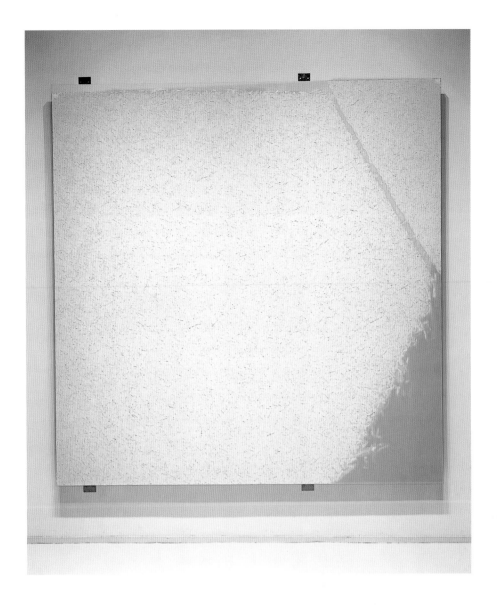

Initial (1989) is a relatively small painting on a thin panel. I had it sitting on a large easel in my studio and, to keep the panel off the bottom of the easel, I put two little wood pegs on the painting to lift it. I painted it and I kept seeing the little pegs of wood, and somehow the wood seemed to be part of the painting. So when I attached it to the wall, I put the two pegs underneath—slightly off angle. They weren't exactly straight under the panel. So the pegs became an element of the painting, and the painting was glued to the wall along with the pegs. It was a unique kind of painting to install because you had to glue it and measure it. That painting was shown in the 1993 retrospec-

tive, and it traveled all over with no problems. But when it came back to the owner it was dropped and a corner of the painting broke. I'm not sure where it is now, but those pegs still go with the painting. *Context* (1989) was just the opposite. It was a large painting with a heavy edge, and it was projected off the wall by steel fasteners at top and bottom, which moved it away from the wall two or three inches. Paradoxically, because of the thickness of the edge, the painting became more part of the wall than if it were right against the wall. The steel fasteners were part of the composition, and they were kind of off-center, so the painting had a slightly different feeling from some of my others.

Robert Ryman

Stretched Drawing, 1963
Charcoal on unprimed stretched
cotton canvas, 14½ x 14½ inches
Private collection

The square? I began with that in the
1950s. The square has always just been
an equal-sided space that I could work
with. Somehow it's become so natural to
me that I just don't think of it any other
way. It doesn't have the feeling of a land-
scape or some kind of window or door-
way that we usually associate with
rectangles. It's just a very neutral kind of
space, and it seems to feel right to me
because of my approach to painting.

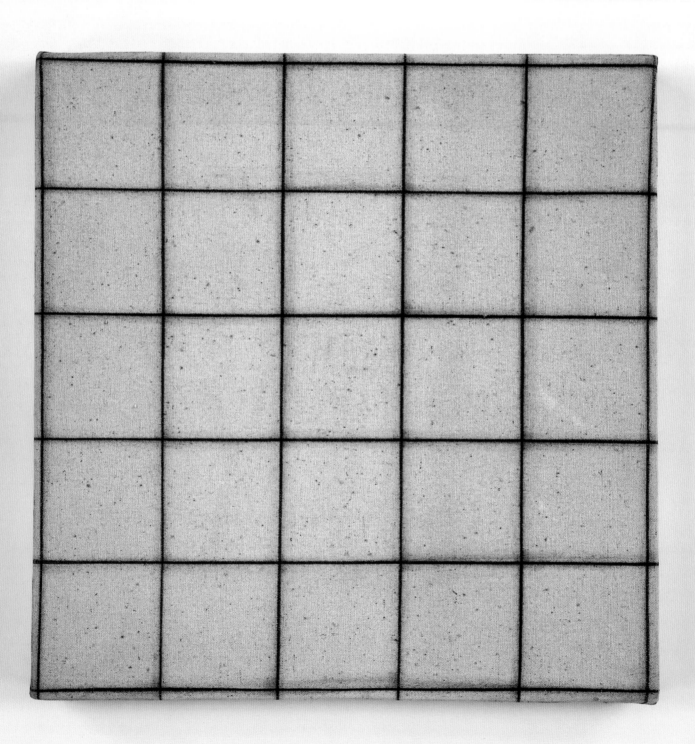

Robert Ryman

Philadelphia Prototype, 2002
Installation at the Pennsylvania
Academy of the Fine Arts, Philadelphia
Acrylic on vinyl sheets and wall, 10
panels, 23 7/8 x 23 7/8 inches each
Collection Pennsylvania Academy of
the Fine Arts, Philadelphia. Alexander
Harrison Fund 2005.19a-j

This work was done first at the Larry Becker Gallery in Philadelphia. The panels are vinyl. But the panels are not really the painting. The painting originally consisted of two walls that joined in a right angle, so the painting curved. Here it's on two opposite walls, and the actual painting consists of the wall itself—echoed in the second wall. The panels are part of the composition of the painting and in each panel there are many nuances which are a part of the composition of the ele ments. The panels are similar but each is unique. The original surfaces of the pan-els are the same (even from the first showing in the gallery). The only thing that changes is the edge that goes onto the wall. I don't always put the tape in the same spots. When you look closely you see that some of the tape is going off of the panel onto the wall, and some of it seems just to appear on the wall, which tells you that it's not really the first time it's been done. I don't know that anyone would ever look that closely, but that's done on purpose because I don't want it to be the same every time. The way light affects the panels is extremely important. Softer light brings out the nuances and you can see that the panels have a glow which would be wiped out in strong straight-on light.

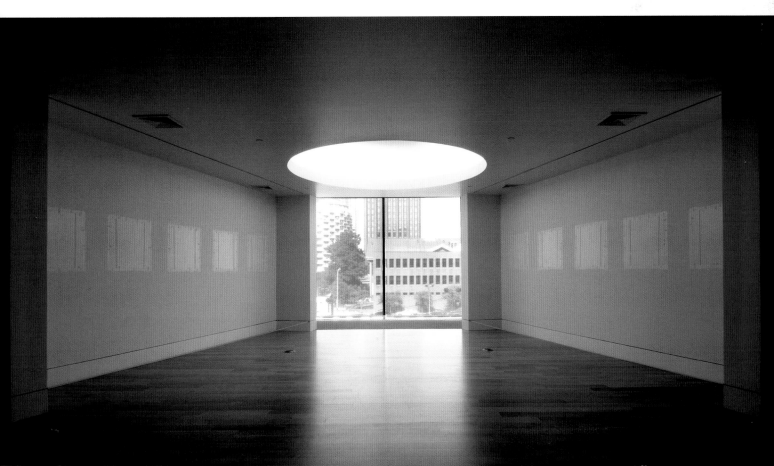

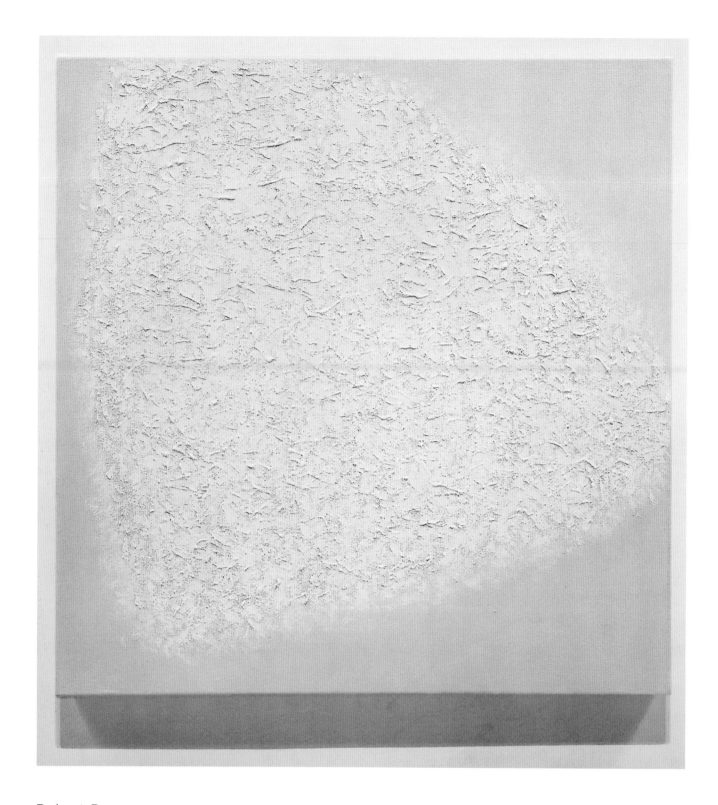

Robert Ryman

In a sense, the paintings move outward aesthetically. They go out into the space of the room. They're involved in that space and certainly they involve the wall itself. So if you have something else next to the painting—if the painting were on a brick wall—that would not be good. You would have a lot of visual activity going on along the wall, and that would dilute the painting. A brightly colored wall would also change

the painting, particularly some of those which are on translucent material or the ones with waxed paper or plastics. All of that changes the feeling of a painting completely. It needs to be on a neutral, smooth surface. Even though light is important, it doesn't have to be special light. But the painting needs a certain reverent atmosphere to be complete. It has to be in a situation so it can reveal itself—since it is

what it is on its own. It's not representing anything else—what you're seeing is really what it is—so it has to be in a certain visual situation because anything else will dilute or disturb it. The paintings do not signify anything other than how they work in the environment. Some people say they look like clouds, or that they look blank. But that's because they're looking at them as if they were pictures of something. So of course they're going to see nothing, or they're going to see something—something that is white. I don't have any control over that. There is a lot of meaning, but not what we usually think of as meaning. It's similar to the meaning of listening to a symphony. You don't know the meaning, and you can't explain it to anyone else who didn't hear it. The painting has to be seen. But there is no meaning outside of what it is.

Catherine Sullivan

I think it's a very high-stakes game, this relationship of interaction between the art work and its audience. I conceive of that in a larger system—let's just call it public address. The issue for me is often that there's one way of thinking that has to do with the way an art work addresses the public very honestly, directly, and objectively —and often in a very reduced way (a purging of artifice) so as to get at a kind of directness of engagement. I interpret that as the formulation of some kind of agenda which in some way regards artifice as highly suspicious, questionable, or dangerous, as if there's a pretense that it somehow confuses the relationship between the art work and the audience. So my question is, "What is it about this engagement to begin with that raises fears that generate this sense of danger?" Why is it if someone is speaking to you from the stage directly that maybe conditions are such that they might put you at ease— whereas if someone is wearing a costume and playing a scene where they cry there is a kind of suspense that makes you uneasy? Pretense or artifice simply raises the stakes to such a level that it activates what is perhaps dangerous or unstable about that relationship to begin with. So I feel that that's a deeper human issue of empathy—a kind of innate sense of or capacity for empathy that one person feels for the other—that a dramatic situa- tion elevates. I think it's a very abstract, basic human identification that theater— or any performative medium—activates.

My work has to do to a large extent with the nature of public address and public assembly as a way to get at some- thing about social engagement which is abstract and doesn't have to do with speech but, rather, with the combination of a lot of different phenomena. It has often been discussed in terms of body language or gesture. I think it's actually a much more complicated series of issues, but it all boils down to public assembly, public address, public engagement, and interlocution. Early on when I started making theater produc- tions there were video components mixed in, which I used to 'spatialize' the perform- ance, so that led me to really have a need to start working with film and video. ('Spatialization' was a device that was very immediate—a way to make a small room or the space of a theater very large, and to suggest other spaces within a small space.) And there was a different kind of perform- ance that grew out of working with the camera. The camera was actually a different kind of audience than a live audience. I was interested in what kinds of intimacies could be generated, or what other things the performer would do, if only the camera were present. And that grew to a different way in which I wanted to look at certain subject matter. In live theater, I really enjoy the pleasure of the eyes to look anywhere and the feeling of a very pleasurable kind of participation—watching and being able to experience a lot of different kinds of spatial compositions and depths. In film it became more about how the body was interpreted once it was broken down and framed in a series of parts and then reassembled by me either through editing or the manner in which it was displayed.

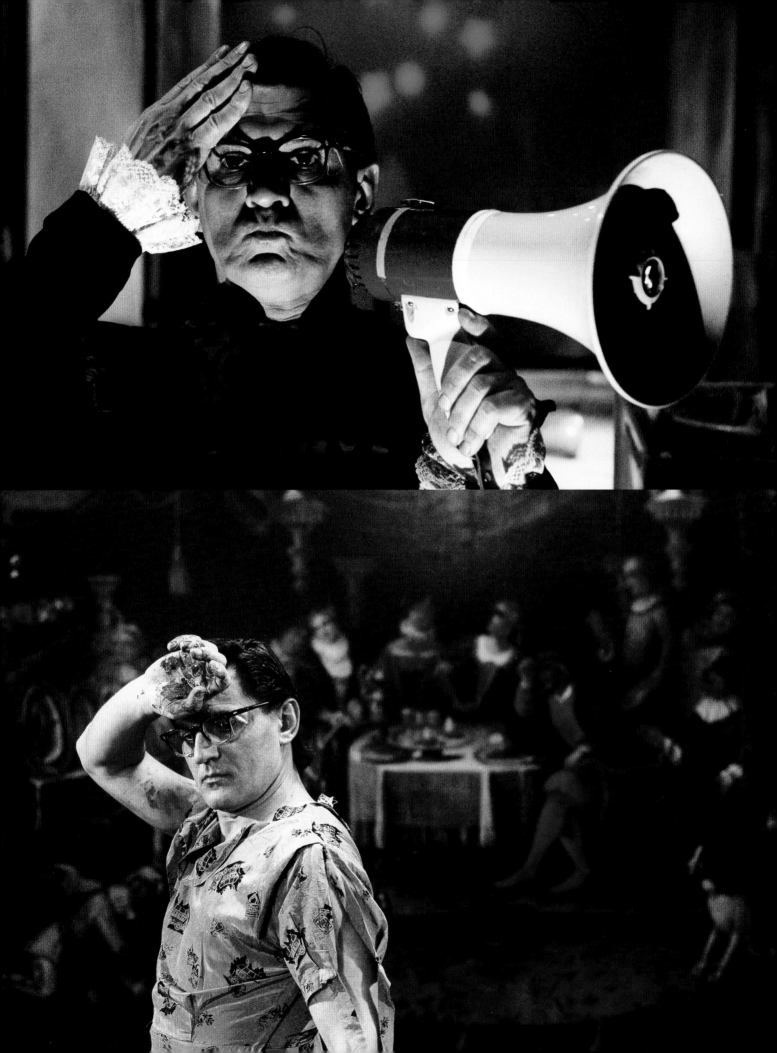

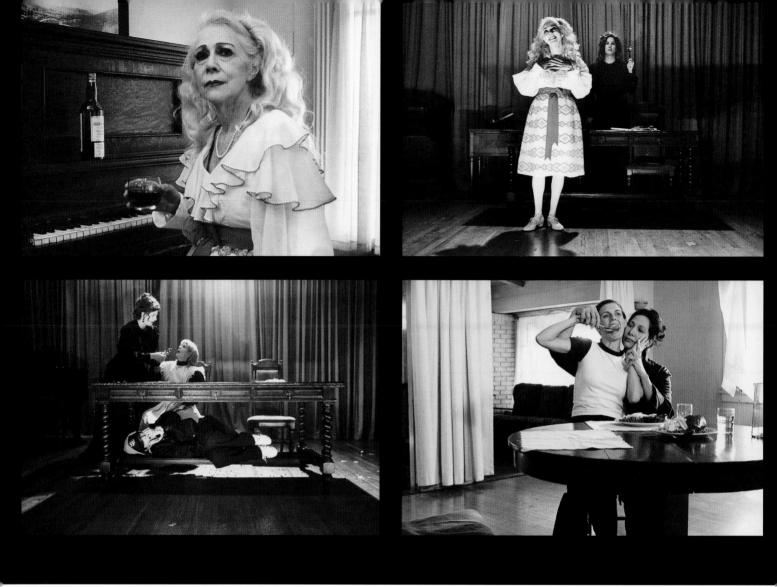

Catherine Sullivan

Big Hunt, production stills, 2002
Five channels shot on 16 mm film
transferred to video, projected from
DVD, 21 min 48 sec per channel,
black and white, silent
Performers (pictured): Alessandra
Assaf, Yun Jun Chang, Cindy Clarke,
Sarah Dornner, Michael Garvey,
Jenifer Kingsley, Monica May,
Valentine Mielli, Roberta Randall,
Sarah Taylor, Jacqueline Wright

I was always interested in the body's capacity for signification. That's one of the reasons why dramatic acting always interested me, provoking questions about its potential for infinite transformation or asking why certain bodies are prohibited from transforming. Is it that the roles they're playing aren't suited to their particular physiognomies, creating some kind of obstruction? Are there other roles they might play, which are suited to their physiognomies, which might set them free? In *Five Economies (big hunt, little hunt)* (2002), one actress is engaged with a number of different roles and styles. So what becomes fascinating to me is that this one person can transform, not only through the roles that she plays but through the styles through which these roles are filtered.

She ends up being a transcendent figure in the piece because she is able to absorb and project such a multitude of codification. Meanwhile, there are other actors in the same piece, who are somehow 'themselves' in every single role and through every different style. Again, that's fascinating to me—how the same kind of character silhouette for one person would be a place of transcendence or transformation, but for another would be an articulation of immobility, a lack of capacity to transform. The role becomes something that articulates the actor just as much as the actor articulates the role.

Five Economies (big hunt, little hunt) began with several sources, some from film, some from real life, and some from research

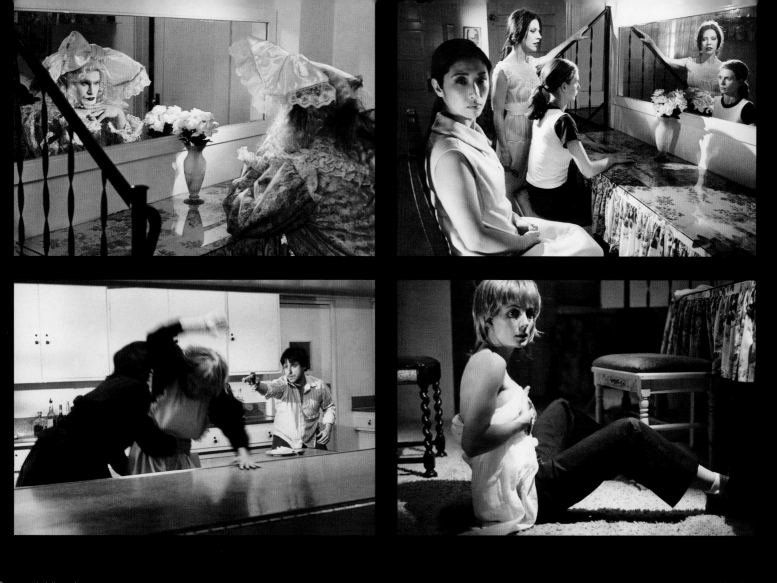

on popular ritual. The films included *Whatever Happened to Baby Jane*, Bergman's *Persona*, *Tim* (an early Mel Gibson film), Peter Brook's *Marat/Sade,* and *The Miracle Worker* (the story of Helen Keller). From real life I took the story of Birdie Jo Hoaks, a twenty-five-year-old woman who tried to pass as a thirteen-year-old boy so she could obtain social services in Utah. The social rituals were games played at wakes in Ireland in the seventeenth and eighteenth centuries. All these sources or models had to do with the paradox—the strange cultural fixation—that we find pleasure in the misfortunes of others. With regard to the popular films, I was questioning why the ascendance of an actor is expressed through the affliction of a character. Why—in order to demonstrate mastery as an actor—does one have to play someone who's disfigured, deformed, or psychotic? It's an odd paradox—that in order to demonstrate one's craft, one has to do it through that kind of role. I had an acting teacher once who said, "If you can do this—play blindness or disease or psychosis—then as an actor you're really hunting the big game." (And that's my title, *Big Hunt*.) The sources all generated a stylistic economy through which all of them were then filtered. This formed a series of scenes, a restaging of the sources. So you have the story of Helen Keller staged in the manner of classic American repertory theater, in a naturalistic manner reminiscent of Ingmar Bergman, and in the *noir*-ish manner of *Whatever Happened to Baby Jane*. And you have a permutation of scenes that is derived from the imagined narrative of Birdie Jo Hoaks. So you have the actors trying to transform, not only through these paradoxical roles but also through constantly shifting styles. Through research into the nature of social ritual I discovered the Irish wake amusement, which seemed particularly pertinent because the games were very cruel—by and large about locating a participant as a booby. So it seemed related, again, to the question, "Why do we take pleasure in other people's misfortunes?" and to the consideration of this kind of cruelty as a basis for the comedic impulse. So, all the sources had to do with that paradox.

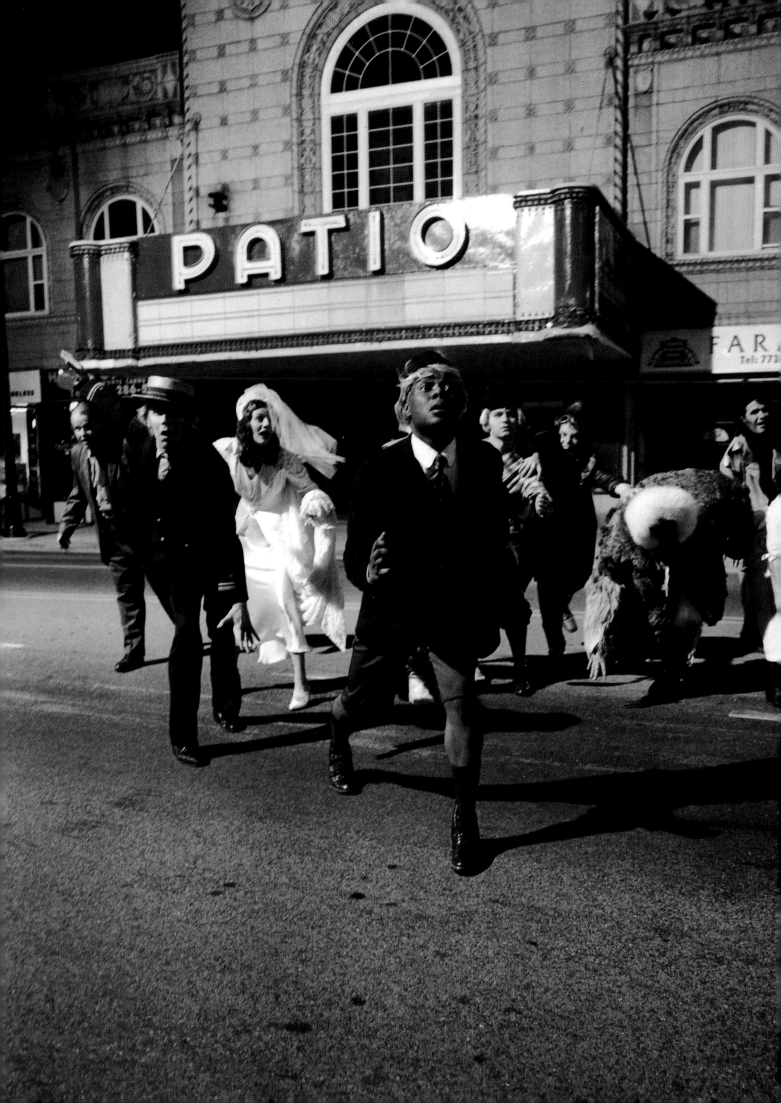

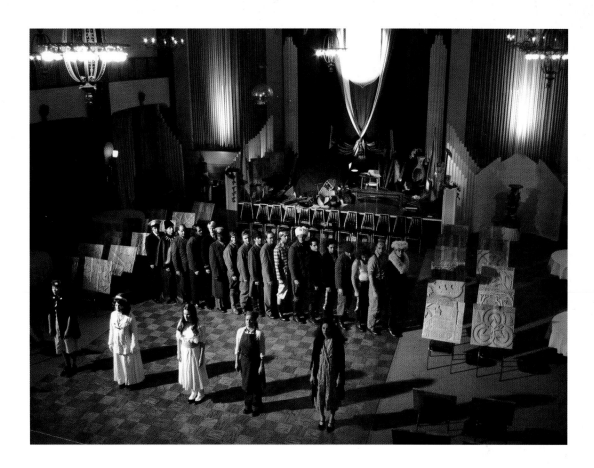

Catherine Sullivan

OPPOSITE AND ABOVE
Ice Floes of Franz Joseph Land,
production stills, 2003
Five channels shot on 16 mm
film transferred to video,
projected from DVD,
21 min 48 sec per channel,
black and white, silent

OPPOSITE
Theaterinis play their theater

ABOVE
Rehearsal photo showing full
cast and main hall of Polish Army
Veterans Association of America
(S.W.A.P.), Chicago, Illinois

The kinds of subjects that have always interested me have been those that I have something and nothing in common with. As a foundation for a project, that's enormously unstable but incredibly interesting because, within that, there's always a reverse sort of projection onto me. If there's an aspect of the work (if, for example, we have to make a costume for an aboriginal from the Russian arctic) and we need to make a decision, certainly there's research we can do to say, "This is what an aboriginal from the Russian arctic looks like." But sometimes it's okay if we just guess because it's the guessing and making of mistakes that then say something about what we don't know. And that is a kind of truth. So there's an incredible amount of conflict in thinking about some of these things. But, at the same time, to have this imperfect apparatus seems to reveal something about my misunderstanding or my lack of understanding, which is then truthful in some way. To assume that I have something in common with the situation, when I

don't, creates an interesting problematic in the work. This relates particularly to *Ice Floes of Franz Joseph Land* (2003). This was a piece that began with my interest in a hostage crisis in Moscow in 2002, when a faction of Chechnyan separatists stormed a theater. (What particularly interested me about that event was that the musical playing in the theater was based on a love and adventure novel about polar aviation and the Russian arctic, and that it had aspirations of being a kind of Broadway spectacle 'with a Russian soul'. I thought that was painful—that, in Russia where there's a tradition of theater as spectacle, the aspiration would be toward a Broadway spectacle.) But it was this horrific event that I found very compelling, which raised a number of questions—one of which had to do with cultural assimilation And I looked at the event as I often do in terms of its surrounding conditions . . . not to go to the musical itself or the Chechnyan or Russian situation, but to work with the novel as material I could project onto.

Catherine Sullivan

In this work, we started with pantomime, thinking about it as a very reduced form of theater that required the actor to work hard to create a kind of 'elsewhere' with nothing else around him. These pantomimes were arbitrary. And because they were arbitrary they could be seen as brutal or mechanized and automatic. The movement style was an analogy for the cultural brutality that was part of the content of the work. If I look at all the works objectively, I think there are certain interests that I have in how the body might ultimately engage with a certain kind of mechanization. So in a general sense it's the idea that the movement itself is a kind of mechanized regime that's impressed upon the actors. And that part of the work is their struggle with it. A lot of that has ended up looking very percussive. It requires very quick transitions between one gesture and another, or often there's no place for transition. It's not that I'm trying to create a sense of suffering. That's not something that interests me. It's more that the content itself suggests oppressive cultural regimes to which I would like the movement to be analogous.

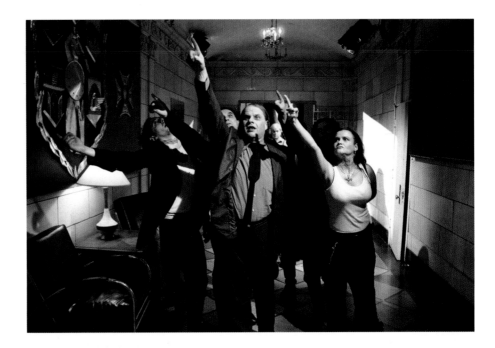

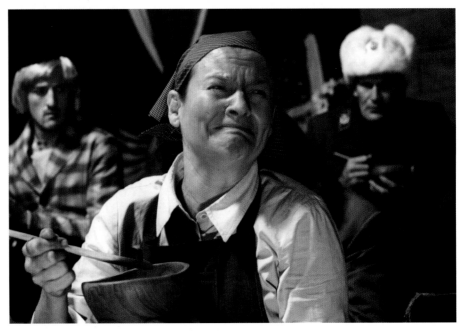

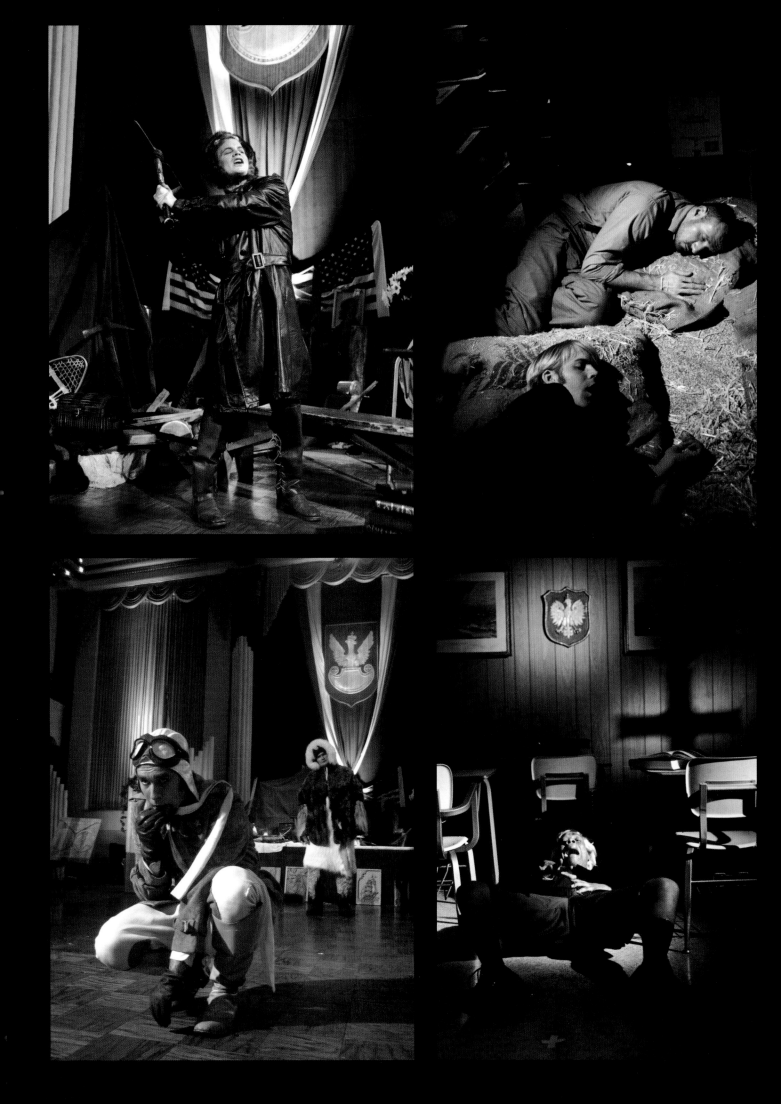

Catherine Sullivan

RIGHT, OPPOSITE, AND BELOW
The Chittendens, production stills, 2005
Five or six channels shot on 16mm film
transferred to video and projected as
digital media, color, sound, variable length
per channel (total length: 2 hours 13 min)
Musical score by Sean Griffin

RIGHT
*The Resuscitation of Uplifting
(Chittenden Lobby: Triangle Aria)*
Performer: Carolyn Shoemaker

BELOW
Misfire #2 (History Hurts), 2006
From the series, *Misfires 0-13
(The Chittendens)*
Color photograph, approximately
11 x 48½ inches
Edition of 6

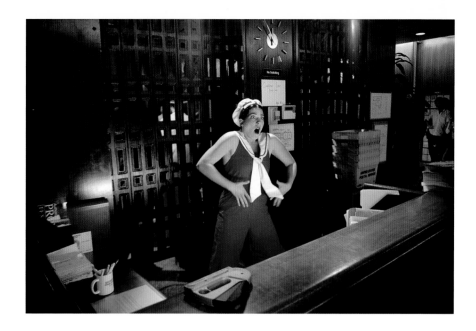

I've thought a lot about the degree to which the inspiration of the work comes through the privilege of being able to consume information. In some way, I try to honor that privilege by saying that I operate in a world of choice. For me, politics is a choice. I don't live in a world where I'm forced to align myself ideologically with a particular regime or think on a daily basis about where my soap is coming from. So, engagement with these issues is a choice. And my choice is to reveal that freedom and privilege to think about certain things without having to suffer their consequences. . . . My imagination can bring together a lot of very painful things and a consideration of different kinds of consequences. I've thought a lot as an artist about what it means to operate with any information I want and with the privilege of using that information in any way I want. If I were to make a different choice, then I would be a journalist. . . . But I'm an artist. I'm interested in these things in an artistic sense. The end result is art.

When Bush was re-elected I was working on the movement sequences for *The Chittendens* (2005). I was so disgusted with the political situation that I started reading Thorstein Veblen's *Theory of the Leisure Class*. That book framed for me a lot of the pathology that was very familiar, having lived with this regime. The process of the piece was to build a mise en scène in which the characters were modeled after twentieth century middle-management and nineteenth century leisure-class archetypes. I started to look at certain

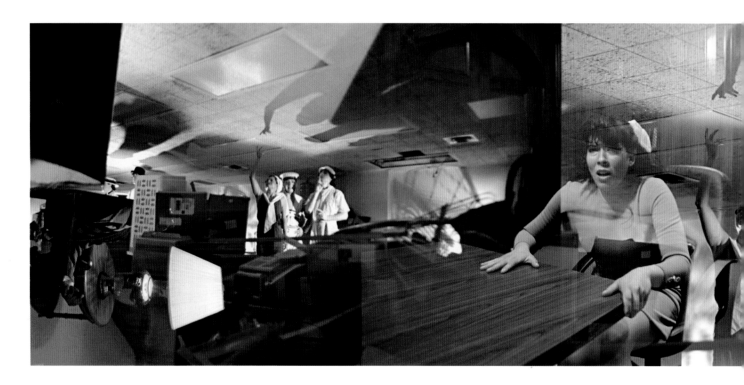

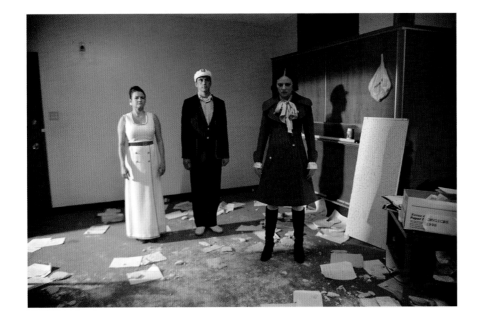

Catherine Sullivan

LEFT
The Resuscitation of Uplifting (Nostalgic Leisure Class Archetypes)
Performers: Beata Pilch, Karl Francis, Nicole Wiesner

FOLLOWING SPREAD
Misfire #4 (Cinematically Distant), 2006
From the series, *Misfires 0-13
(The Chittendens)*
Color photograph, approximately 21 x 35½ inches
Edition of 6

things that were symbolic or visual motifs within their milieu. One of those things was the lighthouse, which is often used in ads for insurance agencies, banks, and mortgage brokers as a symbol of stability in American business culture, and another was the office or corporate headquarters. And I started thinking about these in terms of a mise en scène for the work and that they could be useful as places for these regimented choreographies to happen. (I had actually seen the name The Chittendens and the lighthouse sym-bol on a sign for an insurance agency in Phoenix, Arizona. And, ironically enough, one scene was shot at an abandoned lighthouse on Poverty Island, off the coast of Wisconsin.) The performers' movements are not alienating in and of themselves. It's what happens to those movements once they're in the environ-ment of a particular regime. It is to the regime that judgment is to be directed versus judgment being directed at the individuals within it. And that's been something of a misunderstanding within the work. It's not that I want anyone to look at the actors succeeding or failing within this situation. It's more that any judgment is to be directed at the situation that asks them to behave and perform in this way. So there's a place in the work where automation and mechanization is like a kernel of mindlessness. It's meant to be frightening because it's arbitrary— because you can't understand why. . . . A fundamental principle of the way the regime operates is by giving no explana-tion for itself.

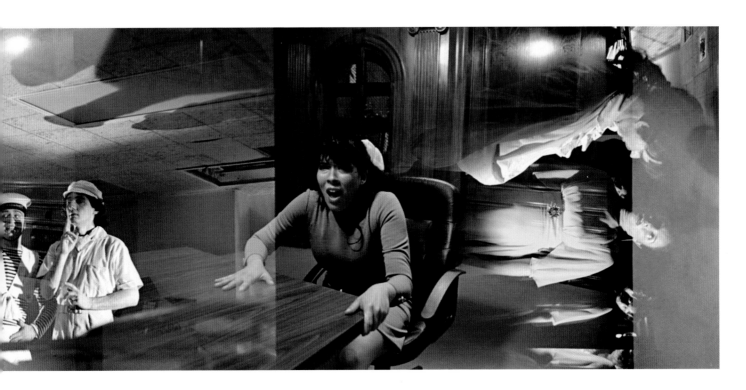

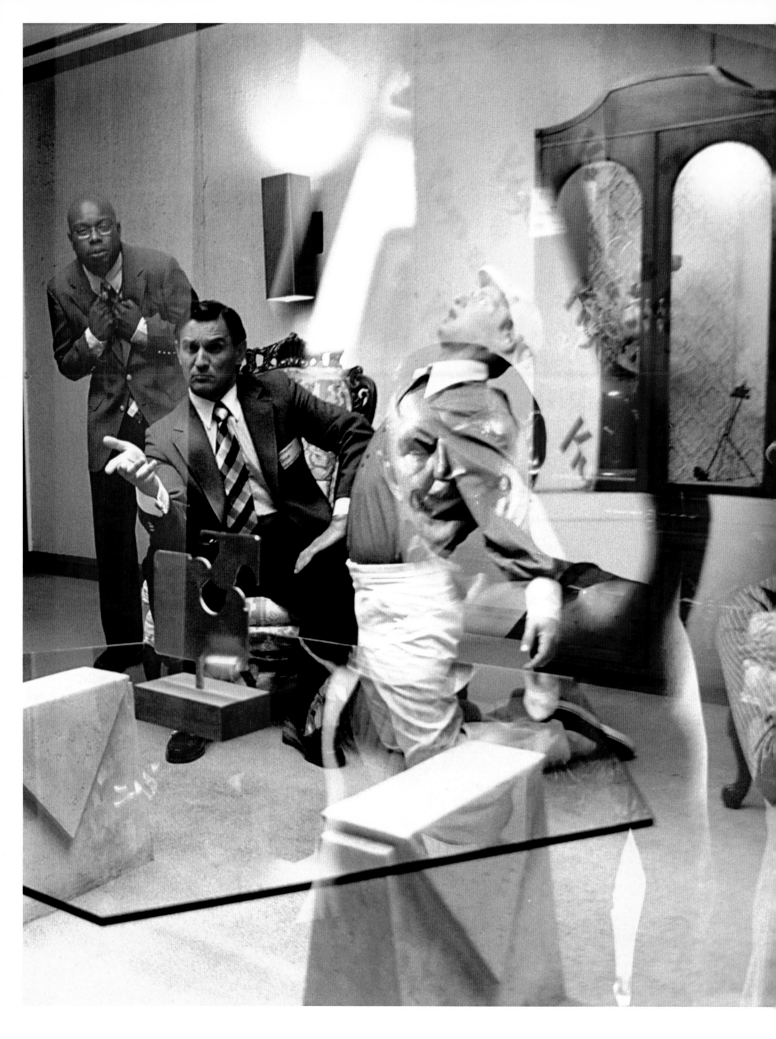

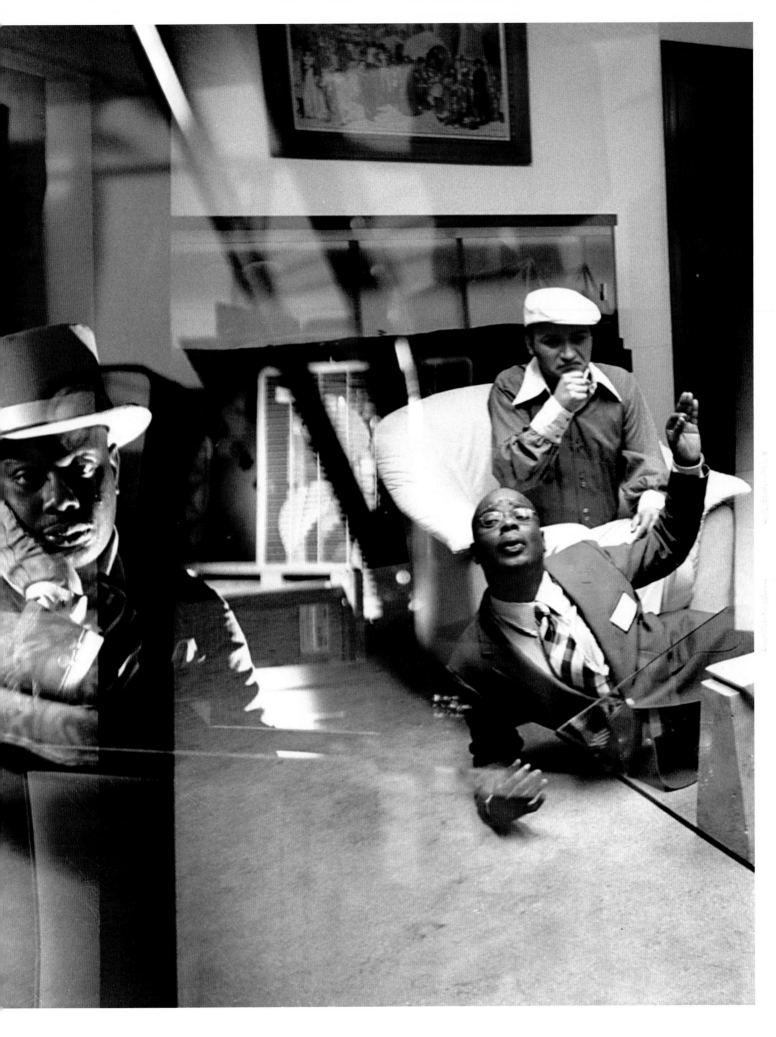

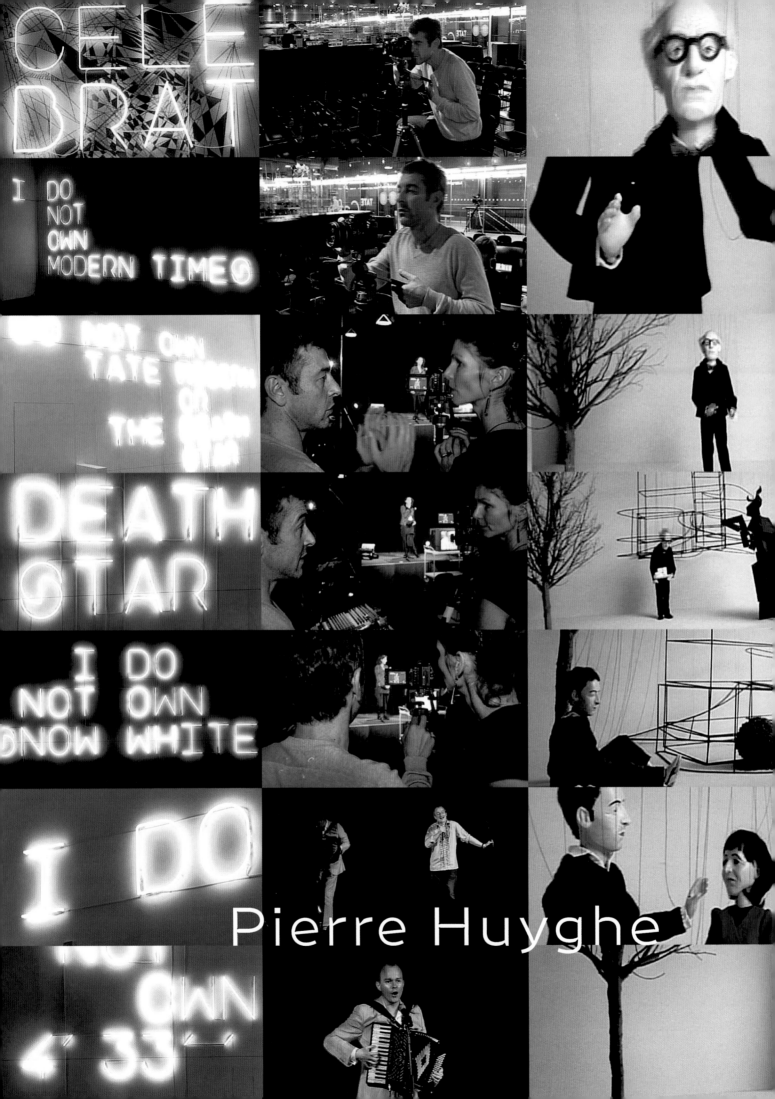

CELE
BRAT

I DO
NOT
OWN
MODERN TIMES

DO NOT OWN
TATE
THE

DEATH
STAR

I DO
NOT OWN
SNOW WHITE

I DO

OWN
4'33"

Pierre Huyghe

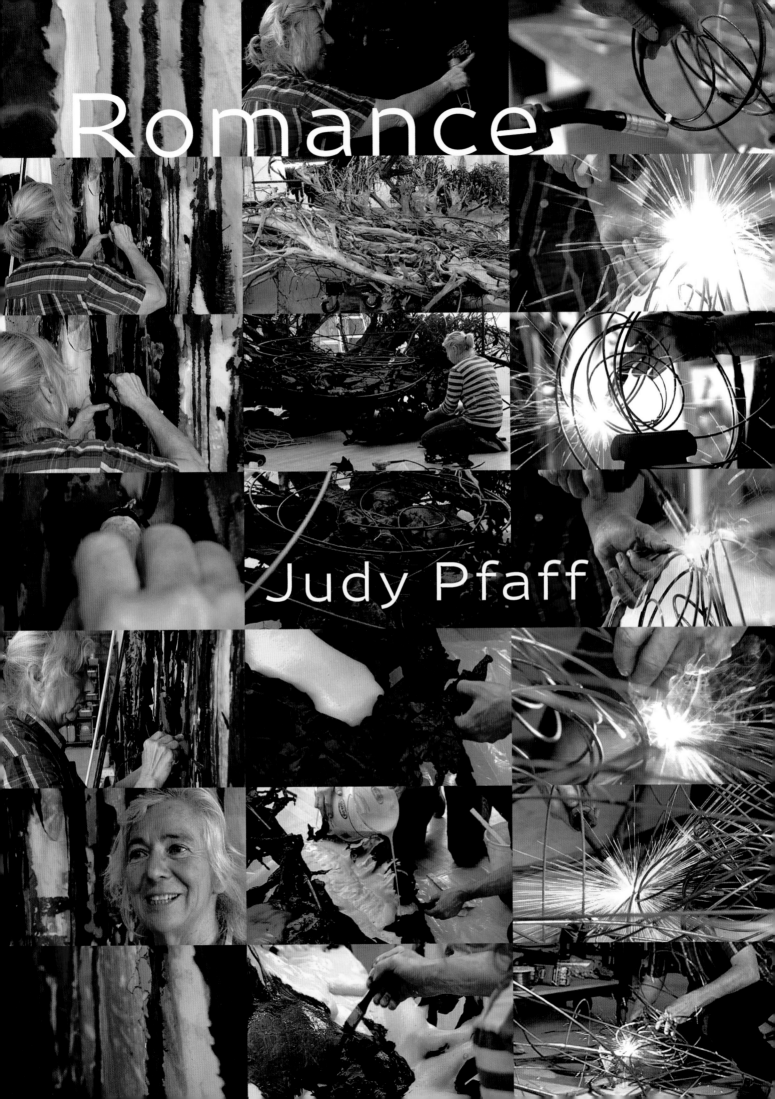

Romance

Judy Pfaff

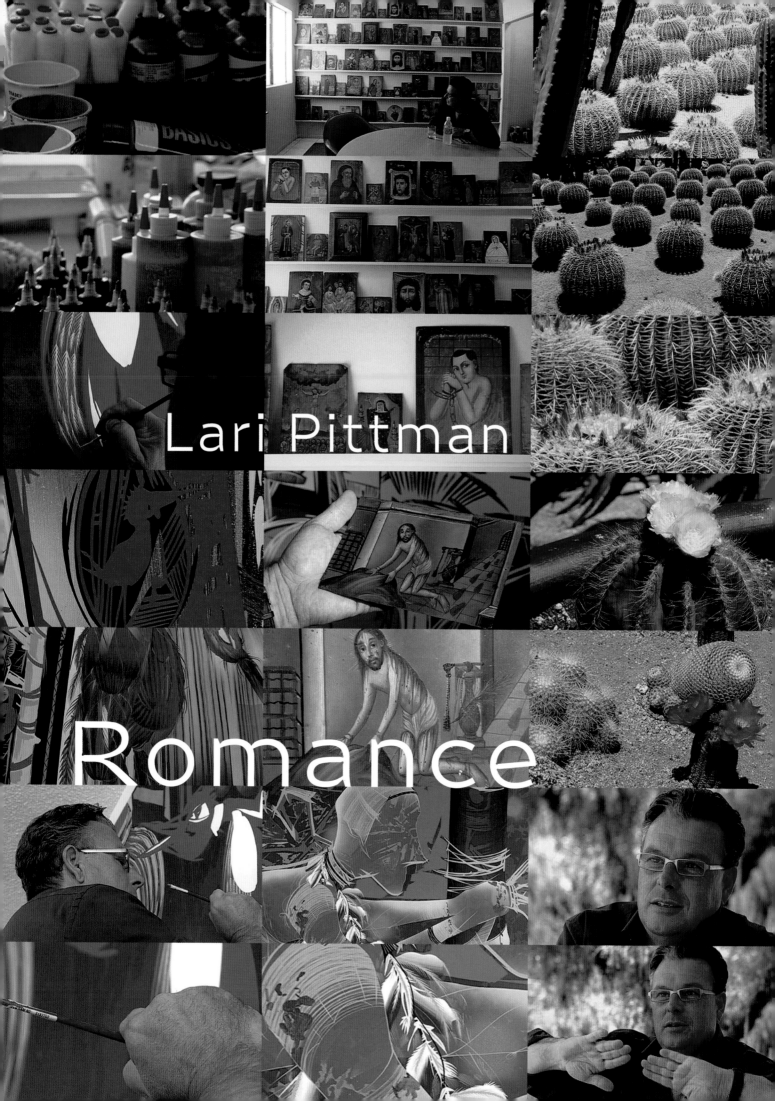

Lari Pittman

Romance

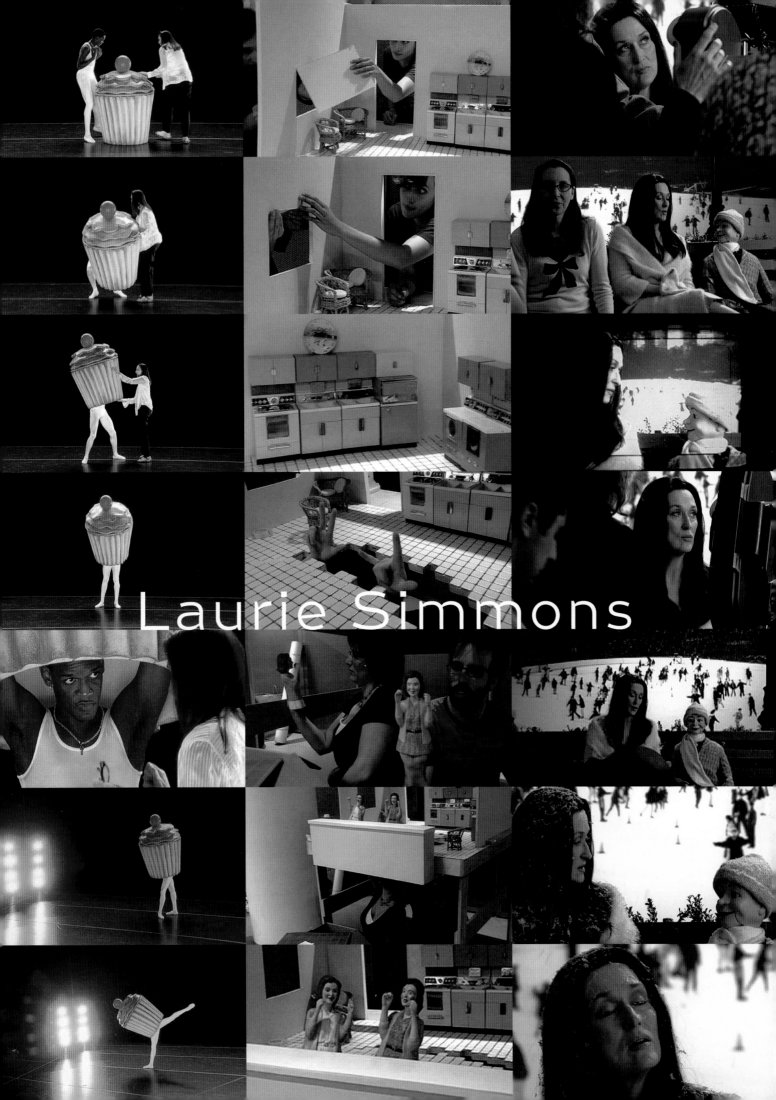

Laurie Simmons

Pierre Huyghe

The nineteenth century is interesting for many reasons, but one for sure is that it was a moment of pre-modernity—a moment when time was thought of in a very different way. The relationship people thought they had with the period in which they were living was very different from the one we have today. The difference is in the way we see each period in relation to the present, past, and future. Today, in a certain way, the notion of projection into the future is gone. At the beginning of the twentieth century there was a moment of suspension, when time was not as regulated—past, present, and future—as it would be maybe ten or twenty years after. When our chronology is a bit shaky, each turn of a century creates a moment of dizziness with time. I'm even wondering now—today—what happened in the last ten years. Where are we in terms of our relation with time? In a way, we are definitely in a kind of hyper-present, in a kind of exponential and endless present—an endless now. It's a moment of indecision for the arrow of time, and I'm really interested in that—deeply, when it comes to a journey or a movement.

RIGHT
Chantier Barbès Rochechouart, 1994
Billboard, Paris, approximately 13 x 10 feet
Offset printed poster (1996), approximately
31 x 47 inches

OPPOSITE
Timekeeper, 1999
Installation: Secession, Vienna, Austria
Hole revealing wall painting of successive
exhibition layers, 8 inches in diameter

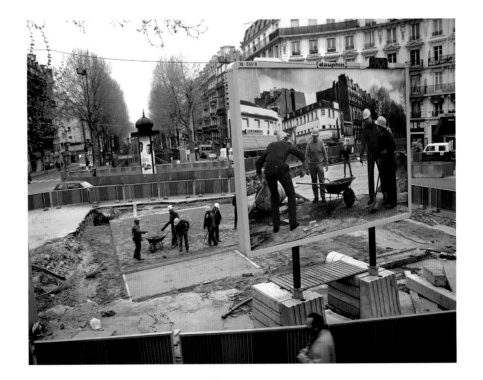

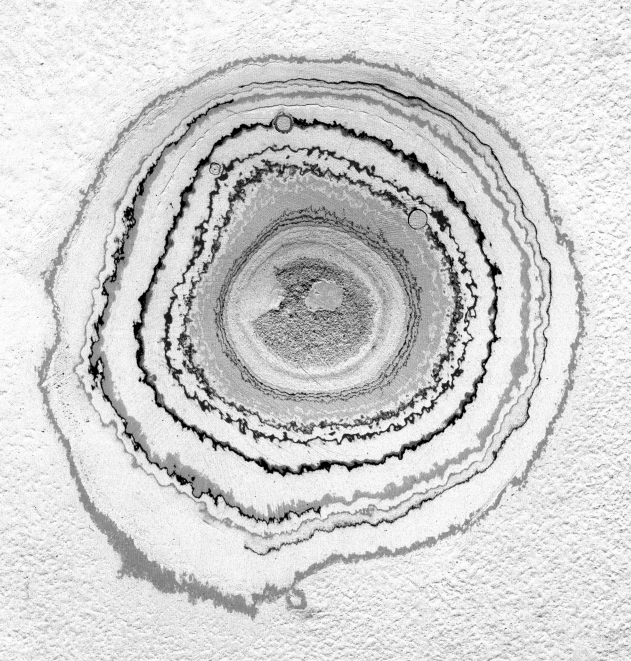

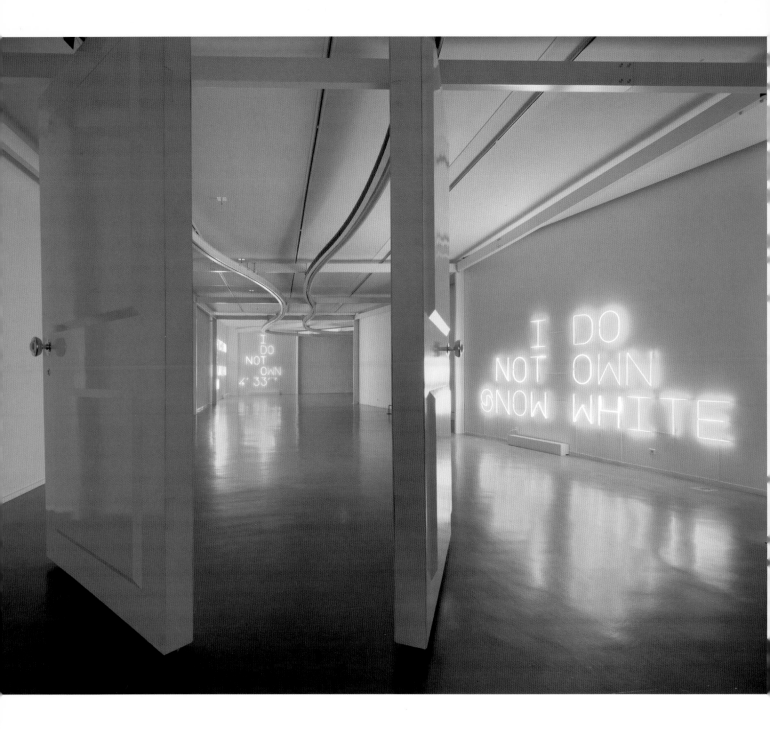

Pierre Huyghe

Celebration Park, 2006
Installation view: Musée d'Art Moderne
de la Ville de Paris/ARC

Gates, 2006
Wood, approximately 142 x 71 x 2 inches

I do not own Snow White (disclaimer), 2005
White neon lights, approximately 10 x 39 feet
Signage system designed at M/M (Paris)

Fictions ne m'appartient pas (disclaimer), 2005
White neon lights, approximately 8 x 19 feet
Signage system designed at M/M (Paris)

Celebration Park (2006) is a collection of
exhibitions, a set of singular experiences.
The format of exhibition is something
to work on: it's a form in itself. Usually
an artist thinks of an exhibition as an end
point, a resolution of something. He's work-
ing in his studio, and there's a process, and
at the end of this process he's showing his
work in what we call an exhibition. I'm not
interested in that. I'm interested that the
exhibition is not the end of the process but
a starting point to go somewhere else. In
a certain way, that's what this is all about.

Like a world's fair, it's a presentation of
some news, some novelty.

You enter the gallery and you see all
these neon disclaimers—the kinds of state-
ments you make in order not to be sued
if you use something that belongs to
someone else. It's a copyright issue, a legal
problem, So you have to say, "I used that,
but it's not mine." And then because you
say, "It's not mine," you have the right to
use it in a certain way. Of course, in my
work I have used the voice of Snow White,
the music of John Cage, and now I'm also

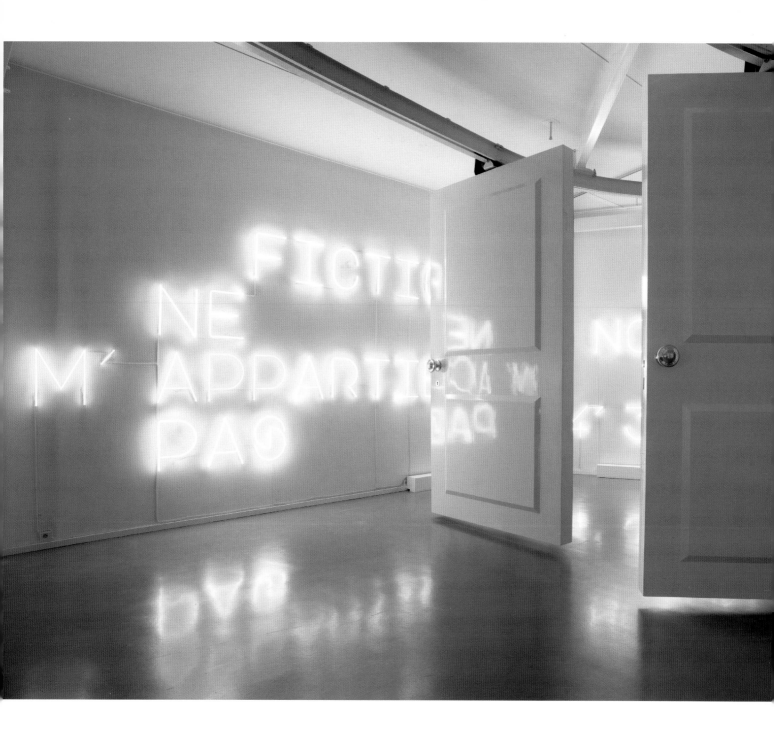

actually using the museum. What do people think when they enter the museum and see *I do not own Snow White* (2005)? They can relate. Snow White is a character we all share. But you need to play with this culture in order to be part of it. There's a production of symbolic material, and you need to be part of it and use it. When you read the text, you say with your inner voice, "I myself do not own Snow White . . . but I know how she sings. . . ." You enter into the play of knowing or not knowing if you own the culture. You used to be able to have a nar-

rative and circulate it through a narrator, and the story would grow and go on indefinitely. But today you cannot do that because there's a copyright attached to it. The story can expand, but it always has to go back to the original because of the copyright issue. Between us we can sing the song of Snow White, but not publicly. This is about the circulation of stories, how we can tell stories to each other—how fluid or not this is.

And that's why there are those moving doors in my installation of *Celebration Park*. They suspend the moment of opening

forever. Usually a door is a fixed object: you're in or you're out. You can or cannot gain access to something. Here, the doors are moving so you don't even know any more where 'outside' is. Who says a door is a threshold that means you are inside or outside something? I guess if the threshold is moving, if the doors are moving, there is no more inside or outside. It's definitely about boundaries and culture, and fluidity. You think you can always be outside, but maybe you are always inside. It's a very simple metaphor.

Pierre Huyghe and Philippe Parreno

No Ghost Just a Shell, 1999–2003

RIGHT
Annlee (original image), 1999

BELOW
A Smile Without a Cat, 2002
Fireworks event, Miami Beach, Florida

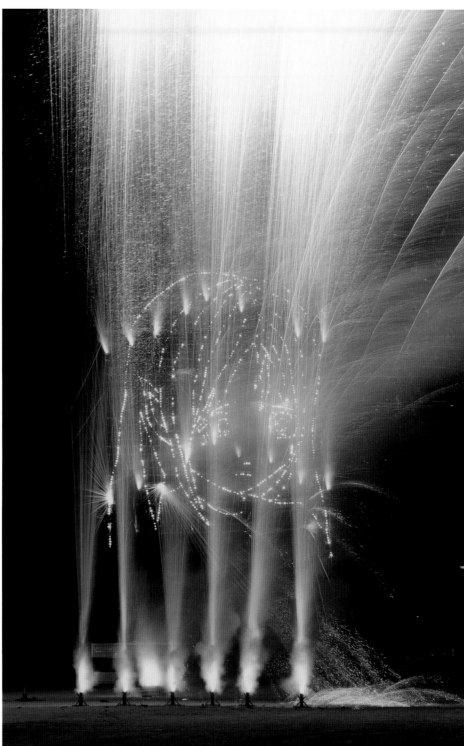

For *No Ghost Just a Shell* (1999–2003), Philippe Parreno and I bought the copyright of a manga character. We can call it a sign. Normally this kind of sign is bought to make little advertising cartoons. It's a platform for a narrative, advertising things. So we bought one of the very cheapest characters and we gave it to different artists so that they could fulfill this empty shell. Different 'authors' speak through the character in different ways and, at the end, it's an exhibition. So you have a film, a sculpture, a painting, and so on. What is important here is the notion of polyphony. This is a collective project and that's what I think is important in a collective exhibition. We could talk about the character—it's like this or that—but what's more interesting is the copyright issue. We bought a sign; we shared it with different authors. And then at the end, it's not so much an open source where you say, "Oh, this belongs to everyone." At the end, we decided to take this character out of representation. So we set up a fireworks event called *A Smile Without a Cat* (2002), blowing it up. And we decided to give the copyright to the sign, to the creature or character itself. I freed it from being represented. It cannot be represented any more. At least, it's a transformation—not an end.

Pierre Huyghe

L'expédition scintillante, a musical, 2002
Installation Kunsthaus, Bregenz, Austria

TOP
L'expédition scintillante, Act 3, 2002
Untitled (black ice stage),
approximately 33 x 25 feet

CENTER
L'expédition scintillante, Act 2, 2002
Untitled (light show): wood, smoke, light,
and audio, approximately 79 x 75 x 61 inches

BOTTOM
L'expédition scintillante, Act 1, 2002
Untitled (ice boat): ice, approximately 9 x 7 x 20 feet
Untitled (weather score): rain, fog, and snow
Untitled (offshore radio): Radio Music, by John Cage

I'm playing with narrative structure.
That's for sure. And I usually like parables
because of their haiku quality. Of course
there is a metaphorical aspect in parables,
and that's also in works I've done, not
only in film but also in the ice boat,
and the ice-skating rink (the show in
Bregenz). Like a lot of people in my
generation, I'm interested in the notion
of the departure point—in something
that is a potential scenario rather than a
plan—but that's a process of suspension.
Still, I like the format of the parable and,
as I was saying, it's really a haiku: it's a
very short way to express something,
more to do with a poem than a novel.
But it's very difficult to say what's poetic
in my work because it's not something
'mathematical'. It's not a recipe. There's
no reason to have a recipe and say
that I'm going to be poetic. I never do
that. It's rarely within the form itself. It's
more in the process. If there is something
poetic, it's poetic in the procedure . . .
in the way things are made.

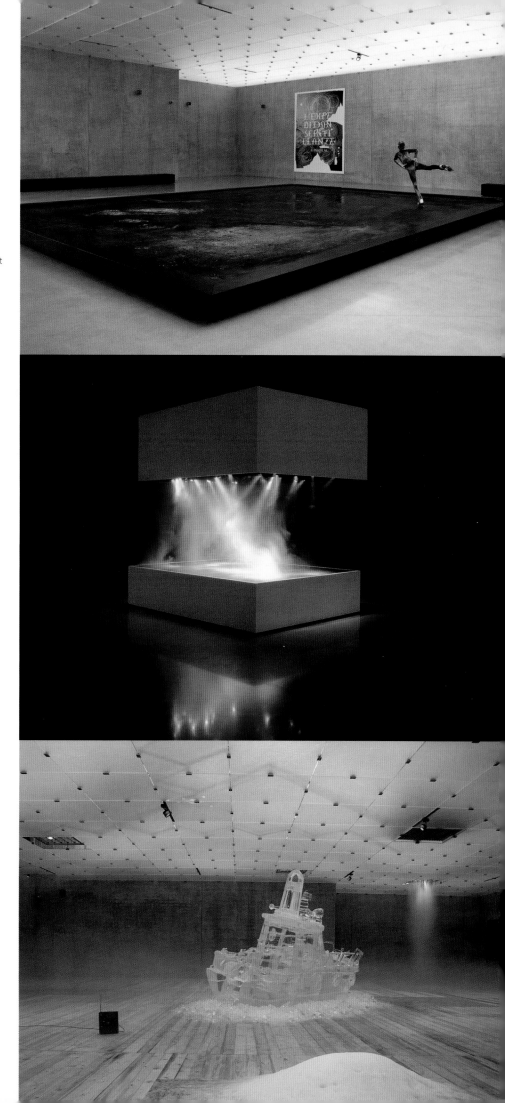

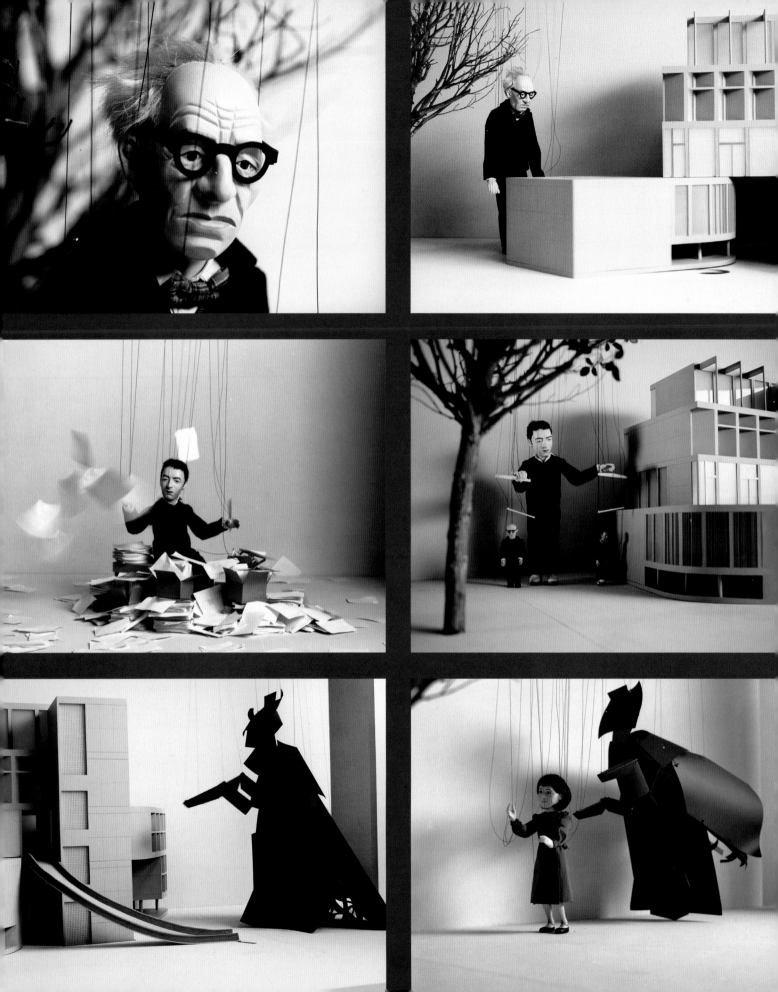

Pierre Huyghe

OPPOSITE AND RIGHT
This Is Not a Time for Dreaming,
production stills, 2004
Live puppet play and super 16mm film,
transferred to DigiBeta, 24 min, color, sound

What I need as I start a project is to create a world. Once the world is created, then I want to enter it as candidly as I can. And my walk through this world is the work. What takes me a long time is to create the world. The work is usually easier. I received a commission to create something in the art center at Harvard University—the only building Le Corbusier ever built in North America. I didn't know what to do. Finally I decided to look at all the archives, and I found that Le Corbusier also had a problem when he was commissioned to design the building at Harvard, and that he published a book about all the negotiations he had with the institution. I found myself in a similar position, and I decided to put the two situations in parallel in a kind of satire or an ironic parable. I decided to make a puppet show—like Punch and Judy—and a musical. That's how it started. I wanted to do an extension of the building, so I built a theatre. And in the theatre is this nonverbal musical, with music from Xenakis and Varèse (both of whom collaborated at some point with Le Corbusier). In a way, it's a course that I am addressing to the people of the campus, and it's about the situation I'm in and about

turning it around. You see Le Corbusier and how he came to weave the intuition of the building—and you see me and how I came with the intuition of a puppet play. There is present time, and the time of the Le Corbusier commission. In the present, there are the two curators who invited me to do the project, and me. They are actually in the play. And then you have Le Corbusier and the two people who commissioned him. Perfect symmetry. In the center, you have this black abstract figure. It's the Dean—representing the administration. And there's the little red bird that comes from an anecdote that Le Corbusier wrote, dreaming that birds would drop some seeds on his building and that the seeds would grow and flower. I took that anecdote and made it grotesque: the building—the utopian modernist dream—is overwhelmed by a kind of tropical monster. The Le Corbusier building *is* a monster building. It's a kind of compilation—the last building he did, a combine of all that he did in his life. In a certain way, it's a pudding cake. It's not really a clear, graphic, photogenic image. It became a kind of very dark, oblique object.

Pierre Huyghe

BELOW AND OPPOSITE
Streamside Day,
production stills, 2003
Film and video transfers,
26 min, color, sound

Streamside is a little town north of New York. It was under construction when I found it, and I created—or invented—a tradition for it. I was interested in the notion of celebration, and what it means to celebrate. I tried to find a story within the context of the local situation, looking for what the people there had in common. I found something basic: they all came from somewhere else and encountered nature. I invented a kind of score, a scripted program, and I filmed that—all these people traveling to experience what they think is wilderness. In fact, it's a wilderness that's a total construct—rebuilt by man for four hundred years. So I started the film with a re-enactment of the beginning of *Bambi*, with the deer going from nature to this new town. And then you have two little girls who go from the town to nature. It's the same movement, once by an animal and once by humans—a simple crossing—two migrations. And that is the basis of the tradition I created. But that's not what really interested me. I was interested in creating a ritual that the people in the town would actually celebrate because it's based on what they share. On a more abstract level, what interested me was to find the coefficient—the part of the fiction that was contained within the particular situation. I'm always doing that—trying to amplify the part of fiction that is contained in a reality, in a given situation. I was trying to find where the potential was in this new town. I was not interested in filming the reality as it was given. And I'm not interested in building fiction. What I am interested in is setting up a reality, building a situation, constructing a world, and documenting it. In *Streamside Day* (2003), I was building a celebration. I was even building a source, a kind of mythology. Then people would play in this mythology in the form of a day off, a celebration, once a year. I organized the whole celebration from the parade to the concert to the food and speeches. In a certain way it's a score that can be played again. It's a program, and next year at the same time you just take out the sheet of paper and say, "Parade!" and it will unfold. The film was just one way to grab the situation.

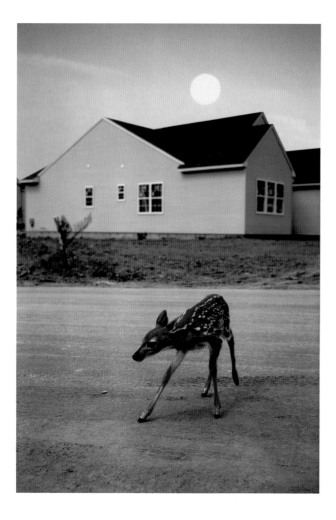
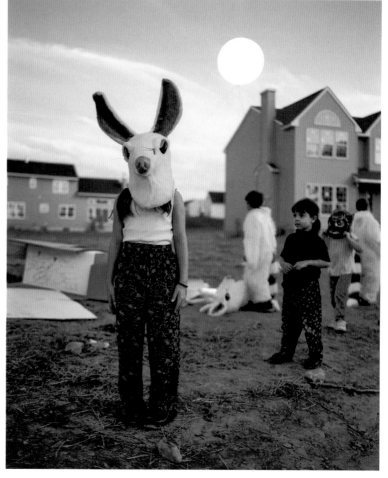

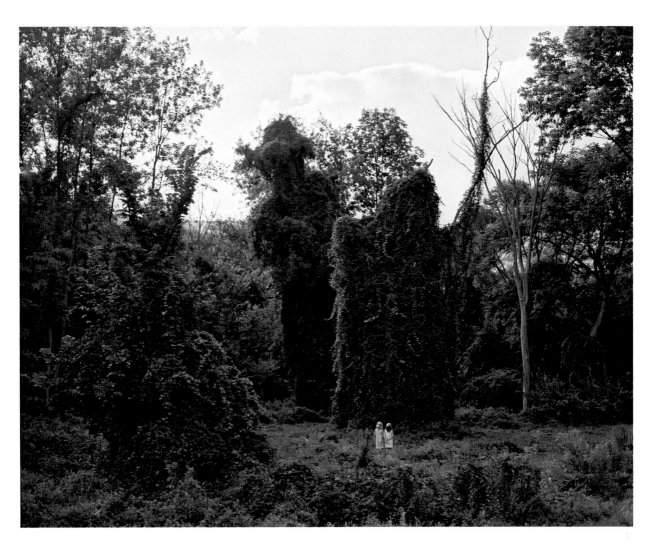

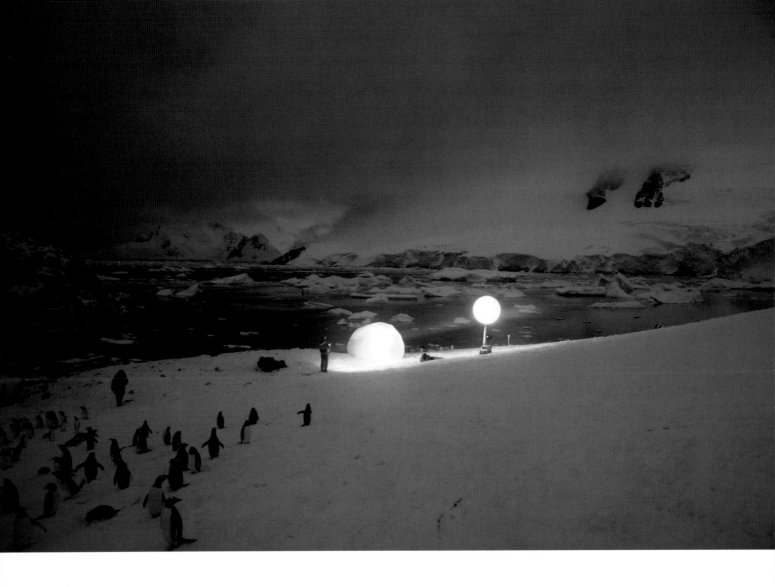

Pierre Huyghe

RIGHT
A Journey That Wasn't, 2005
Animatronics and fur, approximately
21 x 16 x 19 inches

ABOVE
A Journey That Wasn't, 2005
Super 16mm film transferred to HD video,
21 min 41 sec, color, sound
Antarctica

OPPOSITE
A Journey That Wasn't, 2005
Super 16mm film transferred to HD video,
21 min 41 sec, color, sound
A musical at the Wollman Ice Rink,
Central Park, New York

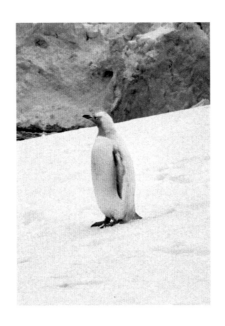

A Journey that Wasn't. It's called that
because the journey happened . . . or did
not. It was also kind of a mental journey,
and maybe that's the one I'm most
interested in. I think of it as a process.
The film is literally a process, a process
of finding an idea and bringing it to
light. You start with a hypothesis. If *if* is
my starting point, it's that I'm trying to
imagine that *elsewhere*—an island—
should exist. I've heard that people say
there is an albino penguin on this island.
It's a rumor; I've read about it. And on
this hypothesis I take a boat, a real boat,
and I try to find out if this hypothesis is
true or not true. (I think we do that. We
just invent fiction and we give ourselves

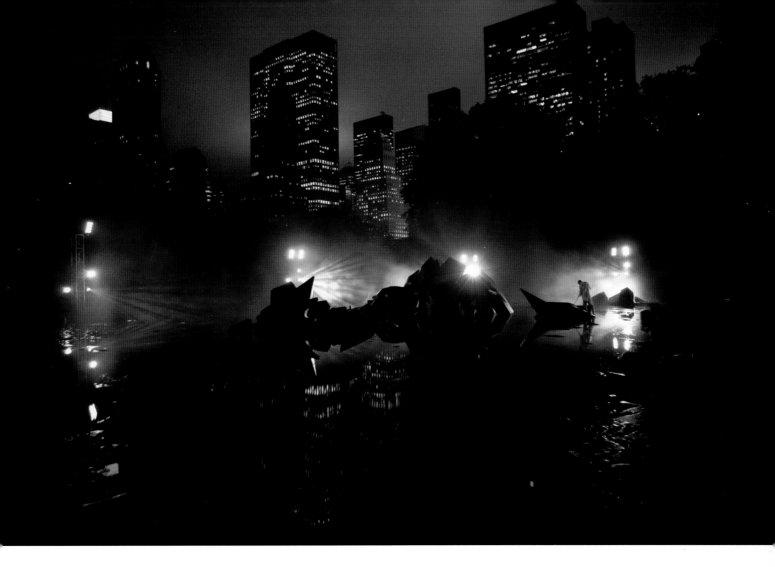

the real means to discover it.) So I take a boat and I cross the Drake Passage, we hit a storm, and we are stuck in the ice. We travel for a month through frozen Antarctica to find this territory and this creature. It's just a process of finding something and bringing it to light. The important thing is the movement. It's not so much what you find as whether the movement exposes something. On the boat there are many artists whom I asked to come along. So it's a collective expedition toward *elsewhere*. And once everybody comes back from this collective experience, each person does something with the experience. I'm filming the actual journey *and* a kind of parallel, a

translation of this journey in the form of a musical in Central Park. The project happened to be in Antarctica so there's all this mythology around it. You can think about Poe's *Narrative of Arthur Gordon Pym*, about all the Antarctic explorers, about the ozone hole. There are many parameters. I'm just trying to navigate through this crowd of references. It gives a certain tension to the work because each image reminds you of this or that, or that. But for me that's just background. . . . We don't know if I even went there—if I saw this island or the albino penguin. Maybe I did. Maybe it's a special effect. I don't care. What is important to me is to put white on the map, create holes in the map, and

bring back some myth to create a zone of no knowledge. It's not obscurantism. It's just to blur certitude. As in the *Narrative of Arthur Gordon Pym*, where Poe plays with the relation between fiction and reality, if something is too amazing to be believed then you have to put it in the costume of fiction to make it believed. But doing so is a trick because the thing is not even true. Modernity has taught us not to believe. The rationality of modernity has tried to remove or put aside everything that has to do with uncertainty, blurriness, and doubt. Like an iceberg, there is the part on the top which is clear, but you also have this huge part that is bigger, unclear.

Judy Pfaff

Romance? It's one of those bad words, like diary and that kind of personal thing. I'm very romantic, extremely so. So that's why these scrims and structures are around. It saves me from romance, the thing that I was given way too much of. It saves me from too much emotion, and not enough of the other things which are hard for me to get to. So the work is to get to the other levels, to the silence, to the breath, to a sweeter sense of things. Romance? It's just low grade. If left to my devices, it's not so great. There are a lot of things which are determined by a kind of romantic impulse, but I try to squelch it. The work is a kind of system. Sometimes I do this canceling thing: if it gets too 'one thing', I will try to overlay it with another so it doesn't get too literal, too poetic, too tough, too anything, too red. Cancel it with a little bit of green or get a vibration.

I was a Cockney from London, and I came to America when I was about twelve and did not fit. I was quite unruly. So I think probably there's a fantasy or a romance in these ideas of real beauty and form coming out of a sense of the land I just love. I was such a scrapper. I still am. I still have a street urchin mentality, even though I know better. There's no reason to have those feelings anymore, but I think you keep a lot of stuff from your past. So I think those other kinds of glorious ideas and those really sane visions of the universe intrigued me because probably essentially I didn't have that. The work has always had those two components in it. There's organization and finesse, which always sort of surprises me, and then this roughness in it and a sort of put-together aspect, too. But I think both of those things interest me. One is probably more who I am, and the other is who I would like to be.

BELOW AND OPPOSITE
Gu, Choki, Pa, 1985
Installation view: *Vernacular Abstraction,*
Spiral/Wacoal Art Center, Tokyo, Japan
Steel, wood, plastic, organic materials, bamboo, lattice, signs, veneer paneling, Formica, steel grating, and paint, 20 x 40 feet (diameter)

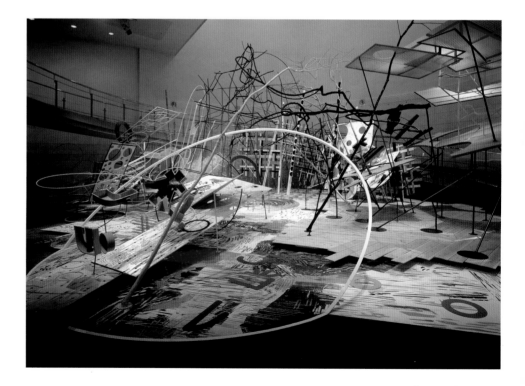

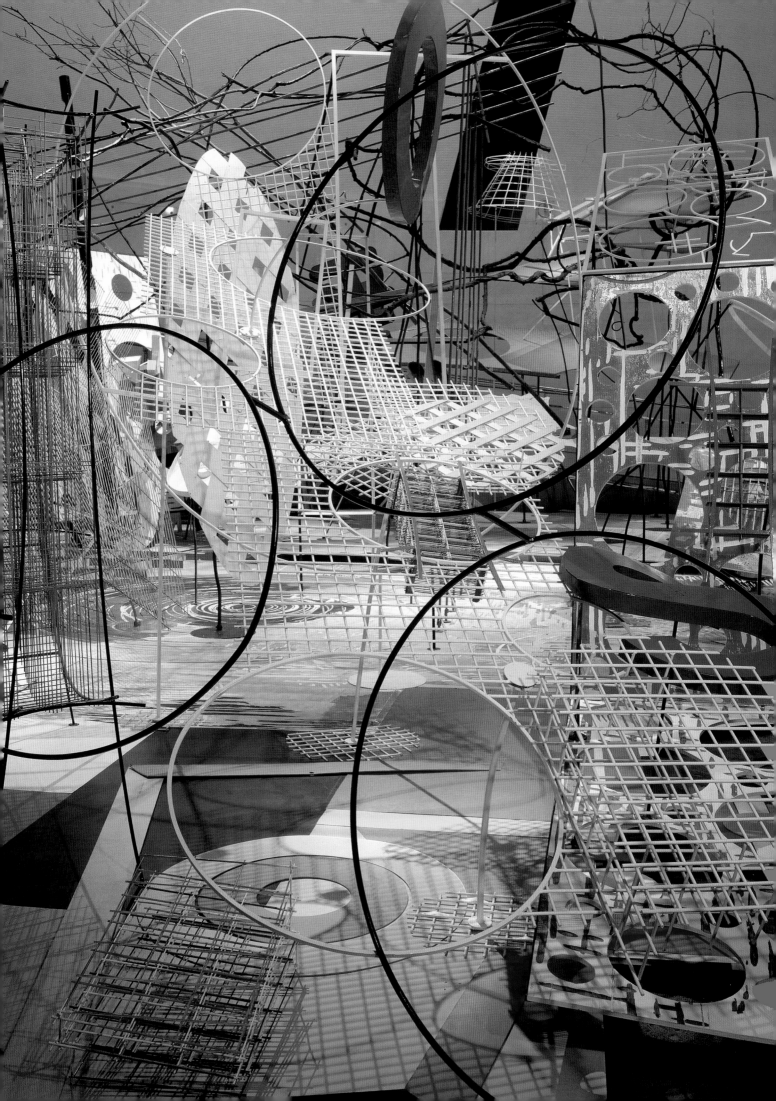

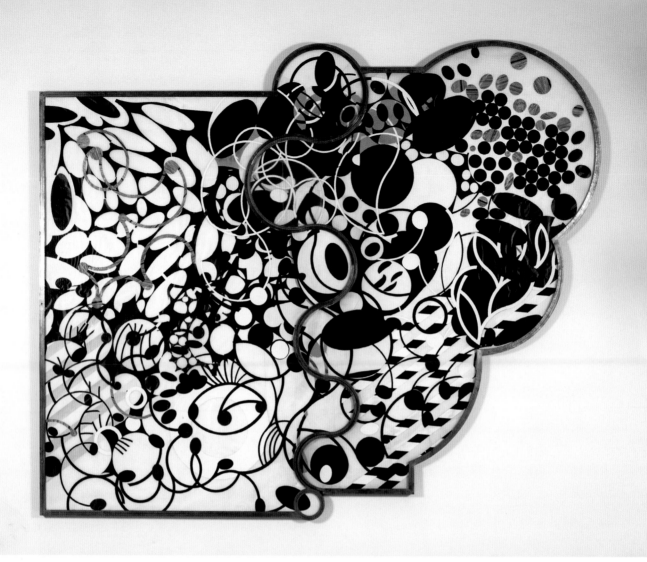

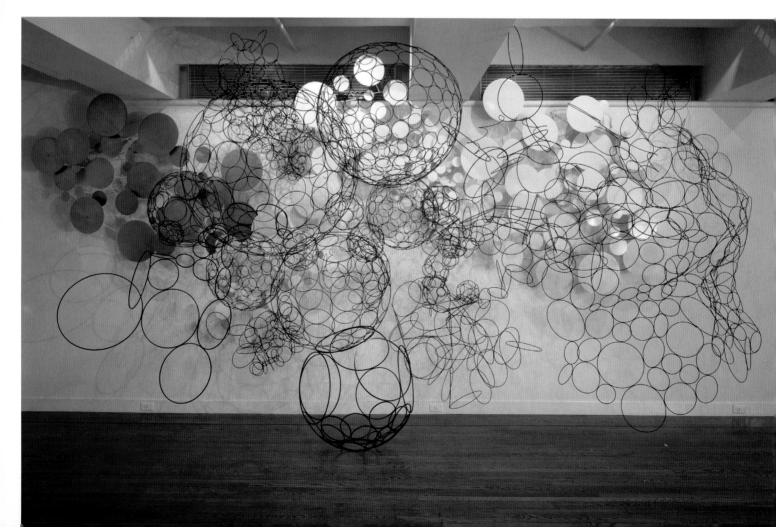

Judy Pfaff

OPPOSITE, TOP
Drawing for Horror Vacui, 1988
Mixed adhesive plastics on Mylar with iron
frame, 103¾ x 124 inches
Collection of the artist

OPPOSITE, BOTTOM
Horror Vacui, 1988
Painted steel and wire, 118 x 258 x 108 inches
Collection of the artist

RIGHT
Hangzhou, 2006
Crown Kozo paper, encaustic, and ink,
57½ x 47½ inches

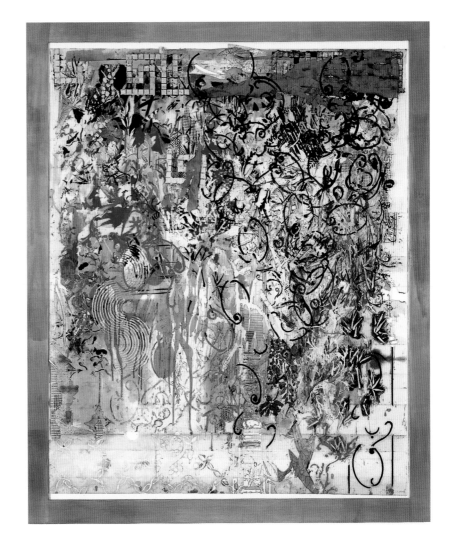

The drawings come before the sculpture. They always have. It's not the other way around. All the imagery is there. In a funny way, drawing teaches me how to move my hands because the drawings are actually quite physical. They're cut pieces of paper, or burnt pieces of paper, or stuff stuck on—collages. But they're very important.

I'm a fast drawer, but I have this thing about skill: it makes me nervous when anything's too clever. When I am around stuff that's too loose and too fast, it seems to have too much bravura. So sculpture slows me down. One of the reasons why I don't paint anymore is because I was too facile. It was emptier than I wanted it to be, and I couldn't slow it down. Now the drawings are painterly except they're not on stretched canvas. I know they're not paintings because paintings make me a little ill, when I make them, because I start doing this push-pull thing, this here-there thing. I'm haunted by all of the rhetoric of painting. Elizabeth Murray is a real painter—such a painter! Her paintings are hard work. They're emotional. They're direct. She's not embarrassed. She is there when she paints. She keeps in touch with her life. I get lost in painting. I can't be there. With the drawings, the collages, I can come and go. I can do other things. Painters are made differently. They concentrate in different ways, and they get pulled in. What I found, when I was a painter, was that I couldn't stop. It was like you got sucked in and, until it was finished, another thought didn't enter. Painting for me was like this terrible marathon. Once I started I couldn't finish until it was over because, if I did finish and come back the next day, I'd have to start all over anyway. It was a grueling pull. But the drawings and sculpture develop over time. Sculptures go on for months. They tell different kinds of stories, so they're not so much one moment. They're a sequence of moments. That works better for the way I'm put together. And I love stuff . . . and I love tools. And I get to get all these things. So I'm always correcting people who say, "All those paintings you did. . . ." They're not paintings. I know that because, if you know painters, you know when you're not one. Even in the drawings, nothing's really direct. That's not true all the time, but very little am I touching a drawing directly. There's usually some tool between it and me (scissors, burning, stencils, dots stuck on). If I get too close to a drawing, I will go into some reverie. So I have to keep myself a little bit distanced. A lot of the work is about my life. We all have the stories—but I just can't do that. There has to be a scrim—a structural scrim, a physical scrim, a tool scrim. If it's just me being expressive, no one needs that—including me. It's too much Judy—too *please give it a break.* So I like that distance. It keeps my brain working. Otherwise, it would all be emotion.

Judy Pfaff

RIGHT AND OPPOSITE
Buckets of Rain, 2006
Installation view: Ameringer & Yohe
Fine Art, New York
Wood, steel, wax, plaster, fluorescent
lights, paint, black foil, expanding foam,
and tape; 2 galleries, 153 x 245½ x 209
inches and 153 x 228½ x 165 inches

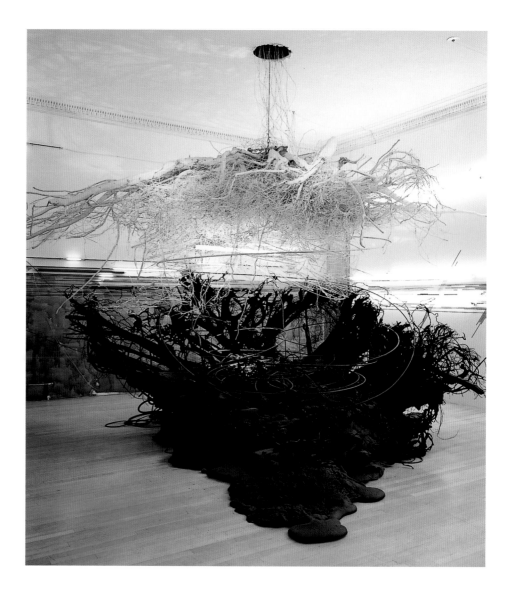

Last year it just seemed like everyone I knew died . . . my mother, Al Held (my former teacher), good friends. And I just wanted my 2006 show to be emotional. So I was basing this work on images of darkness and a kind of wilder characteristic than my other stuff. Before, the work was still chaotic but the last show was so pretty. And I thought, "This is not pretty, this is going to go to the other side." I was even looking at images in Dante's *Inferno.* So it was going to be a lot of dramatic, dark imagery. I don't know if other artists are still as nervous at my age about what people think—but some part of me thought, "I'm known for color, and I hate that. This is going to be like shooting myself in the foot, but I don't think there's going to be any color." So this piece started with a very fixed idea about darkness and death.

I probably have a problem with ideas. Most of the art world is idea-based: this means this; this means that. But I'm really trying to get to something very emotional and murky—more sensation and emotion than idea. Black-and-white is not an idea, but it's based on something. . . . It's life-based—what you gather and try to document. You keep in touch with who you are. I wanted this work to be emotional. That's the only word that keeps coming to me now. I didn't want it to be thoughtful, clever, smart. I wanted it to be emotional. And that's become a terrible dirty word in the art world—in every world. "Oh, she's so emotional." But I think that it's how we make real decisions and that seems to be an artist's prerogative. Other people have to stay in the real world a little longer.

We get these jaunts back into the psyche or the stuff that we're made of. And then we have to pay the bills. But now, I'm just sort of against ideas and want to just get to something which is mucky and basic . . . really basic, really simple. Stupid, not smart. . . .

Before, there have been a couple pieces which have been emotional. But most of the time the work is about form and space, and I might be involved in building or architecture or a romance about being Chinese. *Buckets of Rain* (2006) was directly about a great loss or a kind of drama, and more about choices—black and white, life and death, good and bad, and the impact of that. It just embarrasses me even to think that way, that I did that. But, you know, I didn't feel I had a choice.

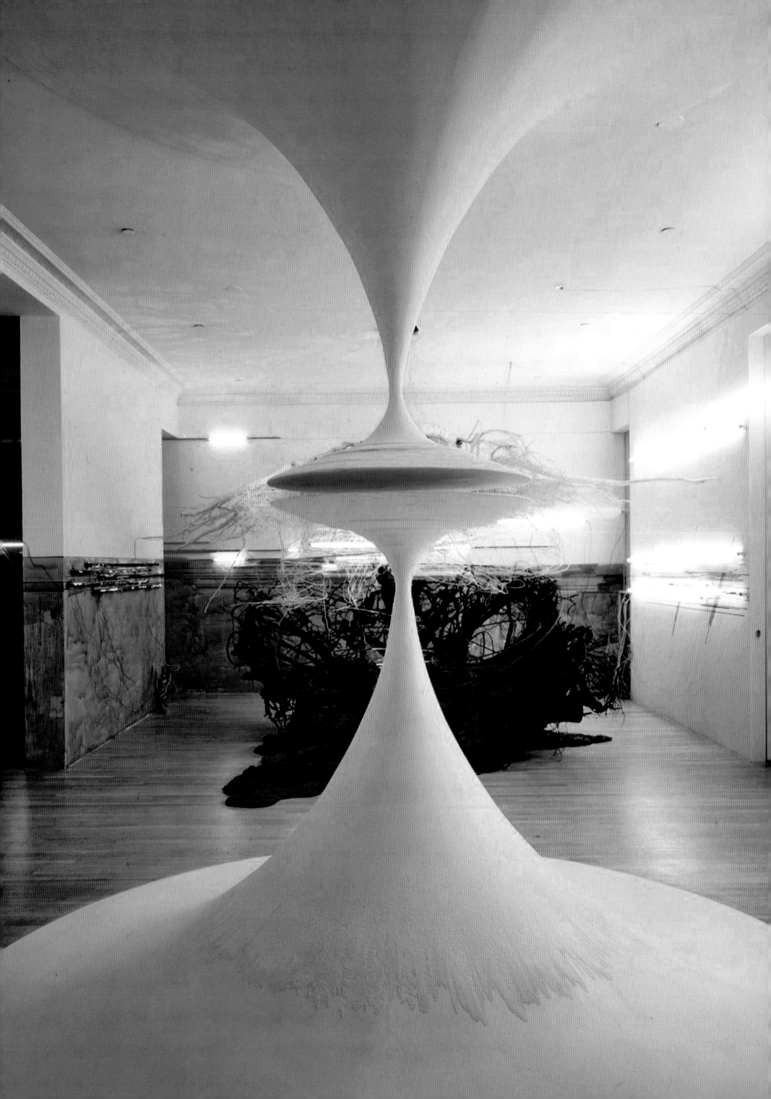

Judy Pfaff

BELOW
Notes on Light and Color, 2000
Installation view: Jaffe-Friede and
Strauss Galleries, Dartmouth College,
Hanover, New Hampshire
Plaster, dyes, UV fluorescent and
incandescent lights, contact paper,
pencil, and glass, 11½ x 70 x 30 feet

OPPOSITE
If I Had a Boat, 2001
Installation view: Paige Court,
Elvehjem Museum of Art, University
of Wisconsin, Madison
Mechanical steel tubing with copper
patina, expanding urethane foam, plaster,
plant matter, dye, cable, ball chain, and
lead, 40 x 63 x 40 feet

I'm very concerned with structure. You know, when you walk into the woods, especially if you're not used to the woods, there is something 'pitched' about it because you're a little nervous about what you'll run into or where you are or if you'll get lost. You're not looking around like a normal person. You're a little bit freaked out, a little hyper-sensitized. So I like installations. I like to have this multivalent thing happening so that you don't really know what you're looking at—so that sensation takes over more than the thought, "Is that a clever move?" or "What is that made of?"

The word *installation*, or the way it's used now, is like a catchall. If you put three paintings together, it's now an installation of paintings. It doesn't seem to mean an awful lot any more. It just sounds very trendy. And lately I actually think it feels so 'performative' that there's something about the word that I don't like. It doesn't feel like what I do. I've always made sculpture that relates to architecture or a whole sensation or feeling. And it came with this moniker. But if I think about what an installation is, it's like *"That's it."* If you were there between September 7th and October 7th, and you saw this thing, then you saw it, and that's it. It doesn't happen again. You can't redo it. It operates in that gallery on 57th Street, on the second floor, in four spaces, in the autumnal equinox. It's very specific.

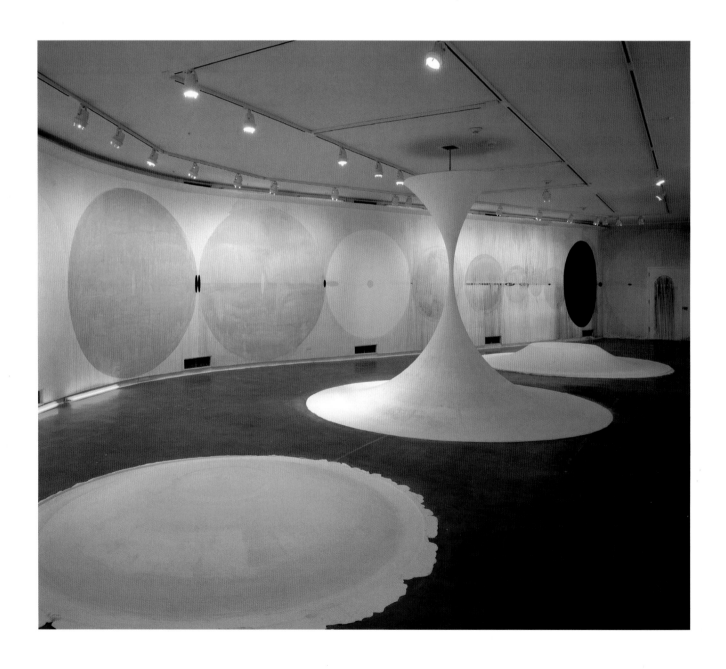

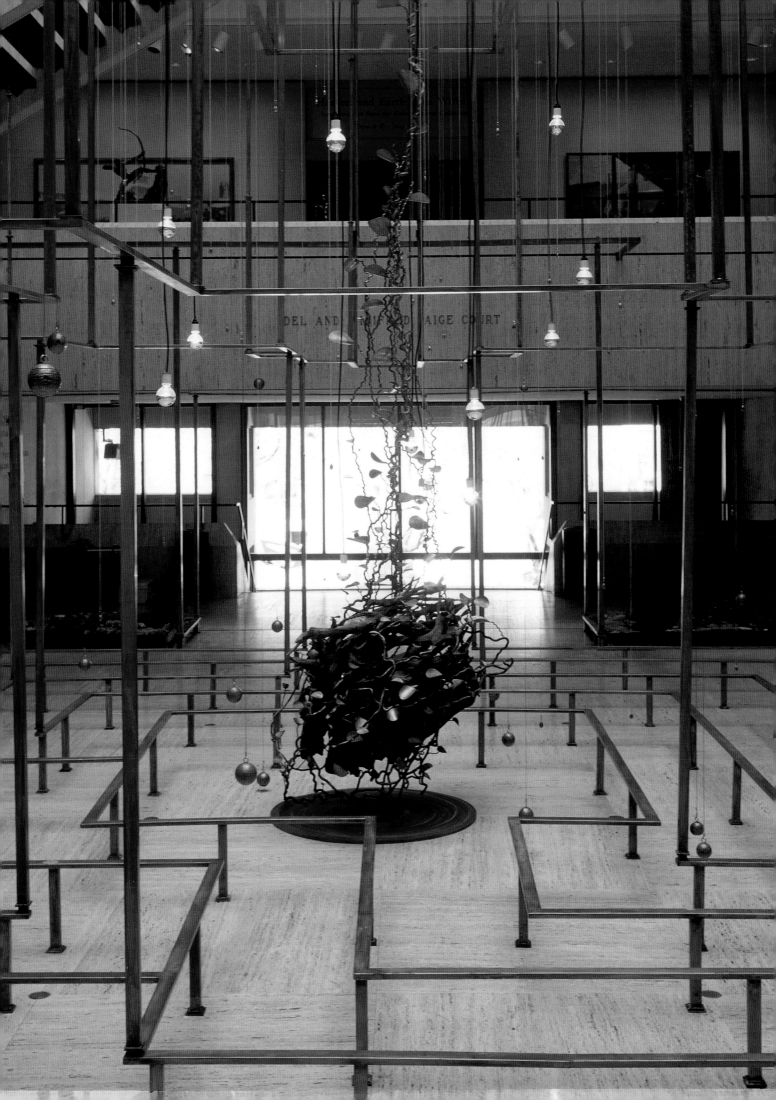

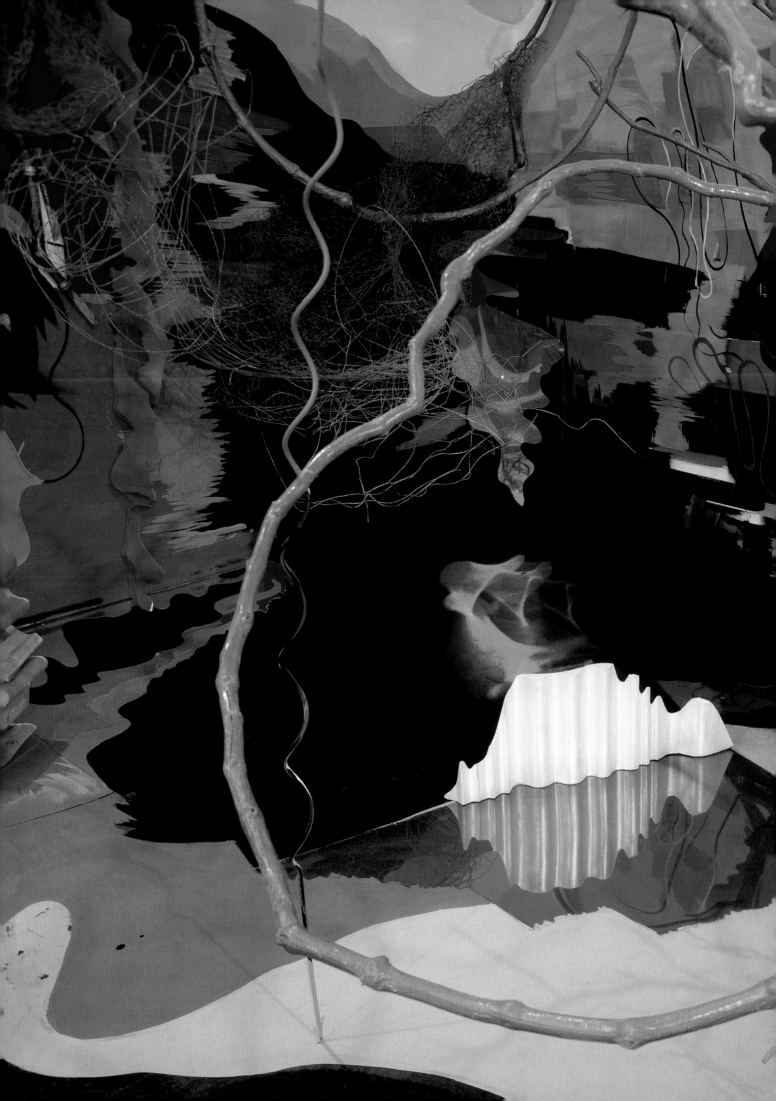

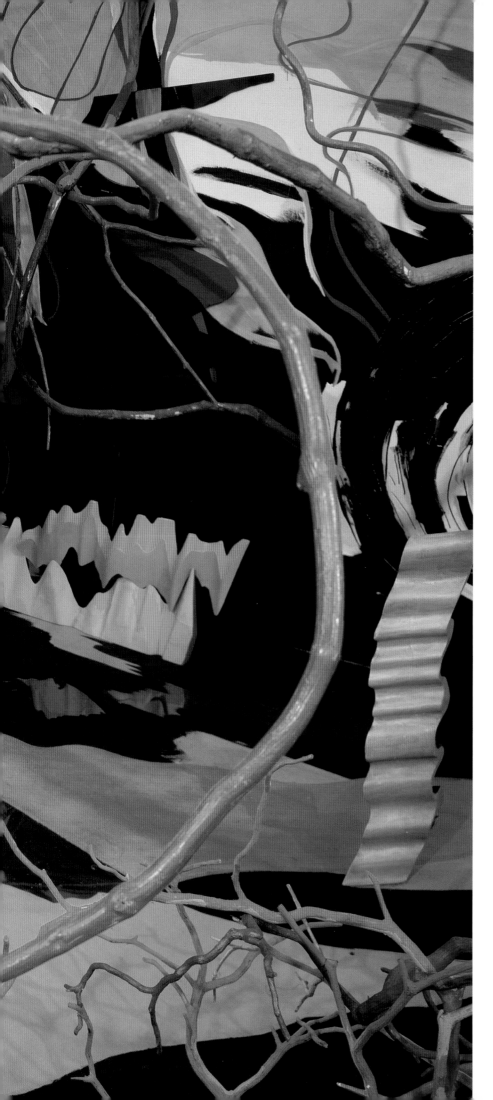

Judy Pfaff

Ziggurat, 1981
Installation view: Museem der stadt
Köln, Cologne, Germany
Wood veneer, Plexiglas, organic
matter, balsa wood, and paint,
approximately 14 x 40 x 40 feet

I've been very involved in not having a signature material. I think there *is* a signature style. It's like handwriting. And I have a feeling that anybody who's seen much of my work would probably recognize it as mine. But I don't use the same materials. I like having different kinds of input coming in. When I first came to New York, I had no money, obviously (no one had any money). And I had the year of aluminum foil. I did the year of little tiny wire structures. And then I would get a router or a tool and it was the year of the router, the year of the jigsaw. It's as if with every new material there's actually a whole new image that comes about from that color, from that material. I like that. So now I've got all of these materials and all of these tools. There is a real range of how I would use steel, how I would use plasters and polyesters, different kinds of paints, from dyes to oils. I will use every variation and just about every surface and every material that I can imagine. I'm sure there are billions out there that I haven't done.

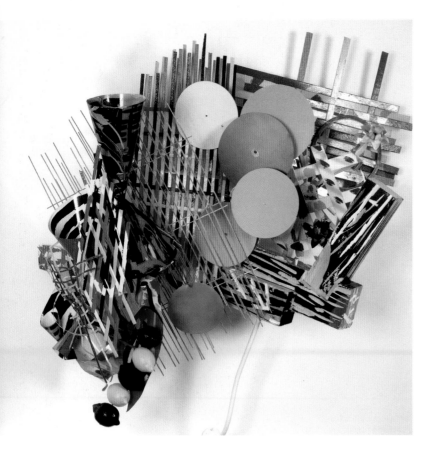

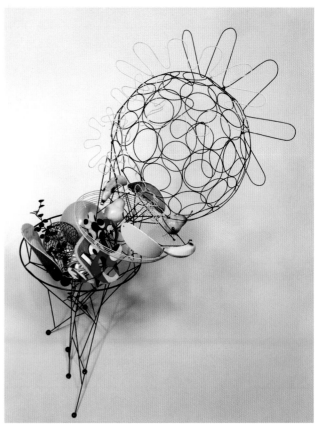

I think there's always a melancholy in the work, though everyone has always thought of my work as being very happy, or jaunty, or—what's that word I get—an explosion in a glitter factory. There's always something that seemed carefree, easygoing. I can hardly remember that. I mean I can have a good time and I can be lighthearted. But there's another quality that will get in, especially with the latest works. When I look at the old works, when they had the explosive stuff in them, I was just young. So there were different materials and things, but I think the underpinnings were always quite tight. I would never just put in a red dot here to balance that green dot there. It was always for a funny kind of need, and I always had to know what it was. It was never just formal. It always had to have a story line.

From the early 1970s, there was a lot of talk about feminism. It was a big subject. What is women's work? What is female sensibility? There were a lot of things like that which I didn't take on. I just wanted to be an artist in art. I didn't want to be original. I didn't want to be different. I wanted to be in that big family. And I thought what was going on, because of these new ideas of space and time and the computer and women, was that the whole Pandora's box was open. It was my responsibility to make things which had that advance—that logic—in them. So I thought making sculpture which was light, sculpture which was transparent, sculpture which was illusionistic, sculpture which you couldn't take home and put in your living room, sculpture which had an open-ended aspect, wasn't just one thing. It was really like a set of experiences or a set of experiments that suggested a larger context. So that was my job, when I was a kid. Now I just do what I do and I have no rationale for it. But it seemed to me at that moment to be involved in a funny way in a feminist orientation. It seemed like the things which had always defined women—their weak points—were now being reevaluated. And I thought that was not only useful, but also that I didn't like those other things. I was at war with minimalism. I was at war with the single object, with a singular identifying material.

Judy Pfaff

ABOVE, LEFT
Moogie Cha, from *Apple and Oranges,* 1986
Painted lattice, Formica, and tin,
56 x 43 x 23½ inches
Private collection

ABOVE, RIGHT
Bingo, 1990
Painted wire and wood, and found objects, 108 x 60 x 60 inches
Collection of the artist

OPPOSITE
Untitled (Chairs), 1989
Painted wood, steel, plastic and chairs,
144 x 120 x 108 inches
Private collection

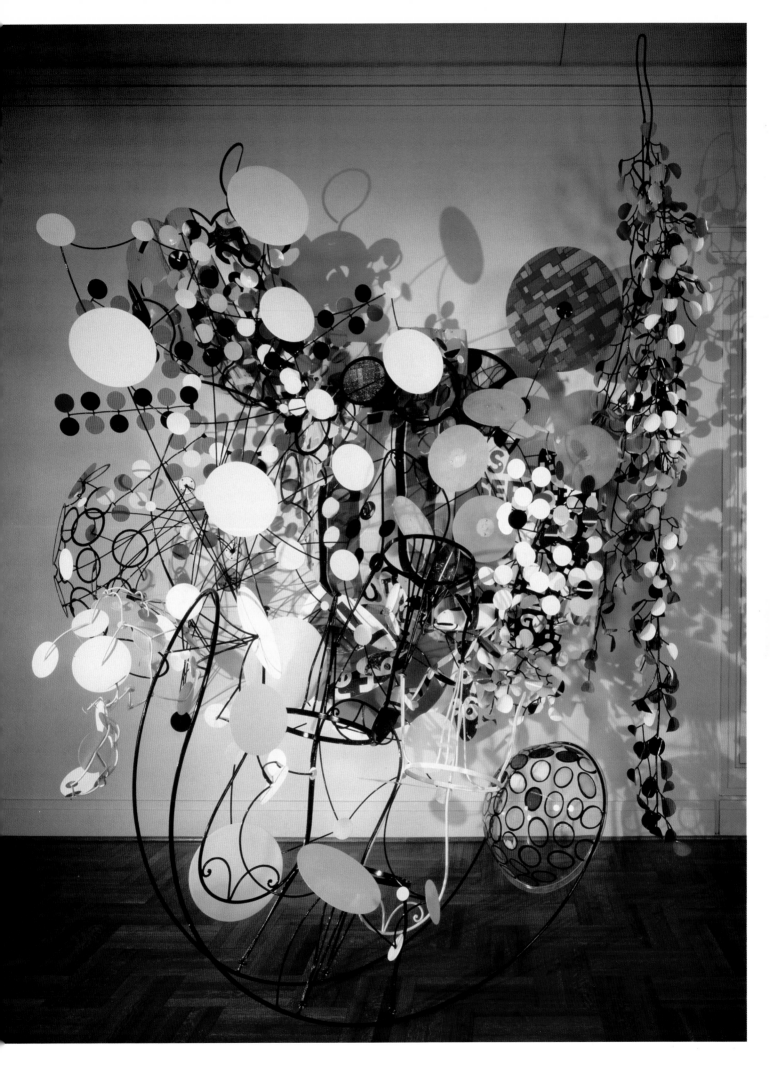

Lari Pittman

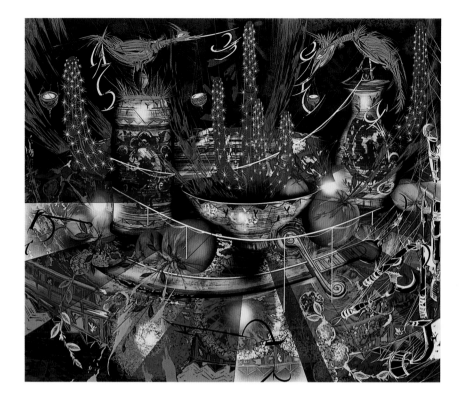

The micromanaging of aesthetics and beauty both in the work and in the way my partner and I conduct our life comes actually from acknowledging something a little sad. I think that we both conflate the managed state of beauty and aesthetics as a zone that allows safety. For us, then, the manic articulation of our surroundings is actually a form of creating a safe zone. I equate the managed aesthetics of my work and the construction of my personal life with creating an area of safety. So beauty is not an additive. The preoccupation with aesthetics is not just on the downtime: it's ideological, political, and conceptual. Of course it's about pleasure, but it's not about divertissement. It's not an aside, not a sidebar. It's actually about safety. I don't know how I could really explain it, but beauty and personal safety are strangely conflated in my mind. Maybe it's anti-chaos. The last two bodies of work and the body I'm working on now really do address more directly the construction of a personal life and what that entails—what actually occupies it and what, literally, it looks like. That's what precipitated the titling of the last paintings in terms of rooms of the house—*The Dining Room, The Living*

Room, In the Garden (all 2005). The titles of these paintings indicate on a political level the importance of residential space that is different from public space in terms of aesthetics and safety. For me, public space is intrinsically male and heterosexual. And residential space, which is the armature that I chose to make the paintings about and through, is a more polymorphous space that allows, historically, for more polymorphous identity. That's why residential space becomes amplified, for me, with ideological resonance and, then, worthy of some sort of representation and depiction in the paintings. So it was important to make a painting about a dining room, a living room, the garden, and infuse that with as much power as the banking world or law. . . . I've never lived a stripped down life. I don't think I could. So regardless of fortune or misfortune, I would devise some sort of bubble or protection for myself. I mean in that sense it's a really keen sense of survival, and a voracious one really. So, regardless of what situation I find myself in, I think that I would use aesthetics as a weapon for self-protection. The embellished Lari, the embellished work, is the real work.

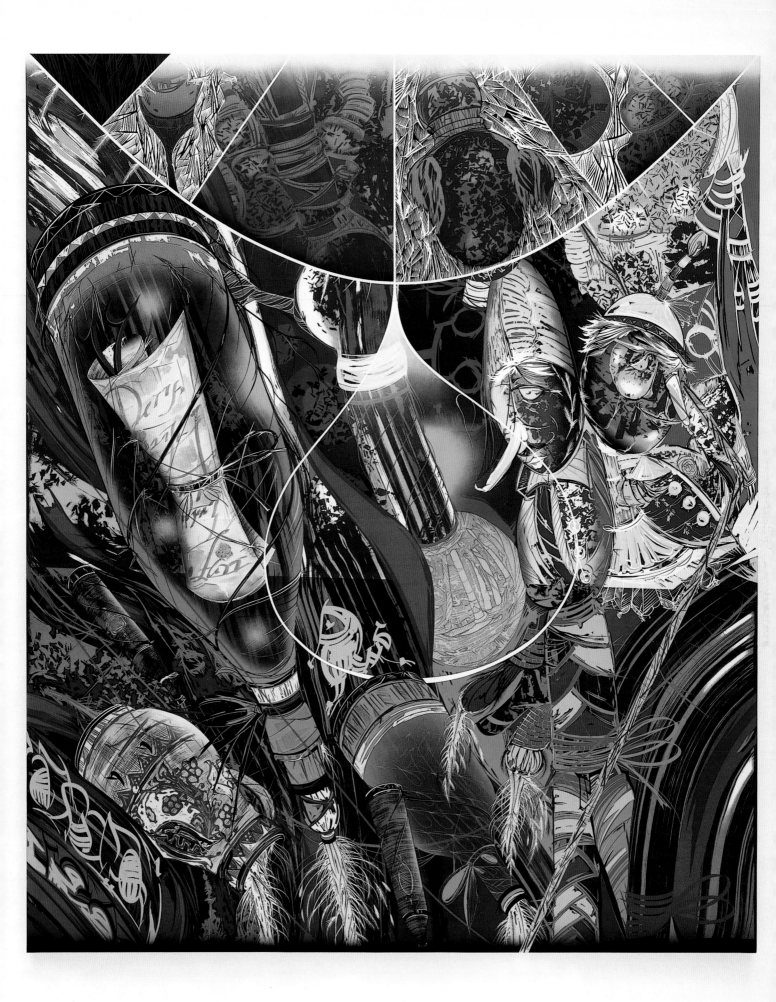

Lari Pittman

Untitled, 2003
Matte oil, aerosol lacquer, and
cel vinyl on gessoed canvas over
wood panel, 76 x 102 inches

For me, craft has always been an ideologi-
cal component in the work because it's
about a type of focus and social comport-
ment that usually isn't expected of a male.
There's a dutifulness that historically has
been referenced or attributed to females,
so I've always seen my devotion to craft
as a type of protest. In the applied arts,
that attention to detail in craft by males
is more permissible. But this kind of
fussiness, lavishing this type of almost
picky detail on a very big painting, just
isn't always attributed to what men do. For
me, from very early on, that attention to
really fine craft was a way of temporarily
transgendering. I like that feeling. I don't
know if I can explain that, but maybe it's
an enculturated transgendering—not some
sort of essentialist idea of gender. In other
words, I feel very liberated and free when
I'm working, being dutiful and attentive to
the object.

 I know the work looks visually micro-
managed, and maybe it is. In the chaos of
what I'm showing you, there is actually a
rationalism of structure underlying every-
thing. But a big part of the making of the
painting is me thinking on my feet and
making decisions on the spot about how
to bring this representation to some
fruition. I don't always know the outcome.

 I don't necessarily view the making
of the painting as a sequence of solving
problems. I see it more as a sequence of
responses. So, for me, there's the big ges-
ture. Okay. I did it. Now what am I going to
do with it? I don't necessarily see it as a
problem, but more as a challenge. How do
I enhance the meaning? How do I perfume
it? So it's more of a call and response. I'm
always allergic to problem-solving because
I just think it's so Puritan. And maybe
that's a cultural thing for me. I've come to
understand and internalize the spectator's
appraisal of the work. And one of the
things that I'm ambivalent about, but don't
totally discard, is the fact that the work
might seem a lot more constructed and
pre-planned than it actually is.

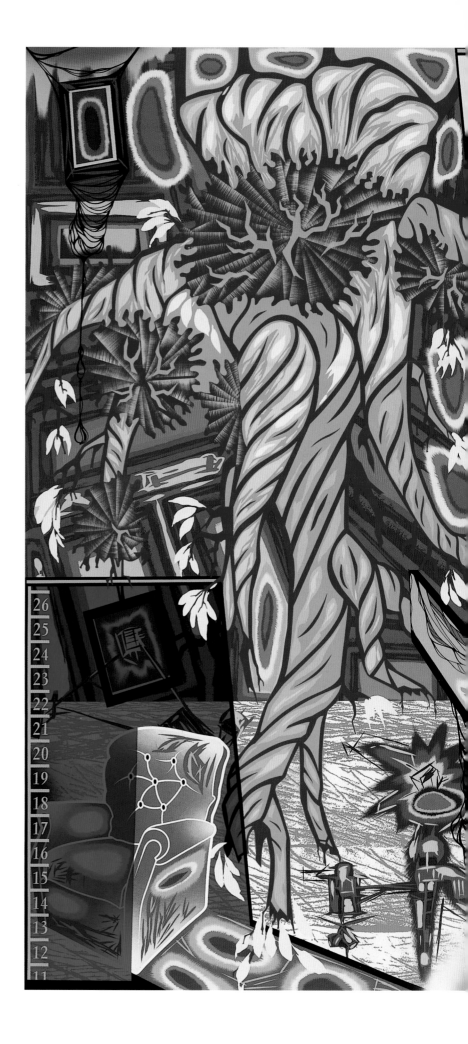

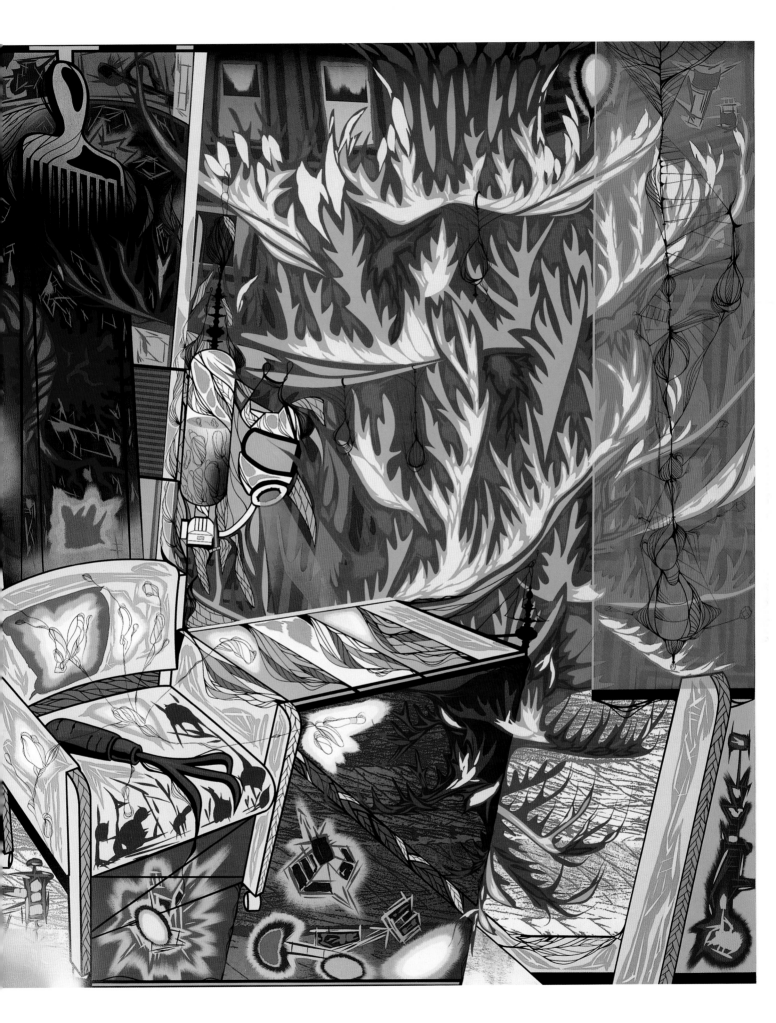

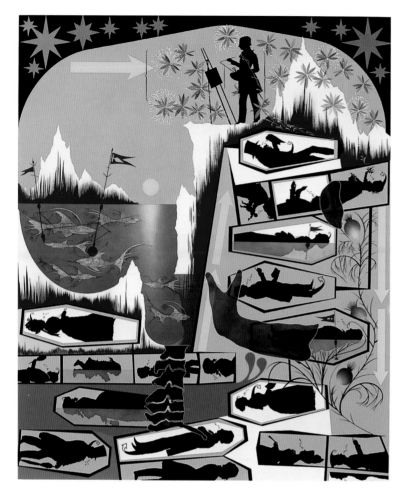

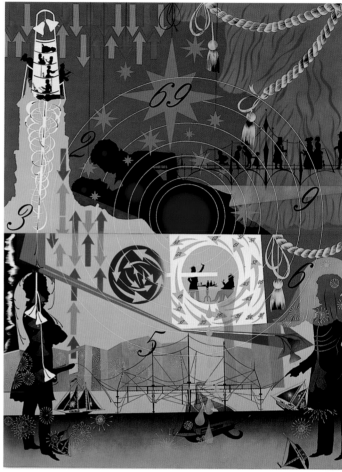

Lari Pittman

I started to use silhouettes in a body of work in the late 1980s. The use of the silhouettes in those very early paintings was not about discussing something specific or about autobiography or personal experience. They were simply being used as surrogates to discuss social conventions, human behavior, encoded behavior. The idea of code is always really important in the work, and surrogates can help you advance this idea. So although, visually, the work appears to have a very strong declarative voice, what is actually being advanced in the paintings is a subtext or a code. When you're looking at the work, you're looking at something visually declarative, but it requires a subtextual reading or a capacity or predisposition for reading code. That's why I used the Victorian silhouettes. It was just a great conceptual armature to be able to filter social code through. I like that the work is visually very declarative and available to everybody. But watch out! There's a code, and you'd better know it.

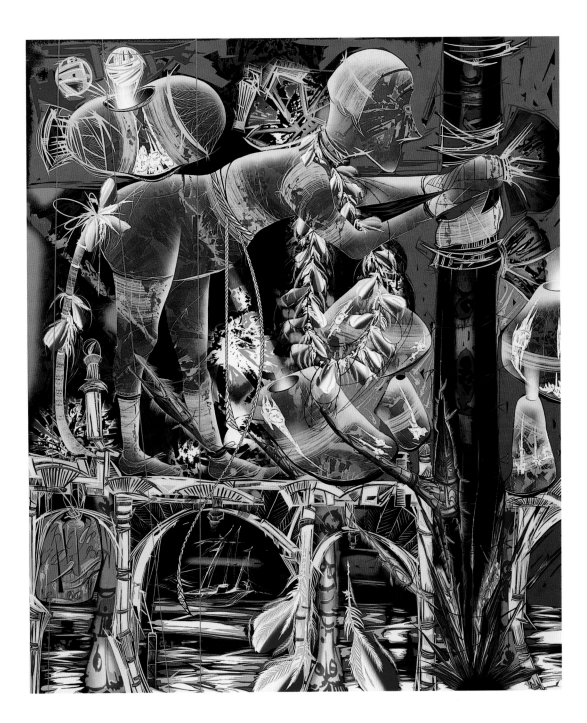

The cues for the basic color palette and figuration in *Attendant* (2006) come from a very small Mexican *retablo*, a devotional painting on tin, dating from the mid- to late nineteenth century. It depicts a flagellated Christ. As an atheist, I am attracted to religious art because it usually represents a hyperbolic moment like the suffering or martyrdom of a saint or, in this retablo, a dramatic moment in the life of Christ and a shocking image of a tortured physical body. So I look at this religious image through a secular lens.

I reconfigured the central image but I had to refer to the *retablo* because I've rarely done figurative work. Before I could just look at nature and invent; here I needed an actual cue for figuration. I've always taken from retablos, but it's been more about a kind of decorative, applied arts painting technique by which one embellishes the surface that I've been doing for over twenty years. This was the first time I sampled so directly. When you look at the painting there's an element that constantly connects one thing to the next,

becoming a vehicle for transit. The bridge is spanning the painting and brings together the lower part with the other part. The connections aren't just conceptual but also physical. The lei that goes around the neck connects to the gourds. The hands connect to the long pole being rammed into the earth. There are a lot of ties, ribbons, bows stuck on to the figure. So even though things might appear disconnected, I'm showing you literal moments of connection all through the painting. And that happens in all the paintings.

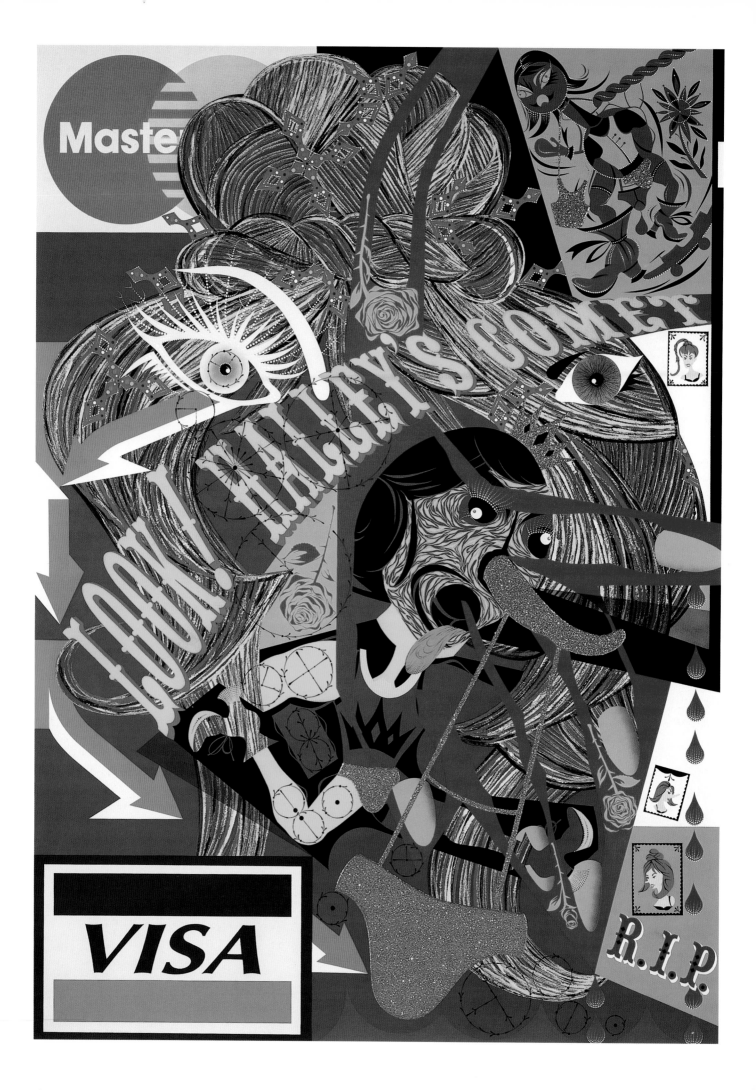

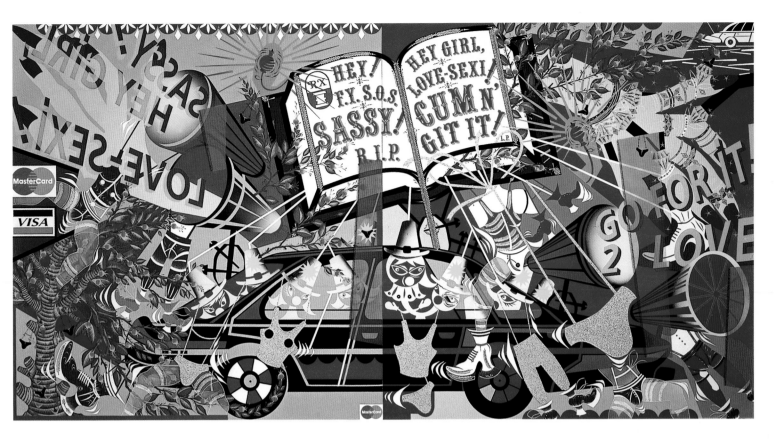

Lari Pittman

OPPOSITE
Untitled #32 (A Decorated Chronology of Insistence and Resignation), 1994
Acrylic, enamel, and glitter on panel,
84 x 60 inches
Private collection

ABOVE
Untitled #30 (A Decorated Chronology of Insistence and Resignation), 1994
Acrylic, enamel, and glitter on two wood panels, 83 x 160 inches
Private collection

I think that, when you understand a Latino or ethnic sensibility, being simultaneously happy and sad is not a problem. Nor is it fundamentally contradictory. And so there's a bitter-sweetness in the work, which I trace back to that identity base. There is also the idea that the sequence of time in the work is multiple, a kind of late Surrealism which is fully declassified in some ways in art making. I think that the Surrealist component can still be traced to that. The paintings show the viewer many temporalities. There's climate and there's time. Sometimes there's even an indication in some of the paintings that the top half of the painting might be at night and the bottom half in daylight. I think that, in southern California (whose only history has been hyper-capitalism) hyper-capitalism foregrounds this idea of episodic time: "This is the eight hours for work; this is the eight hours to sleep. And this is the eight hours for waking leisure." Capitalism really enforces compartmentalized, sequential time. As I look back on my formative years, I didn't grow up in that sense of time. You have to take this in a broader sense. Latino time is profoundly bittersweet because of its simultaneity. Even oppositional events can occupy the same spatial moment, the same time moment, and not really be contradictory. They're just there, side by side. And I think that simultaneity of time and imagery exists in the paintings. If you have a bittersweet cultural context, it allows you to entertain the possibility of the 'gorgeousity' of personal suffering. You can actually fetishize it and make it beautiful. Suffering and beauty are not antithetical, but actually complementary. It isn't about morbidity. It's actually a cultural mindset that is predisposed to aestheticizing even pain and suffering. It's not seen as decadent. It's just about a duality of things.

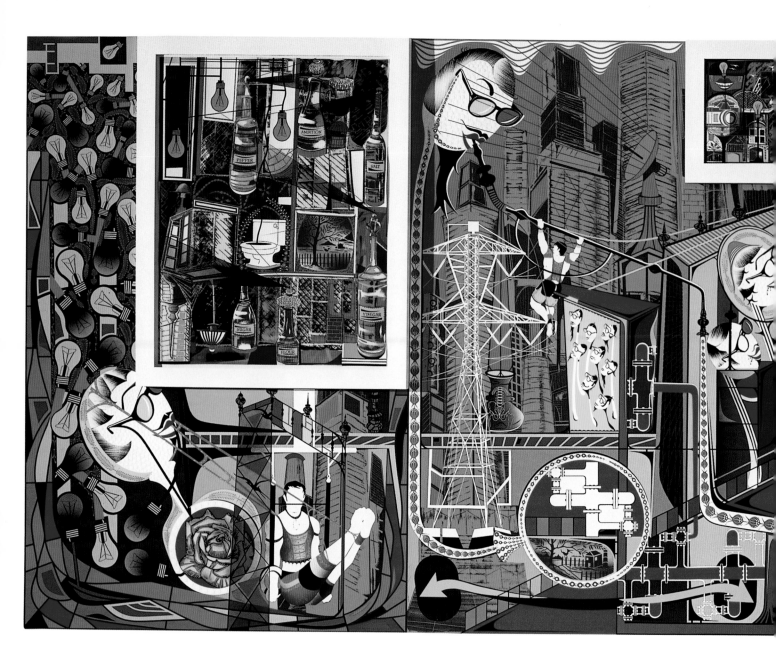

Lari Pittman

Once A Noun, Now A Verb #1, 1997
Flat oil on mahogany panels with attached
framed work on paper and three attached
framed works on panel, 95 x 256 inches
Norton Family Foundation

I think one of the relationships that would
be essential for you to have with the
work is that, when you stand in front of
it (and I'm telling you it's a completely
fabricated, highly mannerized moment),
you either go with it or you resent it. This
is not a simulation of anything; it is a
highly artificialized moment of represen-
tation. The painting has always been
relentless about that. In the same way
that you have to have that type of negoti-
ation when as a contemporary viewer

you go to an opera, there has to be a
complete understanding and accepting
of the whole mannerist endeavor or else
you're just not going to enjoy it. All the
paintings set up this intense mannerism.
Everything is hyperbolized and highly
decorated. And the decoration is deco-
rated. I guess it's trying to insist on the
possibility of a primary experience, but
within the confines of something very
artificial. The work doesn't shy away from
that. It's not about naturalism on any level.

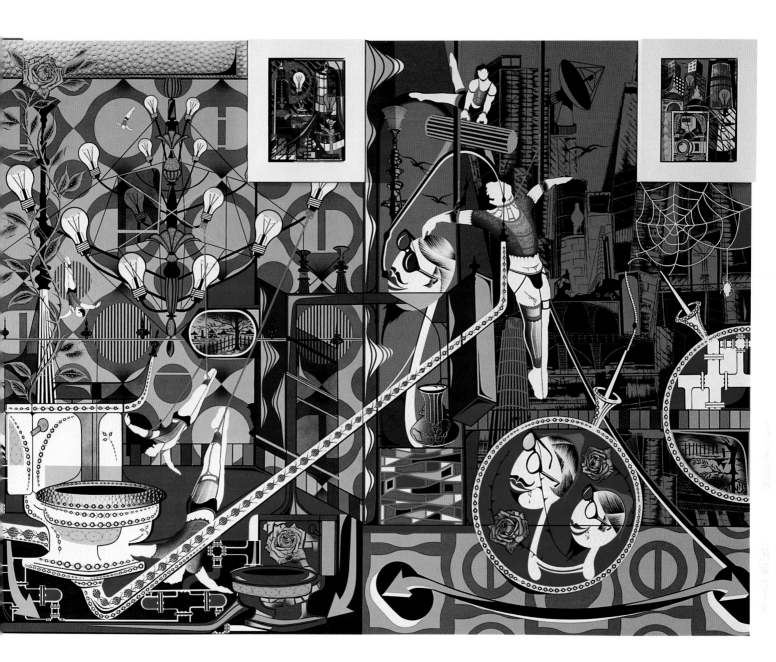

More than anything, I was accorded complete centrality as a young boy—but as a young kind of feminine boy that was given complete and uncensored expression. Whatever kind of predilection or whim I would exhibit there was just simply no raised eyebrow. I think that might have set the stage. . . . I don't know if there were specific memories that, as I look back on them, might have indicated that I would become an artist. But that precondition of allowing me as a young boy to express a fey side was given full rein and never ever commented on. I think that the decorative aspect of the work comes systemically, organically, naturally, to me because it was really allowed to bloom and blossom and wasn't curtailed or curbed when I was a child. You don't understand the implications of those situations when you're a child. Only in retrospect do you acknowledge perhaps how pivotal or how powerful they were as signifiers.

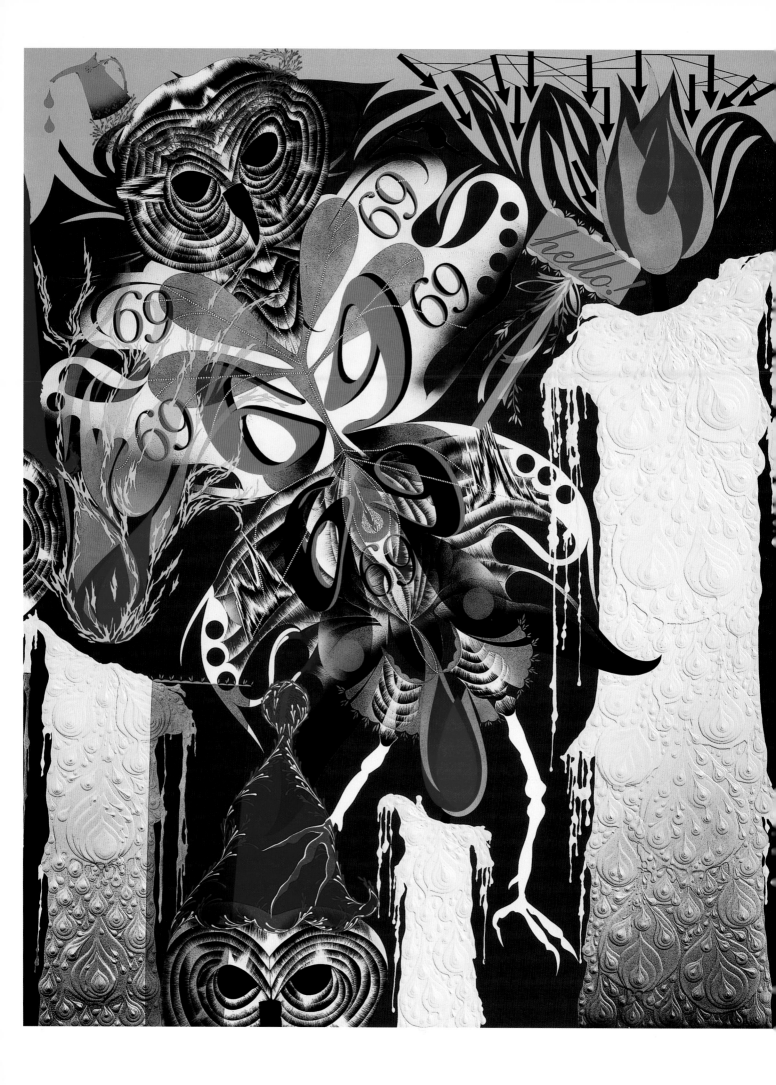

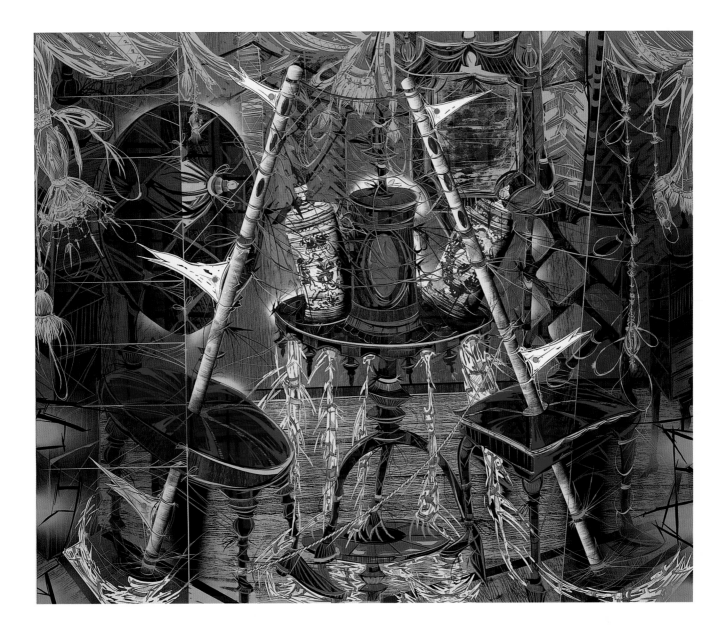

Lari Pittman

OPPOSITE
Miraculous and Needy, 1991
Acrylic and enamel on mahogany panel,
82 x 66 inches
Private collection, Los Angeles

ABOVE
Untitled #1 (The Living Room), 2005
Cel vinyl, acrylic, and alkyd on gessoed
canvas over panel, 86 x 102 inches

The remembrance of death—memento mori—is a big part of the work. And, again, it's bittersweet because you want to commemorate death but you are consumed with the mandate of aesthetics. So you have to fuse within the object the mandate to address life and death, and then the formal mandate to address aesthetics and connoisseurship. They must be fused together in the object.

In all of the paintings, and especially the ones that I showed in New York at the end of 2005, there really is a form of poltergeist or animism inhabiting the scene. Many times it's coming from an inanimate object, or sometimes it's centralized within an animate object. But I'm more interested in that poltergeist being an inanimate object. I understand it to be a really theatrical moment, and it kind of makes me cringe sometimes when it nears itself to science fiction a bit or is sometimes seen that way. I try to suppress it a little bit by it never being too spectacular, just mildly—not overwhelmingly—present. I know that the work has a brutal side to it. There's even a strong implied violence to it, an internalized violence. It's not a personal one, really; it's a social violence. And I still want it somehow not just to be a document of will alone or power alone that somehow has to be mediated through its appearance. I invest a lot in the power of something looking one way but implying another. I'm not interested in brute force. I'm interested in the brute force of high tea. And maybe that's what I might identify with more.

Laurie Simmons

I'm so resistant to the idea of nostalgia. I know that it exists in my pictures and in the film (*Music of Regret,* 2006), but I feel like I work against my tendency to go back in time. Nostalgia can be an easy shot, just an easy recreation of another time or another mood. I think there needs to be more there. And of course nostalgia's been used so much in film and fashion and art, and I'm just always thinking there must be another place to go besides mining my own past, the look and feeling of my past, or everyone's past. I had a funny consciousness of the 'Kodak moment' when I was a kid. I could see that when everybody was dressed up and ready to go out, or when the house was particularly clean, I had a way of framing things and separating myself from the situation—seeing it as something separate from me. And when I first started shooting the interiors, the first photographs that I ever made, I was conscious of creating a moment that wasn't quite real, but was quite perfect. There was the real moment, when the house was a mess and everyone was yelling and the dog was running around and things were out of control, and then there was another kind of reality that I preferred— pristine and still and quiet and beautiful and, lots of times, devoid of people— because life felt very chaotic to me. So when I made the first interiors that I call the dollhouse interiors (even though dolls didn't appear in them for a long time), I wanted them to be picture-perfect like those odd moments that I remembered from being a kid, when things were so beautiful. Of course, when you remember things they get cleaner and more beautiful over the course of time. They just separate from their reality and almost have an aura. That's what memory feels like. So I always want everything I do to be perfect (perfect-looking) given the inherent limitations of my work. How can I get puppets to look as real as possible? How can I get the background to look as real as possible? I'm never trying to make things look fake; I'm trying to work with what I have.

BELOW
The Boxes (Ardis Vinklers) Ballroom II, 2005
Flex print, 40½ x 84 inches

OPPOSITE, TOP
Long House (Den), 2004
Cibachrome print, 48 x 60 inches

OPPOSITE, BOTTOM
Long House (Orange and Green Lounge), 2004
Cibachrome print, 48 x 60 inches

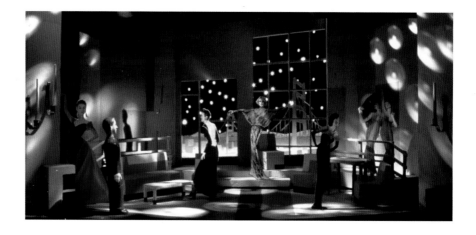

 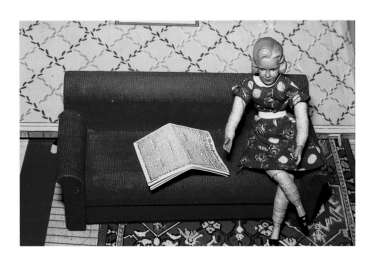

 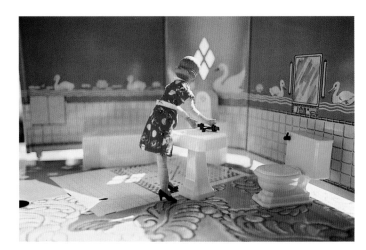

Laurie Simmons

I came to photography a little bit late. I went to art school but did not study photography. I moved to New York and saw the way photography was being used. And I don't mean photojournalism, I mean the way *artists* were using photography. I thought, 'That's it, that's for me.' The whole notion of frozen time was completely new—and that's what I was doing. I was making these setups in my studio where I was throwing things around and juxtaposing small pieces of furniture, walls, wallpaper, tops of books, just everything. It was a crazy, chaotic mess and yet, in the end, I had a very still, quiet moment where I'd frozen time. And I expected viewers to believe that they were entering a real place that really existed, a place where time stood still. There was always a fascination with the artifice of the place that I was creating, which only existed for a couple of minutes, propped up by toothpicks and Scotch tape in my studio. And then in the end I had this bit of frozen time and place.

The most important thing to me when I started to shoot my first photographs in the late 1970s was that I was an artist (not a photographer) using photography as a tool. First of all, I hadn't studied photography so I was terribly self-conscious about my skills (of which I had none). I taught myself and also had my friend Jimmy DeSana pretty much teach me everything. I was really interested in work that I saw in New York, work that used photography in a completely unique way in the more ephemeral works of art, things that could disappear, that only existed for a minute and needed to be documented with a camera. You didn't have to be super-skilled in order to pick up a camera and use it as a tool in your work. That was so completely liberating for me to think about. And I was so excited that I could make things, shoot them, send the pictures to the drugstore, not have to have a darkroom, and not have to be bogged down in photographic history, which by the way was only a hundred years old. So it was really amazing to realize that I could use a camera, and also that I had this funny kind of quasi-camera history, shooting snapshots and having everyone in my family have their little Kodak Brownie cameras. In a way, it was like doing something that I was totally used to, that was familiar to me. But, also, I was starting to explore completely new territory. And I knew that I had a lot to learn. I thought, 'If I'm going to pick up this camera, even though I won't call myself specifically a photographer, I'm going to learn the history. I'm going to read every book I can. I'm going to go to the Museum of Modern Art and look at their collection. I'm going to go to galleries and ask them to pull out works for me to see.' I did that so that I could be conversant in the history and then start to play around with the camera in a way that was maybe a little bit less expected.

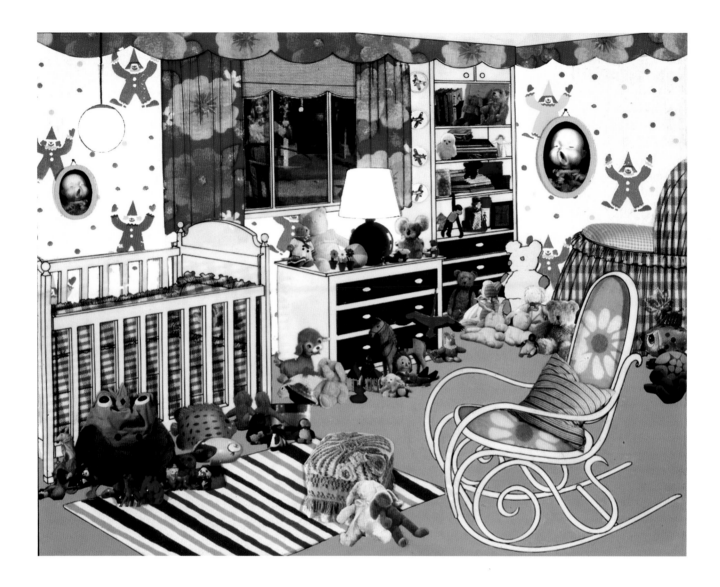

Laurie Simmons

I realize how much more I've been influenced by older painting than I let on. There's a formal compression of space, a juxtaposition of color (things that were in my mind that I never really accepted as influences, ways that I wanted my photographs to look), that I never really understood came so much from Matisse or Manet or even Picasso. These are things that sort of insidiously worked their way into my mind when I was taken to museums as a child, when I was very itchy and not quite understanding if I wanted to be there or not. These things came out later

in my pictures. But you know there's also *Life* magazine in there, and old TV commercials, and fashion photography. It ends up being such a mix of influences that come to bear. But I would never say that there's a connection between my work and the history of still life, even though what I do in my studio is to set up one still life after another. And life truly is still in my studio because I'm using dolls, mannequins, and puppets and nobody speaks—and once a setup is made it's there until it falls over, which is pretty frequently.

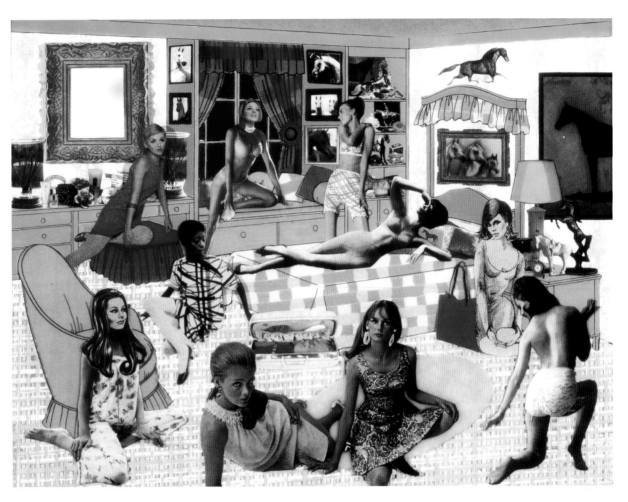

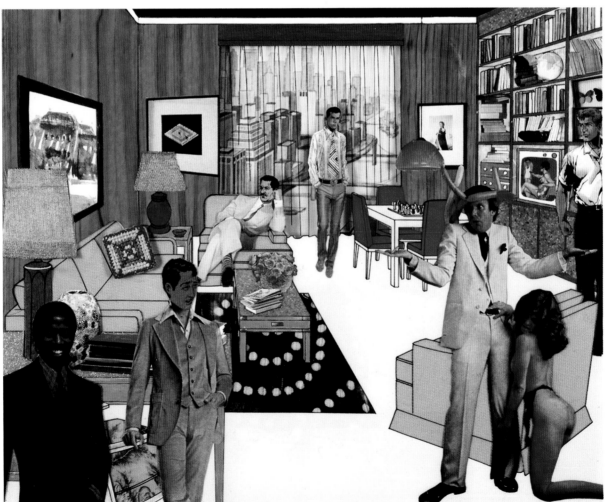

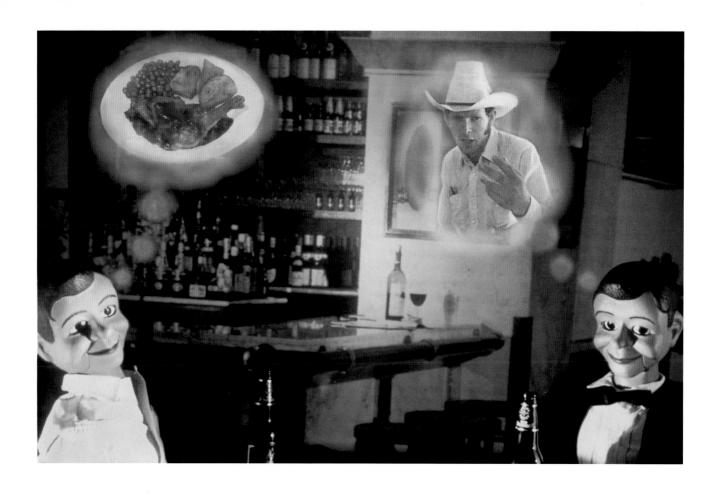

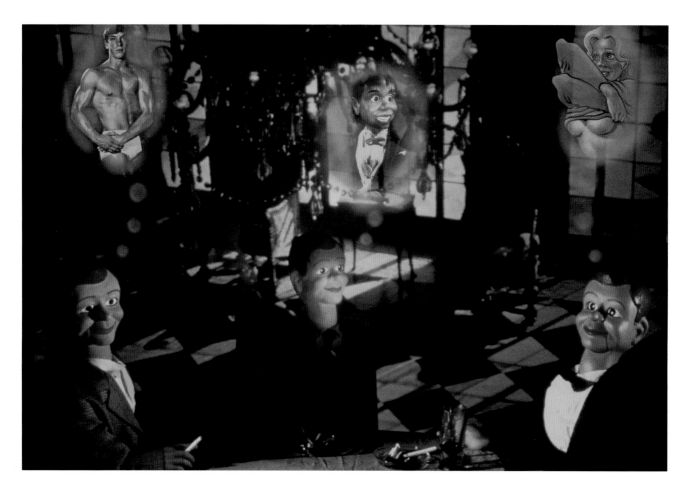

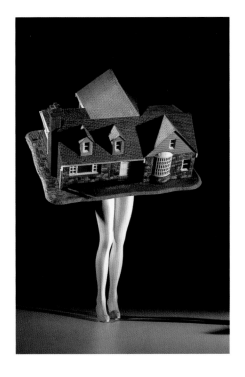 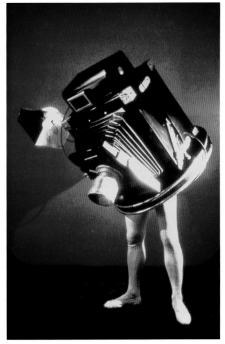 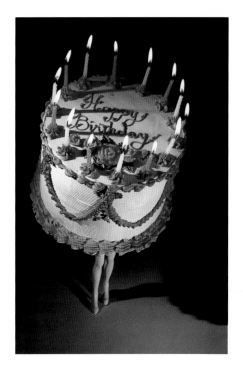

Laurie Simmons

My inner life about my own work is very theatrical and narrative. But that's something I was always afraid to express because I came of age in a time when cool distance in the work and a more conceptual turn of mind were very important. So I had a very secret inner life about the pictures that I was making. I had music in my head that was playing while I was shooting. Sometimes I had a narrative; sometimes I was thinking about a more specific situation. But I always wanted my still photographs to be cool and simple and to have an almost abstract edge. When I worked on a series, whether it was the underwater pictures or the ventriloquist pictures or the objects on legs, there was always a kind of soundtrack. I'd either play music in my studio or actually have songs in my head that were accompanying me to get me going and move me along. For me, the most evocative and emotional experiences I've ever had around pictures are always combined with music.

I remember when I first thought about shooting the objects on legs. I was swimming, of all things! I was swimming along and I was thinking, 'I'm so tired of the ventriloquist; I'm so tired of the chatter; I'm so tired of the shtick, the sarcasm. I need to make a series of photographs that's dead opposite. I need to do something different.'

A couple of weeks before, I had visited a ventriloquist who had a picture of a box of cookies on legs hanging on his wall—a very odd photo. And it jogged a very early memory that I had, a really early memory of dancing cigarette packets, prancing across the stage on early black-and-white TV. And I started to think about not having a brain—just being able to balance these huge objects—and almost morph and become one with these objects. I thought about movement and symbolism as opposed to this kind of constant ventriloquist chattering. And it seemed like the farthest place that I could go to get away from the idea of the ventriloquist. The first one that I shot was the camera that I borrowed from the Museum of the Moving Image. I placed it on my friend Jimmy DeSana, who taught me about photography. It seemed so fitting to put the camera on top of him, put him in a pair of white tights, and photograph him as Jimmy the Camera. After that, each time I wanted to think about a new character to photograph, I had to go swimming to get back to the place where I could actually think of whether it should be a house, an hourglass, a microscope, a microphone, or a birthday cake. And that's how I would get myself into a kind of reverie to think about what would be okay on legs.

Laurie Simmons

LEFT
Walking Gun/The Music of Regret, 2006
Flex print, 84 x 48 inches

RIGHT
*Walking Pocket Watch/The Music
of Regret,* 2006
Flex print, 84 x 48 inches

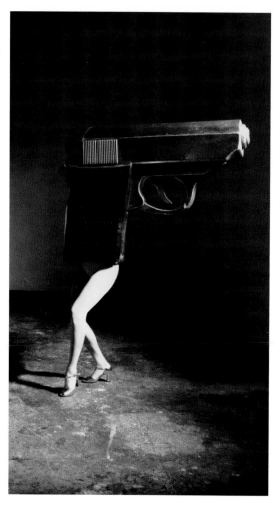
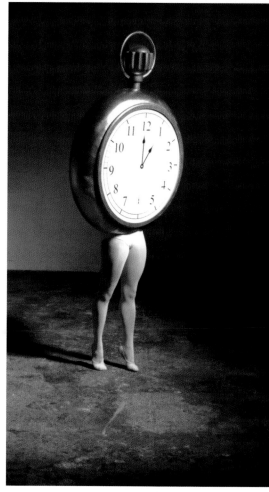

In making the film, *The Music of Regret* (2006), I did something that I've always wanted to do which is, literally, to bring my work to life. I got a chance to really revisit my work—the characters and the ideas that I dealt with for so many years that were just fleeting, still images or just a glimpse of a narrative—and figure out what would happen if suddenly I was looking at a photograph and the characters started to talk to me, or sing or dance. It's a fantasy that I've had for a really long time, but I never really thought I would or could make a movie. Love runs through the film, much to my surprise. I'm surprised to think about the film in terms of being romantic because romance has never been an issue that I've grappled with or brought up consciously in my work except in one series of pictures (*The Music of Regret,* 1994) where the characters were two dummies, male and female. But maybe it was the influence

of the things I love—music, musicals—which are absolutely unafraid to address that topic. I was thinking so much about the American Songbook and musicals, and moving a narrative forward. Maybe that's why romance finally came into my work. And at this time in my life, I'm ready to accept or own a kind of romance and melancholy or melodrama that I wasn't ready to reveal before. It was always there in my inner life as an artist, but I was too afraid to share it. With the movie I was ready to deal with everything that came out, even the idea that I would create a situation that could potentially cause someone to feel emotions or shed a tear. The idea of a movie and time-based work are completely wide-open in a way that the still photographs were not for me—because how much narrative could you pack into one image? And how interested was I in packing an image with narrative? I wasn't.

But a film? That's a different story. Regret is the prevailing emotion in the film. It's very much about the different guises of regret. That's what keeps coming up. It's something I've been exploring for a long time. Every way that I could think about it, I tried to make it come up in the movie. It interests me, as a state of mind, as an emotion, as something that people become mired in. I think that right now the whole country's in a state of regret. No matter what you think, no matter what you feel, you're wondering if this was the right thing to do, no matter what side you're on. Everybody seems like they're wondering. On a small level, in their own lives, people are thinking about what might have been if they'd made a slightly different decision or about how one decision can cascade through the rest of your life and impact everything else that you do. So, yes, I'm really interested in regret.

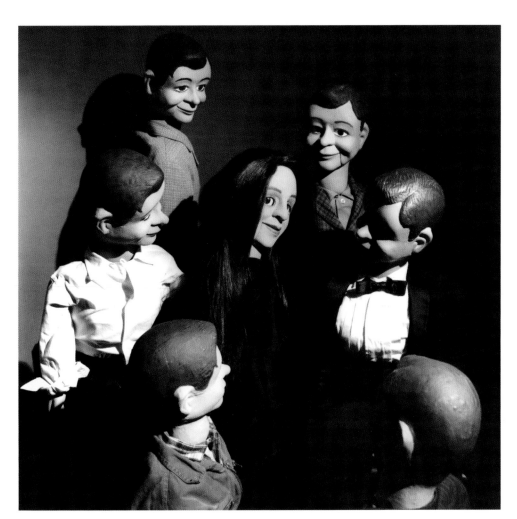

Laurie Simmons

TOP
The Music of Regret XIII, 1994
Cibachrome print, 19½ x 19½ inches

BOTTOM
The Music of Regret (Meryl), 2006
Flex print, 40 x 40 inches

FOLLOWING SPREAD
The Music of Regret, 2006
35 mm film, 40 minutes
Directed by Laurie Simmons; Music,
Michael Rohatyn; Camera, Ed Lachman
ASC; with Meryl Streep, Adam Guettel,
and the Alvin Ailey II Dancers

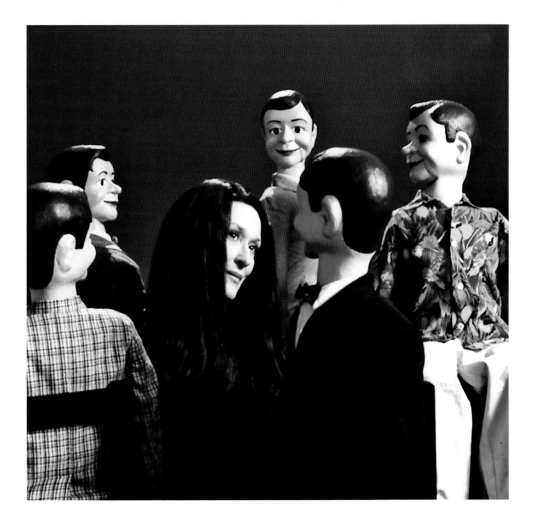

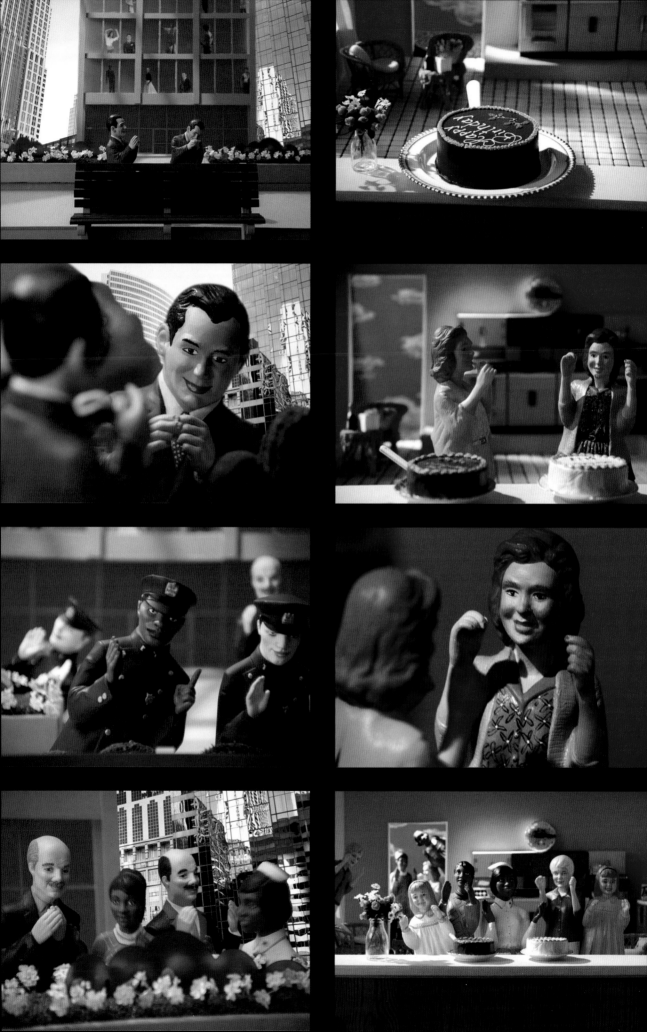

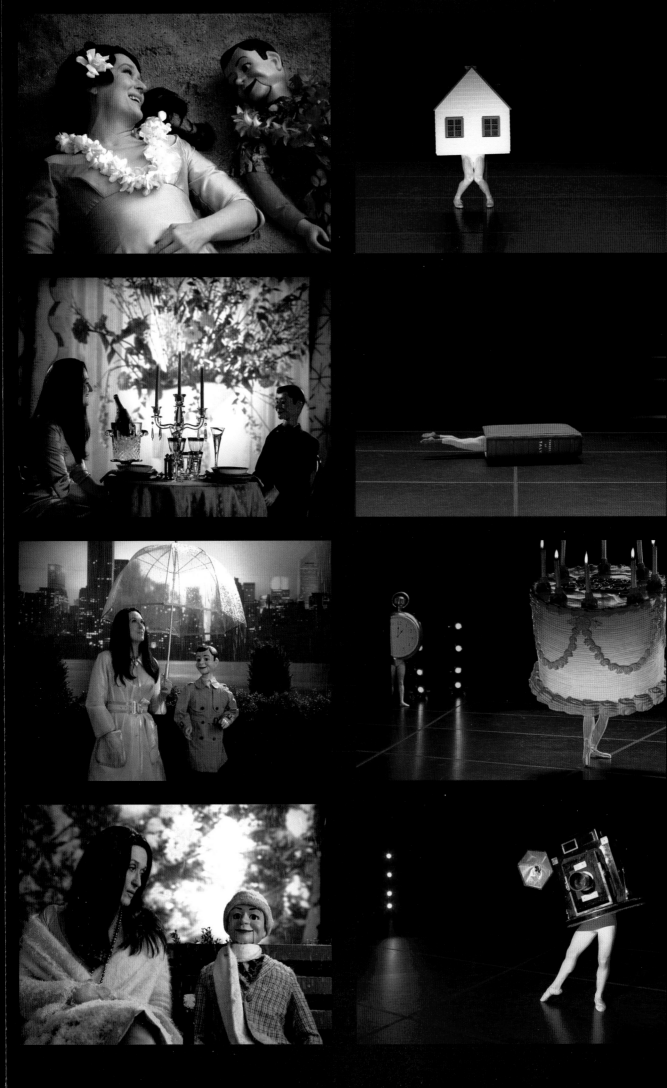

Biographies of the Artists

Robert Adams

Robert Adams was born in Orange, New Jersey in 1937. His refined black-and-white photographs document scenes of the American West of the past four decades, revealing the impact of human activity on the last vestiges of wilderness and open space. Although often devoid of human subjects, or sparsely populated, Adams's photographs capture the physical traces of human life: a garbage-strewn roadside, a clear-cut forest, a half-built house. An underlying tension in Adams's body of work is the contradiction between landscapes visibly transformed or scarred by human presence and the inherent beauty of light and land rendered by the camera. Adams's complex photographs expose the hollowness of the nineteenth-century American doctrine of Manifest Destiny, expressing somber indignation at the idea (still alive in the twenty-first century) that the West represents an unlimited natural resource for human consumption. But his work also conveys hope that change can be effected, and it speaks with joy of what remains glorious in the West. Adams received a BA from the University of Redlands in California and a PhD in English from the University of Southern California. He has received numerous awards, including a John D. and Catherine T. MacArthur Foundation Award (1994); the Spectrum International Prize for Photography (1995); and the Deutsche Börse Photography Prize (2006). Major exhibitions include the San Francisco Museum of Modern Art (2005); Yale University Art Gallery, New Haven (2002); Denver Art Museum (1993); Philadelphia Museum of Art (1989); and the Museum of Modern Art, New York (1979). Robert Adams lives and works in northwestern Oregon.

Allora & Calzadilla

Jennifer Allora was born in Philadelphia, Pennsylvania, in 1974. Guillermo Calzadilla was born in 1972 in Havana, Cuba. Allora received a BA from the University of Richmond in Virginia (1996) and an MS from the Massachusetts Institute of Technology (2003); Calzadilla received a BFA from Escuela de Artes Plásticas, San Juan, Puerto Rico (1996) and an MFA from Bard College (2001). They have collaborated since 1995, approaching visual art as a set of experiments that test whether concepts such as authorship, nationality, borders, and democracy adequately describe today's increasingly global and consumerist society. Believing that art can function as a catalyst for social change, the artists solicit active participation and critical responses from their viewers. The artists' emphasis on cooperation and activism have led them to develop hybrid art forms—sculptures presented solely through video documentation, digitally manipulated photographs, and public art-works generated by pedestrians. Major exhibitions include the Renaissance Society at the University of Chicago (2007); Walker Art Center, Minneapolis (2004); Institute of Contemporary Art, Boston (2004); Aldrich Museum of Contemporary Art, Ridgefield, Connecticut (2002); and Museo de Arte de Puerto Rico, San Juan (2001). Awards include the Korea Foundation Award (2004); Penny McCall Foundation Grant (2003); Joan Mitchell Foundation Grant (2002); and a Cintas Fellowship (2000–2001). Residencies include P.S. 1 Contemporary Arts Center, Long Island City, New York (1998–99); Walker Art Center, Minneapolis (2003–04); and Headlands Center for the Arts, Sausalito, California (2004). Allora & Calzadilla were short listed for the Guggenheim Museum's Hugo Boss Prize (2006). They live and work in San Juan, Puerto Rico.

Mark Bradford

Mark Bradford was born in Los Angeles, California in 1961. He received a BFA (1995) and MFA (1997) from the California Institute of the Arts in Valencia. Mark Bradford transforms materials scavenged from the street into wall-sized collages and installations that respond to the impromptu networks—underground economies, migrant communities, or popular appropriation of abandoned public space—that emerge within a city. Drawing from the diverse cultural and geographic makeup of his southern Californian community, Bradford's work is as informed by his personal background as a third-generation merchant there as it is by the tradition of abstract painting developed worldwide in the twentieth century. Bradford's videos and map-like, multilayered paper collages refer not only to the organization of streets and buildings in downtown Los Angeles, but also to images of crowds, ranging from civil-rights demonstrations of the 1960s to contemporary protests concerning immigration issues. Mark Bradford has received many awards, including the Bucksbaum Award (2006); the Louis Comfort Tiffany Foundation Award (2003); and the Joan Mitchell Foundation Award (2002). He has been included in major exhibitions at the Los Angeles County Museum of Art (2006); Whitney Museum of American Art, New York (2003); REDCAT, Los Angeles (2004); and Studio Museum in Harlem, New York (2001). He has participated in the XXVII São Paulo Bienal (2006); the Whitney Biennial (2006); and *inSite: Art Practices in the Public Domain*, San Diego, California and Tijuana, Mexico (2005). Mark Bradford lives and works in Los Angeles.

Mark Dion

Mark Dion was born in New Bedford, Massachusetts in 1961. He received a BFA (1986) and an honorary doctorate (2003) from the University of Hartford School of Art, Connecticut. Dion's work examines the ways in which dominant ideologies and public institutions shape our understanding of history, knowledge, and the natural world. The job of the artist, he says, is to go against the grain of dominant culture, to challenge perception and convention. Appropriating archaeological and other scientific methods of collecting, ordering, and exhibiting objects, Dion creates works that question the distinctions between 'objective' ('rational') scientific methods and 'subjective' ('irrational') influences. The artist's spectacular and often fantastical curiosity cabinets, modeled on *Wunderkabinetts* of the sixteenth century, exalt atypical orderings of objects and specimens. By locating the roots of environmental politics and public policy in the construction of knowledge about nature, Mark Dion questions the authoritative role of the scientific voice in contemporary society. He has received numerous awards, including the ninth annual Larry Aldrich Foundation Award (2001). He has had major exhibitions at the Miami Art Museum (2006); Museum of Modern Art, New York (2004); Aldrich Museum of Contemporary Art, Ridgefield, Connecticut (2003); and Tate Gallery, London (1999). *Neukom Vivarium* (2006), a permanent outdoor installation and learning lab for the Olympic Sculpture Park, was commissioned by the Seattle Art Museum. Mark Dion lives and works in Pennsylvania.

Jenny Holzer

Jenny Holzer was born in Gallipolis, Ohio in 1950. She received a BA from Ohio University in Athens (1972); an MFA from the Rhode Island School of Design, Providence (1977); and honorary doctorates from the University of Ohio (1993), the Rhode Island School of Design (2003), and New School University, New York (2005). Whether questioning consumerist impulses, describing torture, or lamenting death and disease, Jenny Holzer's use of language provokes a response in the viewer. While her subversive work often blends in among advertisements in public space, its arresting content violates expectations. Holzer's texts—such as the aphorisms "abuse of power comes as no surprise" and "protect me from what I want"—have appeared on posters and condoms, and as electronic LED signs and projections of xenon light. Holzer's recent use of text ranges from silk-screened paintings of declassified government memoranda detailing prisoner abuse, to poetry and prose in a 65-foot-wide wall of light in the lobby of 7 World Trade Center, New York. She has received many awards, including the Golden Lion from the Venice Biennale (1990); the Skowhegan Medal (1994); and the Diploma of Chevalier (2000) from the French government. Major exhibitions include the Neue Nationalgalerie, Berlin (2001); Contemporary Arts Museum, Houston (1997); Dia Art Foundation, New York (1989); and the Solomon R. Guggenheim Museum, New York (1989). Since 1996, Holzer has organized public light projections in cities worldwide. She was the first woman to represent the United States in the Venice Biennale (1990), Jenny Holzer lives and works in Hoosick Falls, New York.

Pierre Huyghe

Pierre Huyghe was born in 1962 in Paris, France. He attended the École Nationale Supérieure des Arts Décoratifs, Paris (1982–85). Employing folly, leisure, adventure, and celebration in creating art, Huyghe's films, installations, and public events range from a small-town parade to a puppet theater, from a model amusement park to an expedition to Antarctica. By filming staged scenarios—such as a re-creation of the true-life bank robbery featured in the movie *Dog Day Afternoon*—Huyghe probes the capacity of cinema to distort and ultimately shape memory. While blurring the traditional distinction between fiction and reality, and revealing the experience of fiction to be as palpable as anything in daily life, Huyghe's playful work often addresses complex social topics such as the yearning for utopia, the lure of spectacle in mass media, and the impact of Modernism on contemporary values and belief systems. He has received many awards, including the Solomon R. Guggenheim Museum's Hugo Boss Prize (2002); the Special Award from the Jury of the Venice Biennial (2001); and a DAAD Fellowship (1999–2000). Huyghe has had solo exhibitions at Tate Modern, London and ARC, Musée d'art Moderne de la Ville de Paris (2006); Carpenter Center, Harvard University, Cambridge, Massachusetts (2004); Modern Art Museum of Fort Worth, Texas (2004); Dia Center for the Arts, New York (2003); Solomon R. Guggenheim Museum, New York (2003); Museum of Contemporary Art, Chicago (2000); and Centre Georges Pompidou, Paris (2000). The Public Art Fund commissioned Huyghe to create *A Journey that Wasn't* (2006), which included an expedition to Antarctica, a performance in Central Park, and a video installation at the Whitney Biennial in New York. Pierre Huyghe lives and works in Paris and New York.

Alfredo Jaar

Alfredo Jaar was born in Santiago, Chile in 1956. He received degrees from Instituto Chileno–Norteamericano de Cultura, Santiago (1979) and Universidad de Chile, Santiago (1981). In installations, photographs, film, and community-based projects, Jaar explores the public's desensitization to images and the limitations of art to represent events such as genocides, epidemics, and famines. Jaar's work bears witness to military conflicts, political corruption, and imbalances of power between industrialized and developing nations. Subjects addressed in his work include the holocaust in Rwanda, gold mining in Brazil, toxic pollution in Nigeria, and issues related to the border between Mexico and the United States. Many of Jaar's works are extended meditations or elegies, including *Muxima* (2006) (a video that portrays and contrasts the oil economy and extreme poverty of Angola) and *The Gramsci Trilogy* (2004–05) (a series of installations dedicated to the Italian philosopher Antonio Gramsci, who was imprisoned under Mussolini's Fascist regime). Jaar has received many awards, including a John D. and Catherine T. MacArthur Foundation Award (2000); a Louis Comfort Tiffany Foundation Award (1987); and fellowships from the National Endowment for the Arts (1987) and the John Simon Guggenheim Memorial Foundation (1985). He has had major exhibitions at the Museum of Fine Arts, Houston (2005); Museo d'Arte Contemporanea, Rome (2005); MIT List Visual Arts Center, Cambridge, Massachusetts (1999); and the Museum of Contemporary Art, Chicago (1992). Jaar emigrated from Chile in 1981, at the height of Pinochet's military dictatorship. His exhibition at Fundación Telefonica Chile, Santiago (2006) is his first in his native country in twenty-five years. Alfredo Jaar lives and works in New York.

An-My Lê

An-My Lê was born in Saigon, Vietnam in 1960. Lê fled Vietnam with her family as a teenager in 1975, the final year of the war, eventually settling in the United States as a political refugee. Lê received BAS and MS degrees in biology from Stanford University (1981; 1985) and an MFA from Yale University (1993). Her photographs and films examine the impact, consequences, and representation of war. Whether in color or black-and-white, her pictures frame a tension between the natural landscape and its violent transformation into battlefields. Projects include *Viêt Nam* (1994–98), in which Lê's memories of a war-torn countryside are reconciled with the contemporary landscape; *Small Wars* (1999–2002), in which Lê photographed and participated in Vietnam War reenactments in South Carolina; and *29 Palms* (2003–04) in which United States Marines preparing for deployment play-act scenarios in a virtual Middle East in the California desert. Suspended between the formal traditions of documentary and staged photography, Lê's work explores the disjunction between wars as historical events and the ubiquitous representation of war in contemporary entertainment, politics, and collective consciousness. She has received many awards, including fellowships from the John Simon Guggenheim Memorial Foundation (1997) and the New York Foundation for the Arts (1996). She has had major exhibitions at the San Francisco Museum of Modern Art (2006); Henry Art Gallery, Seattle (2006); ICP Triennial (2006); P.S. 1 Contemporary Art Center, Long Island City (2002); and the Museum of Modern Art, New York (1997). An-My Lê lives and works in New York.

Iñigo Manglano-Ovalle

Iñigo Manglano-Ovalle was born in Madrid, Spain in 1961, and was raised in Bogotá, Colombia and Chicago, Illinois. He earned a BA in art and art history, and a BA in Latin American and Spanish literature, from Williams College (1983), and an MFA from the School of the Art Institute of Chicago (1989). Manglano-Ovalle's technologically sophisticated sculptures and video installations use natural forms such as clouds, icebergs, and DNA as metaphors for understanding social issues such as immigration, gun violence, and human cloning. In collaboration with astrophysicists, meteorologists, and medical ethicists, Manglano-Ovalle harnesses extraterrestrial radio signals, weather patterns, and biological code, transforming pure data into digital video projections and sculptures realized through computer rendering. His strategy of representing nature through information leads to an investigation of the underlying forces that shape the planet as well as points of human interaction and interference with the environment. Manglano-Ovalle's work is attentive to points of intersection between local and global communities, emphasizing the intricate nature of ecosystems. He has received many awards, including a John D. and Catherine T. MacArthur Foundation Award (2001) and a Media Arts Award from the Wexner Center for the Arts, Columbus, Ohio (1997–2001), as well as a fellowship from the National Endowment for the Arts (1995). He has had major exhibitions at the Rochester Art Center, Minnesota (2006); Art Institute of Chicago (2005); Museo de Arte Contemporáneo de Monterrey, Mexico (2003); Cleveland Center for Contemporary Art, Ohio (2002); and the Museum of Contemporary Art, Chicago (1997). Iñigo Manglano-Ovalle lives and works in Chicago, Illinois.

Judy Pfaff

Judy Pfaff was born in London, England in 1946. She received a BFA from Washington University, Saint Louis (1971) and an MFA from Yale University (1973). Balancing intense planning with improvisational decision-making, Pfaff creates exuberant, sprawling sculptures and installations that weave landscape, architecture, and color into a tense yet organic whole. A pioneer of installation art in the 1970s, Pfaff synthesizes sculpture, painting, and architecture into dynamic environments in which space seems to expand and collapse, fluctuating between the two- and three-dimensional. Pfaff's site-specific installations pierce through walls and careen through the air, achieving lightness and explosive energy. Pfaff's work is a complex ordering of visual information composed of steel, fiberglass, and plaster as well as salvaged signage and natural elements such as tree roots. She has extended her interest in natural motifs in a series of prints integrating vegetation, maps, and medical illustrations, and has developed her dramatic sculptural materials into set designs for several theatrical stage productions. Pfaff has received many awards, including a John D. and Catherine T. MacArthur Foundation Award (2004); a Bessie (1984); and fellowships from the John Simon Guggenheim Memorial Foundation (1983) and the National Endowment for the Arts (1986). She has had major exhibitions at the Elvehjem Musem of Art, University of Wisconsin, Madison (2002); Denver Art Museum (1994); St. Louis Art Museum (1989); and Albright-Knox Art Gallery, Buffalo (1982). Pfaff represented the United States in the 1998 São Paolo Bienal. Judy Pfaff lives and works in Kingston and Tivoli, New York.

Lari Pittman

Lari Pittman was born in Los Angeles, California in 1952. Pittman received both a BFA (1974) and an MFA (1976) from California Institute of the Arts, Valencia. Inspired by commercial advertising, folk art, and decorative traditions, his meticulously layered paintings transform pattern and signage into luxurious scenes fraught with complexity, difference, and desire. In a manner both visually gripping and psychologically strange, Pittman's hallucinatory works reference myriad aesthetic styles, from Victorian silhouettes to social realist murals to Mexican *retablos*. Pittman uses anthropomorphic depictions of furniture, weapons, and animals, loaded with symbolism, to convey themes of romantic love, violence, and mortality. His paintings and drawings are a personal rebellion against rigid, puritanical dichotomies. They demonstrate the complementary nature of beauty and suffering, pain and pleasure, and direct the viewer's attention to bittersweet experiences and the value of sentimentality in art. Despite subject matter that changes from series to series, Pittman's deployment of simultaneously occurring narratives and opulent imagery reflects the rich heterogeneity of American society, the artist's Colombian heritage, and the distorting effects of hyper-capitalism on everyday life. Pittman has received many awards, including a Pacific Design Center Stars of Design Award (2004); the Skowhegan Medal (2002); and three fellowships from the National Endowment for the Arts (1987; 1989; 1993). He has had major exhibitions at the Institute of Contemporary Art, London (1998); Los Angeles County Museum of Art (1996); and Contemporary Arts Museum, Houston (1996). He has participated in the Venice Biennale (2003); Documenta X (1997); and three Whitney Biennials (1993; 1995; 1997). Lari Pittman lives and works in Los Angeles.

Robert Ryman

Robert Ryman was born in Nashville, Tennessee in 1930. Ryman studied at the Tennessee Polytechnic Institute and the George Peabody College for Teachers, Nashville, before serving in the United States Army (1950–52). Ryman's work explodes the classical distinctions between art as object and art as surface, sculpture and painting, structure and ornament—emphasizing instead the role that perception and context play in creating an aesthetic experience. Ryman isolates the most basic of components—material, scale, and support—enforcing limitations that allow the viewer to focus on the physical presence of the work in space. Since the 1950s, Ryman has used primarily white paint on a square surface, whether canvas, paper, metal, plastic, or wood, while harnessing the nuanced effects of light and shadow to animate his work. In Ryman's oeuvre, wall fasteners and tape serve both practical and aesthetic purposes. Neither abstract nor entirely monochromatic, Ryman's paintings are paradoxically 'realist' in the artist's own lexicon. Robert Ryman was elected to the American Academy of Arts and Letters (1994) and has received many awards, including a Skowhegan Medal (1985) and a fellowship from the John Simon Guggenheim Foundation (1974). He has had major exhibitions at the Tate Gallery, London (1993); Museum of Modern Art, New York (1993); San Francisco Museum of Modern Art (1994); Walker Art Center, Minneapolis (1994); Dia Art Foundation (1988); Inverleith House, Royal Botanic Garden, Edinburgh, Scotland (2006); and Pennsylvania Academy of the Fine Arts (2006–07). He has participated in Documenta (1972; 1977; 1982); the Venice Biennale (1976; 1978; 1980); the Whitney Biennial (1977; 1987; 1995); and the Carnegie International (1985, 1988). Robert Ryman lives and works in New York and Pennsylvania.

Laurie Simmons

Laurie Simmons was born on Long Island, New York, in 1949. She received a BFA from the Tyler School of Art, Philadelphia (1971). Simmons stages photographs and films with paper dolls, finger puppets, ventriloquist dummies, and costumed dancers as 'living objects', animating a dollhouse world suffused with nostalgia and colored by an adult's memories, longings, and regrets. Simmons's work blends psychological, political and conceptual approaches to art making, transforming photography's propensity to objectify people, especially women, into a sustained critique of the medium. Mining childhood memories and media constructions of gender roles, her photographs are charged with an eerie, dreamlike quality. On first glance her works often appear whimsical, but there is a disquieting aspect to Simmons's child's play as her characters struggle over identity in an environment in which the value placed on consumption, designer objects, and domestic space is inflated to absurd proportions. Simmons's first film, *The Music of Regret* (2006), extends her photographic practice to performance, incorporating musicians, professional puppeteers, Alvin Ailey dancers, Hollywood cinematographer Ed Lachman, and actress Meryl Streep. She has received many awards, including the Roy Lichtenstein Residency in the Visual Arts at the American Academy in Rome (2005) and fellowships from the John Simon Guggenheim Memorial Foundation (1997) and the National Endowment for the Arts (1984). She has had major exhibitions at the Museum of Modern Art, New York (2006); Baltimore Museum of Art (1997); San Jose Museum of Art, California (1990); Walker Art Center, Minneapolis (1987); and has participated in two Whitney Biennials (1985; 1991). Laurie Simmons lives and works in New York.

Nancy Spero

Nancy Spero was born in Cleveland, Ohio in 1926. She received a BFA from the School of the Art Institute of Chicago (1949), and honorary doctorates from the School of the Art Institute of Chicago (1991) and Williams College (2001). Spero is a pioneer of feminist art. Her work since the 1960s is an unapologetic statement against the pervasive abuse of power, Western privilege, and male dominance. Executed with a raw intensity on paper and in ephemeral installations, her work often draws its imagery and subject matter from current and historical events such as the torture of women in Nicaragua, the extermination of Jews in the Holocaust, and the atrocities of the Vietnam War. Spero samples from a rich range of visual sources of women as protagonists—from Egyptian hieroglyphics, seventeenth-century French history painting, and Frederick's of Hollywood lingerie advertisements. Her figures, in full command of their bodies, co-existing in nonhierarchical compositions on monumental scrolls, visually reinforce principles of equality and tolerance. Spero was elected to the American Academy of Arts and Letters (2006). Awards include a Lifetime Achievement Award from the College Art Association (2005); the Honor Award from the Women's Caucus for Art (2003); the Hiroshima Art Prize (jointly with Leon Golub, 1996); and the Skowhegan Medal (1995). Major exhibitions include Centro Galego de Arte Contemporanea, Santiago de Compostela, Spain (2003); MIT List Visual Arts Center, Cambridge, Massachusetts (1994); Institute of Contemporary Art, Boston (1994); Museum of Modern Art, New York (1992), and the Museum of Contemporary Art, Los Angeles (1988). Nancy Spero lives and works in New York.

Catherine Sullivan

Catherine Sullivan was born in Los Angeles, California in 1968. She earned a BFA from the California Institute of Arts, Valencia (1992) and an MFA from the Art Center College of Design, Pasadena, California (1997). Sullivan's anxiety-inducing films and live performances reveal the degree to which everyday gestures and emotional states are scripted and performed, probing the border between innate and learned behavior. Under Sullivan's direction, actors perform seemingly erratic, seizure-like jumps between gestures and emotional states, all while following a well rehearsed, numerically derived script. Unsettling and disorienting, Sullivan's work oscillates between the uncanny and camp, eliciting a profound critique of 'acceptable' behavior in today's media-saturated society. A maelstrom of references and influences—from vaudeville to film noir to modern dance—Sullivan's appropriation of classic filming styles, period costumes, and contemporary spaces such as corporate offices draws the viewer's attention away from traditional narratives and towards an examination of performance itself. Sullivan received a CalArts Alpert Award in the Arts (2004) and a DAAD Fellowship (2004–2005). She has had major exhibitions at the Walker Art Center, Minneapolis, Minnesota (2007); Tate Modern, London (2005); Vienna Secession, Austria (2005); Kunsthalle Zurich, Switzerland (2005); Wadsworth Atheneum Museum of Art, Hartford, Connecticut (2003); UCLA Armand Hammer Museum, Los Angeles (2002); and the Renaissance Society at the University of Chicago (2002). She has participated in the Prague Biennial (2005), the Whitney Biennial (2004), and La Biennale d'art contemporain de Lyon, France (2003). Catherine Sullivan lives and works in Chicago, Illinois.

Ursula von Rydingsvard

Ursula von Rydingsvard was born in Deensen, Germany in 1942. She received a BA and an MA from the University of Miami, Coral Gables (1965), an MFA from Columbia University (1975), and an honorary doctorate from the Maryland Institute College of Art, Baltimore (1991). Von Rydingsvard's massive sculptures reveal the trace of the human hand and resemble wooden bowls, tools, and walls that seem to echo the artist's family heritage in pre-industrial Poland before World War II. Having spent her childhood in Nazi slave labor and post-war refugee camps, the artist's earliest recollections of displacement and subsistence through humble means infuses her work with emotional potency. Von Rydingsvard builds towering cedar structures, creating an intricate network of individual beams, shaped by sharp and lyrical cuts and glued together to form sensuous, puzzle-like surfaces. While abstract at its core, Von Rydingsvard's work takes visual cues from the landscape, the human body, and utilitarian objects—such as the artist's collection of household vessels—and demonstrates an interest in the point where the man-made meets nature. Von Rydingsvard has received many awards, including a Joan Mitchell Award (1997); an Academy Award from the American Academy of Arts and Letters (1994); fellowships from the John Simon Guggenheim Foundation (1983) and the National Endowment for the Arts (1979; 1986); and exhibition prizes from the International Association of Art Critics (1992; 2000). Major exhibitions include Madison Square Park, New York (2006); the Neuberger Museum, SUNY Purchase, New York (2002); and Storm King Art Center, Mountainville, New York (1992). Ursula von Rydingsvard lives and works in New York.

List of Illustrations

Photographic Credits and Copyrights

PROTEST: p. 14, photo by Andreas Keller, © 2007 Jenny Holzer, member Artist Rights Society (ARS), New York; p. 14, text: "Here is New York," reprinted by permission of Martha, Steve, and John White, copyright © E.B. White 1949, 1976; p. 15, photo by Attilio Maranzano, text: *Arno* (1996), © 2007 Jenny Holzer, member Artist Rights Society (ARS), New York; p. 16 (top), photo by Miguel Bargallo and Tony Coll, text: *Inflammatory Essays* (1979–1982), © 2007 Jenny Holzer, member Artist Rights Society (ARS), New York; p. 16 (bottom), photo by Mindy McDaniel, text: *Inflammatory Essays* (1979–1982), © 2007 Jenny Holzer, member Artist Rights Society (ARS), New York; p. 17, photo by Attilio Maranzano, © 2007 Jenny Holzer, member Artist Rights Society (ARS), New York; p. 17, text: "To the Forty-third President," from *BLACKBIRD AND WOLF* by Henri Cole, used by/reprinted with permission from Farrar, Straus and Giroux, LLC., copyright © 2007 by Henri Cole; p. 18, photo by Attilio Maranzano, © 2007 Jenny Holzer, member Artist Rights Society (ARS), New York; p. 18, text: "Blur," from *MIDDLE EARTH* by Henri Cole, used by/reprinted with permission from Farrar, Straus and Giroux, LLC., copyright © 2003 by Henri Cole; p. 19 (top), photo by John Marchael, text: *Survival* (1983–85), © 2007 Jenny Holzer, member Artist Rights Society (ARS), New York; p. 19 (bottom), photo by Lisa Kahane, text: *Truisms* (1977–79), © 2007 Jenny Holzer, member Artist Rights Society (ARS), New York; pp. 20–21, photos by Attilio Maranzano, text: selections from *Truisms* (1977–79), *Inflammatory Essays* (1979–82), *Living* (1980–82), *Survival* (1983–85), *Under a Rock* (1986), *Laments* (1989), *Mother and Child* (1990), *War* (1992), *Lustmord* (1993–95), *Erlauf* (1995), *Arno* (1996), *Blue* (1998), and *Oh* (2001), © 2007 Jenny Holzer, member Artist Rights Society (ARS), New York; p. 22, photo by Attilio Maranzano, text: *Blue* (1998), © 2007 Jenny Holzer, member Artist Rights Society (ARS), New York; p. 23, photo by Steinar Myhre, text: *Under a Rock* (1986), © 2007 Jenny Holzer, member Artist Rights Society (ARS), New York; pp. 24–25, photos by Christopher Burke, © 2007 Jenny Holzer, member Artist Rights Society (ARS), New York; pp. 4–5, 26–31, © Alfredo Jaar, courtesy Galerie Lelong, New York; p. 32, © Alfredo Jaar, courtesy Thord Thordeman, Malmö, and Galerie Lelong, New York; pp. 33–37, © Alfredo Jaar, courtesy Galerie Lelong, New York; pp. 39–49 © An-My Lê, courtesy Murray Guy, New York; pp. 50–53, photos by David Reynolds, © Nancy Spero, courtesy Galerie Lelong, New York; p. 54, 55 (top), photos by Lothar Sprenger, Dresden, © Nancy Spero, courtesy Barbara Gross Galerie, Munich; p. 55 (bottom), pp. 56–60 photos by David Reynolds, © Nancy Spero, courtesy Galerie Lelong, New York; p. 61, photos by Jason Mandella, © Nancy Spero, courtesy Galerie Lelong, New York.

ECOLOGY: pp. 66–77, © Robert Adams, courtesy Fraenkel Gallery, San Francisco and Matthew Marks Gallery, New York; p. 78, photo by Pablo Mason, courtesy Tanya Bonakdar Gallery, New York; pp. 79–85, courtesy Tanya Bonakdar Gallery, New York; p. 86, photo by Chris Burke Studio, courtesy Tanya Bonakdar Gallery, New York; p. 87, courtesy Tanya Bonakdar Gallery, New York; p. 88, courtesy the Seattle Art Museum; p. 89, photos by Paul McCapia, courtesy the Seattle Art Museum; pp. 90–93, courtesy the artist and Max Protetch Gallery, New York; p. 94, photo by Denis Cowley, courtesy the artist and Max Protetch Gallery, New York; pp. 95–98, courtesy the artist and Max Protetch Gallery, New York; p. 99, photos by Alfredo De Stefano, courtesy the artist and Max Protetch Gallery, New York; pp. 100–101, jacket front (bottom), courtesy the artist and Max Protetch Gallery, New York; pp. 102–113, jacket back (bottom), © Ursula von Rydingsvard, Courtesy Galerie Lelong, New York.

PARADOX: pp. 118–123, jacket back (top), courtesy the artists; p. 124, photo by Florian Kleinefenn, courtesy the artists and Galerie Chantal Crousel, Paris; p. 125, courtesy the artists; pp. 126–127, photo by Dawn Blackman, courtesy the artists and Galerie Chantal Crousel, Paris, Gladstone Gallery, New York and Lisson Gallery, London; pp. 128–129, courtesy the artists; p. 130, courtesy the artist and Sikkema Jenkins & Co.; p. 131, courtesy the Los Angeles County Museum of Art; pp. 132–141, courtesy the artist and Sikkema Jenkins & Co.; p. 142, photo by Ellen Page Wilson, courtesy PaceWildenstein, New York; pp. 143–144, photo by Ellen Labenski, courtesy PaceWildenstein, New York; p. 145, photo by Ellen Page Wilson, courtesy PaceWildenstein, New York; pp. 146–149, courtesy PaceWildenstein, New York; p. 150, photo by Kerry Ryan McFate, courtesy PaceWildenstein, New York; p. 151, courtesy the Pennsylvania Academy of the Fine Arts, Philadelphia; p. 152, photo by Ellen Page Wilson, courtesy PaceWildenstein, New York; p. 153, photo by Bill Jacobson, courtesy PaceWildenstein, New York; pp. 154–165, © Catherine Sullivan, courtesy the artist.

ROMANCE: pp. 170–171, © Pierre Huyghe, courtesy Marian Goodman Gallery, Paris/New York; pp. 172–173, photo by Florian Kleinefenn, © Pierre Huyghe, courtesy Marian Goodman Gallery, Paris/New York; p. 174, © Pierre Huyghe, courtesy Marian Goodman Gallery, Paris/New York; p.175, jacket front (top), photos by KuB, Markus Tretter, © Pierre Huyghe, courtesy Marian Goodman Gallery, Paris/New York; pp. 176–177, photos by Michael Vahrenwald, © Pierre Huyghe, courtesy Marian Goodman Gallery, Paris/New York; p. 178 (left), p. 179 (top), photo by Aaron S. Davidson, © Pierre Huyghe, courtesy Marian Goodman Gallery, Paris/New York; p. 178 (right), p. 179 (bottom), photo by Guilherme Young, © Pierre Huyghe, courtesy Marian Goodman Gallery, Paris/New York; p. 180 (bottom), photo by Xavier Veilhan, © Pierre Huyghe, courtesy Marian Goodman Gallery, Paris/New York; pp. 180–181, photo by Pierre Huyghe, © Pierre Huyghe, courtesy Marian Goodman Gallery, Paris/New York; pp. 2–3, photos by Zonder Title and Jordan Tinker, courtesy the artist and Ameringer & Yohe Fine Art, New York; pp. 182–184, courtesy the artist; p. 185, photo by Jordan Tinker, courtesy the artist and Ameringer & Yohe Fine Art, New York; pp. 186–187, photos by Zonder Title and Jordan Tinker, courtesy the artist and Ameringer & Yohe Fine Art, New York; pp. 188–189, photos by Rob van Erve, courtesy the artist; pp. 190–193, courtesy the artist; pp. 194–205, photos by Douglas M. Parker Studio, courtesy the artist, Regen Projects, Los Angeles and Barbara Gladstone Gallery, New York; pp. 206–215, © Laurie Simmons, courtesy the artist and Sperone Westwater, New York; pp. 216–217, © Laurie Simmons, courtesy the artist and Salon 94, New York.

PRODUCTION STILLS: pp. 10–13, 62–65, 114–117, 166–169, 218–221, © Art21, Inc

ENDPAPERS: Mark Bradford, *Los Moscos*, detail, 2004. Mixed media on canvas, 125 x 190½ inches

TITLE PAGE: Judy Pfaff, *Buckets of Rain*, 2006. Installation view: Ameringer & Yohe Fine Art, New York. Wood, steel, wax, plaster, fluorescent lights, paint, black foil, expanding foam, and tape; 2 galleries,
153 x 245½ x 209 inches and 153 x 228½ x 165 inches

TABLE OF CONTENTS: Alfredo Jaar, *The Ashes of Gramsci*, detail, 2005. Metal architecture model, light box with color transparency, wood base, and motor, dimensions variable

Editor: Marybeth Sollins
Associate Curator: Wesley Miller
Designer: Russell Hassell
Production Manager: Alison Gervais

Library of Congress Cataloging-in-Publication Data

Sollins, Susan.
 Art 21 : art in the twenty-first century 4 / by Susan Sollins.
 p. cm.
Summary: Companion book to Art in the Twenty-First Century, the first broadcast series for National Public Television to focus exclusively on contemporary visual art and artists in the United States today.
 ISBN 13: 978-0-8109-9376-1 (vol. 4)
 ISBN 10: 0-8109-9376-7
 1. Art, American—20th century. 2. Art—Forecasting.
3. Artists—United States—Biography. 4. Artist—United States—Interviews.
I. Title: Art in the 21st century. 4. II. Title: Art twentyone.
III. Sollins, Susan.

 2007923772

Printed and bound in China
10 9 8 7 6 5 4 3 2 1

HNA ▌▌▌▌▌
harry n. abrams, inc.
a subsidiary of La Martinière Groupe
115 West 18th Street
New York, NY 10011
www.hnabooks.com